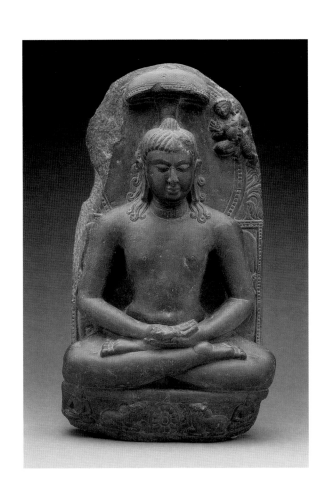

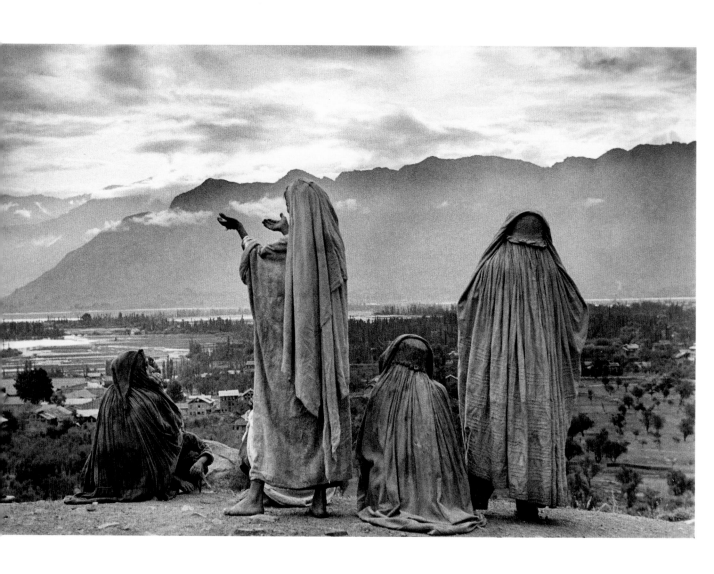

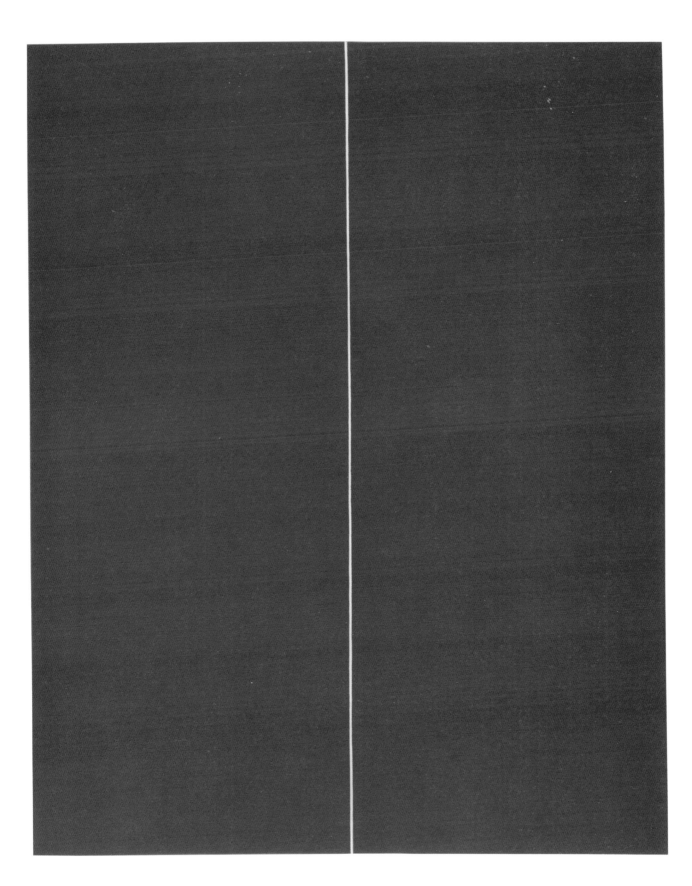

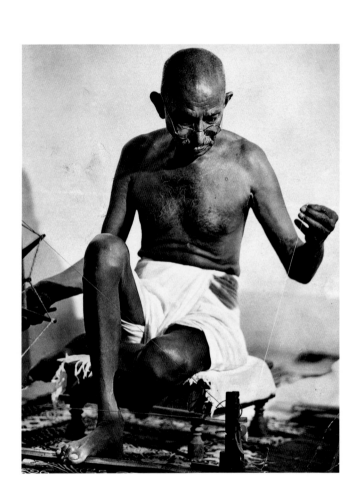

Experiments with Truth

Gandhi and Images of Nonviolence

Editors JOSEF HELFENSTEIN JOSEPH N. NEWLAND

The Menil Collection, Houston

Distributed by Yale University Press, New Haven and London

CONTENTS

Ai Weiwei

Eve Arnold

Umar al-Aqta (attributed)

Frederick C. Baldwin

Nandalal Bose

Walter Bosshard

Margaret Bourke-White

Dan Budnik

Henri Cartier-Bresson

Bernardo Cavallino (attributed)

Mel Chin

Ernest Cole

Bruce Davidson

Marlene Dumas

Henry Dunant

Bob Fitch

Dan Flavin

Suzan Frecon

Theaster Gates

Robert Gober

Shilpa Gupta

Amar Kanwar

William Kentridge

Kimsooja

Yves Klein

Emmanuel Lambardos (attributed)

Danny Lyon

René Magritte

Agnes Martin

Barnett Newman

Robert Rauschenberg

Rembrandt van Rijn

Mark Rothko

Jürgen Schadeberg

Jean Tinguely

Shomei Tomatsu

Andy Warhol

Zarina

Unknown and unnamable calligraphers, photographers, sculptors, and painters

Page 1 Jina Rishabhanatha. East India; Gupta or Pala period, 6th or 7th century. Chlorite, 26 × 16 × 5 inches (66 × 40.6 × 12.7 cm). Yale University Art Gallery, New Haven, Connecticut, Purchased with a gift from Steven M. Kossak, B.A. 1972

Page 2 Henri Cartier-Bresson (France, 1908–2004), Women praying, Srinagar, Jammu and Kashmir, India, 1948, printed 1973. Gelatin silver print, 11 ⅞ × 15 ¾ inches (30.2 × 40 cm). The Menil Collection, Houston

Page 3 Barnett Newman (United States, 1905–1970), Be I, 1949. Oil on canvas, 93 ⅛ × 75 ⅛ inches (128.9 × 119.4 cm). The Menil Collection, Houston, Gift of Annalee Newman

Page 4 Margaret Bourke-White (United States, 1904–1971), Gandhi using his spinning wheel at home, 1946. Gelatin silver print, 14 ⅛ × 11 inches (35.7 × 27.8 cm). The Museum of Fine Arts, Houston, Given in honor of Marjorie G. Horning by Mr. and Mrs. Meredith Long; Isla and Tommy Reckling; Mr. and Mrs. Durga D. Agrawal; Milton D. Rosenau, Jr. and Dr. Ellen R. Gritz; Dr. Ninan and Sushila Mathew; Drs. Ellin and Robert G. Grossman; Mr. and Mrs. Vinod Bhuchar; Mr. and Mrs. Philip J. John, Jr.; and Dr. and Mrs. A. P. Raghuthaman

Opposite page Agnes Martin (United States, 1912–2004), Untitled, 1977. Watercolor, ink, and graphite on paper, 12 ⅛ × 12 ¼ inches (31.2 × 30.5 cm). The Menil Collection, Houston, Anonymous gift in honor of Mr. Walter Hopps

Mohandas K. Gandhi is a complex and complicated figure, deeply shaped by his own inner search and conflicts as well as by British India's overwhelmingly complex transition from colony to divided, hostile modern nation states. Surviving the Independence and Partition only by a few months, Gandhi was both an agent in and an agonized, increasingly powerless observer of this process that captivated not only South Asia but spectators around the globe. Yet, despite our growing distance from his lifetime, Gandhi persistently refuses to sink into the oblivion of history, and instead, perhaps more than ever, continues to arouse strong feelings among both his admirers and his critics and opponents. From the beginning, long before it took the form of an exhibition, the most obvious and perhaps strongest argument against this project, the fact that Gandhi had never manifested great interest in art per se, made this a somehow unpredictable and adventurous endeavor. However, rather than being rooted in an interest in Gandhi as a person, his biography, or the historical context in which he acted, the original idea was triggered by a photograph of some of Gandhi's last possessions, a well-known "portrait" made after his assassination and famously marked by the absence of Gandhi as an individual altogether. The more daunting problem was, therefore, how to define images of or other examples that refer to or can possibly illustrate an *aesthetic of nonviolence*. And, to make things even more unwieldy, is there a relationship between nonviolence and truth, as Gandhi claims? Western art carries a long aversion to being called responsible for or restricted to illustrating reality and especially the horrors of history, and modernism's many movements even more decidedly claimed such a position of independence from, or, sometimes, indifference to historic "truth." The very notion of truth in the title, although referring to Gandhi's autobiography, may therefore be seen as controversial or problematic by some. In any case, a provisional title including the phrase "Art and Truth" was at some point rejected, even though Truth with a capital T was Gandhi's ultimate touchstone.

Many individuals have contributed over the years to the genesis and final shape of this exhibition and book, many more than can be mentioned in the Acknowledgments that follow. Their questions, doubts, critiques, and their own thoughts, deliberations, and contributions became an integral part of the discourse without which this project would never have taken the form it has. I am deeply grateful to all of them. A research trip to India and Nepal that I was granted by the Menil Trustees in November 2009 became the final experience to solidify the exhibition *Experiments with Truth: Gandhi and Images of Nonviolence*. From then on, we gradually created a core Gandhi team at the Menil that included a number of my colleagues who made crucial contributions of research, reaching out to scholars, and bringing new material to our attention that helped to solidify the concept as well as the content of the book. It comprised Eric M. Wolf, Clare Elliott, Karl Kilian, Joseph N. Newland, Toby Kamps, Madeline Kelly, Brooke Stroud, and David Aylsworth. I am deeply grateful for their many enriching contributions and their spirit of collegiality and intellectual creativity which made this one of the most rewarding projects of my entire career. I am especially grateful to Joseph Newland, director of publications, whose passion for and impressive knowledge about many topics relevant for this project made him an ideal leader to envision and then successfully oversee and implement all aspects of this publication. This productive collaborative process became even more meaningful and complex when numerous colleagues from local cultural and other nonprofit institutions and organizations of various kinds–many of which we at the Menil Collection had never engaged and collaborated with before–joined us to expand *Experiments with Truth* into the larger city of Houston. Their for the most part unforeseeable contributions made this a truly enriching, multifaceted, and pleasantly adventuresome process.

Josef Helfenstein
Director

Among the many people who have contributed to shaping this project, our first expression of gratitude goes to the filmmaker and artist Amar Kanwar for engaging in many years of far-flung and wide-ranging discussions with Josef Helfenstein about ideas, art, and artists. We first engaged with the historian and Gandhi scholar Vinay Lal in 2013 and have benefitted immensely from long and probing discussions about Gandhi, his image, and his legacy; Joseph Newland is especially grateful to his counsel during the book's preparation. Additional important discussions were had with Marcia Brennan, Rajmohan Gandhi, Ken Robbins, Vahid Kooros, and Anne C. Klein, as well as Janice Leoshko, Linda Hess, and Stephen Markel. In India, helpful advice was given by Dr. Varsha Das, then-Director of the National Gandhi Museum, New Delhi, Amrut Modi, Peter Nagy, Amithav Nath, Dilip Simeon, and Tridip Suhrud. Closer to home, Consul General of India Houston Parvathaneni Harish deserves our special gratitude.

Roger Mayou, Director of the International Red Cross and Red Crescent Museum, Geneva, was generous with his time and expertise, and we are very happy that a smaller version of the exhibition will be able to travel there, thanks to Roger and Sandra Sunier.

While the exhibition has been shaped around works of art and the wide range of artifacts in the Menil Collection, we are grateful to a number of private and institutional lenders for the loan of important objects to the exhibition: Marlene Dumas; Fondation Henri Cartier-Bresson, Paris; Stephen Flavin; Foundation for Woman Artists, Antwerp; Suzan Frecon; Theaster Gates; Marian Goodman Gallery, New York and Paris; High Museum of Art, Atlanta; Holocaust Museum Houston; International Red Cross and Red Crescent Museum, Geneva; Amar Kanwar; William Kentridge; Kimsooja Studio; Kravis Collection; Los Angeles County Museum of Art; The Library of Congress, Washington, DC; Luhring Augustine, New York; McNay Art Museum, San Antonio, Texas; The Morgan Library & Museum, New York; The Museum of Fine Arts, Houston; Marilyn Oshman; Kenneth and Joyce Robbins; The Rachofsky Collection, Dallas, Texas; Rothko Chapel, Houston; Smithsonian Institution, National Portrait Gallery, Washington, DC; Solomon R. Guggenheim Museum, New York; Karen and Frank Steininger; Nancy Wiener Gallery, New York; Whitney Museum of American Art, New York; Yale University Art Gallery, New Haven, Connecticut; Zarina; David Zwirner, New York/London; and those lenders who wish to remain anonymous.

For special help in securing crucial loans we would like to extend special thanks to Adam Weinberg, the Alice Pratt Brown Director at the Whitney Museum of American Art in New York, and Stephen Markel, while the Harry and Yvonne Lenart Curator and Department Head of South and Southeast Asian Art at the Los Angeles County Museum of Art. Valuable colleagues at other institutions include Alison De Lima Green, Yasufumi Nakamori, Christine Starkman, Anne Tucker, and Dena M. Woodall, The Museum of Fine Arts, Houston; Carol Manley, Director of Collections and Exhibitions/Registrar, Holocaust Museum Houston; and Aude Raimbault, Collections Curator, Fondation Henri Cartier-Bresson.

The input of artists, both creatively and conversationally, evidences the many ways that nonviolence and humanist values can be expressed–even without shared vocabularies–and our sincere appreciation is due to: Ai Weiwei, Fred Baldwin and Wendy Watriss, Janet Cardiff and George Bures Miller, Mel Chin, Bruce Davidson, Marlene Dumas, Suzan Frecon, Theaster Gates, Robert Gober, Shilpa Gupta, Stuart Isett, Amar Kanwar, William Kentridge, Kimsooja, Danny Lyon, Jürgen Schadeberg, Jeff Widener, and Zarina. And for their assistance with some of the above-mentioned: Claudia Carson, Darryl Leung, Graham McNamara, Simon Corless, Claudia Schadeberg, and Kate Hadley Williams.

The following dealers have provided essential support: David Zwirner Gallery, New York, Bellatrix Hubert, Kristine Bell, Martha Moldovan, and Allana Strong D'Amico; Luhring Augustine, New York, Lisa Varghese; Marian Goodman Gallery, New York, Marian Goodman and Leslie Nolen; Galerie Urs Meile, Lucerne and Beijing; Nancy Wiener Gallery, New York, Nancy Wiener and Leiko Cole; and Zeno X Gallery, Antwerp.

The Menil staff has performed with their customary and always appreciated professionalism. In addition to the core project team of Head Librarian Eric M. Wolf, Exhibitions Designer Brooke Stroud, Publisher Joseph N. Newland, Head of Public Progams Karl Kilian, Curator of Modern and Contemporary Art Toby Kamps, Assistant to the Director Madeline Kelly, Assistant Curator Clare Elliott, and Collections Registrar David Alysworth, as the project came closer to realization, Chief Advancement Officer Jean Joransen Ellis and Director of Foundation Relations Tedd Bale jumped in wholeheartedly, and were

joined by project intern Patrick Huang to work with those participants whose offerings made up the community conversation of Gandhi's Legacy: Houston Perspectives (see www.gandhislegacyhouston.org).

Invaluable research was provided by Geraldine Aramanda and Lisa Barkley, who constantly came up with relevant materials in the Menil Archives. Colleagues in the curatorial department who gave their invaluable support include Michelle White, Paul Davis, Susan Sutton, and Paul Doyle. In the registrar's office, the brunt was handled by David Aylsworth with Heather Schweikhardt, supported by their former department head, Anne Adams. Brooke Stroud assisted by Eric Zimmerman shouldered an unusually large and complex exhibition design with characteristic ease and skill. We thank Tom Walsh and his Art Services colleagues Tobin Becker and Tony Rubio for ensuring that the exhibition was installed with care and for bringing out many works for examination during the planning. The careful work of conservators Bradford Epley, Katrina Rush, Jan Burandt, Kari Dodson, and Shelley Smith, and of framer Adam Baker is invaluable. We acknowledge our security and facilities staff under the direction of Getachew Mengesha, Steve McConathy, and Jack Patterson for their role in guaranteeing the continued safety of the works in the exhibition.

In addition to Karl Kilian's extended efforts to secure complementary public programs and work closely with members of Houston's larger community of interest, he and his colleague Tony Martinez always present seamless events.

We appreciate the efforts on behalf of the exhibition and catalogue of all of Jean Joransen Ellis's Advancement staff, including Manager of Individual Giving Amanda Shagrin, Manager of Corporate Relations Caroline Williams, and for her efforts prior to her departure, Alexis Harrigan; Membership Coordinator Jennifer Hennessey and the Special Events Department of Elsian Cozens and Eileen Johnson make certain that numerous programs and gatherings are executed flawlessly. Vance Muse and Gretchen Sammons in Communications never stint in their efforts, and their work on this project was exemplary. For vital behind the scenes work we're fortunate to have Jocelyn Bazile, Lisa DeLatte, Shiow-Chyn Susie Liao, and Patrick Saccomanno ably accounting for so much. For their thoughtful oversight of the project, special thanks are due Budget and Project Manager Melanie Crader, former Chief Financial Officer Michael Cannon, and for constantly keeping both the big picture and myriad details in sight and smoothly running, Deputy Director and Chief Operating Officer Sheryl Kolasinski.

Any book–particularly one conceived as a reader–is built around the words and insights of its authors, and in addition to the many whose texts we have the honor to reprint, for their texts we are indebted to Eric Wolf, Emilee Dawn Whitehurst, Neelima Shukla-Bhatt, Vinay Lal, Toby Kamps, Patricia Holmes, Linda Hess, and Mimi Crossley Detering, many of whom also advised Joseph Newland on his biographies and the excerpts. Our book designers Lorraine Wild and Amy Fortunato at Green Dragon Office quickly grasped a complex conceptual program and highly varied material to produce a book as well articulated as it is handsome. Amie Cooper of The Actualizers oversaw the production with her customary wizardry. At the Menil, Assistant Editor Sarah E. Robinson performed myriad duties with her customary grace, accuracy, and aplomb. We hope the results are an engaging anthology for those new to the subject as well as old hands.

Many other people have contributed in various ways to the endeavor of "the Gandhi project," and while it is not possible to thank each and every one–and we apologize for those where memory fails–we would like to thank Pradeep Anand, Martin Brauen, Laura Bush, Stephanie Chadwick, Corinne Chaponnière, David Cook, Rachel Cooper, Charles Correa, Vishakha N. Desai, Julian Filochowski, Marion Barthleme Fort, Patriccus Fortiori, Eric Ghysels, Roopa Gir, Ramachandra Guha, Roy Hamilton, Stephen Hamilton, Paul Hester, Ashley Clemmer Hoffman, Anita Jaisinghani, Mary Kadish, Fariha de Menil Friedrich Karimnia, Gunilla Knape, Vahid Kooros, Atul B. Kothari, Francesca Leoni, Sonya Quintanilla, Lawrence Rinder, Laureen Schipsi, Bipin Shah, Kavita Singh, Franklin Sirmans, Rev. Bruce Southworth, the late Harald Szeemann, Rev. Nancy Talbot, Koozma J. Tarasoff, Wheeler Thackston, Robert Thurman, Neville Tuli, Richard Tuttle, Suna Umari, Kristina Van Dyke, David White, and John Zipprich.

The museum's Board of Trustees have been strong backers of this project, and we are indebted to their ongoing support, particularly that of President Janet Hobby and Chairman Louisa Stude Sarofim. Further thanks are owed to our sponsors, who have made the exhibition and publication possible through their generous support: Clare Casademont and Michael Metz; Franci Neely Crane; Anne and David Kirkland; Anne and Bill Stewart; Nina and Michael Zilkha; H-E-B; Skadden, Arps; Suzanne Deal Booth; Janet and Paul Hobby; Marilyn Oshman; Baker Hughes Foundation; Diane and Mike Cannon; Molly Gochman in honor of Louisa Stude Sarofim; Mark Wawro and Melanie Gray; Mahatma Gandhi Library; and the City of Houston. United Airlines is the Preferred Airline of the Menil Collection.

Josef Helfenstein Joseph N. Newland

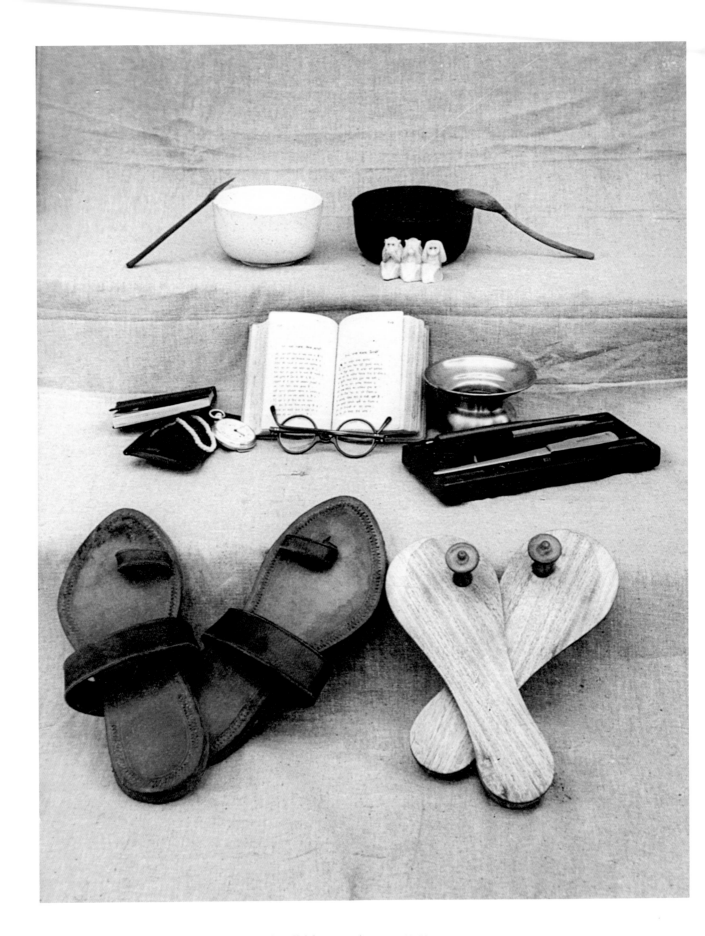

Some of Gandhi's last possessions, ca. 1948–50.
Photographer unknown. James Otis/GandhiServe

16

JOSEF HELFENSTEIN

A Provisional Introduction

Experiments with Truth:
Gandhi and Images of Nonviolence

I must have seen the famous photograph of Gandhi's last possessions the first time as a teenager when I read Mohandas K. Gandhi's *An Autobiography or The Story of my Experiments with Truth*. This captivating image not only felt like a portrait (in absentia) of a charismatic person, but an allegory of a rather extraordinary way of life–in sharp contrast to the environment I grew up in the 1960s and '70s, one of boundless consumer optimism on the one hand, and social upheaval, the Cold War, a crackdown on dissent under apartheid, and violent coups and brutal wars in Asia and Latin America on the other. It was when I started working at the Kunstmuseum Bern and began to engage professionally with visual material that a vague idea emerged that this enigmatic image deserved a more thorough examination. The decision to use this photograph as a catalyst for a project came about coincidentally in 1998 when the Indian architect Charles Correa gave a lecture at the museum, discussing in detail his conceptual work and design of the memorial museum at Gandhi's Sabarmati Ashram in Ahmedabad. A conversation with Correa after his lecture encouraged me for the first time to begin formulating ideas for an exhibition.

It took several years (and a professional move to the United States) to advance this concept into something more concrete–although still far from being a consistent or, even more so, a coherent project. Another coincidental encounter and yet important detail in the gestation process came in 2000 in the first weeks after my arrival at the University of Illinois in Urbana-Champaign when I met Professor Rajmohan Gandhi, a grandson of the Mahatma, at a reception for recently appointed new faculty. It seemed natural to share with him my still vague plans about an exhibition with the photograph of some of Gandhi's last possessions as its inspirational reference point. Rajmohan, in turn, told me about

his much more ambitious, daunting project, a Gandhi biography on which he had worked many decades. He intended to finish his book in the foreseeable future, and his extensive, seven-hundred-page biography was indeed published in 2006 in India, and the following year in the US.[1]

When I arrived at the Menil Collection in Houston in 2004, the now more robust idea of a project focusing on Gandhi and images of non-violence seemed to finally have found the right location to be brought to fruition. I came to realize the degree to which humanism, human rights, and ethical concerns had informed the collection and legacy of this institution. Starting in 1960 with the research that resulted in the publication series The Image of the Black in Western Art, the Menil Foundation has supported various endeavors focusing on broader human and social issues for many decades. The opening of the Rothko Chapel in 1971, a singular art space dedicated to human rights, signaled the beginning of John and Dominque de Menil's public involvement with charismatic leaders of some of the most significant movements for nonviolent social and political reform in the second half of the twenti-eth century. The de Menils believed that human beings are universally entitled to basic rights. They were convinced that art and activism should go hand in hand. As they began to support large causes in the 1950s and '60s, the range of their projects and passions included enhancing education, desegregating schools, funding very specialized research and publications, and, after the Rothko Chapel was founded, organizing international conferences and lectures, many of which were groundbreaking in the context of social causes, interreligious toler-ance, and human rights. A number of awards given by the chapel over the years have recognized activists and humanitarians and publicized their work and causes.

My discovery of a very large group of photographs in the collection by Henri Cartier-Bresson (a close friend of the de Menils), among them iconic images from his first trip to India and Pakistan in 1947–48, as well as a significant number of works by other artists whom I associate with the larger topic of "nonviolence" in the broadest sense, added more layers of content relevant for this project. And, most importantly, from the very beginning, strong positive reactions from colleagues in and outside the Menil Collection, members of the de Menil family, trustees, and especially artists with whom I started to discuss the idea provided the necessary encouragement to begin in earnest working on this exhibition.

1 Rajmohan Gandhi, *Gandhi: The Man, His People, and the Empire* (Berkeley and Los Angeles: University of California Press, 2007).

The foundation for Gandhi's thinking about and implementation of nonviolence was laid in what is now the Republic of South Africa. It was the result of a difficult personal struggle over how to define his position in the face of oppression. Gandhi moved to colonial South Africa in 1893, after studying law in London (1888–91) and failed attempts to establish a legal practice in India.[2] Durban's leading Indians included Muslims (Abdullah Sheth, who had hired Gandhi as legal counselor, was one), Hindus, Parsis, and Christians, and as soon as he arrived, Gandhi made a point to meet with all of them.[3] After working in and from Durban, in 1903 he set up his legal practice in Johannesburg. From the start, Gandhi was thrown into the reality of daily discrimination and racist policies against people of color, all of which led him to quickly become a leading figure of a movement to resist and improve the conditions of Indian immigrants and indentured laborers. He created the strategy of nonviolent resistance gradually and through experience, but the breakthrough came in a crucial moment of his struggle. On September 11, 1906, Gandhi addressed a mass meeting of South Asians (followers of various faiths) at the Empire Theatre in Johannesburg, protesting new racist legislation specifically directed against Indians. It was known as the Black Act, under which all Indians

2 See Ramachandra Guha, *Gandhi before India* (New York: Knopf, 2013), 64ff. At the time of Gandhi's stay, the Union of South Africa was not yet consolidated. Durban, where he arrived, was in the then-British-ruled colony of Natal, whose capital was Pietermaritzburg. The Transvaal region with Johannesburg as its center was in the Boer South African Republic, ruled by an increasingly racist oligarchy of white Afrikaners.

3 R. Gandhi, *Gandhi: The Man*, 58.

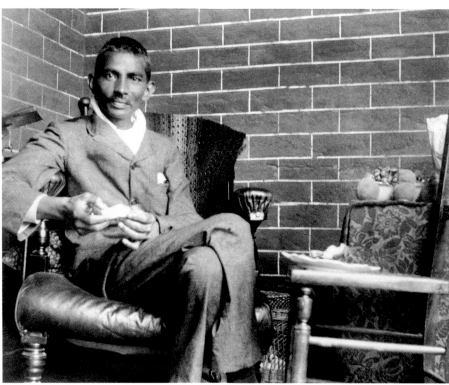

Gandhi recuperating the week after he was beaten when making his way to a registration office, South Africa, February 18, 1908. Photographer unknown.
Dinodia Photos/ Getty Images

in the Boer-ruled Transvaal would be forced to register and give their fingerprints.[4] Gandhi recounts how, during the rally, a senior Muslim proposed that the participants take a sacred oath to refuse to comply with the legislation, a surprise move that galvanized everyone at the meeting and earned unanimous support.[5] This unplanned, yet powerfully transformative act became a turning point for Gandhi, leading to a new form of resistance to unjust laws and an oppressive government. Gandhi would soon call this method of nonviolent resistance *satyagraha*, a newly formed Sanskrit term meaning "firmness adhering to truth" or "soul force."[6]

After living for ten years in an oppressive environment for people of color, Gandhi was convinced that violence would not lead to lasting freedom, independence, or a society based on moral principles such as equality of ethnicity, gender, and religion. From the beginning, however, nonviolence was for Gandhi a more fundamental issue than a mere political tactic. Satyagraha was for him an act based on experiential truth, a way of life that is based on an "understanding about the inherent worth and dignity of all life."[7] He was adamant that nonviolence had nothing to do with what many called passive resistance–in fact, it was the exact opposite of passive behavior. From Gandhi's own experience, he realized that nonviolence requires discipline (especially in cases of sustained oppression and growing fear and frustration) to overcome the reflex of using violent means.[8] It also calls for a great deal of courage and bravery. Before Gandhi undertook civil disobedience campaigns, he therefore tried to prepare the *satyagrahis* (the practitioners of satyagraha) as best as he could for the nonviolent confrontation. To counter intimidation, imprisonments, physical attacks, and other forms of violence used by his opponents, he desired that "satyagrahi be trained in self-discipline to accept such pains and not return violence with violence."[9]

In addition to being mindful of their opponents and methods and therefore acting in a highly disciplined manner, Gandhi insisted that satyagrahis be courageous. He himself had learned that overcoming fear and its paralyzing consequences was difficult, but crucial. Gandhi noted that nonviolent action meant in itself breaking the chains of fear by making an informed decision to act in spite of the consequences; or, bluntly put in his 1908 book *Hind Swaraj*: "Passive resistance cannot proceed a step without fearlessness," and "strength lies in absence of fear, not in the quantity of flesh or muscle we may have on our bodies."[10] Moral courage was indeed central to Gandhi's concept of nonviolence. True heroism in his sense, however, is fundamentally different from Western notions of (military) heroism.[11]

4 M.K. Gandhi, *Satyagraha in South Africa* (1928), vol. 3, *Selected Works of Mahatma Gandhi* (SWMG) 2nd rev. ed. (Ahmedabad : Navajivan Publishing House, 1950), chapter 12, The Advent of Satyagraha, 140ff.

5 R. Gandhi, *Gandhi: The Man,* 112; Jonathan Hyslop, "Gandhi 1869–1915: The Transnational Emergence of a Public Figure," in *The Cambridge Companion to Gandhi*, ed. Judith M. Brown and Anthony Parel (Cambridge: Cambridge University Press, 2011), 44. For a detailed and nuanced report on and assessment of this transformative meeting, see Guha, *Gandhi before India*, 206–11.

6 M.K. Gandhi, *Satyagraha in South Africa,* chapter 12, 150ff.

7 Roland J. Terchek, "Conflict and Nonviolence," in *The Cambridge Companion to Gandhi*, 117.

8 "To resort to violence when confronted with outrageous events or conditions is enormously tempting because of its inherent immediacy and swiftness." Hannah Arendt, *On Violence* (New York: Harcourt, Brace, and World, 1969), 63. On the complex relationship between power and violence, see 5off.

9 M.K. Gandhi, *Satyagraha in South Africa,* chap. 13, Satyagraha v. Passive Resistance; Terchek "Conflict and Nonviolence," 119.

10 Gandhi, *Hind Swaraj* (1910) in *Hind Swaraj and Other Writings* (Cambridge: Cambridge University Press, 2009), 44, 96. See also Nelson Mandela: "I learned that courage was not the absence of fear, but the triumph over it. [...] The brave man is not he who does not feel afraid, but he who conquers that fear." Nelson Mandela, *Long Walk to Freedom: The Autobiography of Nelson Mandela* (Boston and Austin: Little, Brown, 1988), 457.

11 For Gandhi's definition of "Soul-Force" against "Brute Force," see *Hind Swaraj*, 77ff.

Opposite page Gandhi with Abdul Ghaffar Khan during Gandhi's visit to the North-West Frontier Province of India, 1938. Photographer unknown. Imagno/Getty Images

The difficulty, however, of maintaining Gandhi's high standards became apparent in 1922, two years into a noncooperation campaign for Indian independence, when violent oppression and systematic incarceration of virtually all the leaders (including Gandhi) crippled the movement to a degree that disciplined nonviolence could not be sustained. Gandhi therefore decided to stop the campaign. Among the greatest achievements of nonviolent resistance in British India was the movement led by Gandhi's ally, Abdul Ghaffar Khan, called the Frontier Gandhi, and carried out by the Muslim Pashtuns (Pakhtuns). The Pashtuns in Ghaffar Khan's movement practiced nonviolence in perhaps the bravest and most consistent way, and it is a cruel irony of history that their struggle, crushed by both the British (with the complicity of the Muslim League) and later by the Government of Pakistan, has virtually been written out of the history books.[12]

It is important to note that, in addition to its ethical-spiritual basis, Gandhi's concept of nonviolence was initially shaped by pragmatism as well. Moral courage was not enough to create political change. Gandhi, although often portrayed as a naïve idealist, was in fact the opposite: he was not only a trained lawyer but a talented and clever strategist who studied the realities and mechanics of power for many years, especially when discrimination in South Africa pushed him increasingly into political action. By insisting on the use of nonviolent means, he also sought a tactical advantage by determining "the terrain on which the contest will be conducted, rather than [to] accept the violent grounds preferred by many adversaries."[13]

12 Gene Sharp, *Gandhi as a Political Strategist* (Boston: Porter Sargent, 1979), 64. See Abdul Ghaffar Khan, *My Life and Struggle; Autobiography of Badshah Khan as narrated to K.B. Narang*. Trans. Helen H. Bouman. (Delhi: Hind Pocket Books 1969).

13 Terchek, "Conflict and Nonviolence," 128.

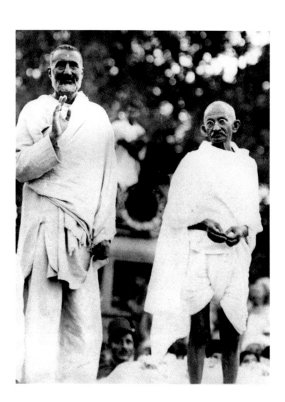

Gandhi repeatedly mentioned that his spiritual search, his very personal pursuit for moral improvement, was inseparable from political action. He always attempted to connect his search for spiritual self-realization with the improvement of economic and political well-being on a large public scale.[14] Politics, religion, morality, even economics formed for him an indivisible whole. They were all part of the search for the realization of the self.[15] In fact, Gandhi later claimed that the deeply humiliating experience of discrimination when he was thrown off the train at Pietermaritzburg Station, Natal, only weeks after arriving in South Africa, resolved the dilemma of his life-goal–"whether it should be political or spiritual."[16]

At the same time, Gandhi was a deeply religious man, although in a very personal, eclectic, or–in today's vocabulary–nonfundamentalist way, searching for a truth that was not necessarily confined to one faith.[17] In the course of his studies of different religious traditions, Gandhi discovered and repeatedly maintained in his writings and speeches that basic commitments to truth and nonviolence can be found in all religions.[18] Resisting any claim of definitive, exclusively "correct," traditional interpretation of holy scriptures, Gandhi declared: "I decline to be bound by any interpretation, however learned it may be, if it is repugnant to reason or moral sense."[19] As he had experienced through the living example of his parents, Gandhi always believed in the natural relationship between personal (spiritual) life and the public life of service to others, especially the poor and disadvantaged.[20] The relationship between personal spiritual practice and public service is a crucial element of Gandhi's understanding of religion, inseparably linked to his own experience.[21]

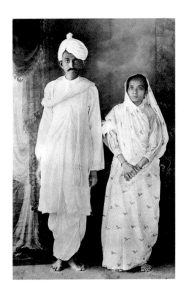

14 Anthony Parel, "Gandhi and Independent India," in *The Cambridge Companion to Gandhi*, 229; Vinay Lal, "Gandhi's Religion: Politics, Faith, and Hermeneutics," *Journal of Sociology and Social Anthropology* 4, no. 1–2 (January and April 2013): 31–40.

15 Thomas Weber, "Gandhi's Moral Economics: The Sins of Wealth without Work and Commerce without Morality," in *The Cambridge Companion to Gandhi*, especially 141.

16 R. Gandhi, *Gandhi: The Man*, 61; M. K. Gandhi, *An Autobiography or The Story of my Experiments with Truth*, translated by Mahadev Desai. Vol. I was published in 1927, vol. II in 1929, part II, VIII (On the Way to Pretoria).

17 On the remarkable depth and eclectic interests of Gandhi's religious studies, see the excellent essays by Akeel Bilgrami and Vinay Lal: Akeel Bilgrami, "Gandhi's Religion and Its Relation to His Politics," in *The Cambridge Companion to Gandhi*, 93–116; Lal, "Gandhi's Religion."

18 R. Gandhi, *Gandhi: The Man*, 38; Bilgrami, "Gandhi's Religion and Its Relation to His Politics," 94.

19 In *Young India* (October, 6, 1921), as quoted in Bilgrami, "Gandhi's Religion and Its Relation to His Politics," 95; also in Lal, "Gandhi's Religion, 37, he is quoted as saying: "Truth is superior to everything and I reject what conflicts with it. Similarly that which is in conflict with nonviolence should be rejected. And on matters which can be reasoned out, that which conflicts with Reason must also be rejected."

20 R. Gandhi, *Gandhi: The Man*, 5–7.

21 See Bilgrami, "Gandhi's Religion and Its Relation to His Politics," 102.

Gandhi and his wife Kasturba just after their return to India, 1915.
Photographer unknown. akg-images/Archiv Peter Rühe

22 M. K. Gandhi, *An Autobiography*, part IV, chap. 5, Result of Introspection.

23 Bilgrami," Gandhi's Religion and Its Relation to His Politics," 102; Lal, "Gandhi's Religion," 37–39.

24 Education is a complex topic in Gandhi's socio-ethical thinking. Although he had benefited from a European education, Gandhi was highly critical of it, mainly because of its lack of emphasis on moral conduct. See his *Hind Swaraj*, 98ff. On a more personal level, Gandhi considered his neglecting the education of his wife and four sons as one of his biggest failures. M. K. Gandhi, *An Autobiography*, part IV, chap. 23, A Peep into the Household. For a more measured study of Gandhi's failings as a husband and, especially, a parent, see Guha, *Gandhi before India*, 201–3, 413–18, and 515ff. On health and sanitation, see Parel, "Gandhi and Independent India," 233.

25 R. Gandhi, *Gandhi: The Man*, 6.

Gandhi's remarkably original definition of morality and religion was based on his eclectic, extended studies of various scriptures and traditions, beginning in England with Christianity, although the *Bhagavad Gita* eventually came to be, as he said, his daily moral guide.[22] Gandhi's unorthodox views about the role and limits of orthodox religions provides a key to his understanding of nonviolence or *ahimsa*. He aimed for what a number of religious leaders and reformers had done before him throughout history (and some of them had paid for it with their lives), transforming the idea of religion "from its doctrinal and textual form to its experiential" and, what Gandhi believed, its universal form.[23]

Although an increasingly influential group of Hindus would come to see Gandhi as a heretic (and, as is well known, he was assassinated by a Hindu nationalist), Gandhi's conception was not new and can in a sense be traced back to India's heritage of nonexclusionary religions including Buddhism, a tradition that the Buddha himself termed not a religion but a system of ethical conduct. Like the Buddha and others long before him, Gandhi rejected untouchability and phobic notions of pollution from the caste system. Instead of debating interpretations of scriptures, Gandhi sought to put them to action. As a religious man, he said he felt compelled to act where help was most needed, that it was his duty to eliminate India's chronic poverty, improve gender equality, establish a just economy, create respect for every religion, reduce the mental and physical distance between the rich and the poor, and improve education, health, and sanitation.[24] However, Gandhi was convinced that none of this was achievable through violent means, and that at the core of nonviolence was the search for spiritual self-realization or, as he came to call it, the search for truth.

A PILGRIM SEARCHING FOR TRUTH: GANDHI'S SELF-IMAGE

Over the course of his life, Gandhi went through a number of considerable changes in his lifestyle even as other customs and habits remained constant. Like most Hindus, Gandhi grew up in a strictly vegetarian household, and the emphasis on practicing simplicity, prayer, fasting, and, to a lesser degree, communal living, was familiar to him. He had seen his deeply religious mother fasting regularly,[25] and, as is well known, Gandhi became highly skilled in using the fast as a powerful instrument for political change.

When Gandhi studied in England, he started to thoroughly study vegetarianism, food, and its connection to a healthy physical as well as social body, and he became a well-known participant and speaker in

vegetarian circles. He also began a rigorous practice of physical exercise, especially long daily walks, which he continued after he returned to India and moving on to South Africa. Even in old age, Gandhi continued to take his long morning and evening walks.[26] On the one hand, he maintained that daily walking improved health and helped in keeping a clear mind.[27] On the other hand, it was an expression of simple living, as most Indians, especially the rural poor who didn't have the means to use mechanical transportation, knew all too well. Walking was a way to connect with India's culture, as it was part of an old tradition of wandering holy men, monks, and other seekers reaching back more than two millennia and before the time of the Buddha. In addition, however, long walks became for Gandhi the strategist a very effective self-presentation as a pilgrim searching for truth; and in South Africa he transformed marches into a powerful symbol of collective resistance. Gandhi's Salt March to the Indian Ocean in the spring of 1930 was probably the most famous example of how he used ancient and very basic forms of communal action–a group walk and making salt–turning them into a nonviolent, highly successful, and globally reported mass movement that challenged the British Empire.

Gandhi gave new meaning to other simple actions based in local idioms that illiterate, poor Indians could easily relate to.[28] These included wearing homespun cloth (*khadi*) and using the spinning wheel (*charkha*), the latter mainly the domain of women; well suited to everyday duties and responsibilities, these things could easily become symbols of political activism, drawing many of the poorest Indians (both men and women) for the first time into political action.

More controversial, not only to non-Indians, was Gandhi's relationship with sex and his decision to link celibacy with nonviolence. The outbreak of the Zulu rebellion against the white rulers in the British colony of Natal in 1906 compelled Gandhi to create (for the second time in South Africa) an Indian ambulance unit. He was, however, horrified by the massacres carried out by the settler militia, and this traumatic experience seems to have propelled him to adopt a more radical (and personal) pacifism that included his decision to give up sex. Sexual abstinence was an established tradition of Hindu devotion, known as *brahmacharya*. At this point in his life as a public figure, Gandhi must have been well aware of the political capital his persona as a man of high moral integrity represented, and this would become even more relevant later in his life. By making simplicity, celibacy, and asceticism "an increasingly central part of his self-image," he was able to present himself as a holy man in the eyes of his followers, and therefore "as a figure of unique political authority."[29]

26 "The walking Gandhi would become a familiar image to his London friends." R. Gandhi, *Gandhi: The Man*, 33 (quote), 50, and 629; also see Guha, *Gandhi before India*, 46: Gandhi "walked an average of 8 miles a day" in London.

27 Gandhi's booklet *A Guide to Health* (1921) was his most widely read work during his lifetime. M. K. Gandhi, *Hind Swaraj*, 62; he completed a second extended version, *Key to Health*, in 1942 (SWMG, 4:377). Mandela commented in similar ways about the importance of physical exercise, especially under the harsh conditions of life in prison: "I have always believed that exercise is not only a key to physical health but to peace of mind.... Exercise dissipates tension, and tension is the enemy of serenity. I found that I worked better and thought more clearly when I was in good physical condition, and so training became one of the inflexible disciplines of my life. In prison, having an outlet for one's frustrations was absolutely essential." Mandela, *Long Walk to Freedom*, 319.

28 Even in 1947 when India and Pakistan became independent nations, female illiteracy was still estimated at 90 percent. Yasmin Khan, "Gandhi's World," in *The Cambridge Companion to Gandhi*, 26.

29 Hyslop, "Gandhi 1869–1915," 43.

One of the most effective manifestations of Gandhi's public persona, in a time of quickly expanding newspaper journalism and movie cameras, was the way he dressed. When growing up in the traditional environment of the princely state of Porpandar in Gujarat in the 1870s, Gandhi dressed in his local clothes and turban. The trip to England in 1888 to study law resulted, however, in a complete change of his appearance. Gandhi spent a considerable amount of money in his effort to dress like an English gentleman; those who aspired to become barristers "were expected to conform to a certain standard of dress," and Gandhi, who was very meticulous in observing and trying to adapt to his environment, was quick in learning "the value of fitting his costume to his role."[30]

During his time working as a lawyer in Durban, Pretoria, and Johannesburg, Gandhi's costume reflected his profession as well as his role as a public figure and leader of the Indian community, whose members were aware of their status as subjects of the British Empire and Commonwealth. Both the authenticity and symbolic nature of Gandhi's costume was put to a test right after his arrival in Durban. Dressed in the unusual combination of elegant European clothes *and* a turban made Gandhi look awkward, puzzling not only to his new employer, a Muslim merchant from Gujarat, but posing a provocation to South Africans whites. Asked to remove his turban in the courtroom, Gandhi refused and left the room (removing a turban was a humiliation for an Indian, and Muslims were not asked to remove theirs in the courtroom). The next day a story published in the local newspaper criticized Gandhi. His polite, but forceful answer, defending the Indian attitude to turbans, appeared soon thereafter in the same paper, giving him an unexpected public platform within days of his arrival in South Africa.[31]

30 R. Gandhi, *Gandhi: The Man*, 32.

31 R. Gandhi, *Gandhi: The Man*, 59.

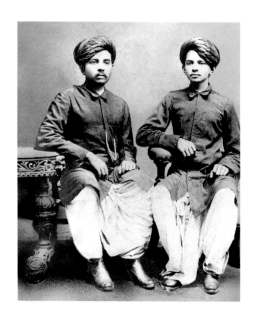

Above Walter Bosshard (Switzerland, 1892–1975), Boycott Button, ca. 1930. Gelatin silver print. Fotostiftung Schweiz, Winterthur, Switzerland

Right Mohandas Gandhi (right) with his brother Laxmidas, India, 1886. Photographer unknown. akg-images/Archiv Peter Rühe

This episode is significant for two reasons: first, the transitional nature of Gandhi's costume echoes his own transformation in an environment still unfamiliar to him; and second, his refusal to compromise when confronted with discrimination. This was a fundamentally different Gandhi from the timid, nervous young barrister who had been unable to speak in public in a Bombay courtroom. Aware of the symbolic meaning of dress, Gandhi was now ready to defend his identity and the rights of his people.

After 1906, as the British and the Boers were forming the Union of South Africa, the racial politics directed against people of color, and specifically against Indians, intensified; with this increased pressure, Gandhi's role as a public leader changed as well. In 1910, he established his second community, Tolstoy Farm, near Johannesburg.[32] Here Gandhi replaced the English suits he wore in his law office with European-style workers clothing–manifesting an egalitarian position, but not, in this case, his Indian identity. It was during a renewed satyagraha campaign in 1913 (his last one in South Africa) that he first appeared in public in drastically simplified dress, with shaved head (a sign of mourning) and in the traditional Indian costume for which he came to be known.[33]

Upon his relocation to India in 1915, Gandhi's dress reflected the deep personal changes he had undergone in his more than twenty years in South Africa. In 1893, Gandhi had traveled on trains as a first-class passenger, wearing European shirts and suits. When he left Africa in 1914, he was traveling third class and wearing the same clothes as an indentured laborer.[34] From then on traveling third class was part of Gandhi's public persona, and wearing the simplest clothes signaled that he was addressing ordinary Indians, rather than Indian elites or members of his own merchant-caste status.[35] In September 1921, reducing his costume even more, he decided to decrease the size of his lower garment by wearing only a waist-to-knee loincloth, or *dhoti*. Gandhi claimed that it was the only response he could make to an India "where millions have to go naked."[36]

32 See the essay in this volume on Gandhi's ashrams by Eric Wolf.

33 Hyslop, "Gandhi 1869–1915," 48; R. Gandhi, *Gandhi: The Man*, 176.

34 M. K. Gandhi, *An Autobiography*, part II, chap 21, The £3 Tax; and part V, chap. 11, Abortion of Indentured Emigration; and R. Gandhi, *Gandhi: The Man*, 171.

35 R. Gandhi, *Gandhi: The Man*, 178ff.

36 In *The Hindu*, October 15, 1921, quoted in R. Gandhi, *Gandhi: The Man*, 244.

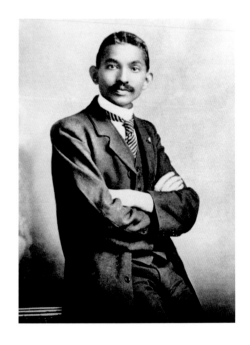

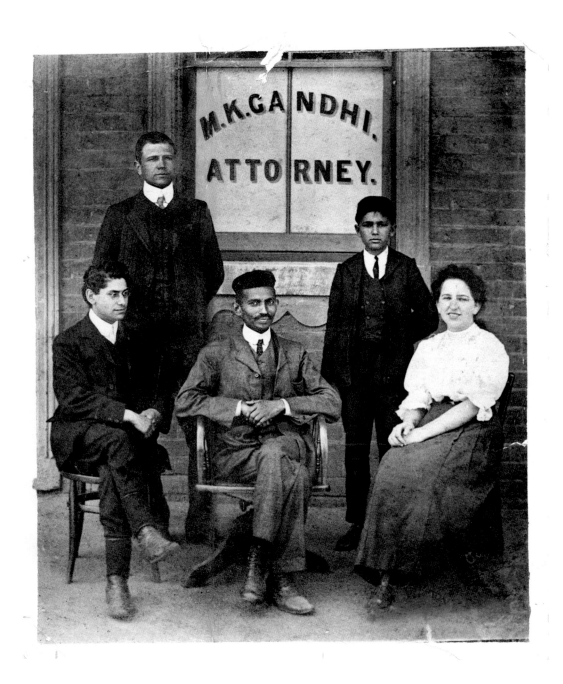

Opposite page Gandhi as a lawyer in Johannesburg.
Photographer unknown. akg-images/ullstein bild

Above Gandhi (center) outside his law office in Johannesburg with Henry S.L. Polak (left),
Sonia Schlesin (right), and two other employees. Photographer unknown

The combination of asceticism, simple communal lifestyle, and above all, the image of a physically fragile and soft-spoken but mentally strong leader of the nonviolent movement in the traditional dress of the Indian poor now became Gandhi's public image in the press. As powerfully demonstrated through his dress, Gandhi had found his public identity, and from this point on, the projection of his bodily appearance was indivisibly connected with his charisma as a spiritual and political leader. It should not be forgotten, however, that, although Gandhi's iconic image became a highly effective political statement, it was far from being universally admired, and for the most part was ridiculed, especially in the European media.[37]

37 Winston Churchill's racist statement from 1931 may be the most famous example of such hostile reactions to Gandhi's appearance: "It is alarming and also nauseating to see Mr Gandhi, a seditious Middle Temple lawyer, now posing as a fakir of a type well known in the East, striding half-naked up the steps of the viceregal palace, while he is still organising and conducting a defiant campaign of civil disobedience, to parlay on equal terms with the representative of the King-Emperor." Speech given on February 23, 1931, Winchester House, Epping. In *Never Give In! The Best of Winston Churchill's Speeches*, ed. Winston S. Churchill (New York: Hyperion, 2003), 97. I am grateful to Eric Wolf for pointing out the correct reference for this often misdated and misquoted speech.

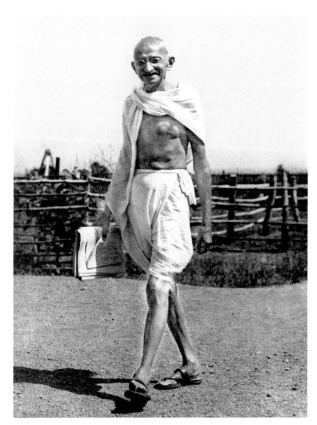

Gandhi at Sevagram, Maharashtra, India, 1935.
Photographer unknown. akg-images/ullstein bild

From the very outset of the exhibition's conception, the selection of objects proved to be a complex undertaking, given its relatively abstract, philosophical rather than visual theme. Its inspiration and catalyst, the mysteriously anonymous picture of Gandhi's possessions, is a carefully constructed image that combines the characteristics of a still life and a portrait of someone who is absent and whose life has just ended. The author of this picture is unknown, as is its exact date, although it seems to have been first published around 1950–51.[38] The photograph documents a deliberate arrangement of a handful of the objects Gandhi owned at the time of his death: two eating bowls, a wooden fork and spoon, porcelain monkeys (see-hear-speak-no-evil), his watch, eyeglasses, prayer beads, a small closed book and an open book apparently of verse (probably the ashram prayer/song book), water vessel, letter opener, and two pairs of sandals. The strikingly formal composition of this arrangement, its straightforward symmetry, underscores the symbolic significance of the objects, which serve as both reminders and incarnations, a sort of visual reliquary, of Gandhi's ascetic lifestyle and his philosophy of nonviolence. The absence of Gandhi as a person seems to only increase the compelling nature of this image; it manifests a powerful dialectic between presence and absence, life and death, portrait and still life, uniting them all.

The first part of the exhibition is centered around photographs of Gandhi and events in India, with images by Henri Cartier-Bresson made during the tumult after India's Partition and Independence, beginning in late 1947 and including an extraordinary group taken just days and even hours before and after Gandhi's assassination on January 30 in New Delhi. These photographs illustrate Cartier-Bresson's artistic credo at its best: to capture the "decisive moment" and to be both unobtrusive and at close range.[39] Remarkably, most of Cartier-Bresson's photographs do not, like Margaret Bourke-White's iconic portrait included here (p. 4), focus on Gandhi by isolating him from his environment; on the contrary, they narrate Gandhi's story in a broader way, mostly through his interaction with people, and, after his assassination, through the reactions of India's gathered poor as they watch the funeral procession and cremation with grief-stricken faces. As such, these pictures tell us a story of Gandhi's impact on the masses, often overlooked by history. Cartier-Bresson's images of these historic events were published in *Life* magazine, and their revelation of the extraordinary emotional impact of Gandhi's death helped make him one of the first world-famous photojournalists. As is well known, the shock of Gandhi's assassination led, paradoxically, to an almost complete cessation of communal violence in both India and Pakistan, although only for a short few days.

38 I am grateful to Vinay Lal for his comments about this photograph, to Clare Elliott and Joseph Newland for research, and to Neelima Shukla-Bhatt for the likely identification of the open book.

39 Henri Cartier-Bresson, *The Decisive Moment: Photography by Henri Cartier-Bresson* (New York: Simon & Schuster, 1952), unpaginated.

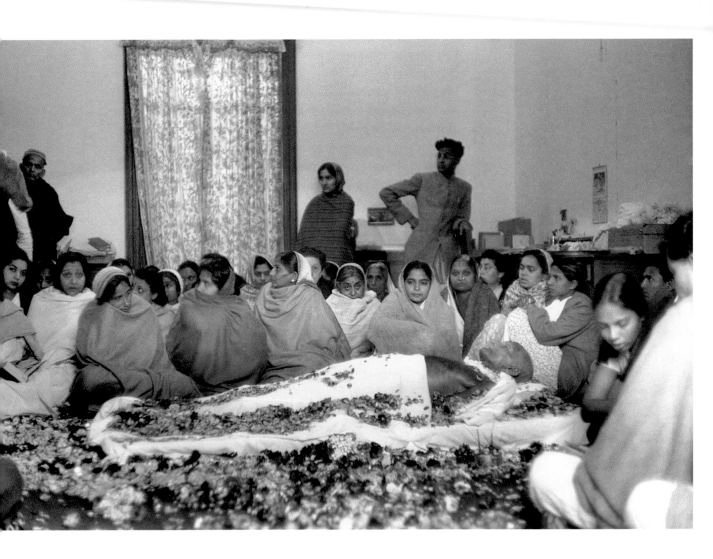

This initial section includes portraits and documents of Gandhi's most important predecessors and contemporaries–Leo Tolstoy (1820–1910), Henry D. Thoreau (1817–1862), Ralph Waldo Emerson (1803–1882), and John Ruskin (1819–1900). Their ideas and writings about social reform, tolerance, and nonviolence had a major impact on Gandhi's thinking. Other leaders in the fight for human rights and social justice are the African American abolitionist and women's rights activist Sojourner Truth (1797–1883); Frederick Douglass (1818–1895), a leader of the abolitionist movement; Clara Barton (1821–1920), an activist on behalf of women's rights, civil rights for African Americans, and founder of the American Red Cross; as well as the English aristocrat Florence Nightingale (1820–1910), a social reformer and the founder of modern nursing. Nursing the sick and wounded is perhaps one of the most

Henri Cartier-Bresson (France, 1908–2004), Gandhi's body lies in state, Birla House, New Delhi, January 31, 1948. Gelatin silver print, 6 ⅝ × 9 ⅝ inches (16.7 × 24.5 cm). Collection Fondation Henri Cartier-Bresson, Paris

40 M. K. Gandhi, *An Autobiography*, part III, chap. 6, Spirit of Service. Gandhi's interest in nursing started early in his life, when as a boy he nursed his terminally ill father.

41 In the late 1870s, as more national societies were being founded, the one in the Ottoman empire adopted the use of the Red Crescent; now the International Red Cross and Red Crescent Movement encompasses many activities around the world.

universally understood expressions of altruism, or, as Gandhi noted, "the spirit of service." In Gandhi's case it was at the core of his profound wish "for humanitarian work of a permanent nature."[40] Both Barton and Nightingale shared their passion for nursing and improved medical treatment with the Swiss businessman Henry Dunant (1828–1910), whose coincidental experience of war in Italy in 1859 (recounted in his *A Memory of Solferino*) turned him into a peace activist. Dunant was the founder of what became the International Committee of the Red Cross in 1863, a paramount humanitarian achievement of the nineteenth century; and was a co-recipient of the first Nobel Peace Prize in 1901.[41] Dunant's visionary drawings (pp. 153, 154) are virtually unknown and have never been on view in the United States.

Another group of works, documents, and artifacts highlights remarkable events and leaders in social and political history. This section focuses on Gandhi's legacy and includes portraits of some of the most eminent leaders of movements of social and political reform in the decades following Gandhi's death. Martin Luther King Jr. (1929–1968) in the American South, Nelson Mandela (1918–2013) in South Africa, the 14th Dalai Lama of Tibet (b. 1935), and Aung San Suu Kyi (b. 1945), Myanmar's moral leader in the footsteps of Gandhi, are among the most prominent; documents and photographs also illustrate the de Menils' personal involvement with some of the same leaders on their course to create a singular art space dedicated to human rights, the Rothko Chapel.

Central to the exhibition is the presentation of major works of art that exemplify diverse artistic visualizations and complex iconographies of nonviolence in different world religions. Some of these reach far back in time and history, including devotional sculptures, paintings, and manuscripts from the classical religions of India—Hinduism, Jainism, Buddhism—that informed Gandhi's thinking. They are displayed among sculptures, paintings, drawings, prints, and manuscripts referring to the Abrahamic religions, where we encounter very different iconographies, although sharing similar themes such as asceticism, compassion, and generosity; later, the equality of the races and abolition of slavery (a theme predominantly present in the Christian tradition) is sometimes included. Major works from the Menil's permanent collection (by Mark Rothko, Barnett Newman, Agnes Martin, Yves Klein, René Magritte, Andy Warhol, Robert Gober), as well as loans from public and private collections, emerge throughout the exhibition, resonating with Gandhi's vision as well as with the spiritual humanism that informs the Menil campus as a whole, the Menil Collection, and the Rothko Chapel.

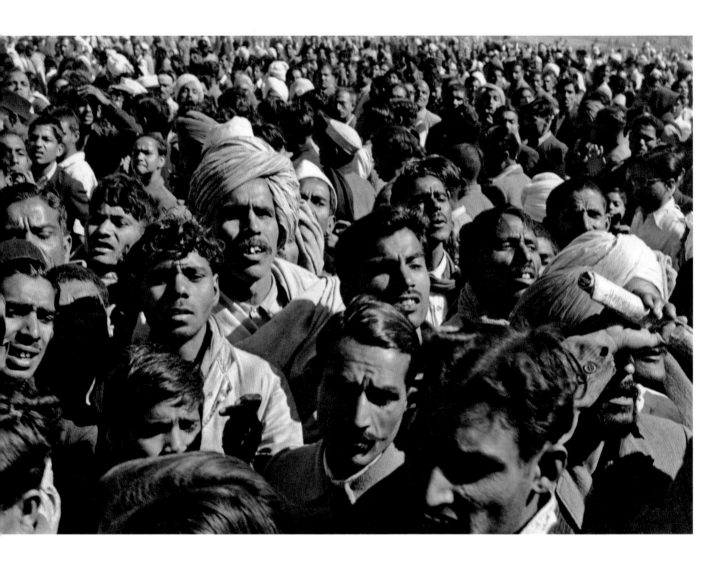

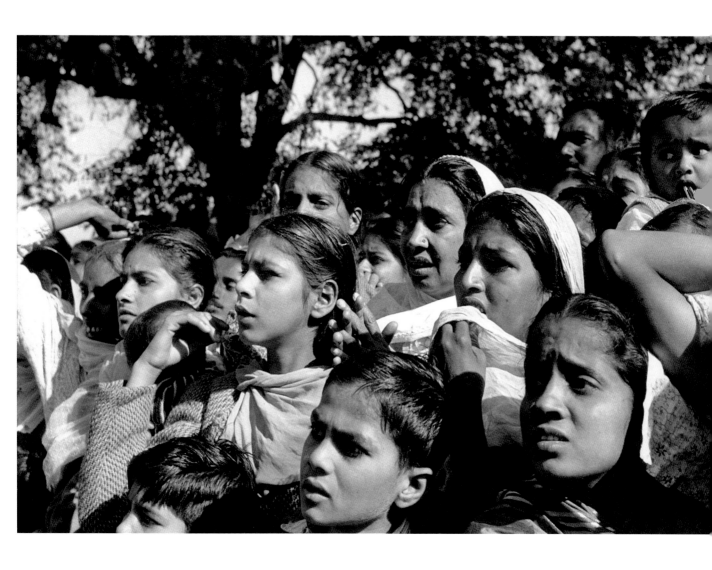

Opposite page Henri Cartier-Bresson. Gandhi's funeral, Delhi,
January 31, 1948, printed 1970s. Gelatin silver print, 9 ⅜ × 11 ¾ inches
(23.9 × 29.8 cm). Collection Fondation Henri Cartier-Bresson, Paris

Above Henri Cartier-Bresson, Gandhi's funeral, Delhi,
January 31, 1948. Gelatin silver print, 6 ⅝ × 9 ⅝ inches (16.7 × 24.5 cm).
Collection Fondation Henri Cartier-Bresson, Paris

Interpreting Gandhi's concept of nonviolence for the purpose of an object-based exhibition certainly proved a risky endeavor because of the diversity (cultural, historical, religious) and heterogeneity of the artifacts and works of art brought together. Museums have an almost inescapable tendency to homogenize the objects they put on display, and this exhibition attempts to overcome that dilemma without eclipsing the "otherness" of those on display or minimizing the complexity of Gandhi's ideas. One of the working principles for *Experiments with Truth* was to avoid the trap of using artworks and artifacts as merely illustrative or anecdotal, and to give them the right to speak for themselves (the documents usually have a more straight-forward purpose). Although, given the far-reaching thematic content of this show, emphasis is given to the associative potential of the objects, it was my intention to respect their distinctiveness, from cultural, historical, and aesthetic perspectives. It is difficult to visualize an ethical (or political or philosophical, depending on one's point of view) topic like nonviolence through mainly visual means. One of my goals was– as frequently attempted at the Menil Collection–to create thoughtful encounters between objects from distinctly different contexts and thereby liberating us as curators from constricting museological habits and to give freedom to visitors.[42] Is there an aesthetic of nonviolence? If yes, its various manifestations must be vastly different. This exhibition tries to present some of these different visual expressions, distinctive in time, style, cultural and religious belief system, as well as medium and technical execution, used by artists over the course of more than fifteen hundred years of tumultuous–antagonistic and destructive as well as (occasionally) relatively harmonious–connective history.

From the outset my goal was to create a dialogue between Gandhi's vision and concept of nonviolence and the spiritual humanism that informs the Rothko Chapel, the Menil Collection, and the surrounding neighborhood. For the argument this exhibition tries to make, it seemed crucial to include archival material, and artifacts as well as major paintings and sculptures from our permanent collection and place them deliberately throughout the presentation, bringing to life the subtle resonance between these distinctly different things, while avoiding a restrictive, didactic narrative. In addition to iconic examples from the collection, this exhibition presents a significant number of lesser-known items from our rich and eclectic holdings, weaving them into the project's broad framework. Throughout the exhibition and this book, rarely or never seen examples from our collection of Asian art, European old masters, our exquisite collection of Byzantine icons, as well as compelling works from our extensive collections of Black Americana and Civil Rights photography are on view.

42 On the Menil Collection's curatorial commitment to a poetic rather than a didactic experience of art, see Pamela G. Smart, *Sacred Modern: Faith, Activism, and Aesthetics in the Menil Collection* (Austin: University of Texas Press, 2010),169ff.

Oxen yoke. Europe. Wood and iron, 6 ¼ × 50 ¾ × 5 inches
(15.9 × 128.9 × 12.7 cm). The Menil Collection, Houston

As I hope has become evident, no single set of styles or aesthetic preferences connects the works gathered here. At the basis, however, is an effort to propose an associative thread that shifts back and forth between different groups–devotional pieces, artworks without religious context, artifacts that belong to either or none of these categories, documentary material of various kinds, and texts connecting some of the objects with central concepts promoted by Gandhi and other leaders of nonviolent struggles. Documentary material and photojournalism are crucial categories as nonviolence is always related to social, political, and economic realities. Documents are essential to provide evidence to establish truthful outcomes; in addition and, not surprisingly, working with documentary means is vital for a considerable number of artists in this show (Warhol, Amar Kanwar, Kimsooja, Marlene Dumas, et al.).

Most of the artifacts have been mined from the deep storage and the archives of the Menil Collection–cartes de visite, memorabilia, prints, posters, and other documents illustrating the iconography of certain leaders in recent social and political history (Abraham Lincoln, King, Mandela, Cesar Chavez, or Gandhi himself). The European oxen yoke (p. 35) and the wax head of Lincoln (p. 149) were selected by Robert Gober for an exhibition he curated in 2005 called *Robert Gober: The Meat Wagon*, drawing upon the museum's diverse collections. Both also appear in *Experiments with Truth*, informed by and evoking a different context. While Lincoln, the abolitionist, can be associated with Gandhi's predecessors, the yoke might reference different strands of the exhibition's topic–as an ancient symbol of the oppressed as well as for Gandhi's dedication to the Indian peasants, manual labor, and village culture. To our knowledge, none of the Indian quilts chosen for this project, mainly from Gujarat and purchased late in her life by Dominique de Menil, have ever been on public display. Although no masterpieces, they are emblematic of the kind of regional domestic products used all over India that Gandhi promoted so vigorously; these were probably fabricated by common people in Gandhi's home province.

Opposite page Quilts, probably late 20th century. India, probably Gujarat. Cotton, above: 78 ½ × 56 inches (199.4 × 142.2 cm); below: 69 ¼ × 51 ¾ inches (175.9 × 131.4 cm). The Menil Collection, Houston

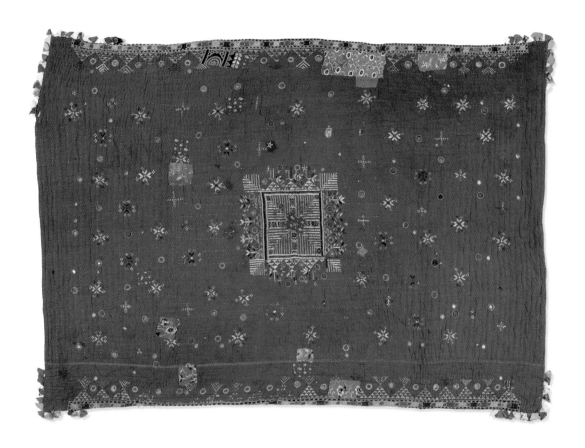

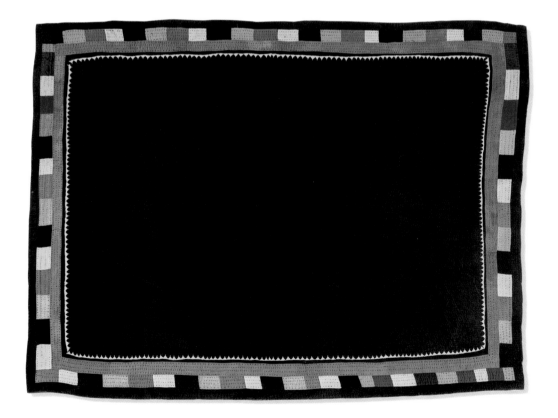

There are beautiful works of art and compelling artifacts and documents in this exhibition, and their "aura" will change depending on the viewer, context, and over the course of time. The goal is to create the conditions to allow for an undistracted, not didactically orchestrated, experience. One of the most informative discoveries I made over the many years of conceptualizing this project was that, although many objects are drawn from different and sometimes distant cultures, they are not unrelated. Our hope, needless to say, is to elicit deeper understanding and perhaps appreciation of these works of art, photographs, books, and other types of artifacts, all of which are in conversation, shedding light on an ancient, complex topic that has concerned humankind throughout history: how to deal with and overcome violence through the cultivation of nonviolent means.

CONVERSATIONS

Dialogues with contemporary artists have shaped my thinking about this project in crucial ways. One of the key moments for me was the experience of seeing Amar Kanwar's powerful film-poem *A Season Outside*, 1997, at Documenta XI in 2002. In this piece Kanwar used footage filmed in different locations in India, including the daily militaristic ritual of the opening and closing at one crossing on the Pakistan-India border, a train bursting with travelers slowly moving through the heavily guarded border zone, episodes of violence among animals, historical footage of Gandhi visiting villages devastated by communal violence, and a sequence about Tibetan refugees. The soundtrack includes a thought-provoking text (spoken by the artist himself) that meanders around the dilemma of violent or nonviolent resistance, including two dialogues: a famous exchange between Gandhi and a representative of the British Empire, and Kanwar's own probing conversation with an exiled Tibetan monk, interrupted by short documentary scenes of raging Chinese police brutality against monks in Tibet. The raw beauty of the film and the melancholic, nonjudgmental complexity of the spoken word touch on many issues and make this work a centerpiece in *Experiments with Truth: Gandhi and Images of Nonviolence*. Over the course of the years, my conversations with Amar became essential to the formation of this project. Late in the process, Zarina's knowledge of the intricate interweavings of religious history in India helped me to fine tune decisions, and her impressive artistic and biographical trajectory add an important dimension. Kimsooja, Suzan Frecon, Shilpa Gupta, Mel Chin, and

Opposite page Amar Kanwar (India, b. 1964), A Season Outside, 1997.
16mm film transferred to video, color with sound, 30 min. Courtesy of the artist and Marian Goodman Gallery, New York and Paris

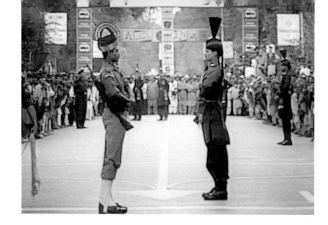

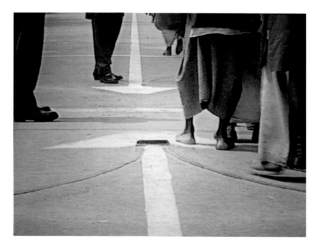

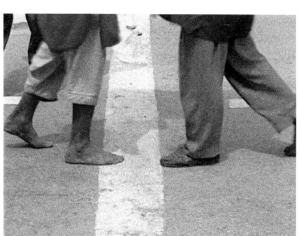

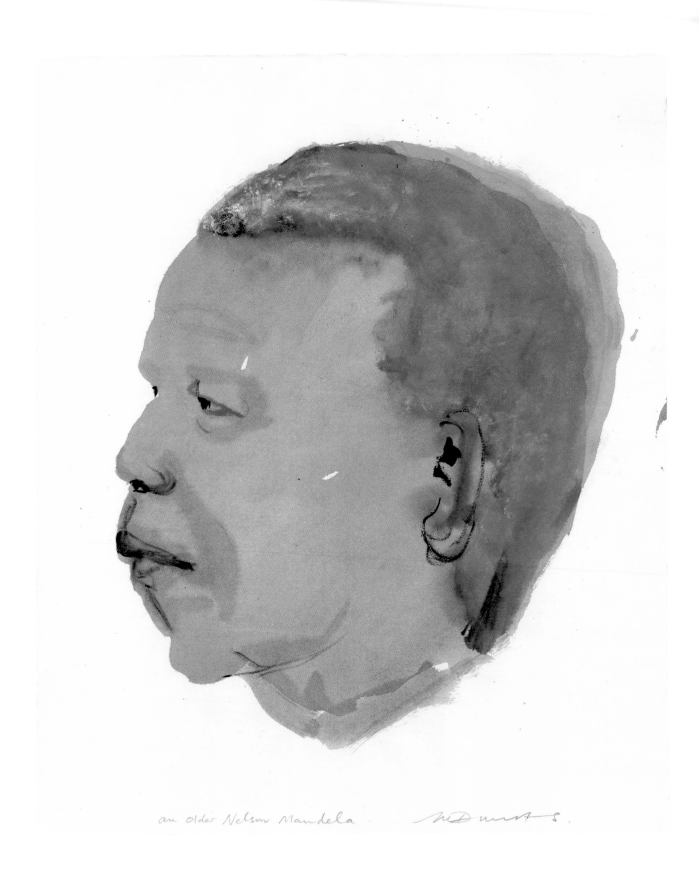

an Older Nelson Mandela

Marlene Dumas (b. South Africa 1953, active Netherlands), An Older Nelson Mandela,
2004–5. Ink and acrylic on paper, 23 ¾ × 19 ¾ inches (60.3 × 50.4 cm). Collection of the artist

Theaster Gates reacted strongly when invited to discuss this project, and we learned a lot from their comments, allowing us to rediscover new aspects of their work as well as our collection, history, and the campus.

Since South Africa was where Gandhi developed and tested his concept of nonviolent resistance, works related to this country and its longer story were therefore critical. The portraits of Nelson Mandela by Jürgen Schadeberg and Marlene Dumas are powerful examples of this figure's iconography in recent history. Schadeberg, one of the pioneer photojournalists in the anti-apartheid movement, first met Mandela in 1951 when the latter was the president of the African National Congress (ANC) Youth League, and they met frequently over the next decade. The German-born Schadeberg left South Africa in 1964, the same year that Mandela was sentenced to life imprisonment. In 1994, Mandela revisited his prison cell shortly after he had been elected the first black president of South Africa. Due to their friendship, Schadeberg was invited to accompany him on this historic occasion. The photographs he captured of Mandela's visit and his gazing out of the prison window became icons in recent portrait photography (p. 291).

William Kentridge is the grandson of prominent attorneys, and his father, Sidney Kentridge, was one of the most prominent trial lawyers in the anti-apartheid movement. Kentridge's four animated films focus on Johannesburg, a city that "made Gandhi,"[43] where both Gandhi and Mandela had law offices, and where Kentridge himself has worked throughout his career. Although he never illustrates events of South Africa's dark political past, apartheid and its legacy reverberate in his work. His animations, technically simple but powerful multisensory expressions, are based on a finite set of sequentially altered charcoal or pastel drawings filmed in old-fashioned stop-motion technique. The free flow of drawing and editing, erasure and transformation, create an enigmatic story, and both the antilogical narrative and process-driven execution undermine any sense of certainty or righteousness.

One of the artists I was able to discuss this project with early on was Robert Gober. His installation Untitled (Prison window) references the prison cell in diverse ways (p. 290), possibly also as a place of reflection, education, and intellectual production–calling to mind how Gandhi, Ghaffar Khan, King, Mandela, Suu Kyi, and many other political prisoners have used it during their struggles.[44] The prison cell has deep allegorical meaning in this project, a place of confinement and humiliation, and yet also of forced introspection and possibly inner stillness, in alignment with Gandhi's idea of individual transformation and self-control as preconditions to realizing the political goal of self-rule and nonviolent behavior. In a different way, Cartier-Bresson's

43 Kentridge in conversation with the author, May 6, 2011, in New York City.

44 In a rather striking coincidence of history repeating itself, Mandela served time in the same Johannesburg jail as Gandhi before him. On the prison cell as a place of education, to advance the political struggle and one's ethical discipline, see Mandela in his autobiography, 292ff.

photographs of the refugee camps in 1947/48 invite a conversation with Kanwar's film *A Season Outside*, Zarina's *Abyss*, and Shilpa Gupta's *1:14.9–1188.5 Miles of Fenced Border–West, North-West* (pp. 38, 43, 128). Several artists and their families (including Kanwar and Zarina) were directly affected by the traumatic events of the Partition in 1947, and their participation and selection of works for this project are therefore all the more meaningful. Zarina's large wall piece *Veil* (p. 277) seems to both refer to and merge ancient expressions of spiritual, yet transdenominational experience and the (not necessarily spiritual) Euro-American tradition of abstract painting. Suzan Frecon's paintings on canvas and paper can be associated with a similarly broad context, although those included here (pp. 281–85) seem to obliquely reference the sphere of Islam–its architecture, manuscript pages, or the words used by the Sufi poet Jelaluddin Rumi. This thirteenth-century theologian, jurist, and mystic is best known in the West as a poet, and his influence has long transcended religious, national, and ethnic boundaries. Interestingly, Rumi's life (1207–1273) nearly coincides with that of Saint Francis of Assisi (1181–1226), the popular Catholic patron saint of animals and the environment, who established poverty as the essential life style for his followers and compassion as the core of their ethical conduct (p. 269). Saint Francis is also famous for his attempted Christian-Muslim reconciliation when he visited the sultan in Egypt in 1219 in the midst of a bloody crusade.

It may be safe to say, without making a statement too universalist or simplistic, that compassion and tolerance have historically been core elements of almost any ethical system or religious tradition. Included here and in the exhibition are examples from vastly different traditions, including themes of tolerance and compassion in Christian iconography: the prints *Christ Preaching*, sometimes alluded to as The Sermon on the Mount, and Christ tending to or healing the sick, better known as *The Hundred Guilder Print*, both by Rembrandt (pp. 239, 44); *The Good Samaritan* (p. 169); and Saint Martin sharing his cape with a beggar (p. 316). I have found it striking to create a visual dialogue between these iconic representations of Christian sympathy and Cartier-Bresson's compelling pictures of India's most downtrodden, the crippled beggars with their forceful, almost threateningly outstretched hands and bowls, craving for food, money, or both (p. 125). The viewer will find in the same room of the exhibition a statue of Green Tara, a representation of a female bodhisattva (p. 271).[45] Bodhisattvas are emblematic of Buddhist qualities and virtues, in this case the practice of compassion and the realization of emptiness.

45 In early Buddhist traditions, the term is used by the Buddha to refer to himself prior to his enlightenment; in later traditions the term takes on a further meaning–it refers to a Buddhist saint who demonstrates an infinite compassion for all beings. *Early Buddhist Discourses*, ed. and trans. John J. Holder (Indianapolis: Hackett Publishing Company, 2006), 202.

Zarina (b. India 1937, active United States), Abyss, 2013. Woodcut on paper,
27 ½ × 22 inches (69.9 × 55.9 cm). Courtesy of the artist and Luhring Augustine, New York

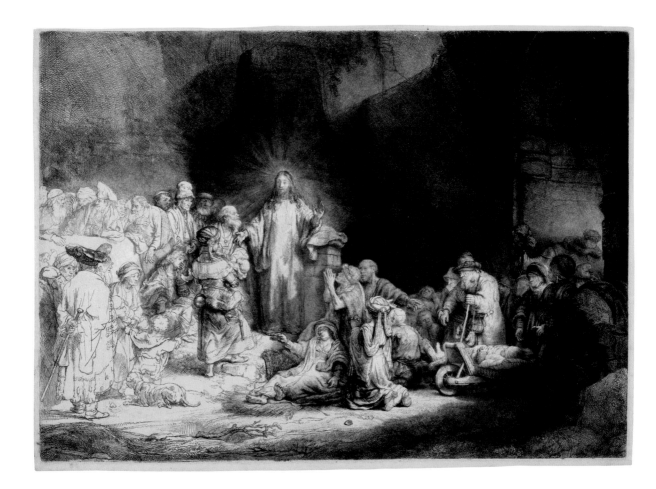

Rembrandt van Rijn (Netherlands, 1606–1669), Christ Healing
the Sick (The Hundred Guilder Print), ca. 1649. Etching, drypoint, and burin on paper,
11 1/8 × 15 5/8 inches (28.3 × 39.5 cm). The Pierpont Morgan Library, New York

Distinguishing nonviolence from violence can be a complex endeavor, as this exhibition proves through many examples. Iconoclastic damage is a remarkably complex topic in itself, as is vandalism for religious, political, or other reasons, including looting by breaking apart the most valuable pieces of sculptures or monuments. It is unclear when or why the damage to the standing Thai Buddha (p. 46) occurred, but the severe injury done to the sculpture, its beheading, has the unintended, but in this case powerfully symbolic effect of increasing its aura of compassion and peace. Notwithstanding its perhaps limited artistic quality, this sculpture, never on public view at our institution, creates a compelling dialogue with a number of works in the show—Ai Weiwei's *Feet*, a collection of symmetrically displayed fragments from destroyed Buddhist figures (p. 47), the anonymous Chinese protester photographed and filmed facing the tanks moving to Tiananmen Square (p. 47), Newman's painting *Be I* (p. 3), Kimsooja's installation *A Needle Woman* (pp. 233–35), or Cartier-Bresson's striking photograph of the praying women in Kashmir (p. 2)—while also illustrating with straightforward directness Gandhi's idea of courage and nonviolent resistance when facing an oppressive opponent. Like the silent protester whose courageous, universally understood action brought the rolling tanks to a brief standstill, the standing Buddha, with its right hand seemingly raised in a gesture that means "fear not," emanates an inner stillness, a powerful antidote to the seemingly unstoppable mind stream of anxiety and fear, and history's blindly unfolding mechanism of destructive action.

Another unexpected visual correspondence can be observed between Gandhi's pocket watch—one of his iconic attributes, visible in the image of some of his last possessions—and Shomei Tomatsu's photograph of the watch stopped at the moment the atomic bomb dropped in Nagasaki exploded (p. 51). Gandhi's pocket watch, although not as well known as the spinning wheel, the loincloth, or his sandals, has acquired equally symbolic value, as it is said to have stopped when Gandhi fell on it at the moment of his assassination. In the image of Gandhi's last possessions his watch does indeed appear to be showing 5:15 p.m., the exact time of his assassination (p. 16).[46]

46 I am grateful to Vinay Lal for suggesting this relationship in a conversation in October 2013, and to Clare Elliott for her careful examination of the photograph.

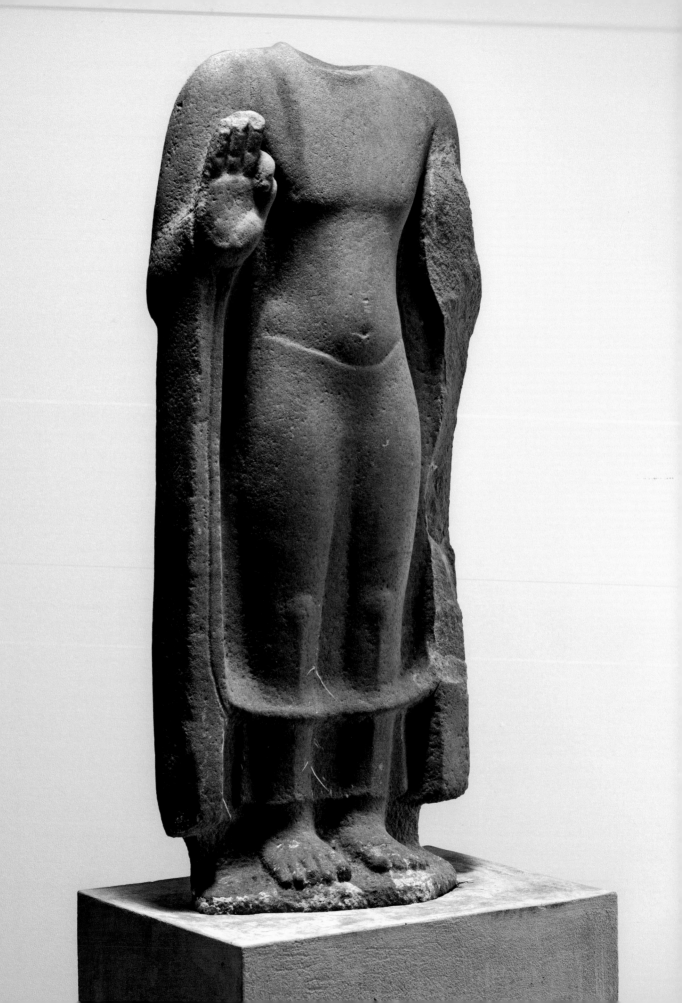

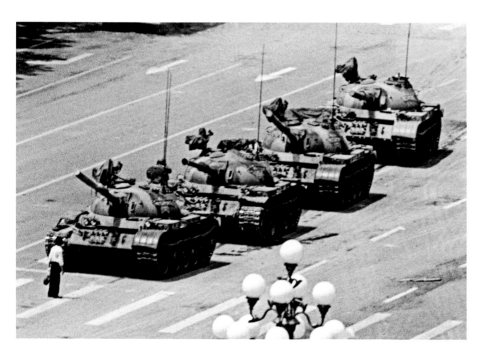

Opposite page Buddha. Thailand, probably Lopburi; probably Mon; Dvaravati period, 7th or 8th century. Stone, 40 ½ × 18 × 9 inches (102.9 × 45.7 × 22.9 cm). The Menil Collection, Houston

Above right Ai Weiwei (China, b. 1957), Feet, 2003. 10 Buddha's feet from sculptures of the Northern Wei period (386–534 CE), with individual wood plinths and table, 49 ⅝ × 26 ¾ × 66 ⅛ inches (126 × 68 × 168 cm). Private collection, Switzerland

Below left A lone man stops a column of tanks near Tiananmen Square following a major government crackdown on demonstrators that left hundreds dead, Beijing, 1989. Photograph by Jeff Widener. AP Photo/Jeff Widener

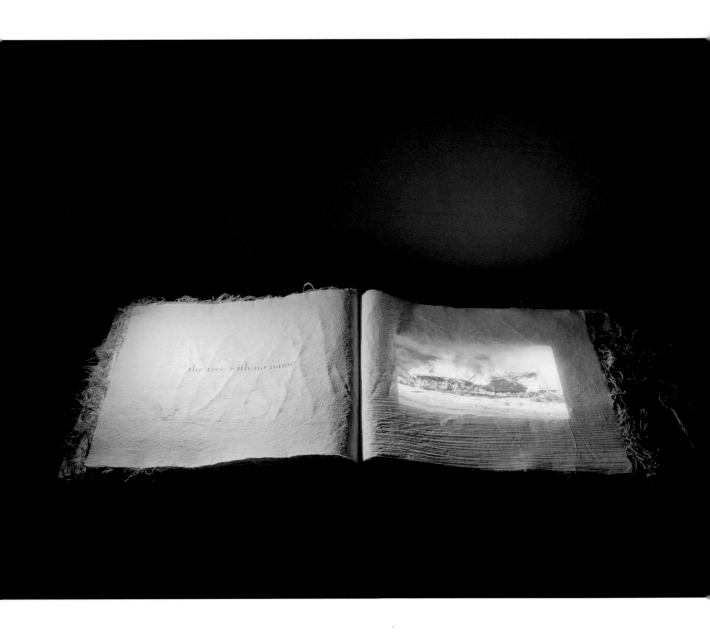

the tree with no name

Amar Kanwar (India, b. 1964), The Prediction, in The Sovereign Forest, 2012/ongoing.
Mixed media installation: single-channel videos, handmade books with projections, hand-
made books, found evidence, and digitally-printed photographs; dimensions variable.
Courtesy of the artist and Marian Goodman Gallery, New York and Paris

From early on, it was clear that the museum as conventional exhibition space was inadequate for this project. An investigation of ideas related to Gandhi and his concept of nonviolence needed intellectual and physical expansion. We therefore envision the Menil's neighborhood of art in its entirety, and especially the Rothko Chapel as its "heart" (both historically as the first art building, as well as metaphorically), as the fitting platform for this endeavor. Moreover, beyond this precinct, it seemed crucial to reach out to a variety of cultural, educational, and civic institutions in Houston and beyond. After several years of conversations with a number of colleagues and their organizations, between October 2014 and January 2015 and beyond, each participating institution is making its own contribution to a diverse array of exhibitions, films, lectures, performances, and educational programs that explore Gandhian legacies, truth and justice, and some of the forms activism for social change has taken in and around Houston. Over the course of years, Kanwar's ongoing modification and expansion of his complex work *The Sovereign Forest* (first shown at Documenta 13 in 2012), led him to create an archive in Bhubaneswar, Odisha (formerly Orissa), which opened to the public in fall 2012. An experiment without private or institutional support other than that of the artist and a growing group of volunteers, it has now become self-sustaining and rooted in local support. It is an honor for the Menil Collection to be, through this exhibition, symbolically connected with Amar's remarkable archive of local history in east India.

Lastly, at a relatively late stage, in the summer of 2013 the opportunity presented itself that the International Red Cross and Red Crescent Museum in Geneva could be a venue for an altered version of this project. It is the only museum of humanitarian history of its kind and located next to the United Nations campus in Geneva, whose general assembly adopted the Universal Declaration of Human Rights on December 10, 1948, less than a year after Gandhi's assassination.[47] We are very pleased about this most meaningful partnership. The year 1948 is relevant to this project for yet another irony of history: systematized apartheid was officially instituted in South Africa in the year of Gandhi's assassination, notwithstanding that some of the lasting results of his efforts there (including Phoenix Settlement) were then still in existence.

47 In a fitting tribute, the second colloquium held at the Rothko Chapel, in December 1973, was "Human Rights/Human Reality," a commemoration of the twenty-fifth anniversary of the United Nations Declaration of Human Rights, an abridged text of which is printed in this volume. On the history of human rights, see Samuel Moyn's excellent study *The Last Utopia: Human Rights in History* (Cambridge, MA: The Belknap Press of Harvard University Press, 2010).

As I stated at the outset, the image of Gandhi's possessions serves as an evocative example of what an aesthetics of nonviolence might be. In this carefully constructed photograph, Gandhi's life has been condensed and eternalized into an allegorical still life exemplifying his ethical ambitions: simplicity, self-discipline, non-possession, detachment, and restraint—all of which can be associated with Gandhi's concept of nonviolence. Characteristically, perhaps, the most basic information about the creation of this image remains unknown to this day. The very lack of certainty about its author, location, exact date, and, perhaps, most importantly, initial purpose serves as an indicator of the vast territory that the exhibition *Experiments with Truth* is attempting to cover. It is impossible (and has never been our aim) to separate ethics from aesthetics in this project—the exhibition takes place as much in the mind of the visitor as in real space; it touches on strong emotions as much as it visualizes ideas and concepts; it alludes to the spiritual as well as the political. *Experiments with Truth: Gandhi and Images of Nonviolence* was never intended to be a show about Gandhi, one of the most controversial and influential figures in the twentieth century, or the complex iconography that developed around his persona. His concept and ideal of nonviolence, however, continues to be deeply relevant to our time.

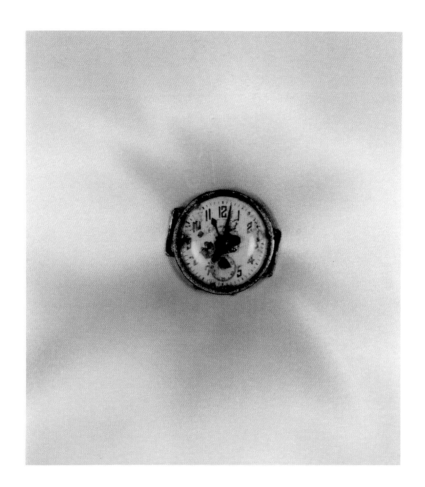

Shomei Tomatsu (Japan, 1930–2012), Atomic bomb damage (wristwatch stopped
at 11:02, August 9, 1945), 1961, printed 1998. Gelatin silver print, 14 ¼ × 12 ¾ inches
(36.2 × 32.4 cm). The Rachofsky Collection, Dallas, Texas

Yves Klein (France, 1928–1962), *Hiroshima*, ca. 1961. Dry pigment in synthetic resin on paper on canvas, 54⅝ × 110⅛ inches (138.7 × 279.7 cm). The Menil Collection, Houston

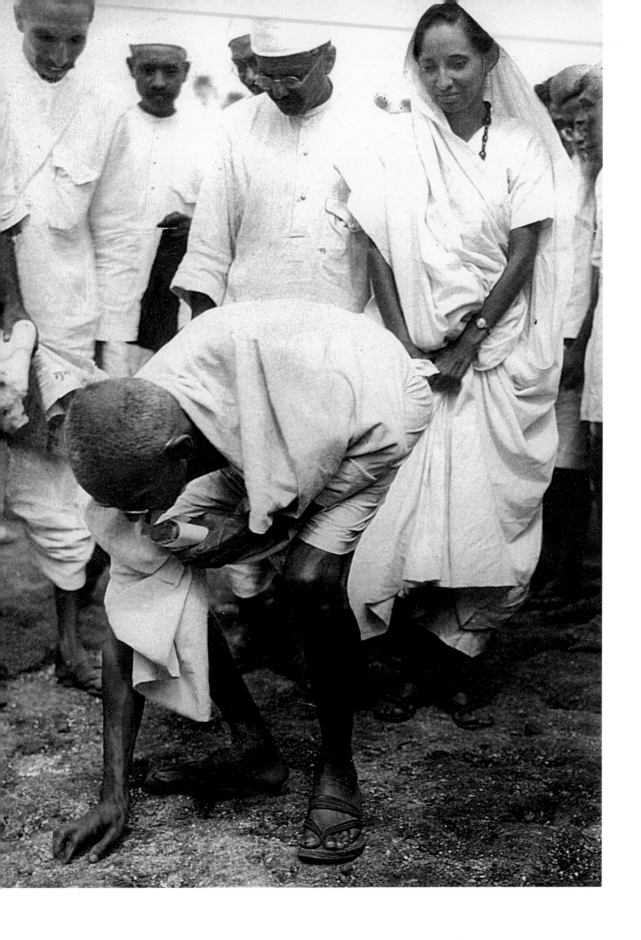

Gandhi breaking the salt laws by picking up a lump of natural salt at Dandi, 8:30 a.m. April 6, 1930. Photographer unknown. GandhiServe

VINAY LAL

Salt and the March to Freedom

Early in 1930, Gandhi, Jawaharlal Nehru, and the Indian National
Congress issued a call for complete independence, or *purna swaraj*, from
British rule in India. Gandhi had led the noncooperation movement
in 1920–21, and the resolute resistance of Indian masses to colonial rule
had even succeeded in paralyzing the British administration in parts
of north India; yet, much to the consternation of his Congress colleagues,
Gandhi suspended the movement in February 1922 when violence
in Chauri Chaura, a small town in Gorakhpur district, led to the death
of twenty-two policemen. This convinced him that the country was
far from being committed to the path of nonviolence. The suspension
was an opportune moment for the British to remove Gandhi from
the political scene, and his conviction on charges of sedition, at what has
been memorialized as "The Great Trial," sent Gandhi into jail. On
his release from prison three years later, in mid-1925, Gandhi immersed
himself in what came to be known as the "Constructive Program,"
which aimed at "village uplift" and comprehensive social reform,
including the lifting of inequalities against women and untouchables,
the promotion of basic education and norms of sanitation and hygiene,
and the promotion of Hindu-Muslim cooperation. The common
understanding of Gandhi, which focuses on him as the political
architect of Indian independence, has largely obscured this equally
vital aspect of his life, thus showing little awareness of the fact that he
thought of freedom as indivisible. In what is described as his last will
and testament, issued just days before his assassination and shortly
after independence in 1947, Gandhi declared that "the Congress has won
political freedom, but it has yet to win economic freedom, social and
moral freedom. These freedoms are harder than the political, if only
because they are constructive, less exciting and not spectacular."

Coming out of what might be termed a political retirement, Gandhi had sought to prepare the ground for the renewal of the movement that would deliver India from colonial servitude. He had searched his mind for some action that might ignite the nation and serve as the expression of the will of the general community. The course of action that Gandhi eventually decided upon is revealed by a remarkable letter, as unusual a document as any that is to be encountered in the global annals of political discourse, that he addressed to Lord Irwin, the viceroy. "Dear Friend," he wrote to his political adversary on March 2, 1930, "I cannot intentionally hurt anything that lives, much less fellow human beings, even though they may do the greatest wrong to me and mine. Whilst, therefore, I hold the British rule to be a curse, I do not intend harm to a single Englishman or to any legitimate interest he may have in India." Gandhi drew the viceroy's attention to the myriad ways in which India had been impoverished and bled under colonial rule, reserving his most detailed analysis for the salaries paid to Indians and to British officials. He underscored the inequities of the system by pointing out that while the average Indian earned less than two annas per day, or one-eighth of a rupee, the British Prime Minister earned Rs. 180 per day, while the viceroy received Rs. 700 per day; more tellingly, the prime minister of Britain received 90 times more than the average Britisher, but the viceroy received "much over five thousand times India's average income." Apologizing for taking a "personal illustration to drive home a painful truth," Gandhi asked the viceroy "on bended knee" to "ponder over this phenomenon." The system of administration carried out in India, founded on the "progressive exploitation" of a people reduced to political serfdom, was "demonstrably the most expensive in the world" and had led to the country's "ruination."

If the British were not prepared to combat the various "evils" afflicting India under colonial rule, Gandhi pronounced himself ready to commence a fresh campaign of "civil disobedience." As he went on to inform Irwin, he intended to break the salt laws–a gesture that no doubt must have struck Irwin as bizarre, considering that Gandhi's own colleagues in the Congress Working Committee responded with incredulity when he first broached the idea with them in mid-February. Salt had very much been on Gandhi's mind since he was a young man: though he may not have been possessed of the scientific findings on salt's critical role in transmitting electrical nerve impulses, Gandhi had struck upon the fact that it is essential in maintaining a properly functioning body, even more so in a hot climate where the risks of dehydration are acute. The first mention of the salt tax in India in Gandhi's work appears in 1905; strikingly, he described the salt tax as "not a small injustice" in Chapter 2 of *Hind Swaraj*, a work that he penned in 1909 and which has ever since been viewed as the principal

articulation of Gandhi's ideas. The British conquest of India in the mid-eighteenth century had led to a state monopoly on the production and sale of salt, and by 1878 a uniform policy on salt, which criminalized both the private manufacture of salt and the possession of salt not derived from the colonial government's sources, had been adopted throughout India.

"I regard this tax [on salt]," Gandhi thus wrote to Irwin, "to be the most iniquitous of all from the poor man's standpoint. As the independence movement is essentially for the poorest in the land the beginning will be made with this evil." Significantly, Gandhi, a compulsive experimenter with foods, had been seeking for years to minimize if not eliminate the use of salt in his own diet–and this is decades before modern warnings on the dangers of sodium-rich foods. But it was the disposition of others, particularly the needs of the poor, which weighed heavily on Gandhi's mind: "There are millions in India," he told his London audience in May 1891, when Gandhi was but 22 years old, "who live upon one-third of a penny a day…. These poor people have only one meal per day, and that consists of stale bread and salt, a heavily taxed article." We are not surprised, then, that on February 27, 1930, in his first lengthy critique of the salt tax, Gandhi defended his choice of targets with words reminiscent of his remarks from four decades before: "Next to air and water, salt is perhaps the greatest necessity of life. It is the only condiment of the poor. Cattle cannot live without salt…. There is no article like salt outside water by taxing which the State can reach even the starving millions, the sick, the maimed and the utterly helpless. The tax constitutes therefore the most inhuman poll tax that the ingenuity of man can devise."

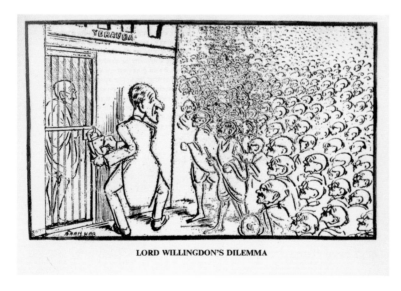

LORD WILLINGDON'S DILEMMA

Lord Willingdon's Dilemma, by Shankar. Published in the *Hidustan Times*, ca. July 1933 with the caption "The Government of India have hardly locked Gandhiji in than they turn round and find that for the one Gandhiji locked in, there are thousands outside." Courtesy of Vinay Lal

It is wholly characteristic of Gandhi, and entirely consonant with his conception of satyagraha (nonviolent resistance), that his letter to the viceroy describes precisely how he would violate the Salt Laws. Gandhi proposed to set out from his ashram in Ahmedabad and walk the 241 miles to the sea and break the law. A practitioner of satyagraha has nothing to hide from his opponents; indeed, secrecy is itself a form of violence, and the practice of satyagraha demands that one's opponent should be allowed every opportunity to retaliate. Gandhi (a London-trained barrister) was keen, as well, on conveying his acceptance of the sovereignty of law: thus his letter speaks not of the moral obligation to violate the law, but rather only a law that is unjust and unacceptable to one's conscience. Since Gandhi intended no harm to the viceroy himself, or indeed to any Englishman, he chose to have his letter delivered in person by a "young English friend who believes in the Indian cause and is a full believer in non-violence." Reginald Reynolds was, moreover, a Quaker–a representative of a strand of Christianity that had a thing or two to teach to those Christians who, forgetful of Christ's own teachings about the power of nonviolent resistance, had harnessed their faith to the project of empire. The viceroy, not unexpectedly, promptly wrote back to express his regret that Gandhi was again "contemplating a course of action which is clearly bound to involve violation of the law and danger to the public peace." In a letter written to the archbishop of Canterbury, Irwin was rather more forthright in his dismissal of "the silly salt stunt." *The Statesman*, the voice of the English community in India, opined that "Mr Gandhi has revealed his secret. His scheme of Civil Disobedience is to go with some of his followers to the seashore to take water from the sea and extract salt from it by evaporation. It is difficult not to laugh, and we imagine that will be the mood of most thinking Indians. There is something almost childishly theatrical in challenging in this way the salt monopoly of the government."

"On bended knees I asked for bread and I have received stone instead," Gandhi remarked, and making good his promise, he set out on March 12 with seventy-eight of his followers and disciples from Sabarmati Ashram on the march to Dandi on the sea. Gandhi's long stay in South Africa had furnished him with a precedent for the political march: he had led more than 2,200 men, women, and children on a five-day march in November 13 from Natal to the Transvaal in protest against repressive legislation. To the people of India, Gandhi with his staff and purposeful stride might well have appeared to be on a religious pilgrimage. All along the way, he addressed large crowds, and with each passing day an increasing number of people joined the march. The marchers kept up a lively pace, none more so than Gandhi; although, as the American journalist William Shirer, who was to visit him in February 1931, would later recall, Gandhi "seemed terribly frail, all skin and bones," his appearance was deceptive–he "walked four or five

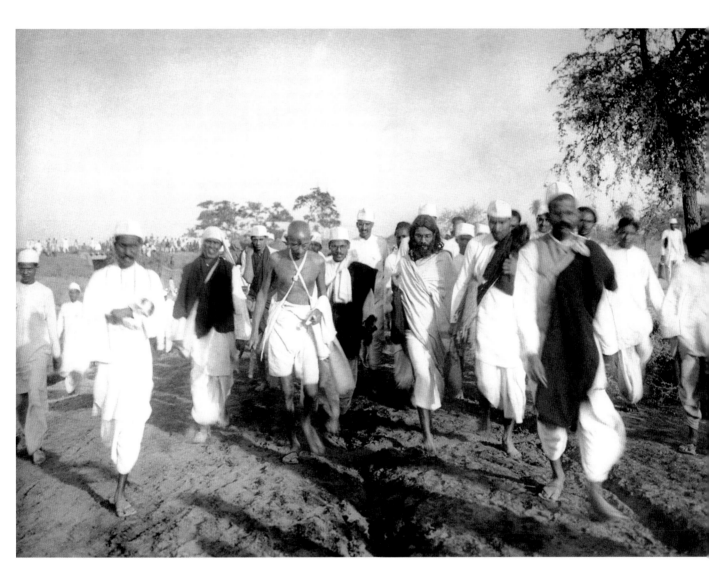

Gandhi and others on the Salt March, March 1930.
Photographer unknown. GandhiServe

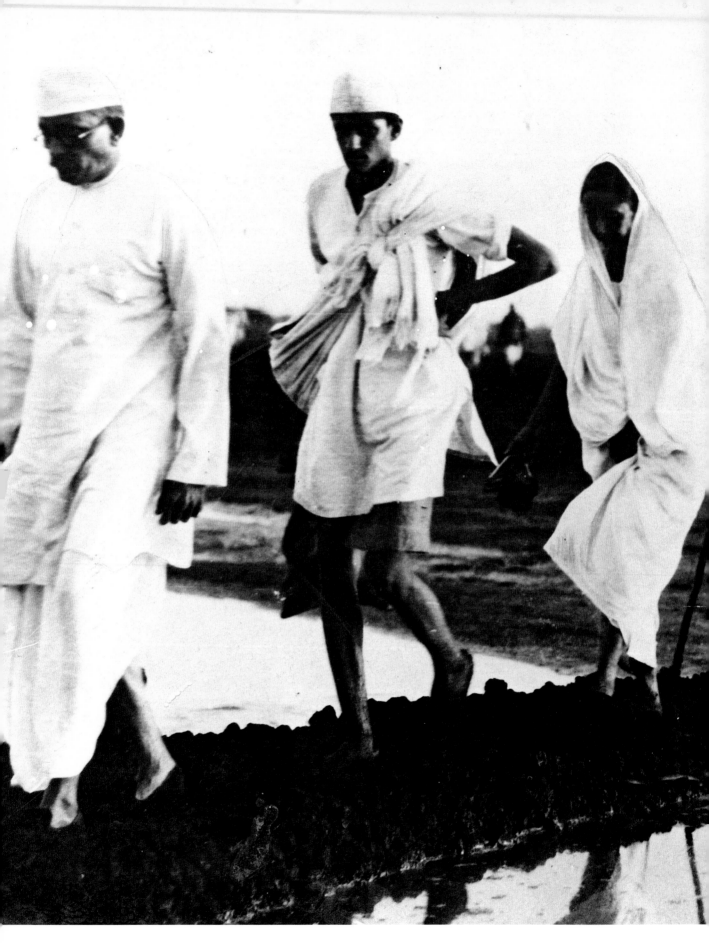

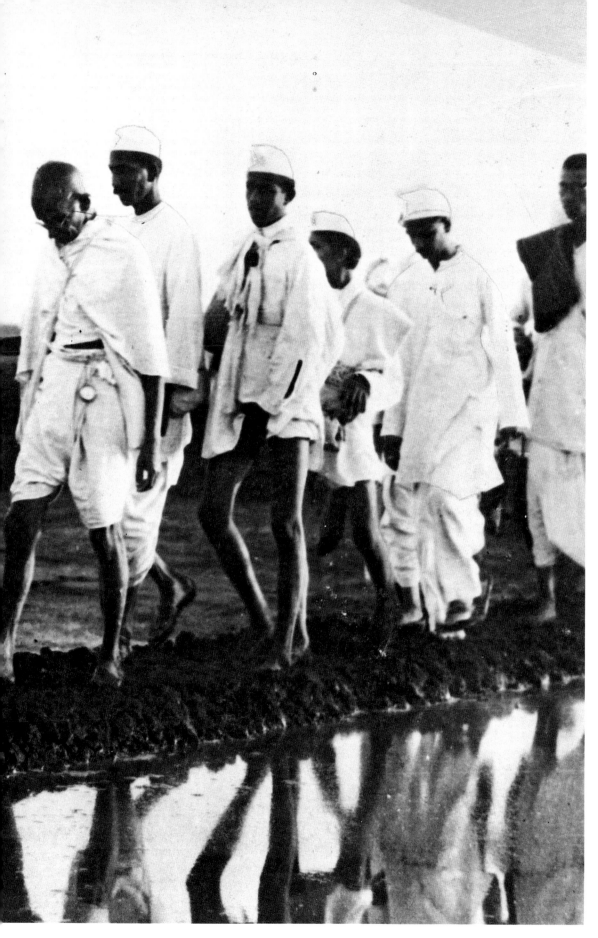

Gandhi and others on the Salt March, 1930. Photographer unknown.
Mansell/The LIFE Picture Collection/Getty Images

miles each morning at a pace so brisk" that Shirer, at less than half his age and "in fair shape from skiing and hiking in the Alps below Vienna, could scarcely keep up" with the Mahatma. It is said that the roads were watered, and fresh flowers and green leaves strewn on the path; and as the satyagrahis walked, they did so to the tune of one of Gandhi's favorite *bhajans, Raghupati Raghav Raja Ram*. On the morning of April 6, which marked the anniversary of the commencement of the 1919 agitation against the repressive Rowlatt Acts, and the initiation of the country into the methods of nonviolent resistance, Gandhi arrived at the sea at Dandi. Narayan Khare mellifluously rendered Gandhi's favorite bhajans, including *Vaishnavajana to*; short prayers were offered; and Gandhi then addressed the crowd before wading into the water. Precisely at 6:30 a.m. he picked up a small lump of natural salt. He had now broken the law; Sarojini Naidu, his close friend and associate, shouted: "Hail, deliverer!" No sooner had Gandhi violated the law than everywhere others followed suit: within one week the jails were full, but the marchers kept coming. Images of disciplined nonviolent resisters being brutalized by the police mobilized world public opinion in favor of Indian independence. Though Gandhi himself would be arrested, many Indians appeared to have thrown off the mental shackles of colonial oppression.

It has been suggested by some historians that nothing substantial was achieved by Gandhi through this campaign of civil disobedience. Gandhi and Irwin signed a truce, and the British Government agreed to call a conference in London to negotiate India's demands for independence. Gandhi was sent by the Congress as its sole representative, but these 1931 negotiations proved to be inconclusive, particularly since various other Indian communities had each been encouraged by the British to send a representative and make the claim that they were not prepared to live in an India under the domination of the Congress. Yet never before had the British consented to negotiate directly with the Congress, and Gandhi met Irwin as his equal. In this respect, the man who most loathed Gandhi, Winston Churchill, understood the extent of his achievement when he declared it "alarming and also nauseating to see Mr. Gandhi, a seditious Middle Temple lawyer, now posing as a fakir of a type well known in the East, striding half-naked up the steps of the viceregal palace, while he is still organizing and conducting a defiant campaign of civil disobedience, to parley on equal terms with the representative of the King-Emperor." Even Nehru was to come to a better appreciation of Gandhi following his march to the sea, since many Indians now appeared to understand that the nation had unshackled itself and achieved a symbolic emancipation. "Staff in hand he goes along the dusty roads of Gujarat," Nehru had written of Gandhi, "clear-eyed and firm of step, with his faithful band trudging along behind him. Many a journey he has undertaken in the past, many a weary road traversed. But longer than any that have gone

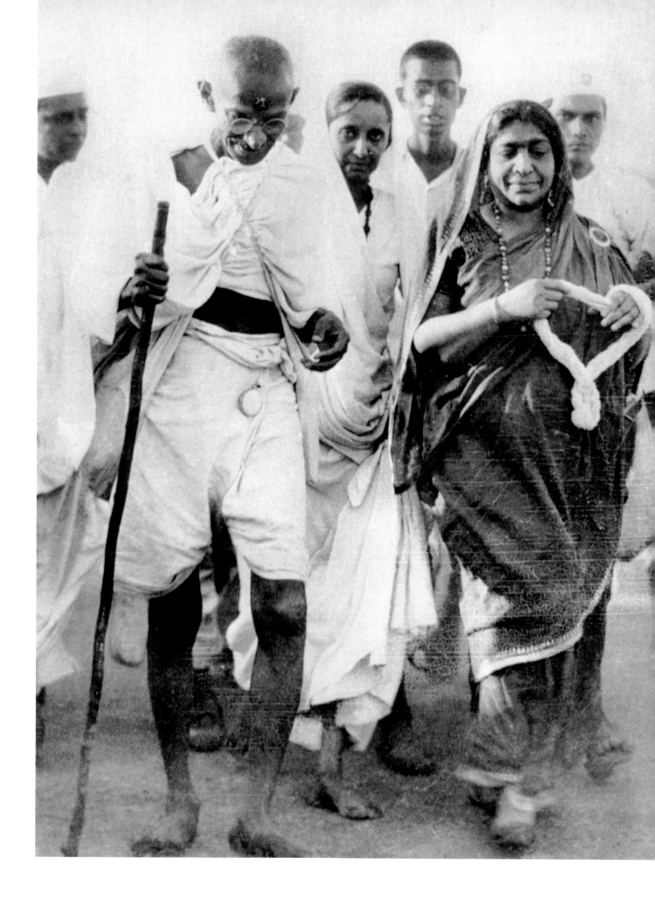

Gandhi and Sarojini Naidu on the Salt March, 1930.
Photographer unknown. Bettmann/Corbis

before is this last journey of his, and many are the obstacles in his way. But the fire of a great resolve is in him and surpassing love of his miserable countrymen. And love of truth that scorches and love of freedom that inspires. And none that passed him can escape the spell, and men of common clay feel the spark of life. It is a long journey, for the goal is the independence of India and the ending of the exploitation of her millions."

The picture of Gandhi, firm of step and walking staff in hand, has endured longer than almost any other image of him, and it is through this representation that the Bengali artist Nandalal Bose sought to immortalize Gandhi. The Salt March remains perhaps the most potent example of both the power of concerted nonviolent resistance and the intuitive strategies of satyagraha. Gandhi sought in various ways to insert the body into the body politic, and he was always alert to the meaning and potential of symbols. An inveterate user of trains, Gandhi was yet alive to the idea that a person's feet were enough to take him wherever he wanted. He also readily opened himself up to criticism: for instance, in hand-picking his marching companions, he had purposely omitted women even though they were full and active members of his ashram community, and many indeed served as his closest associates. Gandhi took the view that the presence of women might deter the British from attacking the satyagrahis, and that no such excuse should be available to the state if it wished to offer retaliation. Behind this lay Gandhi's distinction between nonviolence of the strong and non-violence of the weak, but his thinking was also informed by a certain sense of chivalry, such that any triumph of nonviolence was diminished if the playing field was not level. When Gandhi waded into the sea at Dandi, thousands joined in: the young and the old, believers and nonbelievers, and as many women as men. A revolution had been launched, one that *Time Magazine* recognized when, in anointing Gandhi their Man of the Year in 1930 over Stalin and Hitler, it invoked "the little brown man whose 1930 mark on world history will undoubtedly loom largest of all." Decades later, Bayard Rustin, a Quaker and a principal architect of the 1963 March on Washington, and other leading activists of the Civil Rights Movement acknowledged that Gandhi's march to the sea had given them all the cues they needed to launch "the most significant civil rights demonstration since Gandhi led the Indians to freedom." One suspects that generations to come will be reading about Gandhi's Dandi March–with perhaps a pinch of salt.

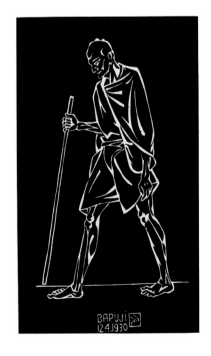

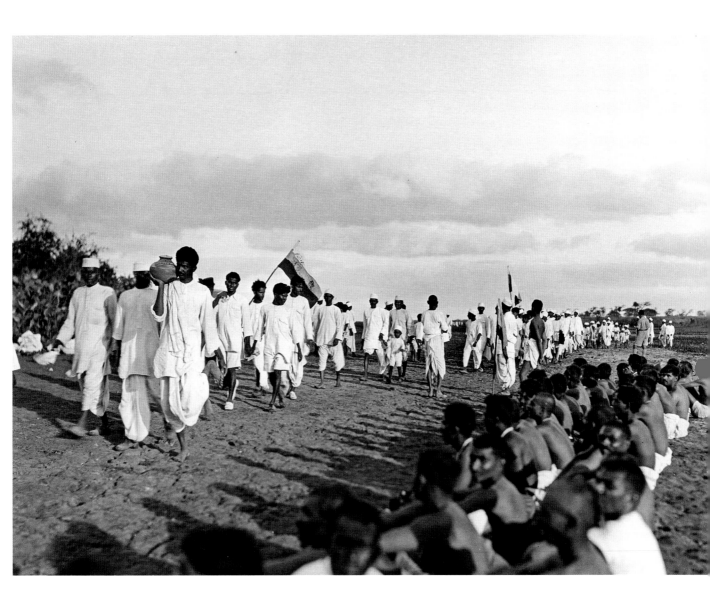

Opposite page Nandalal Bose (India, 1882–1966), Dandi March (Bapuji), 1930. Linocut on paper, 11 ½ × 7 ⅛ inches (29.5 × 18.2 cm). National Gallery of Modern Art, New Delhi

Above Walter Bosshard (Switzerland, 1892–1975), A Group of Volunteers Arrives at the River, 1930. Gelatin silver print. Fotostiftung Schweiz, Winterthur, Switzerland

Letter to Lord Irwin, Viceroy of India

March 2, 1930

Dear Friend,

Before embarking on Civil Disobedience and taking the risk I have dreaded to take all these years, I would fain approach you and find a way out. My personal faith is absolutely dear. I cannot intentionally hurt any thing that lives, much less fellow-human beings even though they may do the greatest wrong to me and mine. *Whilst therefore I hold British rule to be a curse, I do not intend to harm a single Englishman or any legitimate interest he may have in India.*

I must not be misunderstood. Though I hold the British rule in India to be a curse, I do not therefore consider Englishmen in general to be worse than any other people on earth. I have the privilege of claiming many Englishmen as dearest friends. Indeed much that I have learnt of the evil of British rule is due to the writings of frank and courageous Englishmen who have not hesitated to tell the unpalatable truth about that rule.

And why do I regard the British rule as a curse?

It has impoverished the dumb millions by a system of progressive exploitation and by a ruinously expensive military and civil administration which the country can never afford.

It has reduced us politically to serfdom. It has sapped the foundations of our culture, and, by the policy of disarmament, it has degraded us spiritually. Lacking inward strength, we have been reduced by all but universal disarmament to a state bordering on cowardly helplessness.

…

It seems as clear as day light that responsible British statesmen do not contemplate any alteration in British policy that might adversely affect Britain's commerce with India or require impartial and close scrutiny of Britain's transactions with India. If nothing is done to end the process of exploitation, India must be bled with an ever increasing speed....

Let me put before you some of the salient points. The terrific pressure of land revenue which furnishes a large part of the total revenue, must undergo considerable modification in Independent India. Even the much vaunted permanent settlement benefits a few rich Zamindars not the *ryots*. The *ryot* has remained as helpless as ever. He is a mere tenant at will. Not only then has land revenue to be considerably reduced, but the whole revenue system has to be so revised as to make the *ryot's* good its primary concern. But the British system seems to be designed to crush the very life out of him. Even the salt he must use to live is so taxed as to make the burden fall heaviest on him if only because of the heartless impartiality of its incidence. The tax shows itself still more burdensome on the poor man when it is remembered that salt is the one thing he must eat more than the rich man both individually and collectively. The drink and drug revenue too is derived from the poor. It saps the foundations both of their health and morals. It is defended under the false pleas of individual freedom, but in reality it is maintained for its own sake....If the weight of taxation has crushed the poor from above, the destruction of the central supplementary industry, i.e., hand-spinning, has undermined their capacity for producing wealth.

The tale of India's ruination is not complete without a reference to the liabilities incurred in her name. Sufficient has been recently said about these in the public Press. It must be the duty of a free India to subject all liabilities to the strictest investigation and repudiate those that may be adjudged by an impartial tribunal to be unjust and unfair. The iniquities sampled above are maintained in order to carry on a foreign administration, demonstrably the most expensive in the world. Take your own salary. It is over Rs. 21,000 per month besides many other indirect additions. The British Prime Minister gets 5,000 per year, i.e., over Rs. 5,400 per month at the present rate of exchange. You are getting over Rs. 700 per day against India's average income of less than annas 2 per day. The Prime Minister gets Rs. 180 per day against Great Britain's average income of nearly Rs. 2 per day. Thus you are getting much over 5,000 times India's average income. The British Prime Minister is getting only 90 times Britain's average income. On bended knee I ask you to ponder over this phenomenon. I have taken a personal illustration to drive home a painful truth. I have too great a regard for you as a man to wish to hurt your feelings. I know that you do not need the salary you get. Probably the whole of your salary goes for charity. But a system that provides for such an arrangement deserves to be summarily scrapped. What is true of the Viceregal salary is true generally of the whole administration.

A radical cutting down of the revenue, therefore, depends upon an equally radical reduction in expenses of administration. This means a transformation of the scheme of Government....

And the conviction is growing deeper and deeper in me that nothing but unadulterated non-violence can check the organised violence of the British Government. Many think that non-violence is not an active force. It is my purpose to set in motion that force as well against the organised violence force of the British rule as the unorganised violence force of the growing party of violence. To sit still would be to give rein to both the forces above mentioned. Having unquestioning and immovable faith in the efficacy of non-violence as I know it, it would be sinful on my part to wait any longer. This non-violence will be expressed through civil disobedience for the moment confined to the inmates of the Satyagraha Ashram, but ultimately designed to cover all those who choose to join the movement with its obvious limitations.

I know that in embarking on non-violence, I shall be running what might fairly be termed a mad risk, but the victories of truth have never been won without risks, often of the gravest character. Conversion of a nation that has consciously or unconciously, preyed upon another far more numerous, far more ancient and no less cultured than itself is worth any amount of risk.

I have deliberately used the word conversion, for my ambition is no less than to convert the British people through non-violence and thus make them see the wrong they have done to India. I do not seek to harm your people. I want to serve them even as I want to serve my own. I believe that I have always served them. I served them up to 1919 blindly. But when my eyes were opened, and I concieved non-co-operation the object still was to serve them. I employed the same weapon that I have in all humility successfully used against the dearest members of my family. If I have equal love for your people with mine, it will not long remain hidden. It will be acknowledged by them even as members of my family acknowledged it after they had tried me for several years. If people join me as I expect they will, the sufferings they will undergo, unless the British nation sooner retraces its steps, will be enough to melt the stoniest hearts.

The plan through civil disobedience will be to combat such evils as I have sampled out.

...I respectfully invite you then to pave the way for an immediate removal of those evils and thus open a way for a real conference

between equals, interested only in promoting the common good of mankind through voluntary fellowship and in arranging terms of mutual help and commerce suited to both. … But if you cannot see your way to deal with these evils and my letter makes no appeal to your heart, on the 11th day of this month I shall proceed with such co-workers of the Ashram as I can take to disregard the provisions of Salt laws. I regard this tax to be the most iniquitous of all from the poor man's standpoint. As the Independence Movement is essentially for the poorest in the land, the beginning will be made with this evil. The wonder is, that we have submitted to the cruel monopoly for so long. It is, I know, open to you to frustrate my design by arresting me. I hope there will be tens of thousands ready in a disciplined manner to take up the work after me, and in the act of disobeying the Salt Act lay themselves open to the penalties of a law that should never have disfigured the Statute-book.

I have no desire to cause you unnecessary embarrassment or any at all so far as I can help. If you think that there is any substance in my letter, and if you will care to discuss matters with me, and if to that end you would like me to postpone publication of this letter, I shall gladly refrain on receipt of a telegram to that effect soon after this reaches you. You will however do me the favour not to deflect me from my course unless you can see your way to conform to the substance of this letter.

This letter is not in any way intended as a threat, but is a simple and sacred duty peremptory on a civil resister. Therefore I am having it specially delivered by a young English friend, who believes in the Indian cause and is a full believer in non-violence and whom Providence seems to have sent to me as it were for the very purpose.

I remain,
Your Sincere friend.
[signed M. K. GANDHI]

From *Famous Letters of Mahatma Gandhi*
(Lahore: Indian Printing Works, 1947), excerpts.

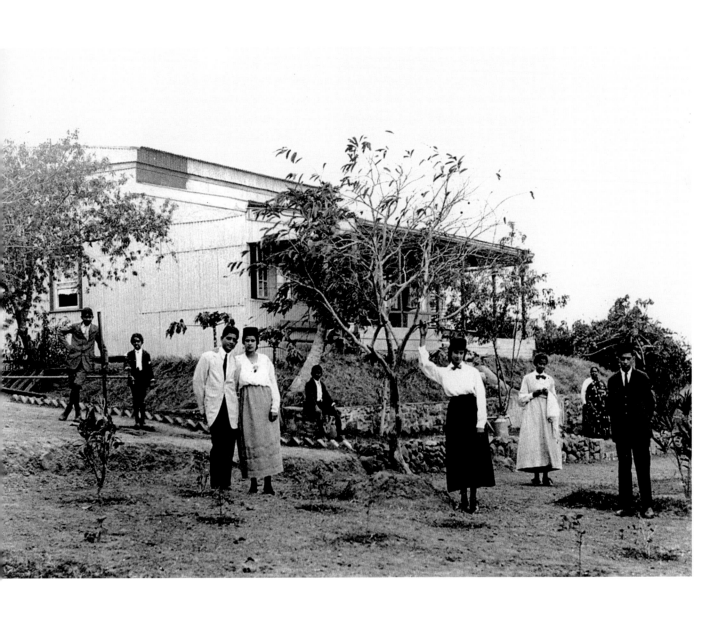

Gandhi's house at Phoenix Settlement, South Africa, ca. 1917.
Photographer unknown. akg-images/Archiv Peter Rühe

ERIC M. WOLF

Four Alternatives to Civilization

Gandhi's Ashrams, Their Principles and Sources

> *Real home-rule is self-rule or self-control*
> –Mohandas K. Gandhi, *Hind Swaraj* [1]

1 Mohandas K. Gandhi, *Hind Swaraj or Indian Home Rule,* 1938 edition, in *Selected Works of Mahatma Gandhi* (SWMG) (Ahmedabad: Navajivan, 1968), 4:201.

Mohandas K. Gandhi was born on the second of October in 1869. He was the thus over thirty years old at the dawn of the twentieth century. That Gandhi, a man who would become one of the greatest world figures of the twentieth century, was already a mature, established adult in the nineteenth century is critical to understanding the provenance, context, and content of much of the philosophy and ideas that would inform his views on what society should look like and how these goals could be achieved. The political history of the Indian independence movement and Gandhi's central role in it is well documented and often debated; however, this essay aims to look away from institutional politics of states and governments and instead to look at the philosophical and theoretical vision of a nonviolent society that Gandhi aspired to bring to India and the world.

What would a nonviolent society built along Gandhian terms look like? Gandhi himself provided some evidence with the four communities he established at different places and times during his own life. While the four communities began at different times in places as distant as southern Africa and northern India, they overlapped, and some of them continued to exist after Gandhi's departure. They were established for varying purposes but shared many common elements and themes. Further, they represent many common intents and, seen as a succession, show both the evolution and constancy in much of Gandhi's thought throughout his life.

The most enduring image of a Gandhian community is doubtless the Sabarmati Ashram outside Ahmedabad, India (founded in 1915, moved to current location in 1917, and inhabited by Gandhi through 1933). However, this was actually the third of four communities that Gandhi would found. The first two were in South Africa, where Gandhi lived from 1893 to 1914, and were known as the Phoenix Settlement (established 1904; inhabited until 1985) and Tolstoy Farm (established 1910; disbanded in 1914). The last community Gandhi established was the Sevagram Ashram (established 1936).

Gandhi's tactics of protest and nonviolent struggle have been analyzed in great depth. Less studied, perhaps, is the end and vision he fought for. Political independence for an Indian republic, though important, was only a small part of his vision, which was for a nonviolent and just society. He clearly articulates this in his earliest, broadest, and most important manifesto, *Hind Swaraj*, translated as "Indian Home Rule" or "Indian Self-Rule." Much of the theory expounded in this 1908 text was to be realized in the communities that Gandhi established and lived in. In an attempt to gain a better understanding of what a Gandhian society would look like, this essay will investigate the Phoenix Settlement, Tolstoy Farm, Sabarmati Ashram, and Sevagram Ashram and their histories as well as Gandhi's intellectual sources for them and the tradition they represent.

QUESTIONING THE VIRTUES OF WESTERN "CIVILIZATION" AND DEFINING ALTERNATIVES

Gandhi's great manifesto, *Hind Swaraj* or "Indian Self-Rule," is a dialog between an "Editor" (Gandhi) and a "Reader" who is a composite of various other factions of the Indian independence movement; particularly those who advocated a forcible removal of the English and the establishment of a modern, industrial, independent Indian nation-state on the model of the Western European industrial democracies. Gandhi would state as late as 1938 that "after the stormy 30 years through which I have since passed, I have seen nothing to make me alter the views expounded in it."[2] To the Reader, who wants India to expel the English and become a world power, Gandhi's Editor responds:

In effect it means this: that we want English rule without the Englishman. You want the tiger's nature, but not the tiger; that is to say, you would make India English. And when it becomes English, it will be called not Hindustan but *Englistan*. This is not the Sawaraj that I want.[3]

2 Ibid., 98.

3 Ibid., 112.

Gandhi clearly rejects this notion of India becoming a modern power along the lines of Japan, a model advanced by many of his rivals in the independence movement. In fact, much of *Hind Swaraj* is a catalogue of the evils of Western civilization, from the terrible conditions of workers in mines and factories, to the brutalities of war and modern weaponry, to the greed and social uselessness that are the products of modern industrial capitalism.

Few are the institutions of modern civilization that are immune from attack by Gandhi in *Hind Swaraj*. Parliament is "like a sterile woman and a prostitute," newspapers "are often dishonest," railways "accentuate the evil nature of man," lawyers "have enslaved India, have accentuated Hindu-Mahomedan dissensions and have confirmed English authority," doctors "have almost unhinged us."[4] This brief listing is merely the tip of the iceberg. Of course Gandhi was not unique nor the first to offer a wholesale critique of Western civilization. He acknowledges many of his sources throughout *Hind Swaraj* and offers a very useful and enlightening list of "authorities" in the appendix to the work:

I. SOME AUTHORITIES

The following books are recommended for perusal to follow up the study of the foregoing:

The Kingdom of God is within You – *Tolstoy*
What is Art? – *Tolstoy*
The Slavery of Our Time – *Tolstoy*
The First Step – *Tolstoy*
How Shall We Escape – *Tolstoy*
Letter to a Hindoo – *Tolstoy*
The White Slaves of England – *Sherard*
Civilization, Its Cause and Cure – *Carpenter*
The Fallacy of Speed – *Taylor*
A New Crusade – *Blount*
On the Duty of Civil Disobedience – *Thoreau*
Life without Principle – *Thoreau*
Unto This Last – *Ruskin*
A Joy for Ever – *Ruskin*
Duties of Man – *Mazzini*
Defense and Death of Socrates – From *Plato*
Paradoxes of Civilization – *Max Nordau*
Poverty and Un-British Rule in India – *Naoroji*
Economic History of India – *Dutt*
Village Communities – *Maine*[5]

4 Ibid., 113, 116, 131, 142, 147, respectively.

5 Ibid., 202.

These and other sources will be investigated to establish the basis for Gandhi's thoughts on what a nonviolent society would look like as he attempted, through his ashrams, to create model communities that could serve as alternatives to the modern industrial society of which he was so critical.

The first item on the list is by Leo Tolstoy. In Gandhi's own words, "Tolstoy's *The Kingdom of God is Within You* overwhelmed me. It left an abiding impression on me."[6] This text is the principle point of departure for my essay. It, together with its sources forms the theoretical basis for much of Gandhi's thought on civilization, nonviolence, and the methods and philosophy of transformation of society. I would go so far as to submit that, either consciously or unconsciously, the title of *Hind Swaraj* itself, with its ambiguity of Indian Home Rule or Indian Self-Rule (i.e., rule of self) is an invocation of Tolstoy's title; in both cases the important and necessary revolution is inside the individual, not inside institutions. The Kingdom of God or Indian Home Rule can only be achieved when a critical mass of individuals renounce violence and its institutions, which include Western industrial civilization.

While Leo Tolstoy (1820–1910) made his name and is best remembered today as a novelist, in the late nineteenth and early twentieth centuries he had largely renounced literature as art and was principally known as a moral philosopher, reformer, activist, and thorn in the side of the Tsarist regime in Russia. He enjoyed too great a reputation and was far too beloved by the Russian people to be exiled or punished in the way that many other enemies of the autocracy were, but he was still highly censored in Russia and excommunicated from the Russian Orthodox Church, of whose doctrine he was scathing in his criticism.

Tolstoy's central tenet in *The Kingdom of God is Within You* is the complete rejection of violence, not just in one's own actions, but also through participation in societal violence through military service and any service run by a state or government that relies on violence as the basis for its authority.[7] Tolstoy based this philosophy on the teachings of Christ as manifest in the Sermon on the Mount (Matthew, Chapters 5–7), particularly the phrase (verse 39) "But I say unto you, that ye resist not evil."[8] Tolstoy's message is clear: true Christianity is not the religion of the church (which in his native Russia was controlled by the state) but rather the code of conduct taught by Christ in the Gospel. Non-resistance to evil by force, nonparticipation in judicial judgment and military service, and refusal to take oaths are all expressed in the Sermon on the Mount but contradicted by the tenets of both church and state. Tolstoy hoped that nonparticipation in these state activities would eventually lead to the collapse of the oppressive Nicholovian

6 Mohandas K. Gandhi, *An Autobiography or the Story of my Experiments with Truth,* in SWMG 1:204. Much has been written on the relationship between Gandhi and Tolstoy; see, e.g., Martin Green, *The Origins of Nonviolence: Tolstoy and Gandhi in their Historical Settings* (University Park: Pennsylvania State University Press, 1986). However, this has mostly concentrated on their correspondence and similarities in their general beliefs and contexts; the level of connection between *Hind Swaraj* and *The Kingdom of God is Within You* and its source material has largely remained unexplored.

7 Tolstoy published *The Kingdom of God is Within You* in 1893, expanding on ideas in his earlier book *What I Believe,* of 1884.

8 Gandhi too singles out this passage, see Gandhi, *An Autobiography,* 1:101.

9 Nicholas I was Tsar of Russia from 1825 to 1855 and ruled as an autocrat with a huge state police apparatus. Serfdom was maintained throughout his reign, and it fell to his successor, Alexander II (r. 1855–1881) to emancipate the serfs. This was done in an unsatisfactory manner that pleased no one, as the serfs did not get land and therefore largely continued in their poverty with little legal recourse. While Tolstoy and Alexander Herzen (see below) initially had hopes for the new tsar, they quickly viewed his reign as a continuation of his father's.

10 Herzen wrote and published the essays in *From the Other Shore* between 1847 and 1850.

Russian autocracy.[9] Anticipating Gandhi's *satyagraha* (literally translated as "truth-force" or "soul-force," satyagraha is the Gandhian term for nonviolent civil disobedience, resistance, and protest), Tolstoy encouraged people to refuse to follow unjust laws and to suffer jail, transportation, and even death rather than submit to the rule of violence. While in language Tolstoy's philosophy is deeply Christian (it has been called "Christian anarchy," though Tolstoy did not use this term himself), it is deeply indebted to many earlier and contemporaneous nonviolent socialist and anarchist sources that will be discussed further below.

Tolstoy associated contemporary society's ills with the modern Western industrial, state, imperialist system. Like the sources and thinkers he followed, he advocated a return to an agrarian, nonindustrial societal model, his being based on the Russian peasant commune or *mir*. In a manner similar to what Gandhi would later do, Tolstoy adopted the mode of dress of the masses, in his case the Russian peasant, and advocated living in the country and living off the land. The peasant commune he used as a model for society was a village economy where cultivated land was held in common and cottage industry rather than urban industry produced the essentials of life. Also, like Gandhi, Tolstoy experimented with a strict vegetarian diet and sexual chastity (similarly, this unilateral decision placed a great deal of stress on his marriage and family relations).

As Gandhi would assert in *Hind Swaraj*, Tolstoy believed firmly that the true revolution takes place within the individual. The tsarist autocracy would only cease to have sway when a critical mass of individuals refused to cooperate and do its bidding. Any other type of revolution is doomed to fail before it begins because it replaces the coercive power of the regime with the coercive power of its own leadership. This idea, like that of the mir as model for a just societal organization, owes a great debt to the luminary Russian radical thinker Alexander Herzen (1812–1870; often called "the father of Russian socialism"). Herzen began as a revolutionary leader who advocated the violent overthrow of the Nicholovian regime. He lived as an exile in Paris during the Revolution of 1848, which was a watershed moment in his political and philosophical thought. As he recounts in *From the Other Shore*, the events he witnessed and their aftermath transformed his view of violence and his notions concerning revolution.[10] Blood spilled in violence is a reality, the ends in whose name it is spilled is merely a possible future, not a reality (as borne out by the failure of the 1848 revolutions), therefore bloody means can never be justified by conditional ends.

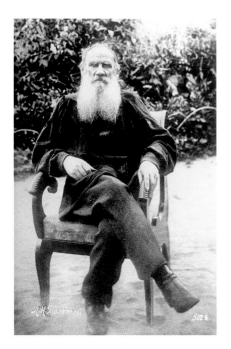

Leo Tolstoy, ca. 1908. Photographer unknown. Popperfoto/Getty Images

As the young Gandhi corresponded with the old Tolstoy, the younger Tolstoy had sought out the older Herzen in his exile in London. Another older radical figure the younger Tolstoy sought out and met was Pierre-Joseph Proudhon (1809-1865), a then-famous anarchist who also questioned the utility of violent revolution. Proudhon's great work was *What is Property?* (the answer to this rhetorical question being "property is theft") in which he challenged the basis of Enlightenment thought on property law and rights of possession and inheritance.[11] Much of Gandhi's later thoughts on what he termed "trusteeship" bears a startling resemblance to Proudhon's conclusions regarding the nature of property. Proudhon challenged the central Enlightenment idea of legal equality of rights, which he thought was worthless without equality of means and therefore merely a legal justification of unjust coercive authority. Though an inhabitant of cities (Proudhon worked as a printer, an industrial activity), Proudhon's philosophy was also based on an agrarian economy and cottage industry and was critical of industrialism and the modern state that he saw as its prerequisite. He favored an anarchistic model of federated agrarian village economies as an alternative.

Though Proudhon was highly critical of him, the still-earlier French utopian thinker Charles Fourier (1772–1837) is one of the most significant early links in the chain of criticism of the modern Western industrial system. Fourier is perhaps best remembered today (when he is remembered at all) as the person who first used the term "feminism" and the creator of the concept of the "phalantstery," a large building that contained an entire community and all of its necessaries. His seminal work was the book *The Theory of the Four Movements* in which he called civilization a disease, but assured the reader that it was just a phase humanity would pass through en route to a better existence and social order.[12] Though much of Fourier's text is taken up with strange utopian visions of improved living conditions changing the ecology of the world (allowing the cultivation of grain at Earth's poles), his criticism of the modern world are at times quite powerful and have a clear, genealogical influence on Gandhi's thoughts and writings. *Civilization, Its Cause and Cure* by Edward Carpenter, one of the works cited by Gandhi in the appendix of *Hind Swaraj*,[13] is largely a summary, with the strangest and more embarrassing parts of Fourier's critique of civilization removed.

Fourier divides the history of humanity into four phases, savagery, barbarism, civilization (where we are now), and the "combined order" or future of happiness where we are going. Carpenter maintains a similar system, though without the seemingly magical changes Fourier associates with what comes after civilization. What is perhaps most

11 Pierre-Joseph Proudhon's *What is Property? An Inquiry into the Principle of Right and of Government* was originally published in 1840.

12 Charles Fourier's *Theory of the Four Movements* was originally published in 1808.

13 Edward Carpenter's *Civilization, Its Cause and Cure* was originally published in 1889.

14 Parallels between Gandhi's
 thoughts on the four Hindu *yugas*
 and Fourier's thought have been
 discussed by Anthony Copley in
 Gandhi: Against the Tide (Oxford:
 Oxford University Press, 1987), 14.

15 Henry David Thoreau, also listed
 in Gandhi's appendix to *Hind
 Swaraj*, also quotes Hindu sources
 in his writing, most notably in
 Walden.

16 Gandhi clearly defines and lays
 out his constructive program in
 the 1941 pamphlet *Constructive
 Programme: Its Meaning and Place*,
 enlarged and revised in 1945.

fascinating here is that we see these European thinkers consciously turning to the East, particularly Hinduism, for the structure and contents of such a system, which might be seen as a loose adaptation of the four *yugas* or phases of the universe, with "civilization" being the stand-in for the *Kali Yuga* or period of decline, the worst period in the four-part cycle.[14] Such use of a Hindu tenet in this tradition of Western philosophy, whether understood properly or not, is a fascinating mirror image of Gandhi's use of Western philosophy in his own writings and shows the complexity and limitations of even using terms such as "Western" and "Eastern" when discussing the history of ideas in the nineteenth and twentieth centuries.[15]

GANDHI'S ASHRAMS

Gandhi worked in two parallel modes: on the one hand were satyagraha and noncooperation, and on the other was what he termed a "constructive program." Satyagraha was active nonviolent resistance to specific laws, institutions, and actions of state authority; it often resulted in the incarceration and even physical beating of the *satyagrahi* (practioner of satyagraha) and was aimed at effecting positive change to the object it opposed. His constructive program, complementary to satyagraha, did not violate any laws but rather consisted of positive actions done outside of the dominant political system.[16] The constructive program consisted of self-improvement, leading a just, self-sufficient life, and finding constructive alternatives to participating in the unjust system of modern, industrial, imperialist civilization. Perhaps the best illustration of the Gandhian constructive program is provided by the spinning wheel and the emphasis on home-spun cloth (*khadi*). When one made the cloth one wore, he or she not only practiced self-sufficiency but also was not buying the produce of factories in Manchester, England, that had left people in India without employment owing to colonial importation. It aimed to revive the village economy of India and helped insure that no Indian would go without clothing.

It is in the light of his constructive program that Gandhi's ashrams can be understood most clearly. They were not chiefly an act of protest (though they at times facilitated protest and satyagraha in various ways), but rather the constructive manifestations: experimental models of nonviolent society, microcosms of just alternatives to the modern system. Like much in Gandhi's life, they were in themselves experiments, "experiments with truth," as well as laboratories where further experiments were conducted. Life lived inside these communities would mirror the ideas outlined in Gandhi's constructive program. Gandhi put into practice his diverse ideas concerning education, diet, medicine,

Margaret Bourke-White and Manilal Gandhi at the printing press at Phoenix Settlement, South Africa, 1945. Photographer unknown. akg-images/Archiv Peter Rühe

and self-sufficiency within the confines of these ashrams. These ashrams were indeed the template for the "Indian village" he espoused (which differed greatly from the impoverished reality in the contemporaneous villages of colonial India); they were the aspirational villages of a future India that had achieved true swaraj.

While Gandhi was vehement in his opposition to industrialism and the machine,[17] a machine must be credited as the impetus for the establishment of Gandhi's first ashram, the Phoenix Settlement, located outside Durban in Natal, South Africa, in 1904. In 1898 Gandhi and others established the International Printing Press or IPP in Durban; in 1903 this press began publication of the newspaper *Indian Opinion*, with Gandhi serving as its editor.[18] The press at the Phoenix Settlement and its newspaper would print and publish extracts and translations of Leo Tolstoy, John Ruskin, Henry David Thoreau, and others mentioned in the appendix of *Hind Swaraj*; *Hind Swaraj* itself would be printed on this press. Some of the pamphlets and papers printed here would be proscribed in India, recalling Alexander Herzen's Free Russian Press in London, which published *The Polestar* and *The Bell*, radical periodicals that circulated illegally in tsarist Russia and exerted a great influence there. Though proscribed, both Gandhi's and Herzen's publications are known to have been read by the regimes they challenged (Tsar Alexander II read *The Bell*, and the British viceroys and their officials in Calcutta read *Hind Swaraj*).[19] Extracts and translation of the *Bhagavad Gita* were also published by the IPP. It is interesting to note that Gandhi himself first read this text closely while a student in England, and in English; it would go on to become central to his thoughts and philosophy.

While the press had existed in the town of Durban, at the Phoenix Settlement it was the center of a community of like-minded people living where they worked, making this work a central part of their existence. For the first time, Gandhi had the opportunity of creating a model community where what he would later term "constructive program" could be put into practice. There would be no caste at the Phoenix Settlement; Hindus, Muslims, Christians, and Jews lived and worked side by side on the press and in carrying out all the functions of communal living, from cooking to sanitation. It was at Phoenix that Gandhi took his vow of *brahmacharya* or chastity in 1906.[20]

Gandhi ascribes the impetus and inspiration for establishing the Phoenix Settlement to another nineteenth-century Western thinker: the Englishman John Ruskin (1819–1900). Though Ruskin is best remembered today as a critic of art and architecture, he was also a Christian philosopher. Henry Polak, a close friend and confidant,

17 For Gandhi's critique of machinery and the societal evils it creates, see *Hind Swaraj*, chapter 19, "Machinery."

18 For a detailed history and analysis of the IPP and *Indian Opinion*, see Isabel Hofmeyr, *Gandhi's Printing Press: Experiments in Slow Reading* (Cambridge, MA: Harvard University Prss, 2013).

19 For discussion of the reading of Herzen's proscribed writings in Russia, including in the imperial palace, see Robert Harris, "Alexander Herzen: Writings on the Man and his Thoughts," in Kathleen Parthé, *A Herzen Reader* (Evanston, IL: Northwestern University Press, 2012); for the banning of Gandhian pamphlets in India, see Hofmeyr, *Gandhi's Printing Press*, 99.

20 Gandhi, *An Autobiography*, 1:310.

gave Gandhi Ruskin's book *Unto This Last* (1862), which Gandhi read on a train from Johannesburg to Durban (interestingly, Polak was Jewish; that a Jew and a Hindu would take such inspiration from a text based on Christ's parables is suggestive of the highly ecumenical and universalist approach to religion and ethics taken by Gandhi and his followers). Gandhi summarized this text:

The teachings of *Unto This Last* I understood to be:
1. That the good of the individual is contained in the good of all.
2. That a lawyer's work has the same value as the barber's, inasmuch as all have the same right of earning their livelihood from their work.
3. That a life of labour, i.e. the life of the tiller of the soil and the handicraftsman, is the life worth living.

The first of these I knew. The second I had dimly realized. The third had never occurred to me. *Unto This Last* made it as clear as daylight for me that the second and third were contained in the first. I arose with the dawn, ready to reduce these principles to practice.[21]

21 Ibid., 2:446.

These tenets, consistent with the Russian and Continental philosophical ideas discussed above, empowered Gandhi to acquire the land outside Durban, invite a select group of family and followers, and found the first of his ashrams.

As Gandhi relates, the first building erected on the farm at Phoenix was the shed for the printing press, which was up and running within a month of the purchase of land. Gandhi brought members of his own family, including son Manilal (who would remain at Phoenix, publishing the *Indian Opinion* newspaper until his death in 1956) and wife Kasturba, as well as Henry Polak (later joined by his wife) and the workers (many of whom were Indian) who ran the press and followed Gandhi. The population of the settlement would eventually reach sixty people. At first they lived in tents while permanent structures for living, farming, and support services were built. Gandhi relates an episode that at the same time illustrates his ambivalence toward machinery and the communal attitude toward labor that Phoenix represented. When the press was first set up there, the engine that powered the press failed. Gandhi had the press hooked up to a hand-wheel, and he, his printers, and the carpenters who had erected the building took turns powering the wheel by hand. As Gandhi relates:

The copies were despatched on time, and everyone was happy.

This initial insistence ensured the regularity of the paper and created an atmosphere of self-reliance in Phoenix. There came a time when

Henry S. L. Polak, ca. 1910. Photographer unknown. akg-images/Archiv Peter Rühe

22 Ibid., 450–52.

23 "Tolstoy Farm I," chapter 23 in
 Satyagraha in South Africa, SWMG,
 3:318–19.

24 Ibid., 320.

25 Ibid., 321.

we deliberately gave up the use of the engine and worked with hand-power only. Those were, to my mind, the days of highest moral uplift for Phoenix.[22]

Whereas the Phoenix Settlement was intended as a permanent community and would continue to produce *Indian Opinion* for more than fifty years after its founding, Gandhi's second ashram in South Africa, Tolstoy Farm, was created for an ad hoc purpose. By 1910 Gandhi's satyagraha against the repressive laws restricting the rights of Indians in the Transvaal was in full force. As Gandhi relates in his book *Satyagraha in South Africa*, when satyagrahis went to jail, their families were sustained with funds contributed by supporters. As more and more people joined the movement, these funds ran short.[23] Encouraging the principle he would later call "trusteeship" (and recalling principles developed by Pierre-Joseph Proudhon regarding ownership and use of land), Gandhi convinced his friend and supporter Hermann Kallenbach, a wealthy Johannesburg architect, to buy a farm outside Johannesburg and transfer it without charge or rent to Gandhi for use as a home for the families of satyagrahis who were serving time in prison. As Gandhi states:

The place required must be in the Transvaal and near Johannesburg. Mr. Kallenbach, whose acquaintance the reader has already made, bought a farm about 1,100 acres and gave the use of it to Satyagrahis free of any rent or charge (May 30, 1910). Upon the farm there were nearly one thousand fruit-bearing trees and a small house at the foot of a hill with accommodation for a half-a-dozen persons. Water was supplied from two wells as well as from a spring. The nearest railway station, Lawley, was about a mile from the farm and Johannesburg was twenty-one miles distant. We decided to build houses upon this Farm and to invite families of Satyagrahis to settle there.[24]

In both his *Autobiography* and *Satyagraha in South Africa*, Gandhi gives more detail about the various experiments in communal living at Tolstoy Farm than he does of any of his other ashrams. The fundamental decisions were made early:

Here we insisted that we should not have any servants either for household work or as far as might be even for farming and building operations. Everything therefore from cooking to scavenging was done with our own hands. As regards accommodation for families, we resolved from the first that the men and women should be housed separately.[25]

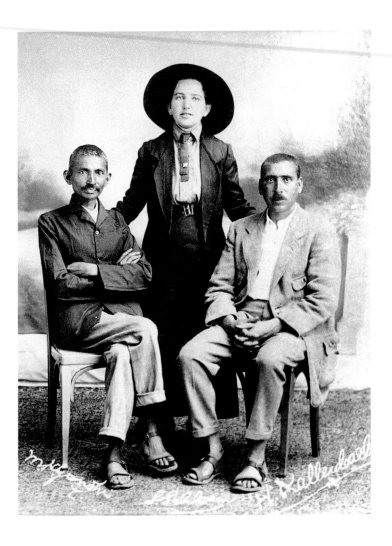

Thus life on Tolstoy Farm was truly communitarian, although the separation of the sexes would generally enforce brahmacharya at the farm. That Gandhi expressly includes "scavenging" (meaning the disposal of human waste) in what would be "done with our own hands" is critical, as in those words he completely rejects the caste system in the life of Tolstoy Farm, as it is precisely the duty assigned by that system to the so-called untouchables (or outcastes). Gandhi enumerates the original inhabitants of the farm as coming from "Gujarat, Tamilnnad, Andhradesh and North India" and including "Hindus, Musalmans, Parsis and Christians"; "about forty of them were young men, two or three old men, five women and twenty to thirty children of whom four or five were girls."[26]

The orchards on Tolstoy Farm would yield more than enough fruit for the needs of the farm's inhabitants. Gandhi discusses his fears of imposing a strict vegetarian diet on the Muslims and Christians who lived on the farm, but was relieved when all willingly agreed

26 Ibid. There was also at least one Jew on the farm, as Hermann Kallenbach, who joined Gandhi at Tolstoy Farm, was of that faith.

Gandhi, Sonia Schlesin, and Hermann Kallenbach before the march from Natal to Transvaal, South Africa, 1913. Photographer unknown. akg-images/Archiv Peter Rühe

27 Ibid., 322–23.

28 Ibid., 327–28.

29 Ibid., 331.

30 Ibid., 332.

to it.[27] A central goal of Tolstoy Farm, and indeed all of Gandhi's ashrams, was self-sufficiency and self-reliance (the very keys of *Hind Swaraj*); to this end, not only was food produced on the farm, but cottage industry was developed (anticipating the later hand-spinning movement in India):

The work before us was to make the Farm a busy hive of industry, thus to save money and in the end to make the families self-supporting.... We therefore determined to learn to make sandals. There is at Mariannhill near Pinetown a monastery of German Catholic monks called the Trappists, where industries of this nature are carried on. Mr. Kallenbach went and acquired the art of making sandals. After he returned, he taught it to me and I in my turn to other workers. Thus several young men learnt how to manufacture sandals, and we commenced selling them to friends.... Another handicraft introduced was that of carpentry. Having founded a sort of village we needed all manner of things large and small from benches to boxes, and we made them all ourselves.[28]

Such cottage industry not only helped provide necessary goods (sandals and the products of carpentry), but they were also sold to produce revenue for the purchase of goods that could not be produced on the farm.

Another problem that faced Gandhi at Tolstoy Farm was how to educate the many children of the satyagrahis in residence. These children spanned a wide range of ages, languages, and religions:

A teacher hardly ever had to teach the kind of heterogeneous class that fell to my lot, containing as it did pupils of all ages and both sexes, from boys and girls of about 7 years of age to young men of twenty and young girls 12 or 13 years old. Some of the boys were wild and mischievous.[29]

Gandhi recounts the difficulties of teaching children with different mother tongues, and his insistence that children of different faiths each receive education in their respective religion's sacred texts and that all learn tolerance. Here Gandhi admits doubt about the success of his efforts, but asserts, "A man cannot borrow faith or courage from others. The doubter is marked out for destruction, as the Gita puts it. My faith and courage were at their highest in Tolstoy Farm."[30]

An important transformation in Gandhi's self-representation also took place at Tolstoy Farm. Previously, he had dressed in the gentlemanly business attire expected of a London-educated barrister. At Tolstoy Farm he followed its namesake and adopted the dress of the laborer:

As we had intended to cut down expenses to the barest minimum, we changed our dress also. In the cities the Indian men including the Satyagrahis put on European dress. Such elaborate clothing was not needed on the Farm. We had all become labourers and therefore put on labourer's dress but in the European style, *viz.* workingmen's trousers and shirts, which were imitated from prisoners' uniform. We all used cheap trousers and shirts which could be had ready-made out of coarse blue cloth. Most of the ladies were good hands at sewing and took charge of the tailoring department.[31]

31 Ibid., 335.

The added association of worker's clothing with prison uniforms gave further poignancy to this practice. As with Tolstoy's adoption of the dress of the Russian peasant, this mode of dress stressed the equality of all honest labor and went against ideas of class and caste. It was also clearly in accord with the tenets of John Ruskin.

By June of 1914 the government of the Transvaal passed the Indian Relief Act, and Gandhi ended satyagraha in South Africa. Tolstoy Farm had served its purpose and was disbanded. The Phoenix Settlement was

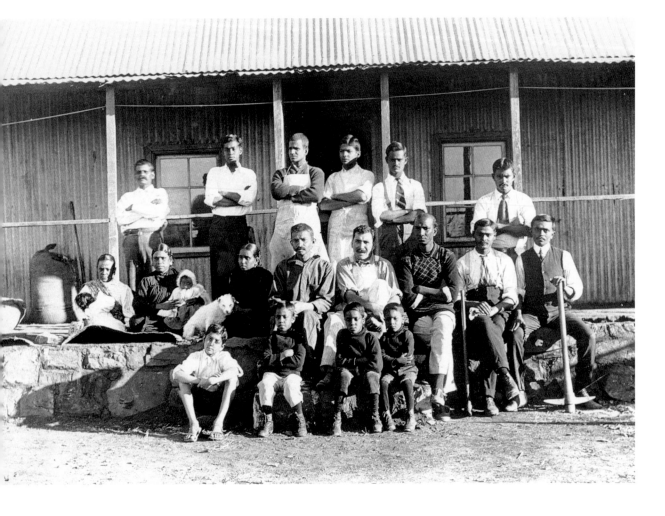

Gandhi (center), Hermann Kallenbach, and other pioneer settlers on Tolstoy Farm,
South Africa, 1910. Photographer unknown. akg-images/Archiv Peter Rühe

left in the capable hands of Manilal Gandhi, and Mohandas K. Gandhi made his return to India via London, finally arriving in India in January of 1915. In May of that year Gandhi would found the third of his ashrams (the first explicitly using that appellation), the Satyagraha Ashram, later called the Sabarmati Ashram outside Ahmedabad:

The Satyagraha Ashram was founded on the 25th of May, 1915 … when I passed through Ahmedabad, many friends pressed me to settle down there, and they volunteered to find the expenses of the Ashram, as well as a house for us to live in.

I had a predilection for Ahmedabad. Being a Gujurati I thought I should be able to render the greatest service to the country through the Gujurati language. And then, as Ahmedabad was an ancient centre of handloom weaving, it was likely to be the most favourable field for the revival of the cottage industry of hand-spinning.[32]

32 Gandhi, *An Autobiography,* 2:589.

From the beginning, two very important points were already established. First, the new ashram would be supported through Gandhi's principle of trusteeship: wealthy friends would provide both land and funds for construction of buildings and support of its operation. Second, cottage industry, particularly hand-spinning for cloth, would be an integral part of life at the ashram.

In many ways the project of establishing an ashram in India would be more difficult than it was in South Africa. For in India, though they were dominated by a colonial regime, Indians were the vast majority, whereas in South Africa, despite their often hostile groups, languages, ethnicities, religions, and castes, they could more easily think of themselves as one minority group to resist the regime. Thus Gandhi, in his quest for true swaraj, had to work to create unity among his own people in spite of their often passionate differences. This became apparent early in his efforts at the Ahmedabad ashram. A few months after its founding, Gandhi admitted an untouchable family; soon thereafter the following occurred:

But the admission created a flutter amongst the friends who had been helping the Ashram. The very first difficulty was found with regard to the use of the well, which was partly controlled by the owner of the bungalow. The man in charge of the water-lift objected that drops of water from our bucket would pollute him. So he took to swearing at us and molesting Dudabhai [one of the untouchables]. I told everyone to put up with the abuse and continue drawing water at any cost. When he saw that we did not return his abuse, the man became ashamed and ceased to bother us.

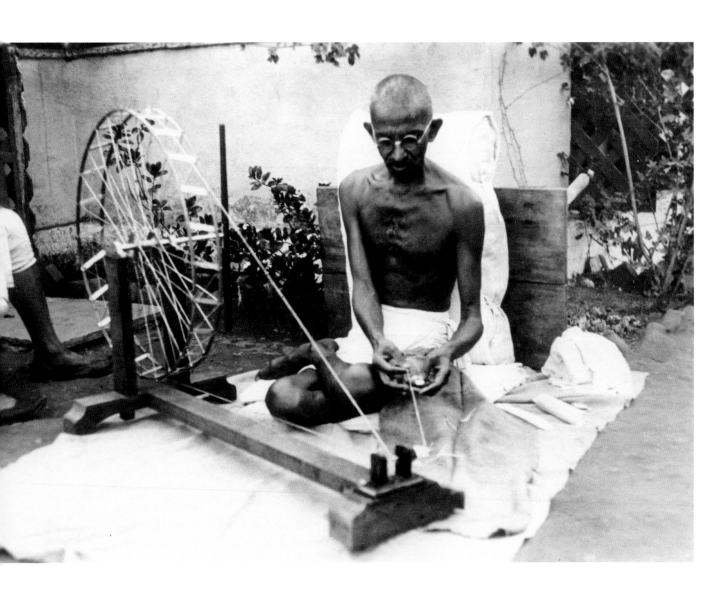

Gandhi using a spinning wheel at Sabarmati Ashram, India, 1925.
Photographer unknown. Bridgeman Images

33 Ibid., 592–93.

34 Ibid., 639–40.

35 Mohandas K. Gandhi, *From Yeravda Mandir,* SWMG 4:211.

All monetary help, however, was stopped. The friend who had asked the question about an untouchable being able to follow the rules of the Ashram had never expected that any such would be forthcoming.[33]

While this problem would be favorably resolved, it illustrates both the strengths and weaknesses of Gandhi's techniques. That the man who abused those drawing water from the well ceased such behavior when his hostility was not returned (through shame) is indeed the desired result of satyagraha; it was truth-force in action and a vindication of Tolstoy's interpretation of the Sermon on the Mount and nonresistance to evil. On the other hand, it also reveals the danger of relying on "trusteeship" or the good will and beneficence of the wealthy.

In 1917 plague broke out in the village of Kochrab, the small village outside Ahmedabad where the ashram was located. For this reason, with the help of Punjabhai Hirachand, an Ahmedabad merchant and another "trustee," Gandhi was able to procure land near the Sabarmati Central Jail and moved the ashram there, giving it its popular name, the Sabarmati Ashram. Location near the jail was regarded by Gandhi as "a special attraction."[34]

It is here worthwhile to address the rules that Gandhi established for members of the ashram. They took the form of vows and were established early, but were not officially published and elaborated on by Gandhi until his incarceration in the Yeravda Central Prison in 1930, when he "wrote weekly letters to the Satyagraha Ashram, containing a cursory examination of the principle Ashram observances."[35] This publication consisted of sixteen letters, roughly corresponding to the necessary vows, which he enumerates as:

I.	Truth (*Satya*)
II.	*Ahimsa* or Love
III.	*Brahmacharya* or Chastity
IV.	Control of Palate
V.	Non-Stealing
VI.	Non-Possession or Poverty
VII.	Fearlessness
VIII.	Removal of Untouchability
IX.	Bread Labor
X, XI.	Tolerance, i.e., Equality of Religions I & II
XII.	Humility
XIII.	Importance of Vows
XIV, XV.	*Yajna* or Sacrifice
XVI.	*Swadeshi* [self-sufficiency through cottage industry]

While most of these ideas were already important and in practice by members of Gandhi's communities in South Africa, they were first codified and required as vows at the Sabarmati Ashram.

Much of the discussion so far has been based on Gandhi's own writings, his *An Autobiography or the Story of My Experiments with Truth,* first published in two volumes (1927 and 1929), and *Satyagraha in South Africa* (1928). Both texts were written while Gandhi was resident at the Sabarmati Ashram. It continued to be his primary abode until he disbanded it in 1933. His last community, the Sevagram Ashram, is harder to document because it does not have a similar primary Gandhian text associated with it. Returning to the notion that the village is the model for a viable alternative to the modern industrial economic and social system, Gandhi set out in 1936 to establish his headquarters in a real, remote, poor, agricultural village where he could literally put his constructive program into practice. For this he chose the village of Segaon near Wardha in Maharashtra, giving it the new name of Sevagram or "the village of service." His initial intent was to live among the villagers with only his wife. Soon, however, many of his followers joined him, and effectively a fourth ashram was formed. Of course he would continue to follow his ashram rules and require those who joined him to do likewise.

Gandhi's experiments at Sevagram were largely continuations of those undertaken in his previous ashrams: introducing sanitation, cleanliness, cottage industry, and improvements to health. Being set in an existing village, Sevagram was different in that Gandhi tried to engage an often reluctant local population. Where previously the ashramites had been a group of people selected by Gandhi, here he, like the nineteenth-century Russian socialists and reformers, tried to take these ideas and ideals "to the people"; like his nineteenth-century antecedents, this proved much harder than anticipated. The existing conditions made this work difficult, as Gandhi himself contracted malaria, which lingered.[36] The course of world events, including the Second World War and the acceleration of Indian independence efforts also forced Gandhi to spend more time traveling and in important meetings in New Delhi and elsewhere. That Birla House in New Delhi, not Sevagram in Maharashtra, would be the site of many of the important events of Gandhi's late career indicates how circumstances prevented him from bringing much of his ambitions there to fruition. His assassination on January 30, 1948, would insure that Gandhi's experiments at his last ashram would never be completed.

36 See Rajmohan Gandhi, *Gandhi: The Man, His People, and the Empire* (Berkeley: University of California Press, 2008), 380–81.

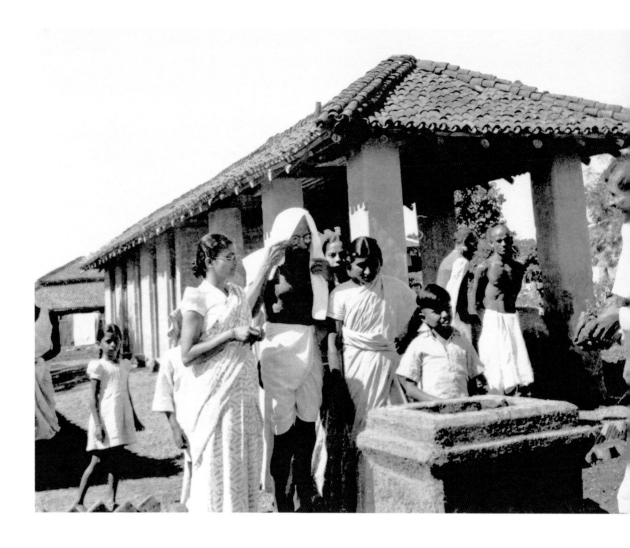

CONCLUDING THOUGHTS

The four ashrams provide perhaps the clearest image available of what a nonviolent society built upon Gandhian lines might look like and how it might function. They clearly followed the tenets outlined in Gandhi's constructive program and served as incubators of satyagraha. Yet they are also elusive as none of them remain, at least in their original form or following their original functions (the Sabarmati Ashram still physically exists, though it is now a Gandhi museum and institute rather than an ashram; some of the buildings at Phoenix remain). This essay has merely touched on the history of these four communities and only offered a sampling of their historical and philosophical bases and significance.

Like the anonymous photograph of some of Gandhi's earthly possessions at the time of his assassination (p. 16), Gandhi's four ashrams offer peripheral evidence of a man and his ideas. Without their complements

Gandhi and ashramites at a tulsi tree planting ceremony at Sevagram, Maharashtra, India, 1946. Photographer unknown. akg-images/Archiv Peter Rühe

of satyagrahis and ashramites, they are much like Gandhi's few possessions without the Mahatma: an incomplete record, one which encourages further inquiry and demands greater understanding. Unlike many of the theorists discussed in the first part of the essay, Gandhi was successful in putting his ideas into action; the Phoenix Settlement would flourish for half a century under the leadership of Gandhi's son Manilal; the second two ashrams fulfilled their intended purposes and were disbanded by Gandhi himself; the last would founder without its leader before its success or failure could be determined. The later history of Independence did not unfold along Gandhian lines; today, India is a growing industrial, economic, technological power and increasingly part of the global capitalist system. Its economy is not based on a system of federated rural villages based on agriculture and cottage industry.

Poverty, violence, and strife remain in the rural villages of India and, indeed, throughout the world. But the four ashrams here discussed continue to offer tangible alternatives to the accepted norms of the modern world. It is of vital importance to realize that they did not fail; rather history took a different course. If and when the merits of this course is called into question, it is fruitful and productive to see what alternatives have looked like. That the Gandhian communities were able to exist is encouraging, as they provided more than a theoretical basis for alternatives to the modern system. In an age where such thinkers as Tolstoy, Herzen, and Proudhon are largely forgotten, a better understanding of the bases of Gandhi's ashrams and constructive program can be helpful, encouraging, and inspiring. While self-control and a revolution within the individual are the necessary prerequisites for such communities to work, they also would seem to depend on external trusteeship; hopefully satyagraha and a constructive program could inspire such internal revolutions and potential trustees. Though elusive, Gandhi's ashrams offer a glimpse at an image of nonviolent society, a glimpse at true swaraj.

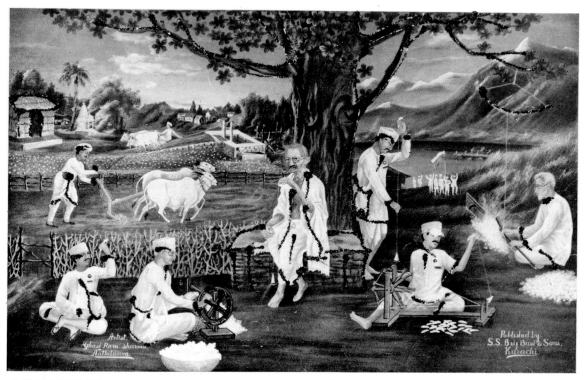

WAY TO SWARAJ
(महात्मा गान्धीजीका उध्योग)

Way to Swaraj. Popular print, 10 × 13 ¾ inches
(25.4 × 34.9 cm). Collection of Vinay Lal

Swaraj flag of the Indian National Congress

Constructive Program (1945)

The constructive programme may otherwise and more fittingly be called construction of Poorna Swaraj or complete Independence by truthful and non-violent means.

COMMUNAL UNITY

Everybody is agreed about the necessity of this unity. But everybody does not know that unity does not mean political unity which may be imposed. It means unbreakable heart unity. The first thing essential for achieving such unity is for every[one], whatever his religion may be, to represent in his own person Hindu, Muslim, Christian, Zoroastrian, Jew, etc., shortly, every Hindu and non-Hindu. He has to feel his identity with every one of the millions of the inhabitants of Hindustan. In order to realize this, every[one] will cultivate personal friendship with person representing faiths other than his own. He should have the same regard for the other faiths as he has for his own.

Khadi

[Homespun cloth, *khadi*] connotes the beginning of economic freedom and equality of all in the country. "The proof of the pudding is in the eating." Let everyone try, and he or she will find out for himself or herself the truth of what I am saying. *Khadi* must be taken with all its implications. It means a wholesale Swadeshi mentality, a determination to find all the necessaries of life in India and that too through the labour and intellect of the villagers. That means a reversal of the existing process. That is to say that, instead of half a dozen cities of India and Great Britain living on the exploitation and the ruin of 700,000 villages of India, the latter will be largely self-contained, and will voluntarily serve the cities of India and even the outside world in so far as it benefits both parties.

...

Moreover, *Khadi* mentality means decentralization of the production and distribution of the necessaries of life. Therefore, the formula so far evolved is, every village to produce all its necessaries and a certain percentage in addition for the requirements of the cities.

Heavy industries will needs be centralized and nationalized. But they will occupy the least part of the national activity which will mainly be in the villages.

OTHER VILLAGE INDUSTRIES

All should make it a point of honour to use only village articles whenever and wherever available. Given the demand there is no doubt that most of our wants can be supplied from our villages. When we have become village-minded, we will not want imitations of the West or machine-made products, but we will develop a true national taste in keeping with the vision of a new India in which pauperism, starvation and idleness will be unknown.

NEW OR BASIC EDUCATION

Primary education is a farce designed without regard to the wants of the India of the villages and for that matter even of the cities. Basic education links the children, whether of the cities or the villages, to all that is best and lasting in India. It develops both the body and the mind, and keeps the child rooted to the soil with a glorious vision of the future in the realization of which he or she begins to take his or her share from the very commencement of his or her career in school.

WOMEN

In a plan of life based on non-violence, woman has as much right to shape her own destiny as man has to shape his. But as every right in a non-violent society proceeds from the previous performance of a duty, it follows that the rules of social conduct must be framed by mutual co-operation and consultation. They can never be imposed from the outside. Men have not realized this truth in its fullness in their behaviour towards women. They have considered themselves to be lords and masters of women instead of considering them as friends and co-workers. It is the privilege of men [in our organization] to give the women of India a lifting hand. Women are in the position somewhat of the slave of old who did not know that he could or ever had to be free. And when freedom came, for the moment he felt helpless. Women have been taught to regard themselves as slaves of men. It is up to Congressmen to see that they enable them to realize their full status and play their part as equals of men.

...

It is hardly necessary to point out that I have given a one-sided picture of the helpless state of India's women. I am quite conscious of the fact that in the villages generally they hold their own with their men folk and in some respects even rule them. But to the impartial outsider the legal and customary status of women is bad enough throughout and demands radical alteration.

EDUCATION IN HEALTH AND HYGIENE

Mens sana in corpore sano [A sound mind in a healthy body] is perhaps the first law for humanity. A healthy mind in a healthy body is a self-evident truth. There is an inevitable connection between mind and body. If we were in possession of healthy minds, we would shed all violence and, naturally obeying the laws of health, we would have healthy bodies without an effort….

Think the purest thoughts and banish all idle and impure thoughts.
Breath the freshest air day and night.
Establish a balance between bodily and mental work.
Stand erect, sit erect, and be neat and clean in every one of your acts, and let these be an expression of your inner condition.
Eat to live for the service of fellow-men. Do not live for indulging yourselves. Hence your food must be just enough to keep your mind and body in good order.

ECONOMIC EQUALITY

This last is the master key to non-violent Independence. Working for economic equality means abolishing the eternal conflict between capital and labour. It means the levelling down of the few rich in whose hands is concentrated the bulk of the nation's wealth on the one hand, and the levelling up of the semi-starved naked millions on the other. A non-violent system of government is clearly an impossibility so long as the wide gulf between the rich and the hungry millions persists. The contrast between the palaces of New Delhi and the miserable hovels of the poor labouring class nearby cannot last one day in a free India in which the poor will enjoy the same power as the richest in the land. A violent and bloody revolution is a certainty one day unless there is a voluntary abdication of riches and the power that riches give and sharing them for the common good.

I adhere to my doctrine of trusteeship in spite of the ridicule that has been poured upon it. It is true that it is difficult to reach. So is non-violence. But we made up our minds in 1920 to negotiate that steep ascent. We have found it worth the effort. It involves a daily growing appreciation of the working of non-violence. They should ask themselves how the existing inequalities can be abolished violently or non-violently. I think we know the violent way. It has not succeeded anywhere.

This non-violent experiment is still in the making. We have nothing much yet to show by way of demonstration. It is certain, however, that the method has begun to work though ever so slowly in the direction of equality. And since nonviolence is a process of conversion, the conversion, if achieved, must be permanent. A society or a nation constructed non-violently must be able to withstand attack upon its structure from without or within. We have moneyed [people] in the organization. They have to lead the way. This fight provides an opportunity for the closest heart searching on the part of every individual. If ever we are to achieve equality, the foundation has to be laid now. Those who think that the major reforms will come after the advent of Swaraj are deceiving themselves as to the elementary working of non-violent Swaraj. It will not drop from heaven all of a sudden one fine morning. But it has to be built up brick by brick by corporate self-effort. We have travelled a fair way in that direction. But a much longer and weary distance has to be covered before we can behold Swaraj in its glorious majesty. Every [person] has to ask himself what he has done towards the attainment of economic equality.

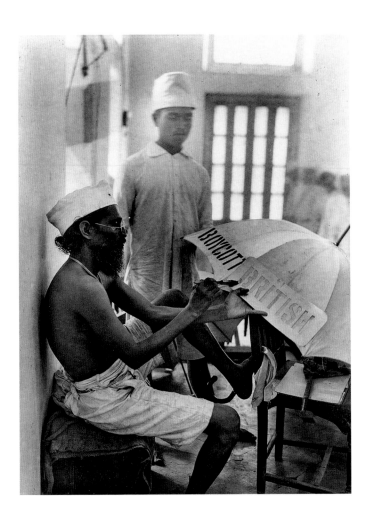

PLACE OF CIVIL DISOBEDIENCE

I have said in these pages that Civil Disobedience is not absolutely necessary to win freedom through purely non-violent effort, if the co-operation of the whole nation is secured in the constructive programme. But such good luck rarely favours nations or individuals. Therefore, it is necessary to know the place of Civil Disobedience in a nation-wide non-violent effort.

It has three definite functions:

1. It can be effectively offered for the redress of a local wrong.
2. It can be offered without regard to effect, though aimed at a particular wrong or evil, by way of self-immolation in order to rouse local consciousness or conscience. Such was the case in Champaram when I offered Civil Disobedience without any regard to the effect and well knowing that even the people might remain apathetic. That it proved otherwise may be taken, according to taste, as God's grace or a stroke of good luck.
3. In the place of a full response to constructive effort, it can be offered as it was in 1941. Though it was a contribution to and part of the battle for freedom, it was purposely centered round a particular issue, i.e. free speech. Civil Disobedience can never be directed for a general cause such as for Independence. The issue must be definite and capable of being clearly understood and within the power of the opponent to yield. This method properly applied must lead to the final goal.

I have not examined here the full scope and possibilities of Civil Disobedience. I have touched enough of it to enable the reader to understand the connection between the constructive programme and Civil Disobedience. In the first two cases, no elaborate constructive programme was or could be necessary. But when Civil Disobedience is itself devised for the attainment of Independence, previous preparation is necessary, and it has to be backed by the visible and conscious effort of those who are engaged in the battle, Civil Disobedience is thus a stimulation for the fighters and a challenge to the opponent. It should be clear to the reader that Civil Disobedience in terms of independence without the co-operation of the millions by way of constructive effort is mere bravado and worse than useless.

Excerpted from M.K. Gandhi, *Constructive Programme, Its Meaning and Place* (1941; enlarged edition, Ahmedabad: Navajivan Publishing House, 1945).

References to "Congressmen" (All India Congress) have been modified. –Ed.

Opposite page Walter Bosshard (Switzerland, 1892–1975), Preparations in the Congress House for "Boycott Week," 1930. Gelatin silver print. Fotostiftung Schweiz, Winterthur, Switzerland

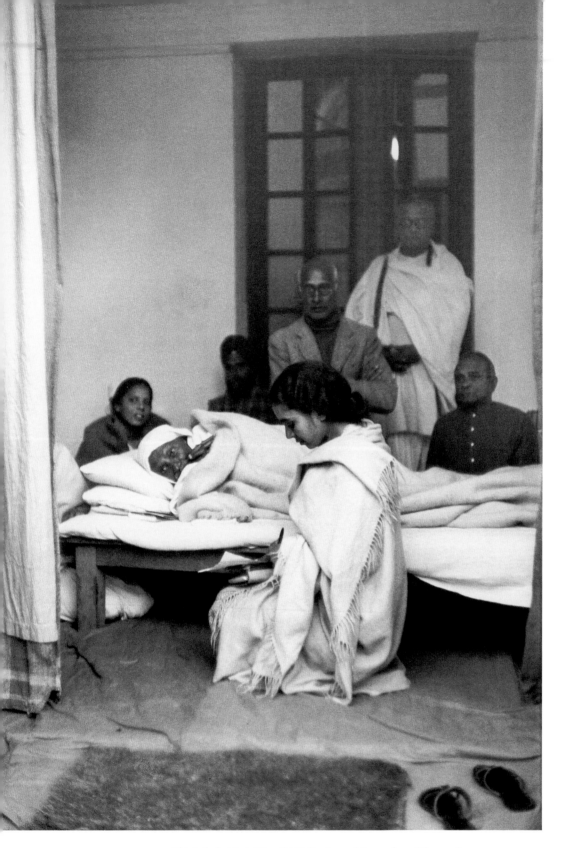

This is the last fast of Gandhi. He lies there while members of the crowds pass
him in silence in a serious flow, touching hands together in signs of respect.

Henri Cartier-Bresson (France, 1908–2004), Gandhi during his last fast,
Birla House, New Delhi, January 18, 1948, printed 1973. Gelatin silver print,
15 ¾ × 11 ⅞ inches (40 × 30.2 cm). The Menil Collection, Houston
The caption above in blue is Cartier-Bresson's own.

TOBY KAMPS

Henri Cartier-Bresson and Gandhi's Last Days

Henri Cartier-Bresson arrived in Bombay (Mumbai), India, via steamship in early December 1947. Dubbed a "documentary humanist," in the catalogue for his exhibition at the Museum of Modern Art in New York earlier that year, the thirty-nine-year-old French photographer was beginning a self-selected three-year assignment for Magnum, the new agency he had cofounded only months earlier. His goal was to report on the transitions to independent rule sweeping South and Southeast Asia—in India and Pakistan as well as Indonesia, Burma (Myanmar), Ceylon (Sri Lanka), and Malaysia. From the outset of his journey, Cartier-Bresson immersed himself in life, and turned encounters with events and personalities into photographs of luminous power and poetry.

A first South Asian subject was the trauma of the Partition, the brutal birth of two nations that had occurred on August 14, when the Dominion of Pakistan was formed and the Union of India gained independence from Great Britain the next day. However, early in his trip, chance made him a witness to the last days of India's tireless advocate for peace and coexistence, Mohandas K. Gandhi, as well as to the dramatic aftermath of this spiritual elder's assassination. Made quickly with great skill and eloquence under difficult conditions, his portraits of Gandhi and this tumultuous time have become enduring icons of the man and legacy inspiring this exhibition.

Born in 1908 to a wealthy Parisian family of textile manufacturers, Cartier-Bresson had no formal higher education. Instead, he pieced together a cosmopolitan training in art, literature, and leftist politics

using his many social connections and lifelong knack for discovering consequential events and individuals. He studied with the modernist painter André Lhote and frequented Surrealist salons, where he counted artists and writers like Max Ernst, André Breton, and Louis Aragon as friends. Photography was a serious avocation for Cartier-Bresson, who began taking pictures as a child, but he distinguished himself around 1932, when he purchased a handheld Leica 35mm camera and began to shoot on the run, or à la sauvette. In Paris, after a year in Africa, where he hunted game and nearly died of blackwater fever,[1] he exchanged his gun for the compact German camera and "prowled the streets all day feeling very strung-up and ready to pounce, determined to 'trap' life."[2] By the time he was sent to a prisoner of war camp in Germany in June 1940, Cartier-Bresson had ranged widely in Mexico, Spain, Italy, the United States, and North Africa in search of subjects, and his early enigmatic and collagelike scenes of street life had been embraced by the Surrealists. After he escaped from Germany in 1943, Cartier-Bresson documented the war's devastation in photographs and films and went on to create many thousands of images of newsworthy, popular-interest, and chanced-upon subjects as well as hundreds of casual and revealing portraits of cultural luminaries. By the end of his life in 2004, Cartier-Bresson had circled the globe many times over in a long and prolific career that blended art, photojournalism, and a humanist world view.[3]

In his career-defining 1952 book, *The Decisive Moment*, Cartier-Bresson summarized his approach as "the simultaneous recognition in a fraction of a second of the significance of an event as well as the precise organization of forms."[4] His street scenes, landscapes, portraits, and especially his depictions of individuals caught up in the everyday are filled with uncanny, telling details and formal rhymes picked out from time's flux as if by magic. Widely imitated but never equaled, his style is pellucid, free from sensationalism, and infused with humor, mystery, and pathos.

Formed in the heyday of illustrated magazines, just before the arrival of television, Magnum expressed the idealism of Cartier-Bresson and his cofounders, fellow war photographers Robert Capa, George Rodger, and David "Chim" Seymour. "Magnum is a community of thought, a shared human quality, a curiosity about what is going on in the world, a respect for what is going on and a desire to transcribe it visually," Cartier-Bresson stated.[5] He rarely had editorial control of his images, and he often shipped undeveloped film to Magnum's offices for distribution and sale, but he would go on to write richly descriptive, if often reworked, captions to set them in their contexts. Magnum's new-model cooperative gave its members rights to their images and

1 The impetus for this trip was a failed love affair with Texas socialite Gretchen Powel, who with her husband Peter, was a member of the free-thinking, free-loving circle of artists surrounding expatriate American Harry and Caresse Crosby. The Powels encouraged Cartier-Bresson's early interest in photography.

2 Henri Cartier-Bresson, *The Decisive Moment: Photography by Henri Cartier Bresson* (New York: Simon and Schuster, 1952), unpaginated; simultaneously published in France as *Images à la sauvette: Photographies* (Paris: Editions Verve, 1952).

3 Late in his career, despite much evidence to the contrary Cartier-Bresson denied ever having been a photojournalist. For a discussion of this controversial statement, see Claude Cookman, "Henri Cartier-Bresson Reinterprets his Career," *History of Photography* 32, no. 1 (Spring 2008), 59–73.

4 Cartier-Bresson, *The Decisive Moment*, unpaginated.

5 On the Magnum Photos website: http://www.magnumphotos .com/C.aspx?VP3=CMS3&VF=MAX —2&FRM=Frame:MAX—3 (accessed January 28, 2014).

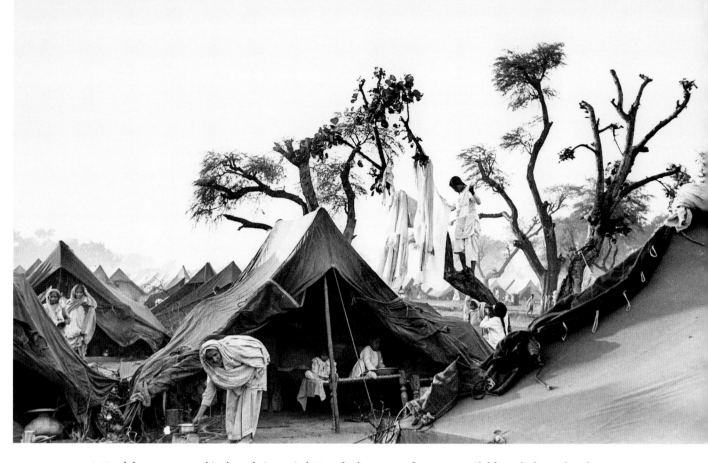

In Kurukshetra camp everything has to be improvised. Water for the 300,000 refugees was provided from a little sacred pond. According to legend, the water flowed out of the ground when God Arjuna shot an arrow through his foot.

freedom to pursue their own interests. In New York in 1946, Cartier-Bresson and his wife Ratna Mohini, a Javanese dancer, met Indonesian delegates to United Nations independence talks and the following year left for Asia convinced that decolonization was the salient issue after the Second World War's end.[6]

6 Peter Galassi, "Henri Cartier-Bresson: The Early Work," in *Henri Cartier-Bresson: The Early Work* (New York: The Museum of Modern Art, 1987), 13.

In December 1947, the photographer landed amid an enormous humanitarian crisis sparked by the Partition. After the failure of Gandhi-led attempts to reconcile Muslim and Hindu nationalists, Independence had come suddenly, and neither the Indians or Pakistanis, nor the British, could avert the ensuing chaos. An estimated 12 million Hindus, Muslims, and Sikhs left their homes on either side of the new borders, many of them forced to seek safety in areas of religious majority. Violence was everywhere. Perhaps as many as one million were killed in bloody riots across India and in West and East Pakistan.

Henri Cartier-Bresson, Refugee camp, Kurukshetra, Haryana, Punjab, India, December 1947, printed 1973. Gelatin silver print, 11 7/8 × 15 3/4 inches (30.2 × 40 cm). The Menil Collection, Houston

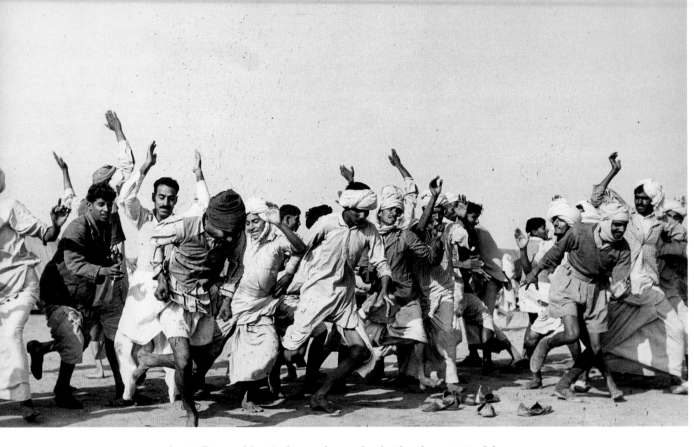

There is idleness and despair where people are gathered without homes. At Kurukshetra camp they were given simple gymnastics to distract them, to work off their energies.

Among Cartier-Bresson's early images from this journey are scenes of displacement and misery. In New Delhi and the adjacent Punjab region, which was itself partitioned and a site of much bloodshed, he photographed destitute refugees traveling in all directions by foot and by rail, as well as life in the giant Kurukshetra camp, temporary home to as many as 300,000 displaced persons. A signal image from the Kurukshetra series shows life in seemingly endless rows of canvas tents. In it, Cartier-Bresson recorded wrinkles in the tents' flaps that echo folds in the refugees' clothing as they tend cooking fires and in their laundry hung high in gnarled trees. By highlighting this classicizing detail, he also catapulted the composition into the realm of art and allegory. It could be seen as a contemporary version of another great study in drapery and desperation, Theódore Géricault's famous painting *The Raft of the Medusa,* 1818–19 (Louvre, Paris), an image of shipwreck survivors hailing rescuers that was in its time seen as a symbol of pointless tragedy.[7]

7 The appointment of the *Medu...*
incompetent captain was bla...
on the newly restored French
monarchy.

Henri Cartier-Bresson, Refugee camp, Kurukshetra, Haryana, Punjab, India, December 1947, printed 1973. Gelatin silver print, 11 ⅞ × 15 ¾ inches (30.2 × 40 cm). The Menil Collection, Houston

Another Kurukshetra photograph shows a group of men flailing and kicking up dust. It was later captioned by the photographer with "they were given simple gymnastics to distract them, to work off their energies." From his moralizing caption for a related image, it is clear Cartier-Bresson viewed events in the camp as related to the mythic past, as Kurukshetra stands "on the old battlefield of the gods":

The great Hindu epic, the Mahabharata, relates that it was here, many thousands of years ago, that a great battle between good and evil took place. The government and some charitable organizations give the refugees food. But what gives them hope?[8]

Recalling his earlier, eerie scenes of children at play associated with Surrealism, this image's spectrum of faces and expressions–ranging from despair to elation–show the artist's empathy for those suffering the birth pains of two nations.

Cartier-Bresson, an inveterate reader, often recounted that Ratna made sure they took a copy of the *Bhagavad Gita*, a portion of the *Mahabharata*, to India.[9] Surely, the Old Testament tenor of the tale of migration and persecution unfolding around them was not lost on him or his magazine audiences. There is a timeless, otherworldly feel to many of Cartier-Bresson's Asian images, one very much at odds with his contemporaneous work from Europe and North American, which concentrated increasingly on materialism's trappings. Some of this contrast can be attributed to differences in attire and customs and between developing and industrialized societies, but Cartier-Bresson's sensitivity to spiritual elements is often clear in his photographs from India and Pakistan. In them, he repeatedly connects his motifs and religious iconography.

On January 12, 1948, Gandhi announced that he would starve himself unless he received promises from leaders of various factions that violence in New Delhi would stop. Six days later the photographer joined the throngs gathering outside Gandhi's rooms at Birla House, the compound of the industrialist Ghanshyamdas Birla where Gandhi was staying, to see him break what would be his last fast. The successful end of this protest was important news, but, like any chance to see a mahatma, or great soul, it also was a moment for receiving *darshan*, a blessing Hindus believe is transmitted through a reverential gazing and exchange of gazes. Cartier-Bresson's most-published photographs from that day are resonant with religious overtones. Images of a frail, seventy-eight-year-old Gandhi dozing under blankets and surrounded by attendants and onlookers recall scenes of the Lamentation of Christ or the Mahparinirvana of the Buddha. A portrait of the breaking of the

8 Cartier-Bresson, *The Decisive Moment*.

9 Galassi, "Henri Cartier-Bresson," 13.

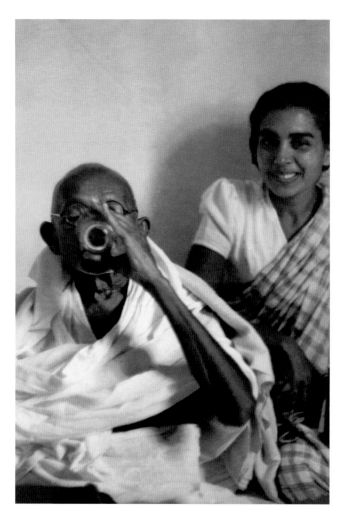

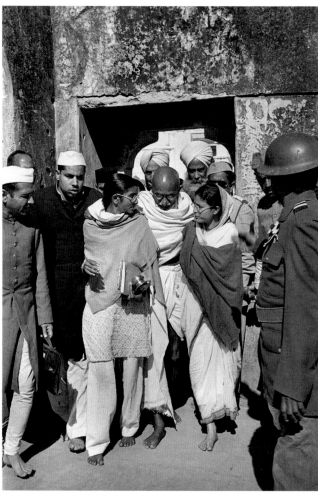

This visit to the shrine of the Sufi saint Qutbuddin Baktiar Kaki Chishti was one of Gandhi's last appearances before his assassination.

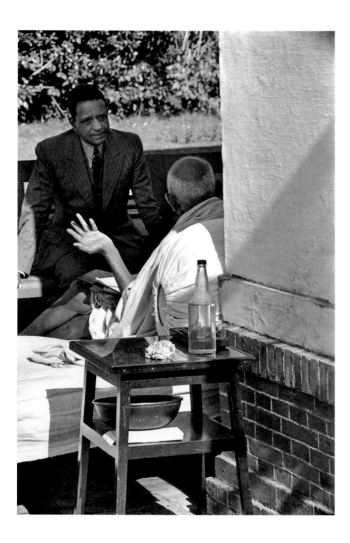

Opposite page left Henri Cartier-Bresson, Gandhi breaking his last fast, Birla House, New Delhi, January 18, 1948, printed 1950s. Gelatin silver print, 13 ⅞ × 9 ⅝ inches (35.3 × 24.3 cm). Collection Fondation Henri Cartier-Bresson, Paris

Opposite page right Henri Cartier-Bresson, Gandhi visits a Muslim shrine, Mehrauli, Delhi, January 27, 1948. Gelatin silver print, 12 × 8 ⅝ inches (30.5 × 22 cm). Collection Fondation Henri Cartier-Bresson, Paris

Above Henri Cartier-Bresson, An interview with Gandhi the day before his assassination, January 29, 1945. Gelatin silver print

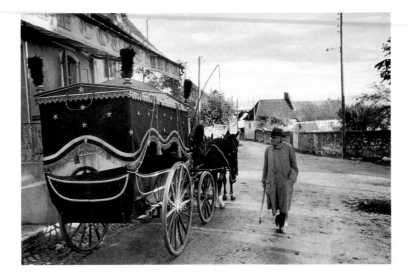

fast by sipping juice–in which Cartier-Bresson puckishly rhymes the bottom of the drinking glass with Gandhi's round spectacles–suggests the miracle of the Resurrection. And a photograph taken on January 27 of a barefoot Gandhi leaving the Sufi shrine of Qutbuddin Bakhtiar Kaki Chishti in Delhi–the site of much sectarian violence–less than ten days after his fast and just a week after a would-be assassin's bomb attack demonstrates his fearless support for religious plurality and his commitment to nonviolence.

In what turned out to be his final portraits of Gandhi, Cartier-Bresson moved from outer to inner circles. In New York, Ratna had befriended the sister of Indian Prime Minister Jawaharlal Nehru, a connection that secured him a photo session with Gandhi on January 29 and an interview the following day.[10] During the shoot, for which Gandhi neither posed nor acknowledged him, the artist fell back on trademark catlike and playful approaches. Shooting past a corner of one of Birla House's terraces, he captured an ironic scene: the diminutive man of peace wearing his habitual homespun *khadi* cloth and a peasant's bamboo hat conversing with a sturdy, uniformed Sikh military man. In another, he captured Gandhi from the back speaking with a man in a suit and tie. In his biography of Cartier-Bresson Pierre Assouline interprets the Mahatma's upturned left hand in this photograph, spotlighted by the sun, as summarizing a life, writing that it "seemed to be saying, 'And now what?'"[11]

The next afternoon, Cartier-Bresson returned with his notebook for a brief interview. According to Assouline, Gandhi studied an image in the catalogue for the photographer's recent New York exhibition and asked, "What is the meaning of this photo?" Cartier-Bresson replied,

10 Galassi, "Henri Cartier-Bresson," 17.

11 Pierre Assouline, *Henri Cartier-Bresson: A Biography* (New York: Thames & Hudson, 2005), 163.

Henri Cartier-Bresson, Paul Claudel in Brangues, France, 1945. Gelatin silver print

The meaning I don't know. It's Paul Claudel, our great Catholic poet–someone preoccupied by the last days of mankind. It was in 1944. We were going along a street in the village near his château de Brangues when a hearse came towards us–empty but harnessed, drawn by some horses. I quickened my pace in order to get opposite him, with the church in the background. He turned round to look, and then....[12]

12 Assouline, *Henri Cartier-Bresson*, 164.

13 Assouline, *Henri Cartier-Bresson*, 164.

According to Assouline's account, Gandhi, very much aware of his own mortality, was transfixed: "At last he spoke: 'Death, death, death....'"[13] The interview was soon over, and Cartier-Bresson left Birla House on his bicycle. Less than an hour later, at about 5:15 p.m., Gandhi was dead, shot on the way to his evening prayer meeting by Nathuram Godse, a Hindu nationalist.

At this point, the photographer whose habit, he said, was to approach his subjects on tiptoe, switched to a flat-out run to capture a rapidly unfolding story. His photographs, beginning just minutes after the murder along with a few earlier, contextualizing images, would form the heart of a February 16, 1948, *LIFE* magazine story, "Gandhi Joins the Hindu Immortals," that also featured the publication's own lead photographer, Margaret Bourke-White, who was in New Delhi as well. Although Bourke-White received top billing, she was represented by five photographs to Cartier-Bresson's nine. Her rigidly composed, often artificially lighted images generally depict events from a distance. Cartier-Bresson's close-in, available-light reportage thrusts the viewer

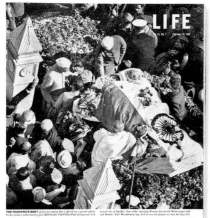

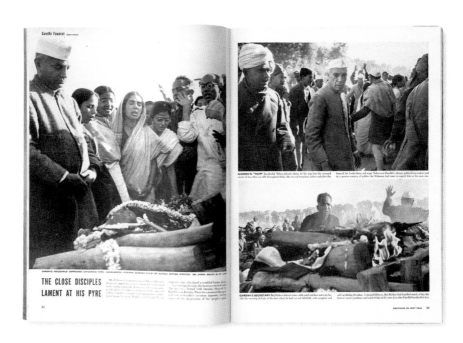

Article about the cremation of Gandhi, with photographs by Margaret Bourke-White and Henri Cartier-Bresson, in *Life* 24, no. 7 (February 16, 1948), 21, 24–25

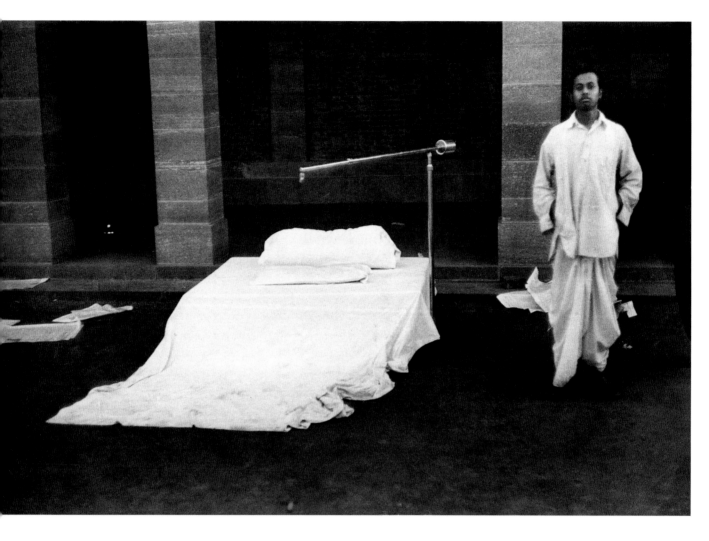

The couch Gandhi was to have used at the prayer meeting he never reached.

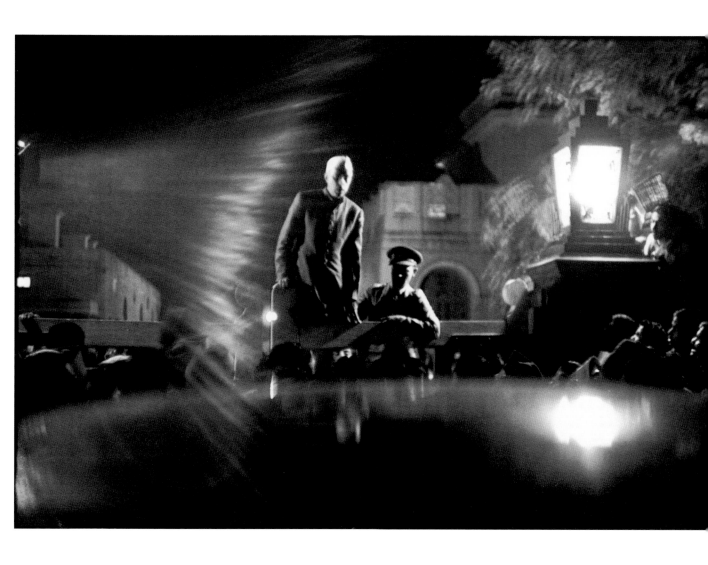

Opposite page Henri Cartier-Bresson, Couch, Birla House, New Delhi,
January 30, 1948, printed 1950s. Gelatin silver print, 6⅝ × 9¾ inches
(16.8 × 24.7 cm). Collection Fondation Henri Cartier-Bresson, Paris

Above Henri Cartier-Bresson, Nehru announces Gandhi's assassination
to a crying crowd, Birla House, New Delhi, 1948. Gelatin silver print

into the story, an affecting approach that would garner him two sole-author pictorials in *LIFE* in the following weeks–"The Last Days of Gandhi," on February 21, and "Sacred Rivers Receive Gandhi's Ashes," on March 15.

Back at Birla House after the tumult and as the day's light faded, Cartier-Bresson made two photographs in which pieces of plain cloth figure prominently. One shows light-colored fabric covering the platform from which Gandhi was to have led prayers. Seen from the front, the dais is neatly draped and flanked by a stunned attendant. Another view of the wooden dais, now uncovered and seen from behind, shows a crumpled ball of cloth that is Gandhi's own homespun *khadi*, surrounded by a gathering crowd of mourners. In these two counterpoints to the anonymous still-life photograph of Gandhi's modest possessions (p. 16), the simple textiles so identified with the leader seem to enact the gathering shock of his death.

That evening, Cartier-Bresson took more exceptional photographs. He worked his way to the front of a large crowd pressing against a window into Gandhi's apartment and, wiping it clean with his shirtsleeve, captured the mahatma's physician and attendants surrounding the body. He also made a difficult long-exposure, wide-aperture shot of Nehru, balanced on a wooden gate to Birla House and illuminated only by a streetlamp, announcing:

Friends and comrades, the light of our lives has gone out, and there is darkness everywhere. I don't know what to say to you or how to say it. Our beloved chief, Bapu as we called him, the Father of the Nation, is no longer.[14]

Full of lens flare and blurs, this photograph encapsulates what was surely a night of darkness and tears for millions.

The next morning Cartier-Bresson returned to Gandhi's rooms to photograph him lying in state, draped in white cloth and covered with flowers. The night before, Bourke-White had attempted to do the same but used flashbulbs, which so angered the mourners that they confiscated her film.[15] Cartier-Bresson's unobtrusive camera, along with his good manners and knack for quick friendships, gave him close-in access to events throughout the official twelve-day mourning period.[16]

14 Jawaharlal Nehru, quoted in Assouline, *Henri Cartier-Bresson*, 164.

15 Claude Cookman, "Margaret Bourke-White and Henri Cartier-Bresson: Gandhi's Funeral," *History of Photography* 22 (Summer 1998): 200.

16 Cartier-Bresson had a close-up view of many events during Gandhi's funeral. It is almost certainly he who can be glimpsed at 00:02:41 of an undated film clip, "Millions Mourn Gandhi": a slender man in a suit and fedora briefly moving behind the seated Lord and Lady Mountbatten. "Millions Mourn Gandhi," a Gaumont British News newsreel, on Gandhimedia.org, http://www.gandhimedia.org/cgi-bin/gm/gm.cgi?action=view&link=Video/Footage—and—Newsreels/Events/Cremation&image=VIFOEVCR1948013102.flv&img=&tt=flv (accessed January 28, 2014).

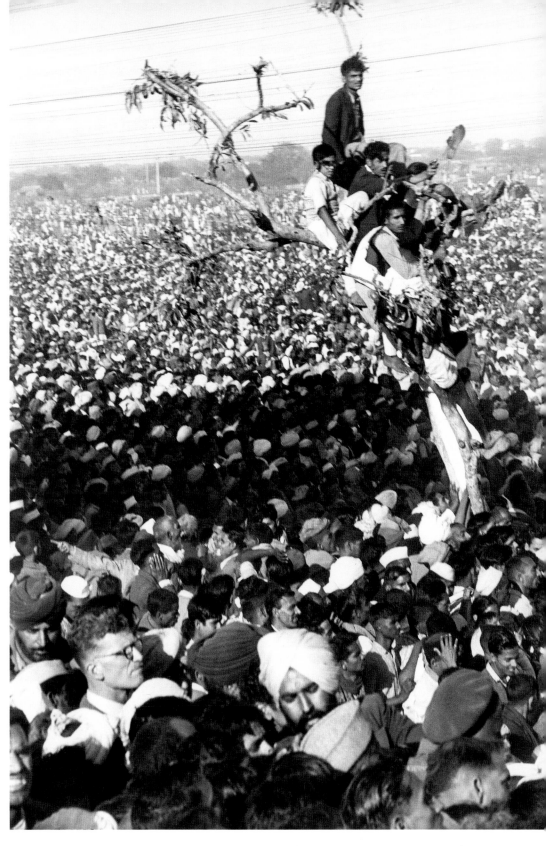

Crowds wait to pay their last respects as the funeral cortège approaches the cremation grounds.

Henri Cartier-Bresson, Gandhi's cremation, Delhi, February 1, 1948, printed 1973.
Gelatin silver print, 15 ¾ × 11 ⅞ inches (40 × 30.2 cm). The Menil Collection, Houston 111

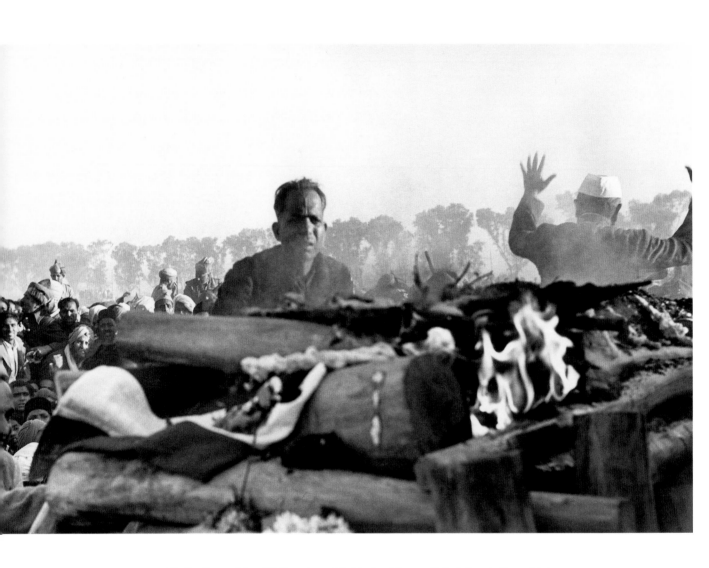

The first flames of Gandhi's funeral pyre. His friend and former aide looks into the flames; his doctor holds up his hands hoping to quiet the crowd; but as the pyre burned brighter the people seemed to be on fire too–they surged forward in a great crushing movement, throwing themselves toward the pyre.

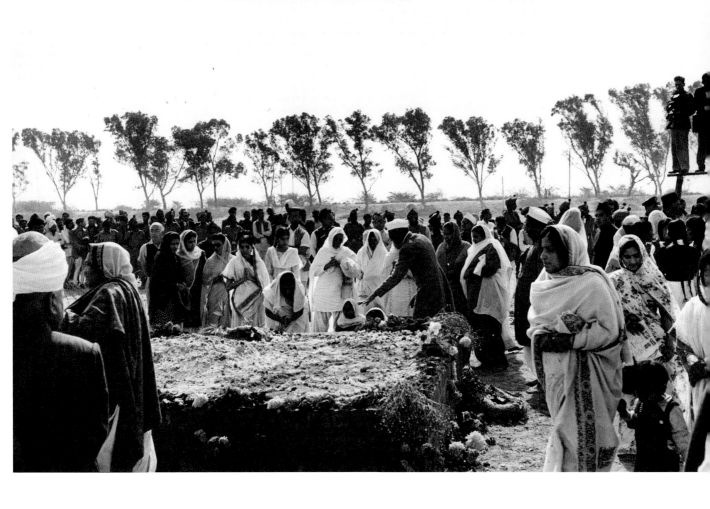

Opposite page Henri Cartier-Bresson, Gandhi's cremation, Delhi, February 1, 1948, printed
1973. Gelatin silver print, 11⅞ × 15¾ inches (30.2 × 40 cm). The Menil Collection, Houston

Above Henri Cartier-Bresson, After Gandhi's cremation, Delhi, February, 1948,
printed 1950s. Gelatin silver print, 9⅜ × 13⅞ inches (23.9 × 35.4 cm). Collection Fondation
Henri Cartier-Bresson, Paris

Joining more than a million mourners in a five-hour funeral procession that has been described as "a curious hybrid of colonial ritual, Hindu tradition, and spontaneous outpouring of public grief," Cartier-Bresson captured some of the enormous shockwaves of Gandhi's death.[17] By doing so, he also gave visual form to a crucial early act of statecraft, as India used the mass gathering to unify and pacify itself. Shooting more than fifty events and one thousand frames of film, Cartier-Bresson recorded the funeral's scope and pathos. He captured a grieving Prime Minister Nehru joining the procession; onlookers climbing lampposts and trees above seas of mourners; the burning funeral pyre; the gathering of sacred ashes; and the masses thronging the rail line of the "Burned-Bone Special" and on the banks of the Jumna (Yamuna) and Ganges (Ganga) as Gandhi's ashes were carried to and deposited at the confluence of India's sacred rivers.

The sad faces of Gandhi's followers at the procession received special attention. Two beautifully illuminated, emotionally charged photographs of mourners, one a group of men, another of women and children, call to mind Danny Lyon's famous 1963 images of stunned crowds lining the route of the funeral of four African American girls killed in a bomb attack on their Sunday school in Birmingham, Alabama, during the U.S. Civil Rights Movement. Both photographers highlighted the resolve of the anonymous individuals joined in peaceful movements to make powerful expressions of humanist values.

Perhaps Cartier-Bresson's most moving image from February 1 was made at the cremation itself. Standing directly in front of the giant pyre, its topmost sandalwood logs nearly at eye level, he caught the first flames and smoke as it was ignited with clarified butter and camphor. Opposite him, a friend and former aide to Gandhi, Brij Krishna, leans forward, his half-shadowed face a study in anguish. To the right of the composition, back to the camera, the Mahatma's physician raises his arms to implore the surging crowd to stay back. The visceral and spectacular nature of this cremation must have seemed elemental and exotic to *LIFE*'s readers, most of whom observed more subdued Christian funeral traditions. The narrator of a British Pathé newsreel imbued it all with a transcendent nature:

As the first plume of scented smoke lifted above the pyre, the great concourse of mourners swept across the barriers toward it. Against this tremendous human tide, the police were almost powerless. Mourners were forced close to the fiercely burning *ghat*, but, as in Gandhi's lifetime, peace won where force had failed. The mass hysteria was broken by the chanting of a hymn: "Mahatma Gandhi has become immortal." In the rising flames, the spirit of a great man passed to his gods.[18]

17 Yasmin Khan, "Performing Peace: Gandhi's Assassination as a Critical Moment in the Consolidation of the Nehruvian State," *Modern Asian Studies* 45, no. 1 (January 2011): 64.

18 Transcription from undated video clip from "Funeral of Gandhi," a British Pathé newsreel, on Gandhimedia.org, http:// www.gandhimedia.org/cgi-bin /gm/gm.cgi?action=view&link =Video/Footage—and—Newsreels /Events/Cremation&image =VIFOEVCR1948025010.flv&img =&tt=flv (accessed January 28, 2014).

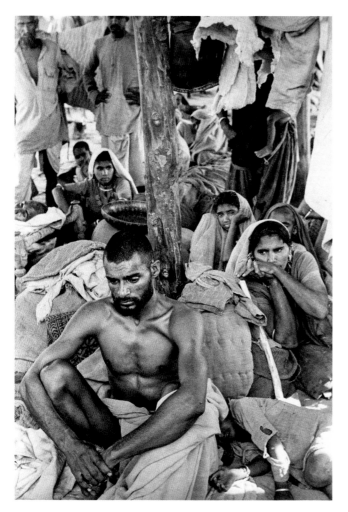

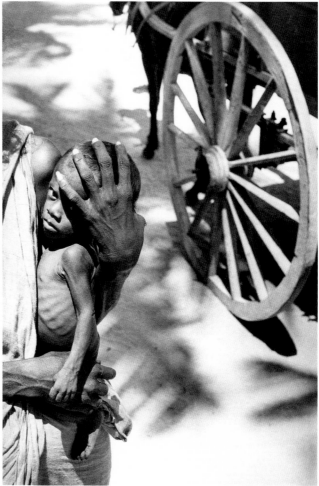

Left Henri Cartier-Bresson, Lahore, Pakistan, April 1948, printed 1973. Gelatin silver print, 15 ¾ × 11 ⅞ inches (40 × 30.2 cm). The Menil Collection, Houston

Right Henri Cartier-Bresson, Madurai, Tamil Nadu, India, March 1950, printed 1973. Gelatin silver print, 15 ¾ × 11 ⅞ inches (40 × 30.2 cm). The Menil Collection, Houston

HENRI CARTIER-BRESSON AND GANDHI'S LAST DAYS

Following these harrowing images, many of Cartier-Bresson's later photographs from India and Pakistan seem especially piercing, as if his experiences there had sharpened his eye and softened his heart. An image of a shirtless, seated man with a downcast gaze surrounded by women in headscarves taken in Lahore, Pakistan, a month or two later, becomes a universal emblem of disconsolation that, like that earlier image of Gandhi on Birla House's terrace, that seems to ask, "And now what?" A composition made in 1950 in Madurai, in South India, that balances a malnourished baby in its mother's arms in the lower-left foreground and a wagon wheel in the upper-right might seem to hint at the "wheel of rebirth" and the how karma determines one's lot in life. And another 1950 photograph, of blind and crippled beggars sprawled on steps in Madras (Chennai), the defining subject of which is a man with a withered leg extending his bowl and gaze to the photographer (p. 125), is a pointed reminder of the plight of those at the bottom.

If one image could emblematize Cartier-Bresson's sensitivity to the spiritual aspects of his momentous first trip to India and Pakistan, it is the beautiful and monumental composition, *Women praying, Srinagar* (p. 2). Forced by deadlines for the Gandhi story to ship undeveloped exposures, he was not able to create his own edit of this body of work until *The Decisive Moment* four years later. In the book, this photograph taken approximately six months after the assassination is the penultimate image in a series of twenty-five pictures from India and Pakistan, likely because it provides a sense of catharsis.[19] It depicts of a group of women, two standing and two seated, one of whom obscures a crouching child, on a hillside facing a valley bordered on its far side by a cloud-covered mountain range. A woman standing center-left is seen in three-quarters view, her hands held open in front of her in a gesture of both supplication and hope. In a grace note only Cartier-Bresson could discover, her gesture is exalted by its alignment with two small clouds floating in the middle distance. Regeneration can follow tragedy, the photograph seems to say. The way it and so much of Gandhi and his final hours was recorded by Cartier-Bresson suggests that, in the right hands, if the camera cannot convey the miracle of darshan, it can fix the sparks thrown off by extraordinary and ordinary men and women and their noble and compassionate deeds.

19 The final photograph is the image of the Kurukshetra exercisers, which concludes the series on an ambivalent, open-ended note.

Opposite page Jean Tinguely (Switzerland, 1925–1991), Prayer Wheel, 1954. Steel wire and electric motor on wood base, 29 ½ × 21 × 14 inches (74.9 × 53.3 × 35.6 cm). The Museum of Fine Arts, Houston, Museum purchase funded by D. and J. de Menil

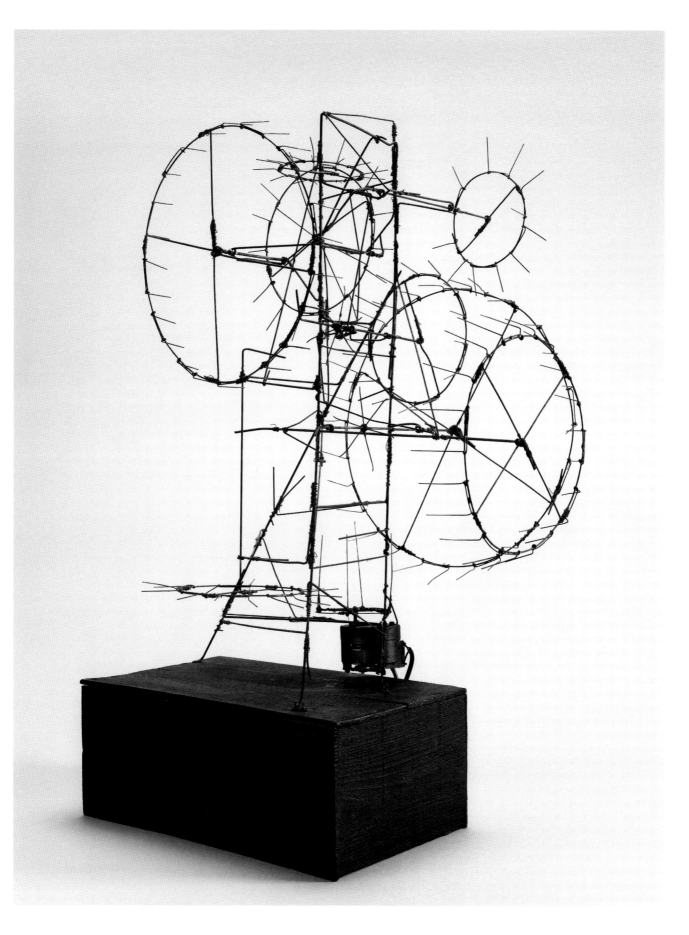

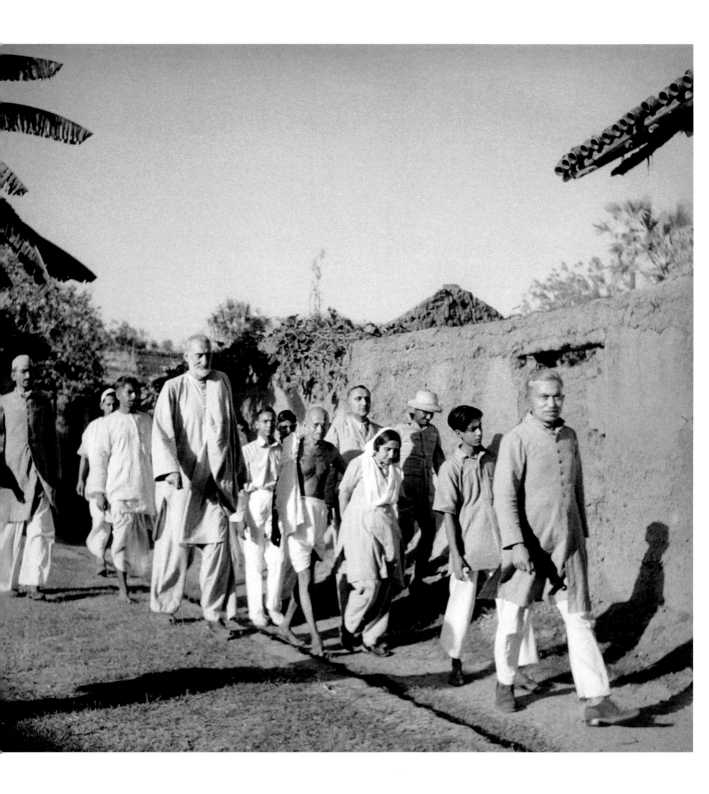

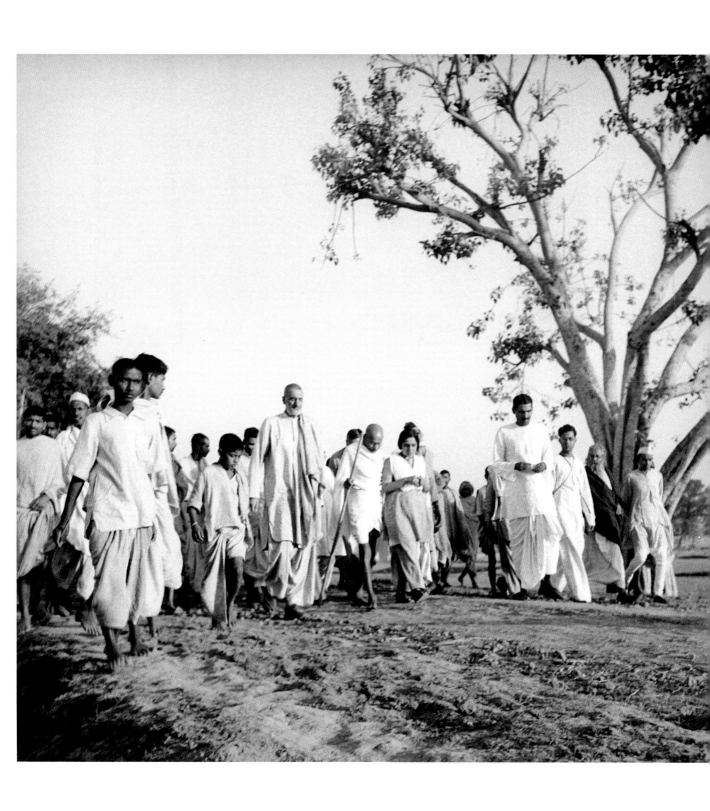

Abdul Ghaffar Khan, Gandhi, Mridula Sarabhai (left to right, in center),
and others on their visits to villages in strife-torn Bihar, India, March 27, 1947.
Photographs by Jagan Mehta. Jagan Mehta/GandhiServe

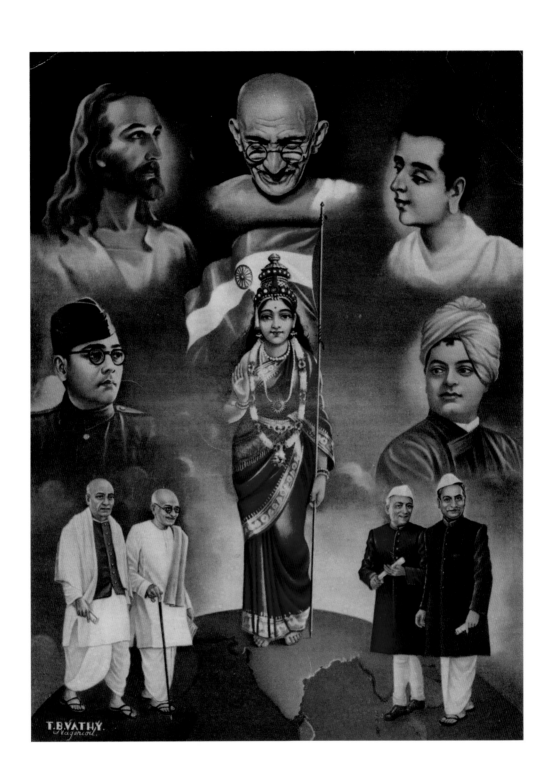

Message of Love: Mother India Surrounded by Saints. Popular print,
19 ⅝ × 13 ¾ inches (49.8 × 34.9 cm). Collection of Vinay Lal

Gandhi in East Bengal (1950)

In Noakhali during the communal riots in 1947, I remember, the earliest stars of dawn would see him already engaged, after meditation, in scrutinizing statistics of harvest, disease and the social usages; his hurricane lantern grew dimmer as the morning broke upon rows of slender areca-nut palms, stacks of burnt tins and shattered, silent homes. Along dew-drenched muddy lanes he would rapidly walk, bare-footed, observing each village, field, tank, weed-locked canal, his face lighting up as he met an early passer-by of either community. He would ask questions, negotiate precarious bamboo-bridges, and the whole journey would soon become a complete adventure. All the time, the still morning air could be felt in his expression. One could also sense a supreme urgency in the utter calm of his words. His comprehensive vitality, if that is the phrase for full spiritual activity, touched many levels of material and emotional fact, and related them to the crucial events, and to the actions that must follow, without breaking the peace of the golden moment.

For most of us, used to one-dimensional habits of thought and work, this apparent contradiction in Gandhiji's activities must remain mysterious. In moving from one village to another, whether in East Bengal or in grievously afflicted Bihar, he followed a simple track. And yet it was the track of convergent paths, not the one-track simplicity enjoined by shirkers or extreme practitioners. You could call it the road of humanity.

Excerpted from Amiya Chakravarty, *A Saint at Work: A View of Gandhi's Work and Message,* William Penn Lecture 1950, http://www.quaker.org/pamphlets /wpl1950a.html (accessed March 24, 2014).

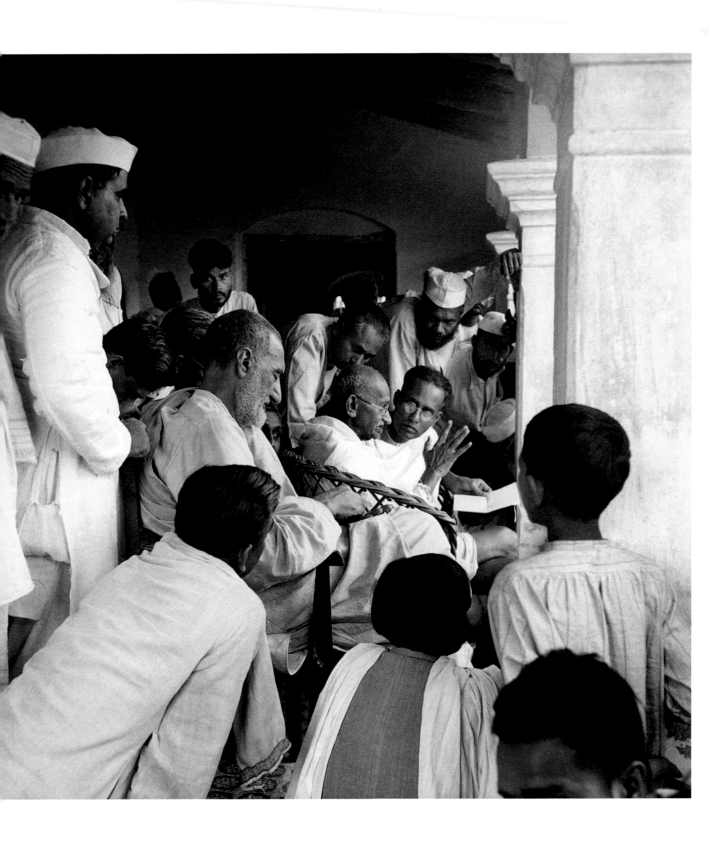

Abdul Ghaffar Khan and Gandhi (center) giving a peace message to Muslim
refugees at the house of the president of the Muslim League in Ghosi, Bihar, India,
March 27, 1947. Photograph by Jagan Mehta. Jagan Mehta/GandhiServe

Gandhi's 1947 East Bengal March

New Delhi, India
February 16, 1947

Two weeks ago I traveled for five days in order to walk for an hour with Gandhi.

The journey was worth the effort. It was revealing to watch Gandhi throwing himself during this critical season into the remoteness of East Bengal's Noakhali district for a barefooted village-to-village pilgrimage in search of Hindu-Muslim amity. Here was a 77-year-old ascetic, rising above the physical ordeal, immersed in a peculiarly Indian approach to the cleavage that threatens the country.

The region in which Gandhi has secluded himself is deep in the Ganges-Brahmaputra delta; one of the least accessible flat lands of India. To reach his party, I traveled by air, rail, steamer, bicycle, and on foot.

Hardly a wheel turns in this teeming, jute-and-rice-growing delta. I saw no motorable road. The bullock cart, one of India's truest symbols, does not exist here. The civilization is amphibious, as fields are always flooded between April and October. In the wet season little remains above water except occasional ribbons of *bund* and isolated village clumps marked by coconut palms, bamboos, and betel trees. People stay at home or, at best, move about in hand-hewn skiffs. Though some of their crops grow under water, they farm mostly in the winter dry season.

Here, in an entirely rural area about forty miles square, are jammed nearly two and half million people: 1,400 per square mile or more than two per acre. Eighty per cent of these peasants are Muslims. Apart from a few wealthy families they "have nothing but their numbers," in the words of one senior Muslim official.

Impoverished cultivators racially indistinguishable from their Hindu neighbors, they suffered severely in the 1943 Bengal famine. The tiny Hindu minority in this region is divided into two groups, of whom the more numerous are also peasants and low caste village artisans. With the upper crust of landlords, moneylenders, grain merchants, and lawyers, peasants of both communities had shared little sympathy for many years past, I judged.

In this closely-packed, rupee-starved, isolated district, terror struck last fall in the wake of vicious riots in Calcutta and other Indian cities. It was the first real flare-up in a rural area. Roving bands paddled over the flooded fields from village to village, killing Hindus, looting and burning their property, abducting some women, and registering conversions from Hinduism to Islam. Many of those murdered and robbed were the wealthy who had incurred the peasant's ire in 1943. The movement took a communal twist, however, from politicians (since disowned by the Muslim League) who led the village crowds with the cry of Pakistan. In some villages mobs burned huts even of outcastes.

The upheaval swept over about half the district. Perhaps a million people were caught up in the turmoil, and refugees eventually were counted in tens of thousands. This was bad enough. But the effect was multiplied a thousand-fold across the breadth of Hindu India by exaggerated, inflammatory reports of what had occurred.

This was the pitch of feeling in India when Gandhi decided to go to East Bengal himself. A few days before he left Delhi, Mildred and I walked with him for half an hour in the sweepers' settlement where he stayed and talked of the wave of mass fratricide which was then rolling over the country. Although he denied letting emotions affect his judgment, we sensed a feeling of frustration, if not of failure. This had nothing to do with the validity of the creed of non-violence itself. Its truth, he repeated, could never be challenged. But he could not be happy with the way in which his teachings were being flouted.

To test the applicability of his faith, therefore, he went to the heart of the trouble. He chose East Bengal, and when people asked why he had not gone to Bihar province where the damage was greater and the culprits were Hindus, he replied that the people of Bihar had repented. Besides, he said, he could control the government and people of Bihar from Noakhali, but had no special powers over the people of Noakhali.

In a tiny village that suddenly acquired fame, bustling visitors, police attendants, press observers and even telegraph facilities, the old man settled into a hut and began meeting people, hearing their stories and assessing the task ahead of him. Finally, early in January, he began the trek that will take its place in the Gandhi epic as the East Bengal March. Rising at four, he finishes his morning prayers, takes a glass of hot water containing honey, and works at correspondence for two hours or so until dawn. At 7:30 he sets off on the day's walk across newly plowed dew-soaked fields to the next village on his itinerary.

The Gandhi march is an astonishing sight. With a staff in one hand and the other on his granddaughter's shoulder, the old man briskly takes the lead as the sun breaks over the horizon. He usually wraps himself in a handwoven shawl, as the January mornings are cold enough for him to see his breath. But he walks barefooted despite chilblains. This is a fashion he started in order to relieve a blister, but continued because he liked the idea of walking as Indian pilgrims normally travel. Clustered around him is his immediate party: his Bengali interpreter, a professor of geography at Calcutta University; a Sikh attendant who fawns as much as Gandhi will permit; a retired engineer-turned-swami; and one or two youths. The dozen Indian pressmen who are following this trek walk behind. Sometimes this little body of the faithful, like other truth-seekers before them, sing of God as they walk. His name here is Ram. A squad of policemen, detailed (against repeated protests from Gandhi) by Muslim League premier H.S. Suhrawardy to accompany and protect the Gandhi party, mix with the group. As the sun begins to climb, villagers from places along the way join the trek. They come by twos and fours or by dozens and scores, swelling the crowd as

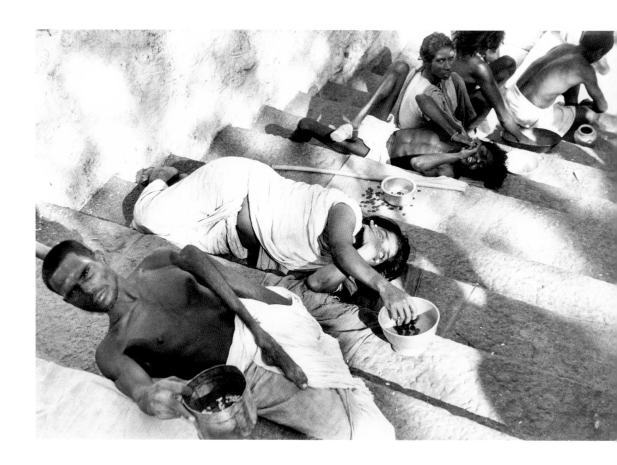

Henri Cartier-Bresson (France, 1908–2004), Pilgrims, Chennai,
Tamil Nadu, India, April 1950, printed 1973. Gelatin silver print, 11 7/8 × 15 3/4 inches
(30.2 × 40 cm). The Menil Collection, Houston

the snows swell India's rivers in spring. They press in on the old man, while their children dance around the edges of the moving body. Here, if I ever saw one, is a pilgrimage. Here is the Indian–and the world's?–idea of sainthood: a little old man who has renounced personal possessions, walking with bare feet on the cold earth in search of a great human ideal. Sometimes a new arrival drops to the ground in front of Gandhi in an effort to touch those feet, but the big Sikh gently lifts up the man. As Gandhi nears the day's destination, another crowd from that village surges toward him, singing their own hymns, waiting to greet and welcome him. They lead him to his new hut, where three or four peasant women give him the special Bengal greeting, a high, warbling trill that I have heard nowhere else.

This is the Gandhi march, one of two highlights of the Mahatma's day and the act that has caught the imagination of many co-nationalists, and particularly co-religionists. After arriving at the new village, Gandhi rests while his granddaughter bathes his feet. He meets his hosts. Then, at 9:30 he gets a massage and bath, and at 11 he takes a meager lunch which is usually a boiled paste of scraped and ground vegetables, moistened with a glassful of hot milk. After another rest (during which he indulges himself in his widely known "nature cure" consisting of mud plasters on his forehead and stomach), Gandhi works at correspondence and interviews until the time for evening prayers.

In his daily prayer meeting Gandhi meets the world; this is his best platform. Welcoming all who will come to his open-air meeting, he proceeds through a ritual that reveals his eclectic faith. One by one, the audience hears an extract from Buddhist scriptures (suggested by a Japanese monk who stayed at Gandhi's ashram until he was interned at Pearl Harbor); several recitations from revered Hindu writings; ashramite vows (truth, nonviolence, nonstealing, celibacy, nonpossession, removal of untouchability, etc.); readings from the Quran; a Zend Avesta (Zoroastrian) quotation; a hymn which may be Hindi, Bengali, or some Christian song in translation; and a joyous tuneful recital of the name of Ram, to the accompaniment in-cadence of hand-clapping. This devotional exercise is followed each day by a talk in which Gandhi gives expression to almost any thought exercising his mind. Listeners may hear of village sanitation, women, in purdah, Hindu-Muslim relations, reactions to the latest Muslim League resolution, a hint as to what new course the Congress will adopt, and observations on London's policy. Taken together, reports of these after-prayer talks furnish perhaps the best guide to the trend of Gandhian thought. These reports, I might add, are authentic. While his Bengali interpreter translates his remarks to the village crowd, Gandhi sits crosslegged on his small

platform, penning out the authorized English version of what he has said in Hindi. He writes in third person and refers to himself by his initial. "Addressing the prayer gathering at Bansa this evening, G. said…"

After the prayers, Gandhi takes another brisk walk. Except on his weekly day of silence, he uses this exercise period to talk with villagers and visitors who half-trot at his side. Then Gandhi returns to his hut for another footbath and more correspondence and interviews. Later one of the Indian pressmen arrives to read the day's news to him. Gandhi usually sleeps at about 9 o'clock.

Talking to villagers, Gandhi gives full rein to his anarchist instincts. A firm believer that no government is good government, Gandhi admonishes these peasants to live together quietly and to rely on themselves. "If a neighbor was ailing, would they run to the Congress or the League to ask them what should be done? That was an unthinkable proposition," says the report of one prayer speech; "They should in such matters [a solution of their daily problems of life] look toward themselves and if they did that, then their desire for neighborly peace would be reflected by the leaders." If the Hindu and Muslim inhabitants of one village can begin practicing what he calls the nonviolence of the strong, Gandhi believes, the path to communal peace throughout India will be open.

What progress has he made with this doctrine? Gandhi himself has never underestimated the task. Writing to a relative in December, he explained:

> My present mission is the most complicated and difficult one of my life. I can sing with cent percent truth: "The night is dark and I am far from home; Lead Thou Me On." I have never experienced such darkness in my life before. The nights seem to be pretty long. The only consolation is that I feel neither baffled nor disappointed. I am prepared for any eventuality. "Do or die" has to be put to test here, "Do" here means Hindus and Mussalmans should learn to live together in peace and amity. Otherwise, I should die in the attempt. It is really a difficult task. God's will be done.

Abridged from Phillips Talbot, "With Gandhi in Noakhali, February 16, 1947," *An American Witness to India's Partition* (Los Angeles: Sage Publications, 2007), 200–212.

Shilpa Gupta (India, b. 1976), 1:14.9, 1188.5 Miles of Fenced Border–West, North-West, 2011–12. Thread, wood, glass, and brass, 64 ¼ × 22 × 20 inches (163 × 55.9 × 50.8 cm). Solomon R. Guggenheim Museum, New York, Guggenheim UBS MAP Purchase Fund, 2012

1:14.9, 1188.5 Miles of Fenced Border–West, North-West

In a glass vitrine lies a large ball of thread. On coming closer, you can see a brass plaque placed in front, on which is etched:

1:14.9

1188.5 Miles of Fenced Border–West, North-West

Data Update: Dec 31, 2007

Hand wound over several months, the ovoid orb is made of 79.5 miles of thread. When multiplied by 14.9 (ratio on plaque) it equals to 1188.5 miles, which is the length of fence that has been constructed on the India-Pakistan border, as per the data released by the Home Ministry of India in 2007.

The very act of winding miles and miles of thread into a single whole, where the ball is held and turned around thousands of times, embodies a wide range of dervish emotions, be they hysteria, anxiety, hope–which vanish only to reappear when lines drawn across communities that have been around longer than countries were formed continue to simmer.

The plaque text intentionally says "West, North-West" rather than stating the names of the countries, dislodging ideas of location every time the work itself would move. There is also a sense of the futility of such mammoth fencing vis-à-vis nature, be it from the human will to move, or the vast expanse of empty deserts and rivers through which the border runs, or the sea and high ice-capped mountains into which it must end.

Also, the ratio, 14.9, is a little off from a rounded-off 15, to deal with a sense of inherent doubt with the large-scale mapping exercises that get undertaken.

Only Breath

Not Christian or Jew or Muslim,
not Hindu, Buddhist, Sufi, or Zen.
I am not from the East or the West,
not out of the ocean or up from the ground.
Not natural or ethereal,
not composed of elements at all.
I do not exist.

I am not from China or India,
not from the town of Bulghar on the Volga,
nor from remote Arabian Saqsin.
Not from either Iraq, the one between the rivers,
or the one in western Persia.

Not an entity in this world or the next.
I did not descend from Adam and Eve or any origin story.
My place is the placeless, a trace of the traceless,
neither body or soul. I belong to the beloved,
have seen the two worlds as one,
and that one call to and know,
first, last, outer, inner,
only that breath breathing human being.

Translation by Coleman Barks
Rumi: The Big Red Book, 352

Two gods?

Brother, where did your two gods come from?
Tell me, who made you mad?
Ram, Allah, Keshav, Karim, Hari, Hazrat–
so many names.
So many ornaments, all one gold,
it has no double nature.
For conversation we make two–
this *namaz*, that *puja*,
this Mahadev, that Muhammad,
this Brahma, that Adam,
this a Hindu, that a Turk,
but all spring from the earth.
Vedas, Qur'ans, all those books,
those Mullas and those Brahmins–
so many names, so many names,
but the pots are all one clay.
Kabir says, nobody can find Ram,
both sides are lost in schisms.
One slaughters goats, one slaughters cows,
they squander their birth in isms.

Translation by Linda Hess
The Bijak of Kabir, 50–51

Quakers,
or the Society of Friends

Since the mid-seventeenth century, the Society of Friends, commonly called the Quakers, have been the best-known Christian group stringently advocating peace. Christian predecessors include a movement in the twelfth century that took the Sermon on the Mount as a foundation and refused to fight or take human life, Saint Francis of Assisi (1181/82–1226), and Erasmus (1456–1536), who advocated love, patience, innocence, and justice. About 1650, at a time of great religious strife and war in England, seekers began to gather in fellowship around George Fox (1624–1691) and bear witness to sincerity, honesty, and nonviolence based on personal and often mystical experiences of light and truth that "shines through all" people.

As succinctly stated by the eminent American Quaker philosopher Rufus M. Jones (1863–1948):

What comes first to mind when the Quaker way of life is mentioned is, almost certainly, the Quaker faith in the sacredness of human life and the refusal to use violent methods of force to change situations that are manifestly evil. The Quaker has unmistakably committed his trust for moral and social victories to the armor of light and the sword of the spirit, to methods that may be called gentle. He has been pretty consistently the bearer of a testimony for peace and in a good degree he has been a peacemaker. He has suffered much for his unyielding opposition to war. But his attitude toward peace and war is not an isolated attitude. It springs out of a deeper inward soil. It is an essential aspect of a larger whole of life....

In 1659, George Fox wrote: "All Friends everywhere, who are dead to all carnal Weapons and have beaten them to pieces, stand in that which takes away the occasion of Wars, in the Power which saves men's lives, and destroys none, nor would have others (destroy)." He quotes no texts. He gives no reasons. He simply says Friends cannot do the things which war involves.

Quakerism, then, let us say, is a bold experiment, not merely in pacifism, in the midst of warring peoples, but an experiment with patience and endurance to exhibit a way of life which implements this high estimate of man's divine possibilities, and which even in the fell circumstances of war and hate goes on with a service of love and a mission of good will, the condition of peace....

It is first and last a positive and creative way of life and of enlarging the area of light and truth and love. This spirit and way of life which explain the Quaker attitude to war lie also behind the humanitarian endeavors of Friends from the days of George Fox to the present time.

Mohandas K. Gandhi had especially important friendships with two British Quakers, Horace Alexander and Reginald Reynolds, and some of the Quaker visitors and guests at his ashrams took on important roles in his nonviolent causes. As Rufus Jones said: "Mahatma Gandhi has described his life work as 'My Experiments with Truth.' I should like to have that term applied to our Quaker service: 'The Quaker Experiments with Truth.'"

Quote from Rufus M. Jones, *Rethinking Quaker Principles*, Pendle Hill Pamphlet 8 (Wallingford, PA: Pendle Hill Publications, 1941), 17, 19, 20.

Quaker Declaration of 1660

A Declaration from the Harmless and Innocent People of God, Called Quakers, Against All Sedition, Plotters, and Fighters in the World: For Removing the Ground of Jealousy and Suspicion from Magistrates and People Concerning Wars and Fightings.

Presented to the King upon the 21st day of the 11th Month, 1660.

OUR principle is, and our practices have always been, to seek peace and ensue it; to follow after righteousness and the knowledge of God; seeking the good and welfare, and doing that which tends to the peace of all. We know that wars and fightings proceed from the lusts of men, as James 4:1-3, out of which lusts the Lord hath redeemed us, and so out of the occasion of war. The occasion of war, and war itself (wherein envious men, who are lovers of themselves more than lovers of God, lust, kill, and desire to have men's lives or estates) ariseth from lust. All bloody principles and practices we (as to our own particulars) do utterly deny; with all outward wars and strife, and fightings with outward weapons, for any end, or under any pretense whatsoever; this is our testimony to the whole world.

…

And whereas men come against us with clubs, staves, drawn swords, pistols cocked, and beat, cut, and abuse us, yet we never resisted them; but to them our hair, backs, and cheeks, have been ready. It is not an honour, to manhood or nobility, to run upon harmless people, who lift not up a hand against them, with arms and weapons.

…

Our weapons are spiritual, and not carnal, yet mighty through God, to the pulling down of the strongholds of sin and Satan, who is the author of wars, fighting, murder, and plots. Our swords are broken into ploughshares, and spears into pruning-hooks, as prophesied of in Micah 4. Therefore we cannot learn war any more, neither rise up against nation or kingdom with outward weapons, though you have numbered us amongst the transgressors and plotters. The Lord knows our innocency herein, and will plead our cause with all people upon earth, at the day of their judgment, when all men shall have a reward according to their works.

Excerpted from the 8th and Bicentenary Edition of Fox's *Journal*, 2 vols. (London: Friends' Tract Association, 1891), http://www.qhpress.org/quakerpages/qwhp/dec1660.htm (accessed February 2, 2014)

Leo Tolstoy

(1821–1912)

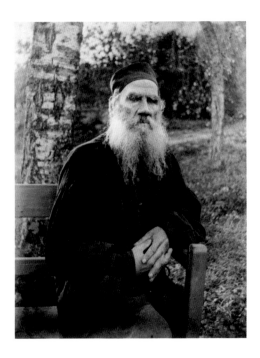

Although best known for his epic romantic novels *War and Peace* and *Anna Karenina*, Count Leo Tolstoy regarded these masterpieces as less important than his lifelong search for the universal truth about man's relationship to man and God's purpose for all. In his forties, Tolstoy suffered a midlife crisis and began to question the value of his worldly success. This personal turmoil occurred at a time when Western European ideas and industrialization were making headway in Russia, resulting in disruption and hardship for the peasants. During the same period, the Russian autocracy and Orthodox Christian Church hierarchy were tightening their controls on society in an attempt to stem popular discord. Tolstoy retreated to his family's country estate and delved into the writings of both European and Asian thinkers, seeking an alternative path.

He believed he found truth in the admonition in the Christian Gospels to "resist not evil" and to turn the other cheek to those who would harm you. Beginning in the 1880s, his goal became one of peaceful revolution within Russia's existing autocratic political structure by proselytizing a message of non-violent Christian anarchism. He preached that if individuals lived their life in a simple, nonviolent, economically self-sufficient manner, a new moral consensus would emerge and people would refuse to participate in state institutions, the state-recognized Orthodox Church, and the military. Over time, these institutions based on power, fear, and violence would crumble. Noncoercive associations based on Christian love would eventually, but inevitably, evolve in their place.

In his seminal religious work *The Kingdom of God is Within You*, as well as letters, short stories, and essays, Tolstoy urged the tsar to enact radical social, political, and economic reform. Ultimately, however, it was not his message of nonviolence and noncooperation but his outspoken denunciations of

Leo Tolstoy, ca. 1897. Photograph by F.W. Taylor

political callousness and injustice that made Tolstoy a national and international symbol of moral protest against the repression of the dignity of the individual in modern society.

In polemics against Western civilization, imperialism, and organized religion, he encouraged the Russian people to refuse peacefully to cooperate with the Russian government. But when the 1905 Revolution in Russia turned violent on all sides, Tolstoy wrote that the Russian people were already too damaged by the incursion of Western ideas and a more "backward" people in the East would have to lead the way to a new, moral world order.

During Gandhi's years in South Africa, he often found philosophical form for his own observations and beliefs in Tolstoy's writings. Before 1906, Gandhi was inspired by Tolstoy's asceticism and personal moral reform. Between 1906 and 1910, while he was developing and using noncooperation as a tool in his struggle to persuade the British and South African governments that the Indian Registration Act was immoral and unacceptable, he drew inspiration from Tolstoy's writings on nonviolence and noncooperation as a means of achieving social and political change. Where the aloof Tolstoy urged individuals to withdraw from an immoral society and change their own life

in order to achieve long term, universal change, however, Gandhi avidly engaged in the political arena, using "truth force" (*satyagraha*) to gain freedom for the Indian population in South Africa and, later, in India.

Gandhi named his base for the satyagraha campaigns "Tolstoy Farm." In October 1909, at a time when Tolstoy was ill and disillusioned, Gandhi wrote his first letter to him. In their ensuing correspondence, Gandhi described the inspiration he had derived from Tolstoy and sought the older man's blessing for his work and aid in publicizing the Indians' struggle. Tolstoy did both before he died in September 1910. In his eulogy for Tolstoy, Gandhi called him the greatest of *satyagrahis* (practitioners of truth force).

Patricia Hunt Holmes

The Kingdom of God Is Within You (1893)

"The kingdom of God cometh not with outward show; neither shall they say, Lo here! Or, Lo there! For behold, the kingdom of God is within you." (Luke 17:20–21)

Among the first responses called forth by my book [*What I Believe*] were some letters from American Quakers. In these letters, expressing their sympathy with my views on the unlawfulness for a Christian of war and the use of force of any kind, the Quakers gave me details of their own so-called sect, which for more than two hundred years has actually professed the teaching of Christ on non-resistance to evil by force, and does not make use of weapons in self-defense. The Quakers sent me books, from which I learnt how they had, years ago, established beyond doubt the duty for a Christian of fulfilling the command of non-resistance to evil by force, and had exposed the error of the Church's teaching in allowing war and capital punishment.

Another champion of non-resistance has been overlooked in the same way–the American Adin Ballou, who lately died, after spending fifty years on preaching this doctrine...And here is a version of Ballou's catechism composed for his flock:

> **CATECHISM OF NON-RESISTANCE.**
> Q. Whence is the word "non-resistance" derived?
> A. From the command, "Resist not evil" (Matthew 5:39)
> Q. What does this word express?
> A. It expresses a lofty Christian virtue enjoined on us by Christ.
> Q. What is there to show that Christ enjoined non-resistance
> in that sense?
> A. It is shown by the words he uttered at the same time. He said, 'Ye
> have heard, it was said of old, An eye for an eye, and a tooth for a
> tooth. But I say unto you Resist not evil. But if one smites thee on
> the right cheek, turn to him the other also; and if one will go to
> law with thee to take thy coat from thee, give him thy cloak also.'"

Works of this kind, dealing with the very essence of Christian doctrine, ought, one would have thought, to have been examined and accepted as true, or refuted and rejected, but nothing of the kind has occurred,

and the same fate has been repeated with all those works. Men of the most diverse views, believers, and what is surprising, unbelieving liberals also, as though by agreement, all preserve the same persistent silence about them, and all that has been done by people to explain the true meaning of Christ's doctrine remains either ignored or forgotten.

…

The Christian doctrine shows man that the essence of his soul is love–that his happiness depends not on loving this or that object, but on loving the principle of the whole–God, whom he recognizes within himself as love, and therefore, he loves all things and all men.

…

All state obligations are against the conscience of a Christian–the oath of allegiance, taxes, law proceedings, and military service. And the whole power of the government rests on these very obligations. Revolutionary enemies attack the government from without. Christianity does not attack it at all, but, from within, it destroys all the foundations on which government rests.

The progressive movement of humanity does not proceed from the better elements in society seizing power and making those who are subject to them better, by forcible means, as both conservatives and revolutionists imagine. It proceeds first and principally from the fact that all men in general are advancing steadily and undeviatingly toward a more and more conscious assimilation of the Christian theory of life.

And so the movement goes on more and more quickly, and on an ever-increasing scale like a snowball, till at last a public opinion in harmony with the new truth is created and then the whole mass of men is carried over all at once by its momentum to the new truth and establishes a new social order in accordance with it.

The conditions of the new order of life cannot be known by us because we have to create them by our own labors. That is all that life is, to learn the unknown, and to adapt our actions to this new knowledge. That is the life of each individual man, and that is the life of human societies and of humanity.

The sole meaning of life is to serve humanity by contributing to the establishment of the kingdom of God, which can only be done by the recognition and profession of the truth by every man.

Translated by Constance Garnett

John Ruskin

(1819–1900)

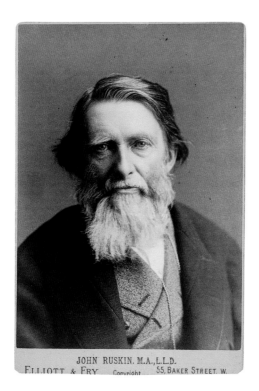

JOHN RUSKIN. M.A.,L.L.D.
ELLIOTT & FRY Copyright 55, BAKER STREET. W.

this included modern painters who were aesthetically adventurous but his writings and influence helped shape a highly naturalistic Victorian style of painting. A crisis of faith in the late 1850s shifted his intellectual quest away from art and architecture toward social issues and the question of an ideal society. Ruskin began to attack as dehumanizing the industrial capitalism that was rampant in Britain and wrote about political economy and labor issues. The book *Unto This Last: Four Essays on the First Principles of Political Economy* (1862) developed these themes and, although initially much criticized, it began to have an influence at a time when others, such as writers and workshops affiliated with the Arts and Crafts movement, were exploring alternatives as well. *Unto This Last* turned out to be extremely influential for the social thinking of Mohandas K. Gandhi after he discovered it in South Africa, and Gandhi's succinct paraphrase of its key points is found in Eric M. Wolf's essay in this volume, "Four Alternatives to Civilization: Gandhi's Ashrams, Their Principles and Sources" (see p. 80).

John Ruskin was a prominent English author, art critic, and social thinker whose writings ranged widely but had at their center nature and society. Truth to nature was a primary value Ruskin saw in the arts, and he promoted it and his own aesthetic preferences with a moralistic zeal; at first

John Ruskin, mid to late 1800s. Photograph by Elliott & Fry. Albumen cabinet card, 6 ½ × 4 ¼ inches (16.5 × 10.8 cm). The Menil Collection, Houston

Ralph Waldo Emerson

(1803–1882)

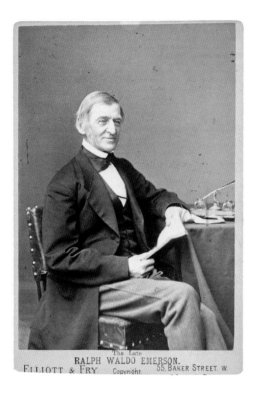

The Late
RALPH WALDO EMERSON.
ELLIOTT & FRY Copyright 55, BAKER STREET. W.

The lecturer, essayist, and poet Ralph Waldo Emerson was a pivotal figure in the American Romantic philosophical and literary movement known as Transcendentalism that developed in New England in the mid nineteenth century. Emerson and his circle took nature and human nature as their touchstone and revelation of the divine. After graduating from Harvard College, in the early 1830s Emerson worked as a junior pastor at a Boston church, but he grew dubious of the institution and church doctrines and resigned after three years.

He became a strong proponent of personal freedom and responsibility and of studying the natural world, which he saw as a microcosm of the universe. In addition to the Greco-Roman Classics and contemporary literature, Emerson read Asian texts in translation; he and his friend Henry David Thoreau both studied the first translation into English of the *Bhagavad Gita* and were sympathetic to much they found there and in other Indian scriptures. Rather than having a directly discernable effect on Gandhi, Emerson would be more influential through the intellectual currents he helped create, the championing of each individual being true to their inner voice and vision, and by helping to bring Thoreau to prominence.

Ralph Waldo Emerson, mid to late 1800s. Photograph by Elliott & Fry. Albumen cabinet card, 6 ⅜ × 4 ¼ inches (16.2 × 10.8 cm). The Menil Collection, Houston

139

Henry David Thoreau

(1817–1862)

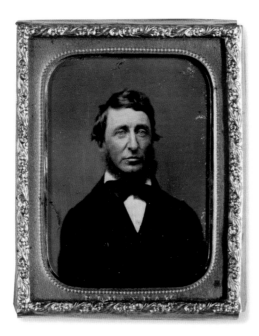

Henry David Thoreau is famous as an author, a naturalist, and a philosopher. After gradu-ating from college he variously made a living as a school teacher, a surveyor, or a manufacturer of pencils, while he drifted more and more towards writing. Thoreau and his mentor, friend, and neighbor Ralph Waldo Emerson are the key figures in the Transcendentalist movement, which placed greater reliance on individuals and their own consciences than in external authorities, especially religious, and in Thoreau's case especially, political. During his two years, two months, and two days spent living by himself at Walden Pond– which resulted the famous book *Walden, or Life in the Woods* (1854)–Thoreau went to town one day on an errand, and after refusing to pay some back taxes because they supported a war with Mexico, he was arrested and spent a night in jail. Based on this experience he wrote his most-famous essay, "Resistance to Civil Government" (1849), commonly called "Civil Disobedience." This is an ur text setting forth principles of noncompliance to government acts or requirements that a person considers morally wrong, and it includes the famous line: "Under a government which imprisons unjustly, the true place for a just man is also a prison." Thoreau denounced slavery in "Civil Disobedience," in lectures and texts defending the actions of abolitionist John Brown, and essays such as "Slavery in Massachusetts" (1859). A copy of Thoreau's essay on civil disobedience and resistance to governmental injustice was famously sent by Leo Tolstoy to Mohandas Gandhi, on whom its effect was pivotal.

Henry David Thoreau, 1856. Photograph by Benjamin D. Maxham. Daguerreotype, 2 ½ × 1 ⅞ inches (6.3 × 4.7 cm). National Portrait Gallery, Smithsonian Institution, Washington, DC

Resistance to Civil Government (1849), *or Civil Disobedience*

Can there not be a government in which the majorities do not virtually decide right and wrong, but conscience?–in which majorities decide only those questions to which the rule of expediency is applicable? Must the citizen ever for a moment, or in the least degree, resign his conscience to the legislator? Why has every man a conscience then? I think that we should be men first, and subjects afterward. It is not desirable to cultivate a respect for the law, so much as for the right. The only obligation which I have a right to assume is to do at any time what I think right. It is truly enough said that a corporation has no conscience; but a corporation of conscientious men is a corporation *with* a conscience. Law never made men a whit more just; and, by means of their respect for it, even the well-disposed are daily made the agents on injustice. A common and natural result of an undue respect for the law is, that you may see a file of soldiers, colonel, captain, corporal, privates, powder-monkeys, and all, marching in admirable order over hill and dale to the wars, against their wills, ay, against their common sense and consciences, which makes it very steep marching indeed, and produces a palpitation of the heart. They have no doubt that it is a damnable business in which they are concerned; they are all peaceably inclined.

It is not a man's duty, as a matter of course, to devote himself to the eradication of any, even to most enormous wrong; he may still properly have other concerns to engage him; but it is his duty, at least, to wash his hands of it, and, if he gives it no thought longer, not to give it practically his support. If I devote myself to other pursuits and contemplations, I must first see, at least, that I do not pursue them sitting upon another man's shoulders. I must get off him first, that he may pursue his contemplations too.

The authority of government, even such as I am willing to submit to–for I will cheerfully obey those who know and can do better than I, and in many things even those who neither know nor can do so well–is still an impure one: to be strictly just, it must have the sanction and consent of the governed. It can have no pure right over my person and property but what I concede to it. The progress from an absolute to a limited monarchy, from a limited monarchy to a democracy,

is a progress toward a true respect for the individual. Even the Chinese philosopher was wise enough to regard the individual as the basis of the empire. Is a democracy, such as we know it, the last improvement possible in government? Is it not possible to take a step further towards recognizing and organizing the rights of man? There will never be a really free and enlightened State until the State comes to recognize the individual as a higher and independent power, from which all its own power and authority are derived, and treats him accordingly. I please myself with imagining a State at last which can afford to be just to all men, and to treat the individual with respect as a neighbor; which even would not think it inconsistent with its own repose if a few were to live aloof from it, not meddling with it, nor embraced by it, who fulfilled all the duties of neighbors and fellow men.

A State which bore this kind of fruit, and suffered it to drop off as fast as it ripened, would prepare the way for a still more perfect and glorious State, which I have also imagined, but not yet anywhere seen.

Opposite page Sojourner Truth, 1864. Photographer unknown. Albumen carte de visite, 3 ¼ × 2 ¼ inches (8.1 × 5.7 cm). National Portrait Gallery, Smithsonian Institution, Washington, DC

Sojourner Truth

(ca. 1797–1883)

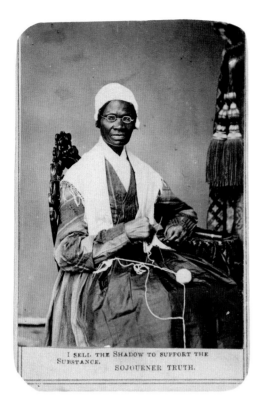

I SELL THE SHADOW TO SUPPORT THE SUBSTANCE.
SOJOURNER TRUTH.

abolitionists and social reformers. Through Garrison's networks Truth began in 1844 to give speeches against slavery. As the anti-slavery movement and women's rights movements were intertwined in that decade (though separating), Truth also became friendly with Lucretia Mott and other early feminists. In 1851 she galvanized the Ohio Women's Rights Convention in Akron and became the stuff of legend, which was largely left in the hands of later writers and fabulists, since despite her unschooled eloquence Truth was illiterate.

Truth made a strong impression on all who heard her, and even Douglass–an advocate for betterment of those freed through education–recognized her ability and "strange compound of wit and wisdom, of wild enthusiasm and flint-like common sense." During the Civil War and after Truth worked tirelessly for the welfare of former slaves, many of them displaced and without prospects, with the National Freedmen's Relief Association and the government's Freedman's Bureau; working in Washington during the war, she briefly met President Lincoln. In the first half of the 1870s Truth advocated settlement in Kansas and traveled to stump for this effort. Black suffrage and woman's suffrage remained causes to which Truth devoted her efforts, all this supported by a network of friends, donations, and sales of small carte-de-visite portraits, most stating "I sell the shadow to support the substance." Even before her death in 1883, Sojourner Truth had become a symbol and began to be invoked, and her well-known face used, in support of the oppressed and numerous causes.

Sojourner Truth, a prominent anti-slavery and women's rights advocate in the mid nineteenth century, was born Isabella, a slave, about 1797 in upstate New York. She became a free woman when slavery was abolished in that state in 1827. Around the same time, she became a Methodist and the next year moved to New York City, where she became active in Perfectionist, or Pentecostal, religious circles; for a time she moved to a rural religious community. Then on June 1, 1843, the day Pentecost was celebrated, Isabella was impelled by the spirit to adopt the name Sojourner Truth, follow a calling as a preacher, and take to the road. She soon landed at the cooperative, utopian Northhampton Association in Massachusetts, where she met William Lloyd Garrison, Frederick Douglass, and other prominent

Frederick Douglass

(ca. 1818–1895)

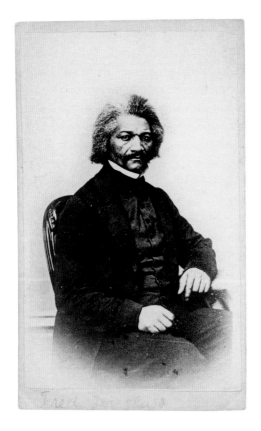

Frederick Douglass was born Frederick Bailey, a slave on Maryland's Eastern Shore, and he grew up to be a persistent, persuasive, and prolific advocate for abolition and a leading spokesperson for freed people before and after the Civil War. He helped change how the country thought about race. While growing up, Frederick learned to read and began plotting his escape; in 1838 he traveled to New York City with false papers and declared himself free, gave himself a new surname from the hero of a book he admired, and settled in Massachusetts. Douglass met the prominent abolitionist William Lloyd Garrison and became a speaker for the Massachusetts Anti-Slavery Society. In 1845 he published the first of three volumes of his autobiography, considered a classic account of a slave's life; while touring Ireland and Britain to avoid possible recapture or return to his now-revealed owner, Douglass met one of the last living abolitionists responsible for the 1807 act that ended the British slave trade, and his freedom was bought by some English supporters. Douglass then settled in Rochester, New York, and began editing an abolitionist newspaper, published under three different names from 1847 to 1863. Douglass was a vocal proponent for education and literacy of freed people, and was an eloquent example of their benefits.

After attending the Seneca Falls Convention in 1848 Douglass also began to promote women's suffrage and linked it to suffrage for African Americans. During the Civil War he helped recruit black soldiers for what he considered a war against slavery and argue for their enfranchisement owing to their service. Entitlement did not come until after the war and the passage of the 13th, 14th, and 15th Amendments to the Constitution, however, and in 1876 in his keynote speech at the Emancipation Memorial dedication, Douglass rued the fact that the nation's leaders had not been sufficiently supportive of the people even as they led the fight against the institution of slavery. In his later years Douglass remained outspoken for his many causes and did become involved in politics.

Frederick Douglass, mid to late 1880s. Photographer unknown.
Albumen carte de visite, 4 × 2 ⅜ inches (10.2 × 6 cm). The Menil Collection, Houston

The End of All Compromises with Slavery–Now and Forever (1854)

Against the indignant voice of the Northern people–against the commonest honesty–against the most solemn warnings from statesmen and patriots–against the most explicit and public pledges of both the great parties–against the declared purpose of Pres't Pierce on assuming the reins of government–against every obligation of honor, and the faith of mankind–against the stern resistance of a brave minority of our representatives–against the plainest dictates of the Christian religion, and the voice of its ministers, the hell-black scheme for extending slavery over Nebraska, where thirty-four years ago it was solemnly protected from slavery forever, has triumphed. The audacious villainy of the slave power, and the contemptible pusillanimity of the North, have begotten this monster, and sent him forth to blast and devour whatsoever remains of liberty, humanity and justice in the land. The North is again whipt–driven to the wall. The brick is knocked down at the end of the row, by which the remainder are laid prostrate. The Republic swings clear from all her ancient moorings, and moves off upon a tempestuous and perilous sea. Woe! woe! woe to slavery! Her mightiest shield is broken. A bolt that bound the North and South together has been surged asunder, and a mighty barricade, which has intervened between the forces of slavery and freedom, has been madly demolished by the slave power itself; and for one, we now say, in the name of God, let the battle come. Is this the language of excitement? It may be; but it is also the language of truth. The man who is unmoved now, misconceives the crisis; or he is intensely selfish, caring nothing about the affairs of his country and kind. Washington, long the abode of political profligacy and corruption, is now the scene of the revelry of triumphant wickedness, laughing to scorn the moral sense of the nation, and grinding the iron heel of bondage into the bleeding heart of living millions. Great God in mercy, overrule this great wrath to thy praise!

But what is to be done? Why, let this be done: let the whole North awake, arise; let the people assemble in every free State of the Union; and let a great party of freedom be organized, on whose broad banner let it be inscribed, All compromises with slavery ended–The abolition of slavery essential to the preservation of liberty. Let the old parties go to destruction, whither they have nearly sunk the nation. Let their names be

blotted out, and their memory rot; and henceforth let there be only a free party, and a slave party. The banner of God and liberty, and the bloody flag of slavery and chains shall then swing out from our respective battlements, and rally under them our respective armies, and let the inquiry go forth now, as of old, Who is on the Lord's side? Let the ministers of religion, all over the country, whose remonstrances have been treated with contempt–whose calling has been despised–whose names have been made a byword–whose rights as citizens have been insolently denied–and whose God has been blasphemed by the plotters of this great wickedness, now buckle on the armor of their master, and heartily strive with their immense power, to arrest the nation in its downward progress, and save it from the deep damnation to which it is sinking.

If ye have whispered truth, whisper no longer,
Speak as the tempest does, sterner and stronger.

The time for action has come. While a grand political party is forming, let companies of emigrants from the free States be collected together– funds provided–and with every solemnity which the name and power of God can inspire. Let them be sent out to possess the goodly land, to which, by a law of Heaven and a law of man, they are justly entitled.

Frederick Douglass' Paper, May 26, 1854

Postcard with portraits of Booker T. Washington, Abraham Lincoln, Fredrick Douglass, and others, n.d. Lithograph on card, 5 ½ × 3 ½ inches (14 × 8.9 cm). The Menil Collection, Houston, Gift of Adelaide de Menil Carpenter

Abraham Lincoln

(1809–1865)

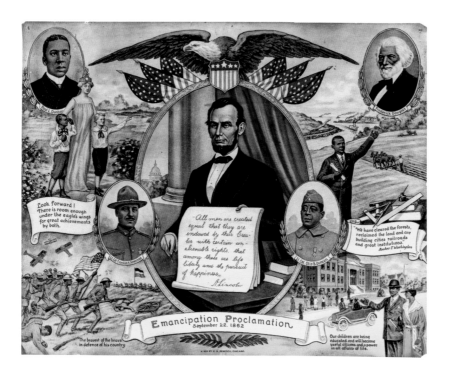

The Emancipation Proclamation
January 1, 1863

By the President of The United States Of America:

A Proclamation....

That on the first day of January, in the year of our Lord one thousand eight hundred and sixty-three, all persons held as slaves within any State or designated part of a State, the people whereof shall then be in rebellion against the United States, shall be then, thenceforward, and forever free; and the Executive Government of the United States, including the military and naval authority thereof, will recognize

Poster celebrating the Emancipation Proclamation, 1919, by E.G. Renesch.
Offset lithograph on paper, 16 ⅛ × 20 inches (40.9 × 50.8 cm).
The Menil Collection, Houston, Gift of Adelaide de Menil Carpenter

and maintain the freedom of such persons, and will do no act or acts to repress such persons, or any of them, in any efforts they may make for their actual freedom.

...

And by virtue of the power, and for the purpose aforesaid, I do order and declare that all persons held as slaves within said designated States, and parts of States, are, and henceforward shall be free; and that the Executive government of the United States, including the military and naval authorities thereof, will recognize and maintain the freedom of said persons.

And I hereby enjoin upon the people so declared to be free to abstain from all violence, unless in necessary self-defence; and I recommend to them that, in all cases when allowed, they labor faithfully for reasonable wages.

And I further declare and make known, that such persons of suitable condition, will be received into the armed service of the United States to garrison forts, positions, stations, and other places, and to man vessels of all sorts in said service.

And upon this act, sincerely believed to be an act of justice, warranted by the Constitution, upon military necessity, I invoke the considerate judgment of mankind, and the gracious favor of Almighty God.

In witness whereof, I have hereunto set my hand and caused the seal of the United States to be affixed.

Done at the City of Washington, this first day of January, in the year of our Lord one thousand eight hundred and sixty three, and of the Independence of the United States of America the eighty-seventh.

By the President: ABRAHAM LINCOLN
WILLIAM H. SEWARD, Secretary of State.

Left Abraham Lincoln, ca. 1860s. Photograph by Matthew Brady.
Albumen carte de visite, 4 × 2 ½ inches (10.2 × 6.4 cm). The Menil Collection, Houston

Above right Abraham Lincoln with Flowers, Butterflies, and Scarabs, 19th century.
United States. Mixed materials on cotton, framed: 27 × 23 inches (68.6 × 58.4 cm).
The Menil Collection, Houston

Below right Head of Abraham Lincoln, 19th or 20th century. Possibly from
the Wax Museum in Kansas City. Wax, hair, glass, and silk, 9 ¾ × 7 ½ × 9 ¼ inches
(24.8 × 19.1 × 23.5 cm). The Menil Collection, Houston

Florence Nightingale

(1820–1910)

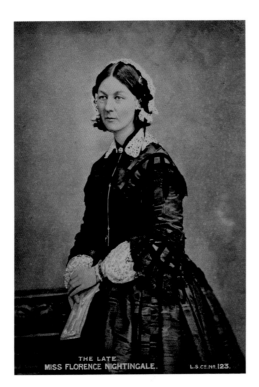

THE LATE
MISS FLORENCE NIGHTINGALE. L.S.C℮.N℮.123.

Florence Nightingale was an Englishwoman who advocated for nursing as an honorable profession and spent her life as a tireless champion of public health and welfare. Born into a wealthy family and educated at home, she was fluent in several modern and classical languages. After a "call to service" at the age of sixteen, Nightingale wanted to become a nurse, but she was held back by her family until about the age of thirty. She then quickly became a respected authority on the training of nurses, helped make it a respectable profession, and in 1854 led the first group of British nurses sent to war, to Crimea. There she found that more soldiers died of infectious diseases than battle wounds, and realized that more than nursing the wounded and sick would be necessary for health. After her return to England in 1856, Nightingale began detailed analytical research on health problems and their solutions, beginning with the army at home and abroad, for which a royal commission was established. Her *Notes on Nursing* published in 1859 helped revolutionize how care was given. That same year, following the Indian Revolt (or First War of Indian Independence), Nightingale headed a royal commission on army conditions in India. She remained an active advocate for public health and improved living conditions in India, first for the colonials and increasingly for the general populace. In her later life, Nightingale's crusading shifted to social issues such as self-governance, and two volumes of her collected works–*Health in India* and *Social Change in India*–cover forty years and are about one thousand pages each.

Florence Nightingale, mid to late 19th century. Photographer unknown. Private collection

Letter to the Lord Mayor of London (1877)

with a check for the Mansion House Relief Fund, published in the *Daily Telegraph* April 19 and the *Times* of London, April 20, 1877

August 17, 1877

My Lord

If English people knew what an Indian famine is—worse than a battlefield, worse than a retreat, and this famine too, is in its second year—there is not an English man, woman or child who would not give of their abundance or out of their economy.

If we do not, we are [those] who put an end to the wounded—and worse than they, for they put an end to the enemy's wounded, but we neglect our own starving subjects. And there is not a more industrious being on the face of the earth than the Indian ryot. He deserves all we can do.

Having seen your advertisement this morning only, and thanking God you have initiated this relief, I hasten to enclose what I can £25—hoping I may be allowed to repeat the mite again, for all will be wanted. Between this and January our fellow creatures in India will need everybody's mite—given now at once, then repeated again and again. And may God bless the fund!

Pray believe in me, my Lord
ever your faithful servant
Florence Nightingale

From *Florence Nightingale on Health in India,* ed. Gérard Vallée, *Collected Works of Florence Nightingale* vol. 9 (Waterloo, Ontario: Wilfrid Laurier University Press, 2006), 769

Henry Dunant

(1828–1910)

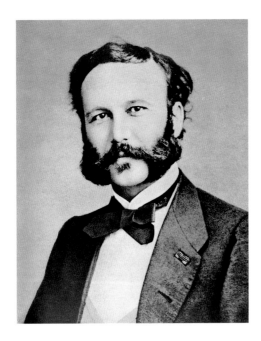

Henry Dunant, born Jean Henri Dunant, was a Swiss businessman who, horrified the suffering of war, founded the International Red Cross. He also promoted international humanitarian cooperation that resulted in the first Geneva Convention, so called. Born into a civic-minded family in Geneva, Dunant took an active part in religious activities, leading him to found the World Alliance of Young Men's Christian Associations in 1855. At that time, he was doing business in North Africa. Seeking water rights he needed to make the business profitable, Dunant decided to make his case in person to Emperor Napoleon III, which in 1859 took him to northern Italian town of Solférino during an independence struggle. Arriving during a battle, Dunant was shocked by the brutally wounded filling the streets and their lack of adequate care or resources. He reflected on their needs and three years later published a cri de coeur titled *A Memory of Solférino (Un souvenir de Solférino)*. Following graphic depictions of carnage and suffering, Dunant proposes that nations form relief organizations of volunteers, train them, and grant them neutrality during combat so that they could minister to the wounded and the dying. A welfare society in Geneva appointed Dunant to a committee to take such action, in essence forming the Red Cross, and he devoted his effort to the cause. A treaty proposal was also written, and after a conference of sixteen nations in October 1863 approved resolutions to create what became the Red Cross, twelve nations signed the international treaty now called the first Geneva Convention. It guaranteed neutrality and access to battlefields for personnel identified by a red cross on a white ground. During a later conflict in the Ottoman Empire, the sign of a red crescent on a white ground as adopted to signify the same thing.

Soon after the success of the Geneva Convention, Dunant went bankrupt, was reduced to penury, and turned from a successful public figure into a solitary. He worked hard to create a universal library and realize other international or universal ventures, but from the mid 1870s he dropped completely from sight for many years. In 1895 was discovered living in a hospice in the village of Heiden, and honors and visitors came his way. In 1901, Dunant was the corecipient with Frédéric Passy–then considered the dean of the international peace movement–of the very first Nobel Peace Prize.

Henry Dunant, 1863. Photograph by Frédéric Boissonnas.
International Red Cross Photo Library

Henry Dunant, Chronological Symbolic Diagram of Several Prophesies from the Holy Scriptures (Diagramme symbolique chronologique de quelques Prophéties de Saintes-Ecritures), ca. 1890. Ink, colored pencil, and watercolor on paper, 43 ¼ × 31 ½ inches (110 × 80.5 cm). International Red Cross and Red Crescent Museum, Geneva

Henry Dunant, Chronological Symbolic Diagram of Several Prophesies from
the Holy Scriptures (Noah) (Diagramme symbolique chronologique de quelques
Prophéties de Saintes-Ecritures [Noé]), ca. 1890. Ink, colored pencil, and
watercolor on paper, 43 ¼ × 31 ¼ inches (110 × 77 cm). International Red Cross
and Red Crescent Museum, Geneva

The Blood-Drenched Future (ca. 1880s)

If the start of the century was a time of troubles and great wars, it is woeful to consider that the end of this century appears even more troubled. It seems destined to become prey to a bloody delirium, for it is a time of great upheaval in the minds of men and this decrepit world no longer has confidence in itself amidst the confusion that has taken hold of a portion of humanity.

We have spoken so often of glory that now we speak of it less; and yet we prepare for it more than before, hoping to take advantage of the coolly, scientifically-prepared slaughters of the future. An atmosphere of distrust or hatred spreads across a Christian world that has little in common with the spirit of Christ. At present, from the Pyrenees to the Urals, the European continent shimmers with the gleam of the bayonets of over 22 million soldiers. When the call to arms rings out, when the hour of these supposedly gentlemanly rivalries is at hand, and, like animals blinded by rage, seized by madness, men rise up against each other, what tragic spectacles will reward us? The most powerful beasts will take the lead; the small game will suffer. Men will destroy in order to keep from being destroyed; once the beasts have been released, there will be no turning back. In this duel that has returned time and again over the centuries, the combatants are ready for new battles, for a never-ending struggle into which they are determined to drag all of Europe– perhaps the whole world. This, at a time when monarchy, churches, and the honored institutions of the past are on the verge of ruin, behind which many glimpse, a dark abyss. Willing or unwilling, most of the world's civilized peoples will be pulled into the conflict, and, forgetting their shining but deceptive civilization, will return to a barbaric state– scientific barbarism! And in this great battle between the races all will experience, to varying degrees, the horrifying consequences.

In addition, this moral crisis of our times–more pronounced among the Latin races where it has taken on an alarming aspect–becomes more acute with each passing year and seems to threaten society with a veritable cataclysm. The tide rises slowly; it will surely engulf the barriers we build against it. It will submerge, and perhaps sweep away, all that has until now been considered permanent and impregnable to its waters.

As if to hasten this final crisis, intensify anarchic thought, and push the world toward social dissolution, we see the most powerful forces of nature converted into instruments of destruction. We see the most intelligent nations–fearful of a general conflagration–avidly seeking to become the greatest and most powerful through brute force, by steel and by fire. Civilized nations are armed to the teeth; they consider neither halting nor even slowing this expansion.

Of all man's inventions, there is none that he has perfected with the diligence he has applied to those whose sole purpose is murdering his fellow man. What high-minded deliberations we have used to justify this this as a "law of human nature"! Habit, tradition, and need have consecrated war; we envelop it in admiration and praise, and we have reached the extreme of glorifying, as inviolable, wars of expansion, wars of conquest, and even war for the sake of war!

We will witness, in no particular order: revolutions and anarchy, followed by new tyrannies that will in turn be driven out like the ones that came before; retaliations, with unknown outcome, in the conflict between the Germanic and Latin peoples, an epic combat that will return again and again, to everyone's detriment; Europe dragged into an all-out war, with unknown outcome, leading surely to the redrawing of its borders; the ambitions of the Caesars of the North, the Cossack invasion, and in the Orient, the complications that surely follow; the great question of the Orient, with all its by-products and problems, which will intensify and for which a resolution seems ever more out of reach; the dissolution of the Ottoman Empire, opening the door to many unforeseen events; the possible formation of a Slavic confederation and the likely creation of a Latin confederation, which would revive the hatred between races and bring with it the persecution of tyrannies and their overthrow, opening the way to universal social revolution in a semi-depopulated world.

In one word: blood, blood, and more blood! Blood everywhere!

Translation by Marina Harss

Robert Gober (United States, b. 1954), Untitled, 2007–8. Wood, pewter,
cast gypsum polymer, beeswax, paint, and pigment, 31 ¾ × 16 ½ × 18 inches
(80.6 × 41.9 × 45.7 cm). Kravis Collection

Clara Barton

(1821–1912)

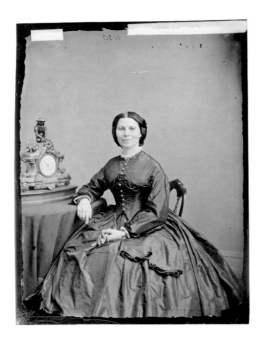

Clara Barton, born Clarissa Howe Barton, founded the American Red Cross. A native of Massachusetts, Barton began working as a school teacher, and after about a decade moved to Washington, DC, to become a patent clerk, one of the first women to be employed by the United States Government and on a par with men. In the early days of the Civil War, when large numbers of troops were coming through the city and fighting raged in the area, Barton became active in assembling supplies for regiments at nearby battlefields; she was soon was involved in caring for soldiers in need. Barton lobbied to be able to deliver bandages, food, and clothing to the front, and after receiving permission started to help care for soldiers in field hospitals. With her talent for effective organization, she was able to greatly contribute to relief efforts.

Devoted to volunteer service, after the war Barton ran an office for missing soldiers and traveled the country lecturing about her experiences. She met Susan B. Anthony and Frederick Douglass and become a proponent of women's suffrage and civil rights. On a trip to Switzerland in 1869, Barton discovered in Geneva the recently founded Red Cross and read *A Memory of Solférino* by its founder, Henry Dunant, who called for international treaties and organizations for aid in wartime. Upon her return to the US, Barton advocated ratification of the Dunant-inspired Geneva Treaty, or Convention, of 1864, which eventually took place in 1882. Barton herself, at the age of sixty, founded the American Red Cross in 1881, and would go on to lead it for more than two decades. One of her most important contributions was extending aid not just in war but for natural disasters. The American Red Cross undertook such efforts, and in 1884 Barton was able to have an amendment to the Geneva Convention endorsing the practice passed at the Third International Red Cross Conference.

The Congressional Charter of the American Red Cross states as its purpose: "To continue and carry on a system of national and international relief in time of peace and apply the same in mitigating the sufferings caused by pestilence, famine, fire, floods, and other great national calamities, and to devise and carry on measures for preventing the same."

Clara Barton, ca. 1860s. Photograph by Matthew Brady

Te Whiti

(1832?–1907)

Te Whiti-o-Rongomai III was a spiritual and temporal leader in New Zealand who led nonviolent resistance to the expropriation of native land by the colonizing British. A descendant of community leaders, Te Whiti was given much traditional knowledge, which he combined with the Christian teachings he learned from missionaries to give him authority and garner respect. After some hostilities over land in 1864, Te Whiti abjured violence and thereafter only used peaceful means when negotiating with the government. Combining Maori rhetoric and Christian teachings, he was quite forceful in negotiations and actions, especially when land long disused by settlers was not allowed to revert to communal ownership or new expropriations did not set aside reserves for the original inhabitants. Protestors and the dispossessed began to gather around Te Whiti, and in 1879 when the government tried to confiscate 16,000 acres with no accommodations for the Maori people, Te Whiti led actions to disrupt surveying and settlement. A key tactic was the plowing of land claimed by settlers. When the resistance did not die down as expected but lasted into 1881, more than 1,500 armed constables were sent in: they were met by about 2,000 seated Maori, but no fighting took place. The protestors were dispersed or arrested, as were Te Whiti and the other paramount leader of the action. After almost two years imprisonment without a trial, Te Whiti was finally released. Protests continued but did not stem the tide.

In 1886 Te Whiti again urged protest plowing, and this time was tried and sent to jail for six months. Even in 1897 nearly a hundred Maori were arrested for plowing in protest over the lack of resolution over native lands and trusteeship.

Te Whiti-o-Rongomai during a *hui* at Parikhaka, New Zealand, 1880, sketch by William Francis Robert Gordon. Alexander Turnbull Library, Wellington, New Zealand

Doukhobors

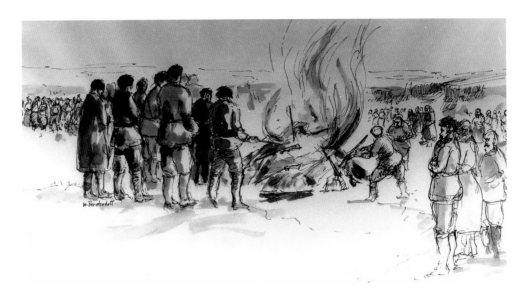

The Russian Christian anarchist group called the Doukhobors (Spirit Wrestlers, or Spirit Warriors of Christ) base their beliefs on love, the teachings of Jesus, and the individual's inner voice–they roundly rejected the Orthodox Church and the tsarist government of their native land. During the nineteenth century their heterodox beliefs and resistance to military conscription resulted in internal exile to the Transcaucasus. In the 1880s there were about 20,000 pacifists in the Doukhobor communities; they saw similarities between their philosophy and that of Leo Tolstoy, who recognized them as kindred spirits. In 1895, in the face of a renewed attempt by Tsar Nicholas II to make them swear allegiance to the government and be assimilated into the military, several communities began to make overt protests. Demonstrations began on Easter Sunday when a Doukhobor soldier in what is now Azerbaijan turned in his gun and said he served Christ not the military; a number of others followed his lead and all were punished. Protests spread through the region among a dissident faction, and on the night of June 28/29 (Gregorian July 10/11), three communities in what is now Georgia, Armenia, and Turkey held bonfires of weapons. Thousands of believers were driven from their homes, and a mass migration began. Helped by Tolstoy, Pyotr Kropotkin, and other sympathizers–and largely funded by Tolstoy and the Society of Friends– Doukhobor communities began to emigrate. Around 8,000 persons settled on the prairies of Canada; although there were protests against what they felt was government interference there as well, a number of communities now thrive in Saskatchewan and British Columbia. Pacificism is still a hallmark, and there have been memorial gun burnings as an expression of belief.

See Koozma J. Tarasoff, Historic 1895 Burning of Guns, http://goo.gl/JwimTW.

The Doukhobors' 1895 burning of arms, sketch by William Perehudoff, 1969. Courtesy of Koozma J. Tarasoff

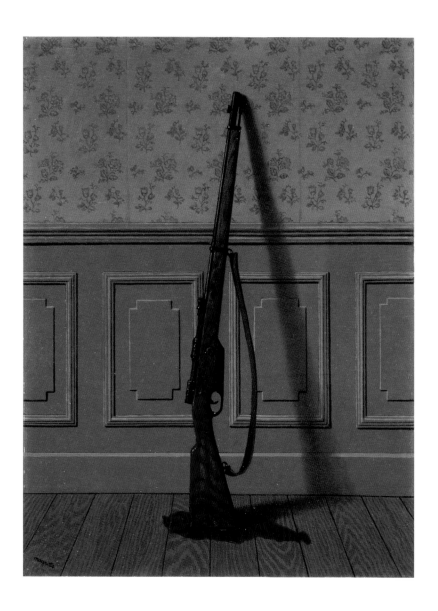

René Magritte (Belgium, 1898–1967), The Survivor (Le survivant), 1950.
Oil on canvas, 31 ½ × 23 ¾ inches (80 × 60.3 cm). The Menil Collection, Houston

"HOMEySEW 9"

*Strapped with my Glock on your block and ready to let loose on
the first imitator that I spot*
 –Calvin C. Broadus Jr., Andre Young, "Pump Pump," *Doggystyle*, 1993

*First, genuine aura appears in all things, not just in certain kinds
of things, as people imagine.*
 –Walter Benjamin, "Protocols of Drug Experiments,"
 On Hashish, 1930

HOMEySEW 9 is a self-contained, action-activated, fully functional,
self-medicating emergency gunshot trauma treatment kit. It disarms
the aura of "gun" through a covert, surgical implantation of life-saving
potential.

The Glock 17 was developed as a sidearm for the Austrian military and
police forces. International marketing and promotion plus populariza-
tion through the film, music, and video-gaming industries led to its
adoption by almost every law enforcement department in the world.
The Glock's deadly capacity has been proved in many killings, such as
the mass shooting at Luby's Cafeteria in Kileen, Texas, in 1991 and the
1999 shooting of Amadou Diallo, who was torn apart by 46 semiauto-
matic rounds, fired by NYPD.

The artist decided that an artistic alteration of the firearm's external
physical form would have little effect in undermining the aura
of the gun in this age of increased mechanical reproduction. A covert
transformation was effected by gutting the internal mechanics for an
alternative life-saving use. The selection of components in this working
model is based on sound emergency procedure for gunshot wounds.

In a societal sense, the adoption of specific accessories, from clothing
to concealed weapons, speaks to the power of enhanced marketing
in targeting the consumption of branded products. In any group, peer
pressure can drive the impulse to transform oneself, or to apply critical
self-evaluation to a life. *HOMEySEW 9* recognizes the nature of aura
and its use in social survival while simultaneously offering a concep-
tual concealed space to nurture another agenda.

Mel Chin (United States, b. 1951), "HOMEySEW 9," 1994. Glock 9mm handgun
and emergency trauma treatment kit with: 2 in. elastic bandage, micro electronic
locator, normal saline with IV needle and polyethylene tubing, narcotic analgesic
(5 mg oxycodone hydrochloride, 500 mg acetaminophen), intramuscular epinephrine
(0.3mg), and angiocatheter (14 gauge), 5 ½ × 7 ⅜ × 1 ¼ inches (13.8 × 18.6 × 3 cm).
Whitney Museum of American Art, New York, Purchase, with funds from the
Contemporary Painting and Sculpture Committee

Albert Schweitzer

(1875–1965)

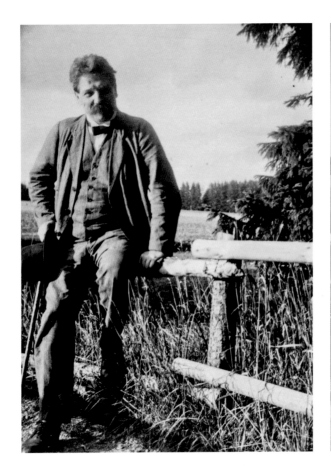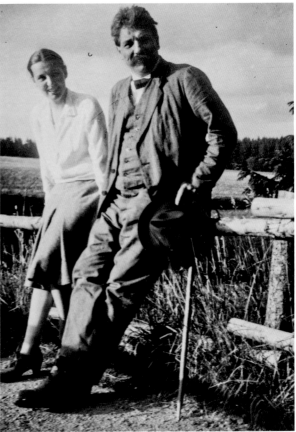

Left Albert Schweitzer

Right Albert Schweitzer and Anne Bargeton

Opposite page Albert Schweitzer and Helene Schweitzer
All photographs by Dominique de Menil, August 1928. The Menil Collection, Houston

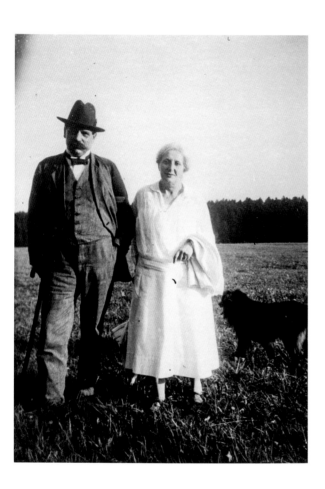

*The struggle for human rights must be at the forefront
of all that we do.*
 –Dominique de Menil

Abdul Ghaffar Khan

(1890–1988)

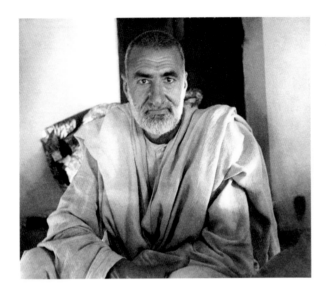

Abdul Ghaffar Khan was born in the Swat Valley, a son of the Pakhtun (Pashtun) village chief of Utmanzai in the North-West Frontier Province (NWFP) of colonial India. Ghaffar Khan was schooled in a madrasa, at the province's single municipal school, and with English missionaries, but unlike his brother Dr. Khan Sahib (Abdul Jabbar Khan) he was not permitted by his mother to go to England to further his education. In 1919 he organized local protests against the Raj's Rowlatt Act allowing imprisonment of up to two years without a trial, and spent three months in British jails. Active in trans-colonial/national Pakhtun solidarity efforts and the Muslim Khalifat movement, which recommended noncooperation, Ghaffar Khan was suspected of "sedition." Realizing that education was key to freedom and responsibility for the Pakhtun people in the NWFP and Frontier Tribal Areas–created by

the British as a buffer zone on the Indian border, and where power-sharing reforms with the locals in India were not enacted–in 1921 Ghaffar Khan helped start a school in Utmanzai and an organization running a network of schools that combined religious, vocational, and educational instruction. After defiance of the colonial government's request to close them, he was given three years rigorous imprisonment (1921–24).

In the 1920s Ghaffar Khan became committed to nonviolence, much to the disbelief of those knowing the Pakhtuns for feuds and revenge. In 1928 he went to Calcutta where both Khalifat and All India Congress meetings were being held and observed their differences. Largely to fill a void of social services, in fall 1929 Ghaffar Khan founded the Servants of God, or Khudai Khidmatgar, a Pakhtun organization pledged explicitly to nonviolence and to providing much that the government did not. The Servants of God spread rapidly and became popular among the people. This threatened the British, who feared it would become a political organization. Despite sometimes brutal suppression by the British or at the hands of their ally the Muslim League, the Khudai Khidmatgar provided social services throughout rural areas, and when the League would not aid or ally with them, they and Ghaffar Khan joined forces with the Congress to work on empowerment and freedom, as well as independence for a unified India, up to Partition (1947).

Abdul Ghaffar Khan, 1946. Photographer unknown. akg-images/Archiv Peter Rühe

In December 1931, after the widespread actions sparked by the Salt March, Ghaffar Khan, along with his brother, was thrown in prison for three more years, much of which he spent in solitary confinement. Shuttled among prisons, he learned from fellow inmates about their religions and organized interfaith cooperation. The Khan brothers were finally released in August 1934, but Ghaffar Khan was forbidden to go to his home province; he traveled across north India speaking truth to power and soon was convicted of sedition and sentenced to two more years rigorous imprisonment. Ghaffar Khan was a close associate of Gandhi, went to many Congress meetings (sometimes with Khudai Kidmatgars), and brought both Gandhi and Jawaharlal Nehru to the NWFP to witness conditions there firsthand.

Provincial elections in 1937 produced a Khudai Khidmatgar victory in the NFWP despite Ghaffar Khan's banning, and Dr. Khan Sahib became chief minister for two years. Back in the province during the Quit India resistance of 1940–42, Ghaffar Khan was again arrested and sent to prison. Joining in a fast for a week in solidarity with the imprisoned Mahatma, Ghaffar Khan acquired the appellation "the Frontier Gandhi." While he was in jail until 1945, the split between Muslim and Hindu political factions widened, but rather than join fellow Muslims in the ascendant League, whom experience told him not to trust, Ghaffar Khan remained allied with the Congress–much to his disappointment when they "deserted" the Pakhtuns at Partition. Ever hopeful for Muslim-Hindu amity, after murderous communal violence Ghaffar Khan based himself in Bihar in January 1947 and traveled there and with Gandhi in East Bengal. After Pakistan was founded, its new rulers kept Ghaffar Khan in jail for fifteen of the last eighteen years of his life, saying that his campaign for an autonomous region for Pakhtuns was separatist. Partly to escape further incarceration and partly to live in what he hoped would someday become Pakhtunistan, even when he traveled to major cities for health care near the end of his ninety-eight-year life, Ghaffar Khan returned to a home in Jalalabad, Afghanistan, where he was buried.

Despite his long years in prison, and losing most of his teeth during an early stint when he was malnourished, Ghaffar Khan was gentle, and he was regal and humble at the same time. Even in his eighties he insisted on carrying his own luggage, and one touching story tells how he insisted the man who just cut his hair be served the first cup of tea. Dedicated to raising the station of his Pakhtun sisters and brothers, Badshah Abdul Ghaffar Khan more than embodied the oath of the Servants of God:

I am a Khudai Khidmatgar, and as God needs no service I shall serve Him by serving his creatures selfishly.

I promise not to use violence and to refrain from retaliation or taking revenge, and I shall forgive anyone who indulges in oppression and excesses against me.

I promise to live a simple life, to practice virtue, and refrain from evil.

I promise to practice good manners and good behavior, and not to lead a life of idleness.

I shall expect no reward for my services. I shall be fearless and be prepared for any sacrifice.

On Non-Violence (1969)

When I was released from prison in 1945 I was seriously ill. I always get ill when I am in prison. Gandhiji was in Bombay at that time and he wrote and asked me to go to Bombay too. Whenever I went to Bombay, or to Sevagram, I used to spend at least one night in Delhi with Devadas Gandhi. Devadas' wife was always very hospitable and kind, and I felt completely at home with them. I never had the feeling I was a visitor or a guest. Well, I went to Bombay. Gandhiji was staying with the Birlas and they invited me too. When we were chatting one day, the subject of non-violence came up, and I said to Gandhiji:

"Gandhiji, you have been preaching non-violence in India for a long time now, but I started teaching the Pathans non-violence only a short time ago. Yet, in comparison, the Pathans seem to have learned this lesson and grasped the idea of non-violence much quicker and much better than the Indians. Just think how much violence there was in India during the war, in 1942. Yet in the North West Frontier Province, in spite of all the cruelty and the oppression the British inflicted upon them, not one Pathan resorted to violence, though they, too, possess the instruments of violence. How do you explain that?"

Gandhiji replied: "Non-violence is not for cowards. It is for the brave, courageous. And the Pathans are more brave and courageous than the Hindus. That is the reason why the Pathans were able to remain non-violent."

Whenever I am at a prayer meeting in Harijan Colony, or at Sevagram, or anywhere else, I always read first from the Holy Koran. At Sevagram, a Japanese Buddhist used to chant from his holy scriptures. Then the Hindu prayers would begin. Gandhiji had the same respect for all religions, and believed that they were all based on the same Truth. As that has always been my firm belief, too, I have studied both the Holy Koran and the Bhagavat Gita profoundly and reverently.

When I was in Dera Ghazi Khan prison my Sikh fellow prisoners often read out to me from the Guru Granth Saheb. I was also very interested in studying Buddhism because our people were Buddhists before they embraced Islam. But, alas, I have never come across any book on Buddhism that I could have studied. I became acquainted with the

New Testament when I was at the Mission High School, and in prison I often used to read the Old Testament. I was also very interested in the Parsee religion, the teachings of Zoroaster, because he was our messenger, he was born in Balkh in Afghanistan. But, again alas! Until now I have not been able to find any literature about him. I have asked Khursheedbehn and some Parsee friends, but nobody has yet sent me any book on Zoroaster and his teaching.

My religion is truth, love, and service to God and humanity.

Every religion that has come into the world has brought the message of love and brotherhood. And those who are indifferent to the welfare of their fellow men, those whose hearts are empty of love, those who do not know the meaning of brotherhood, those who harbor hatred and resentment in their hearts, they do not know the meaning of Religion.

Abdul Ghaffar Khan, *My Life and Struggle: Autobiography of Badshah Khan, as Narrated to K.B. Narag* [trans. Helen H. Bouman] (Delhi: Hind Pocket Books, [1969]), 193–94.

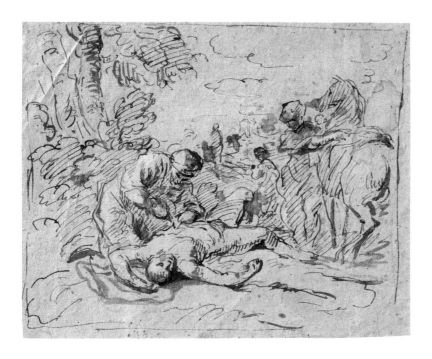

Attributed to Bernardo Cavallino (Italy, 1616 or 1622–1654 or 1656),
The Good Samaritan (Il buon Samaritano), 17th century. Ink and wash on paper,
8 ⅛ × 10 ¼ inches (20.6 × 25.9 cm). The Menil Collection, Houston

Gandhi's Early Advocates in America

As word and images of M. K. Gandhi's actions, writings, and leadership of a vast nonviolent movement were spread in a world increasingly tied together by modern communications, followers and those he inspired proliferated in many places. A number of Quakers and spiritual seekers from England and Europe visited India, most to return home or travel on, and many wrote about their experiences. Horace Alexander (1889–1989) and C. F. Andrews (1871–1940) are among the most prominent in the literature in English, but they and figures like Lanza del Vasto (1901–1981), who founded the Gandhian Community of the Ark now in France, represent just a few of the histories and biographies worth exploring.

In the United States, certain names come up again and again in the Gandhian record. The Fellowship of Reconciliation (FOR) grew out of a European ecumenical effort to forestall World War I, and in 1915 the English Quaker who founded the British organization helped start a branch in New York City with John Haynes Holmes and others. A number of its leaders were jailed or mistreated as conscientious objectors, and the FOR was instrumental in helping to create alternative forms of service in World War II. The Fellowship was led from 1940 to 1953 by the noted émigré pacifist preacher and labor activist A. J. Muste (1885–1967), a galvanizing speaker who sewed the seeds of antiwar sentiment and nonviolent resistance among college students such as the young Martin Luther King Jr. In the forties Muste helped his field secretary Bayard Rustin work first with conscientious objectors and then devote his time to organizing against discrimination as the director of the FOR's civil rights department and its committee on racial equality.

In addition to peace activists, among the earliest to take an interest in or to visit Gandhi were African Americans, who were well aware of similarities between his struggle against colonialism and theirs against segregation. W. E. B. Du Bois (1868–1963) took a global view of the conflict, and in addition to writing about Gandhi, asked him in 1929 to contribute a statement to the NAACP's magazine *The Crisis*, which Du Bois edited. Howard Thurman (1899–1981) led a pilgrimage of friendship to India and visited Gandhi in 1935; Thurman said Gandhi challenged him to find in his Christian faith a source like the Mahatma's Hindu basis for nonviolent principles,

which not only Thurman but many Christian Gandhians did. Thurman had become deeply engaged with the relation of inner work to outer action when he spent a term studying with the Quaker philosopher Rufus M. Jones (1863–1948) at Haverford College, a Quaker-founded school outside Philadelphia. A respected scholar and practitioner of mysticism, Jones contributed a foreword to the first edition of the book *The Philosophy of Non-Violence* by the social thinker Richard B. Gregg (1885–1974). A Harvard-trained lawyer who worked in labor law for a number of years but became disaffected with the adversarial legal system, Gregg had encountered Gandhi's work in the early 1920s, and in 1925 he went to India for several years, visited Gandhi's Sabarmati Ashram, and witnessed the Salt March of 1930. When published in 1934, *The Philosophy of Non-Violence* was the first book to set forth analytically various practical methods based on Gandhi's nonviolent resistance; Gregg's concept of "moral jiu-jitsu" has been singled out as an important contribution. In 1960 Gregg produced a second revised edition, including cases of nonviolent successes during World War II, and this edition came with a new foreword by Martin Luther King Jr. The book was included by King in a list of works most important to him during the early days of the fight for desegregation. *The Philosophy of Non-Violence* had been given to King in 1956 by Glenn Smiley, the national field secretary for the Fellowship of Reconciliation. The next decade and a half would see the continued convergence of Gandhian nonviolent conflict and protest methods with the Civil Rights Movement and then the anti–Viet Nam War movement.

John Haynes Holmes

(1879–1964)

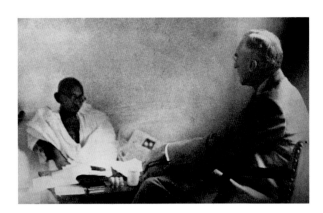

John Haynes Holmes was a minister and activist in New York City whose 1921 sermon on Gandhi, "Who Is the Greatest Man in the World Today?" published soon after, was a pivotal introduction of Gandhian thought into American peace and justice circles. After graduating from Harvard, in 1902 Holmes went to New York to become pastor of a Unitarian congregation. His vocal opposition to the First World War did not sit well with the country or the Protestant mainstream, so Holmes left the Unitarians and the congregation became the independent Community Church of New York, where he remained as head pastor until 1949. One of the founders of the National Association for the Advancement of Colored People (NAACP), Holmes first served as its vice president in 1909; from 1917 to 1964 he was a director of the National Civil Liberties Union/ACLU, and was chair of its board for ten years. In 1915 he helped found of the American branch of the Fellowship of Reconciliation; Holmes was president of the War Resisters League in the 1930s. The Community Church became a hub for activists, and in 1953 was the site of the founding, and then housed the offices, of the American Committee on Africa, an important conduit for information about colonial liberation on the continent and apartheid in South Africa.

Holmes was in Europe when Gandhi traveled to London for the Round Table Conference on a constitution for India in the fall of 1931, and he went to England to meet the Mahatma. The next year Holmes awarded him the first Community Church Medal for Distinguished Religious Service for, he said, the discipline of Gandhi's inner life, his rule of brotherhood, and his mastery of love and its manifestation as *satyagraha*, soul or truth force. In 1947–48 a lectureship took Holmes to India, where he met with Gandhi not long before his assassination. In 1953 Holmes published *My Gandhi*, with this photograph of the two men taken by his son as the frontispiece.

Gandhi and John Haynes Holmes, New Delhi, October 12, 1947. Photograph by Roger Holmes

Who Is the Greatest Man in the World Today? (1921)

THE COMMUNITY PULPIT, APRIL 10, 1921

I am going to speak to you this morning upon what I hope will be the interesting question as to who is the greatest man in the world today... I turn away from the storm of the Great War, and from the men who rode that storm to power and place; and I look elsewhere for that man who impresses me as the greatest man who is living in the world today.

What we need is a universal man – a man who combines in perfect balance the supreme qualities of an idealist and a realist, a dreamer and a doer, a prophet who sees "the heavenly vision" and, "not unfaithful to (that) vision" makes it come true. Is there any such person living in the world?...

I believe that there is–unquestionably the greatest man living in the world today, and one of the greatest men who has ever lived....The man whom I have in mind is Mohandas Karamchand Gandhi, the Indian leader of the present great revolutionary movement against British rule in India, known and reverenced by his countrymen as Mahatma, "the Saint." I wonder how many of you have ever heard of him, or know the story of his life. Listen while I tell this story, and see if I am not right in calling its hero the greatest man in the world today!...

What we have, under Gandhi's leadership, is a revolution – but a revolution different from any other of which history has knowledge. It is characterized by four distinctive features.

In the first place, it is a movement directed straight and hard against English rule in India. There is no concealment of Gandhi's determination to free his people from the injustice and cruelty implicit in alien domination....With all this unbending opposition to English rule, however, there is mingled no hatred against the English people. Gandhi has never at any time been guilty of the sin to which most of us were tempted during the war with Germany, of confusing a government with its people. "I tell the British people," says Gandhi, "that I love them, and that I want their association"; but this must be on conditions not inconsistent with "self-respect and...absolute equality."

Secondly, Gandhi's movement is a revolution which has no place for force or violence of any kind. "Non-violence" is its most conspicuous motto and slogan. For Gandhi, as we have seen, is a non-resistant; and in India as in South Africa, will win his victory by peaceful means, or not at all!…In advocating thus the policy of non-violence, Gandhi takes pains to emphasize that he is not doing this because the Indians are weak. On the contrary, he commends non-violence just because India is so strong and thus so well able to meet the hazards involved….At bottom, of course, Gandhi advocates and practices non-resistance because he thinks it right.

Non-violence, however, is not enough. Non-resistance means something more than mere acquiescence in suffering. It must have a positive or aggressive policy–and it is this which Gandhi provides in what he calls "non-co-operation." To all his followers, Gandhi recommends refusal to co-operate in any of the political or social functions which are essential to the continuance of British rule in India. He urges that the Indians boycott everything English, and thus paralyze the whole English system of control.

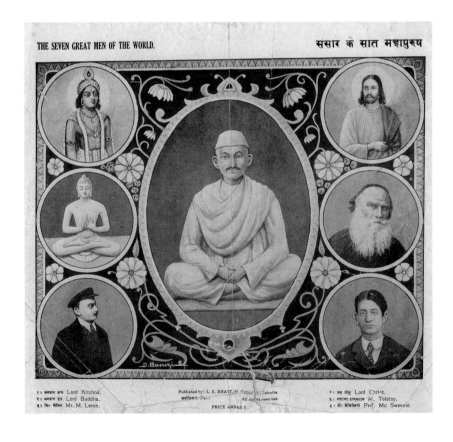

Seven Great Men of the World, 20th century. Chromolithograph on paper, $11 \times 12\frac{5}{8}$ inches (28×32 cm). Collection of Kenneth and Joyce Robbins

Lastly, as the crown of his great movement, Gandhi seeks the moral and spiritual regeneration of India on the lines of Indian thought, Indian custom, and Indian idealism. This means the exclusion, so far as possible, of the influence of the west, with its industry, trial slavery, its materialism, its money-worship and its wars....He seeks the obliteration of caste distinction and religious differences; Mohammedan must live peaceably with Hindu, and Hindu with Mohammedan. Then must come a leadership of mankind in ways of peace and amity. "I believe absolutely," says Gandhi, "that India has a mission for the world." His idealism, therefore, transcends the boundaries of race and country, and seeks to make itself one with the highest hopes of humanity. "My religion" he cries, "has no geographical limits. If I have a living faith in it, it will transcend my love for India herself."

Such is Mahatma Gandhi!

GANDHI'S PLACE IN HISTORY
"Mahatma Gandhi: A Memorial Service," February 1, 1948

Gandhi's program of non-violent resistance is unprecedented in the history of mankind. The principle itself, resist not evil and love your enemies, is nothing new. It is at least as ancient as the teachings of Jesus of Nazareth in the Sermon on the Mount. But Gandhi did what had never been done before. Up to his time the practice of these non-resistant principles had been limited to single individuals, or to little groups of individuals. Gandhi worked out the discipline and the program for the practicing of this particular kind of principle by unnumbered masses of human beings. He worked out a program, in other words, not merely for an individual, or a small group of individuals, but for a whole nation, and that, I say to you, is something new in the experience of man.

From John Haynes Holmes and Bruce A Southworth, *Mahatma Gandhi: An American Portrait* (Cambridge, MA: Harvard Square Library, 2010); online at http://www.harvardsquarelibrary.org/collection /gandhi-american-portrait/ (accessed June 21, 2011).

Martin Luther King Jr.

(1928–1968)

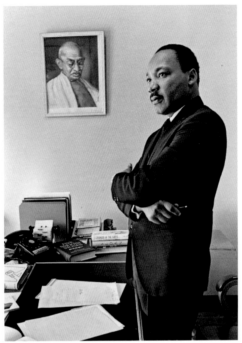

year, in December 1955, Rosa Parks refused to give in to the customary segregation of the Montgomery public buses, and while the NAACP litigated, King led the African American community's more-than-year-long bus boycott. Its success ignited a broader movement for civil rights across the South and the country, and propelled King to its forefront. An eloquent speaker and writer, King's own words reprinted following this short biographical note best chronicle the effect Gandhi had on King and his strategic thinking about nonviolence. He made a pilgrimage to India in 1959, about which he published an article in the popular magazine *Ebony*, familiarizing even more African Americans with Gandhi and his legacy.

Martin Luther King Jr. is, after Gandhi, the most famous and respected leader of a successful movement for justice and liberation through nonviolent action in the twentieth century. The son of a Baptist preacher in Atlanta, Georgia, King first heard of Gandhi in 1948 while a seminary student, in a sermon given in Philadelphia by Mordecai Johnson, the president of Howard University. King then began to study in earnest Gandhi's ideas and application of nonviolent resistance. After receiving his doctorate at Boston University–where the chaplain was Howard Thurman, an important ecumenical leader who was a friend of Martin Luther King Sr. and in 1935 led a delegation of African Americans to meet Gandhi in India–King became pastor at a church in Montgomery, Alabama. The next

When in 1964 he was given the Nobel Peace Prize at the age of thirty-five, Martin Luther King Jr. was its youngest laureate. A masterly leader who labored long and hard to build a coalition of conscience for social justice, equality, and freedom at home, King joined with another preacher-activist, Albert Mvumbi Luthuli, to cosponsor a worldwide effort to put pressure on South Africa's apartheid regime. In the late sixties King spoke vigorously against war, appearing with the Vietnamese peace advocate Thich Nhat Hanh, whom King nominated for the 1967 Nobel Peace Prize. King was assassinated on April 4, 1968, the day after addressing striking sanitation workers in Memphis, Tennessee, and giving his famous "I've Been to the Mountaintop" speech.

Bob Fitch (United States, b. 1939), Martin Luther King Jr. in the Southern Christian Leadership Conference Office, Atlanta, 1966. Gelatin silver print, 13 × 8 ⅞ inches (30 × 22.5 cm). High Museum of Art, Atlanta, Purchase with funds from Charlotte and Jim Dixon. Courtesy of Bob Fitch Photo Archive/Stanford University Libraries

On Gandhi (1958)

From the beginning a basic philosphy guided the movement. This guiding principle has since been referred to variously as nonviolent resistance, noncoöperation, and passive resistance. But in the first days of the protest none of these expressions was mentioned; the phrase most often heard was "Christian love." It was the Sermon on the Mount, rather than a doctrine of passive resistance, that initially inspired the Negroes of Montgomery to dignified social action. It was Jesus of Nazareth that stirred the Negroes to protest with the creative weapon of love.

As the days [of December 1955] unfolded, however, the inspiration of Mahatma Gandhi began to exert its influence. I had come to see early that the Christian doctrine of love operating through the Gandhian method of nonviolence was one of the most potent weapons available to the Negro in his struggle for freedom. About a week after the protest started, a white woman who understood and sympathized with the Negroes' efforts wrote a letter to the editor of the *Montgomery Advertiser* comparing the bus protest to the Gandhian movement in India. Miss Juliette Morgan, sensitive and frail, did not long survive the rejection and condemnation of the white community, but long before she died in the summer of 1957 the name of Mahatma Gandhi was well-known in Montgomery. People who had never heard of the little brown saint of India were now saying his name with an air of familiarity. Nonviolent resistance has emerged as the technique of the movement, while love stood as the regulating ideal. In other words, Christ furnished the spirit and motiviation, while Gandhi furnished the method.
…
During [my studies at Crozer Theological Seminary beginning in 1948] I had about despaired of the power of love in solving social problems.
…
Then one Sunday afternoon I traveled to Philadelphia to hear a sermon by Dr. Mordecai Johnson, president of Howard University. He was there to preach for the Fellowship House of Philadelphia. Dr. Johnson had just returned from a trip to India, and, to my great interest, he spoke of the life and teachings of Mahatma Gandhi. His message was so profound and electrifying that I left the meeting and bought a half-dozen books on Gandhi's life and works.

Like most people I had heard of Gandhi, but I had never studied him seriously. As I read I became deeply fascinated by his campaigns of nonviolent resistance. I was particularly moved by the Salt March to the Sea and his numerous fasts. The whole concept of "Satyagraha" (*Satya* is truth which equals love, and *agraha* is force; "Satyagraha," therefore, means truth-force or love force) was profoundly significant to me. As I delved deeper into the philosophy of Gandhi my skepticism concerning the power of love gradually diminished, and I came to see for the first time its potency in the area of social reform. Prior to reading Gandhi, I had about concluded that the ethics of Jesus were only effective in individual relationship. The "turn the other cheek" philosophy and the "love your enemies" philosophy were only valid, I felt, when individuals were in conflict with other individuals; when racial groups and nations were in conflict a more realistic approach seemed necessary. But after reading Gandhi, I saw how utterly mistaken I was.

Gandhi was probably the first person in history to lift the love ethic of Jesus above mere interaction between individuals and to a powerful an effective social force on a large scale. Love for Gandhi was a potent instrument for social and collective transformation. It was in this Gandhian emphasis on love and nonviolence that I discovered the method for social reform that I had been seeking for so many months. The intellectual and moral satisfaction that I failed to gain from the utilitarianism of Bentham and Mill, the revolutionary methods of Marx and Lenin, the social-contracts theory of Hobbes, the "back to nature" optimism of Rousseau, and the superman philosophy of Nietzsche, I found in the nonviolent resistance philosophy of Gandhi. I came to feel that this was the only morally and practically sound method open to oppressed people in their struggle for freedom.

Martin Luther King Jr., *Stride Toward Freedom: The Montgomery Story* (1958; New York: Ballantine Books, 1960), 67, 76–77.

Excerpted from "The Movement Gathers Momentum," 67; and "Pilgrimage to Nonviolence," 76–77.

Six Aspects of Nonviolence and Nonviolent Resistance (1958)

Since the philosophy of nonviolence played such a positive role in the Montgomery Movement, it may be wise to turn to a brief discussion of some basic aspects of this philosophy.

First, it must be emphasized that nonviolent resistance is not a method for cowards; it does resist. If one uses this method because he is afraid or merely because he lacks the instruments of violence, he is not truly nonviolent. This is why Gandhi often said that if cowardice is the only alternative to violence, it is better to fight. He made this statement conscious of the fact that there is always another alternative: no individual or group need submit to any wrong, nor need they use violence to right the wrong; there is the way of nonviolent resistance. This is ultimately the way of the strong man. It is not a stagnant passivity. The phrase "passive resistance" often gives the false impression that this is a sort of "do-nothing method" in which the resister quietly and passively accepts evil. But nothing is further from the truth. For while the nonviolent resister is passive in the sense that is not physically aggressive toward his opponent, his mind and emotions are always active, constantly seeking to persuade his opponent that he is wrong. The method is passive physically, but strongly active spiritually. It is not passive nonresistance to evil, it is active nonviolent resistance to evil.

A second basic fact that characterizes nonviolence is that it does not seek to defeat or humiliate the opponent, but to win his friendship and understanding. The nonviolent resister must often express his protest through noncoöperation or boycotts, but he realizes that these are not ends in themselves; they are merely means to awaken a sense of moral shame in the opponent. The end is redemption and reconciliation. The aftermath of nonviolence is the creation of the beloved community, while the aftermath of violence is tragic bitterness.

A third characteristic of this method is that the attack is directed against forces of evil rather than against persons who happen to be doing the evil. It is evil that the nonviolent resister seeks to defeat, not the persons victimized by evil. If he is opposing racial injustice, the nonviolent resister has the vision to see that the basic tension is not

between races. As I like to say to the people in Montgomery: "The tension in this city is not between white people and Negro people. The tension is, at bottom, between justice and injustice, between the forces of light and the forces of darkness. And if there is a victory, it will be a victory not merely for fifty thousand Negroes, but a victory for justice and the forces of light. We are out to defeat injustice and not white persons who may be unjust."

A fourth point that characterizes nonviolent resistance is a willingness to accept suffering without retaliation, to accept blows from the opponent without striking back. "Rivers of blood may have to flow before we gain our freedom, but it must be our blood," Gandhi said to his countrymen. The nonviolent resister is willing to accept violence if necessary, but never to inflict it. He does not seek to dodge jail. If going to jail is necessary, he enters it "as a bridegroom enters the bride's chamber."

One may well ask: "What is the nonviolent resister's justification for this ordeal to which he invites men, for this mass political application of the ancient doctrine of turning the other cheek?" The answer is found in the realization that unearned suffering is redemptive. Suffering, the nonviolent resister realizes, has tremendous education and transformative possibilities. "Things of fundamental importance to people are not secured by reason alone, but have to be purchased with their suffering," said Gandhi. He continues: "Suffering is infinitely more powerful than the law of the jungle for converting the opponent and opening his ears which are otherwise shut to the voice of reason."

A fifth point concerning nonviolent resistance is that it avoids not only external physical violence but also internal violence of spirit. The nonviolent resister not only refuses to shoot his opponent but he refuses to hate him. At the center of nonviolence stands the principle of love. The nonviolent resister would contend that in the struggle for human dignity, the oppressed people of the world must not succumb to the temptation of becoming bitter or indulging in hate campaigns. To retaliate in kind would do nothing but intensify the existence of hate in the universe. Along the way of life, someone must have sense enough and morality enough to cut off the chain of hate. This can only be done by projecting the ethic of love to the center of our lives.

In speaking of love at this point, we are not referring to some sentimental or affectionate emotion....

Agape is not a weak, passive love. It is love in action. *Agape* is love seeking to preserve and create community. It is insistence on community

even when one seeks to break it. *Agape* is a willingness to sacrifice in the interest of mutuality. *Agape* is a willingness to go to any length to restore community. It doesn't stop at the first mile, but it goes to the second mile to restore community. It is a willingness to forgive, not seven times but seven times seventy to restore community.…

Love, *agape,* is the only cement that can hold this broken community together. When I am commanded to love, I am commanded to restore community, to resist injustice, and to meet the needs of my brothers.

A sixth basic fact about nonviolent resistance is that it is based on the conviction that the universe is on the side of justice. Consequently, the believer in nonviolence has deep faith in the future. This faith is another reason why the nonviolent resister can accept suffering without retaliation. For he knows that in his struggle for justice he has cosmic companionship. It is true that there are devout believers in nonviolence who find it difficult to believe in a personal God. But even these persons believe in the existence of some creative force that works for universal wholeness. Whether we call it an unconscious process, an impersonal Brahman, or a Personal Being of matchless power and infinite love, there is a creative force in this universe that works to bring the disconnected aspects of reality into a harmonious whole.

Martin Luther King Jr., *Stride Toward Freedom: The Montgomery Story* (1958; New York: Ballantine Books, 1960), 81–86.

Danny Lyon (United States, b. 1942), Teenage girls in a stockade outside of Leesburg, Georgia, 1963. Gelatin silver print, 11 × 14 inches (27.9 × 35.6 cm). The Menil Collection, Houston, Gift of Edmund Carpenter and Adelaide de Menil

Bayard Rustin

(1912–1987)

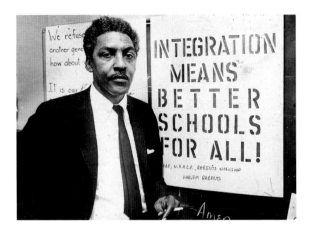

Bayard Rustin was a key figure in maintaining peaceful resistance and nonviolence in the American Civil Rights Movement beginning in the 1940s, and he remained a humanitarian activist his entire life. Rustin grew up in West Chester, Pennsylvania, a town whose many Quakers had promoted abolition and peace, and after attending American Friends Committee–sponsored programs and hearing peace proponents, including Rufus M. Jones, while he was in college, Rustin declared himself a Quaker. Upon moving to New York City after leaving school, Rustin became a youth secretary at the Fellowship of Reconciliation (FOR) office run by the Christian pacifist A. J. Muste. Rustin too became immersed in leftist and labor causes, and after helping conscientious objectors in the early years of World War II was incarcerated for a year as one. Following the war the FOR joined African American leaders like Howard Thurman and J. Holmes Smith and young activists, including Rustin, James Farmer, and George Houser, to bring Gandhian *satyagraha*,

resistance and civil disobedience with moral force, into the Movement.

In 1947 Rustin organized the first Freedom Ride challenging segregation on interstate buses, and the next year he visited India, where he lectured on pacifism and resistance to racism in the United States. Rustin's experience and sagacity made him an invaluable advisor to activists in the Congress on Racial Equality, the Southern Christian Leadership Conference, and the Student Nonviolent Coordinating Committee. An important collaborator with Martin Luther King Jr. as early as 1955, Rustin not only emphasized the importance of nonviolence, he lobbied to ally the Civil Rights Movement with labor and promote equal employment opportunities for those discriminated against by institutionalized practices. Rustin was the principal architect, albeit largely behind the scenes, of the 1964 March on Washington for Jobs and Freedom. Though he remained equally active, Rustin's role became less public because, in the climate of the times–including covert repression of the Movement by J. Edgar Hoover's FBI–Rustin's youthful flirtation with communism and his sexuality made him a target. Rustin was gay, and in his later life became an advocate for gay and lesbian rights. After the passage of the Civil Rights Act and other legislation, Rustin moved in policy circles and traveled internationally, working with Freedom House and the International Rescue Committee. In 2013 President Obama presented Rustin a posthumous Presidential Medal of Freedom.

Bayard Rustin at the Citywide Committee for Integration's headquarters,
Siloam Presbyterian Church, Brooklyn, New York, February 2, 1964.
Photograph by Patrick A. Burns. New York Times Co./Getty Images

James Lawson

(b. 1928)

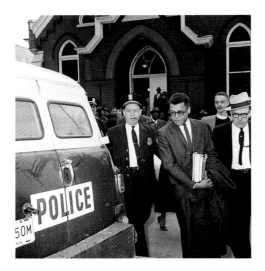

James Lawson is a living link to the Civil Rights Movement that brought social and legislative changes that helped end legal and institutionalized racial discrimination in the United States. He grew up in Ohio, the son of a Methodist preacher who taught him to defend himself if necessary, but at a young age experienced a "sanctification" when his mother told him love was more powerful than his vengeful slapping of a child who called him a racial slur. Lawson developed a deeply held pacifism and in college read Gandhi and joined the Fellowship of Reconciliation (FOR). His beliefs in nonviolent resistance were tested when he refused to register for the draft during the Korean War; rather than take a deferment as a divinity student, he served thirteen months in federal prison. Lawson spent three years in India as a missionary and learned Gandhi's philosophy, tactics, and techniques for *satyagraha*, action through moral force rather than violence. News accounts of the Montgomery, Alabama, bus boycott of 1955–56 and its spokesperson Martin Luther King Jr. convinced Lawson to return to the States and get involved. He enrolled in graduate school at Oberlin College, where he met King, who recognized a kindred spirit and Lawson's promise. King urged him to abandon his plan for further study prior to becoming a pastor and to start the work as soon as possible. Lawson took this advice and then a job as a Southern field secretary for the FOR, moved to Nashville, Tennessee, and in fall 1959 began nonviolence training for small groups of college students, convinced that dedicated young people could bring change but that discipline and the ability to withstand taunts, possible injury, and certainly arrest were necessary. Lunch counter sit-ins began in February 1960, the numbers of willing demonstrators swelled; before long demonstrations, Freedom Rides, and actions spread across the South. In Nashville after three months of sit-ins, numerous arrests, and boycotts of downtown merchants, the mayor denounced segregation and businesses were integrated. In 1961 Lawson-trained Freedom Riders went from Montgomery to Jackson, Mississippi, where they were stopped, and their choice of jail over paying fines followed by police beatings brought out even more protestors and galvanized the Kennedy administration to take action and force the complete desegregation of interstate travel.

James Lawson being led to a police wagon, March 5, 1960. Photographer unknown. Bettmann/Corbis

Lawson become the pastor at a Memphis church in 1962, and he led a strategy committee and mobilized community support for the 1968 sanitation workers' strike that produced the famous "I Am a Man" campaign and ended with successful labor negotiations, but sadly King was assassinated after giving a speech there in support.

In 1974 Lawson moved to a church in Los Angeles, and has been involved in civil liberties movements for gay and reproductive rights as well as economic justice and labor fairness such as living wage laws. He engaged in actions protesting US government support of a murderous government in El Salvador in 1989 and economic sanctions against the people of Iraq in 2000; he joined several organizations in the launch of an Immigrant Worker Freedom Ride in 2003. In 2005 Vanderbilt University in Nashville–which had expelled him from graduate

school in 1960s for his activism–named Lawson a distinguished alumnus; he served as a distinguished visiting professor for the next three years. Lawson remains a busy and eloquent advocate of social justice and nonviolence as a timely idea for liberating human aspiration from what he calls the juggernaut of militarism and war: "Life itself is powerful and the gift of life gives power.…I like to say philosophically that nonviolence is the power of creation given to human beings."

In 2011 the International Center on Nonviolent Conflict (ICNC) gave its first annual James Lawson Awards for achievements in nonviolent conflict. In August 2014 Lawson participated in an eight-day workshop in Nashville on the strategic evaluation of nonviolent civil resistance at the ICNC's James Lawson Institute.

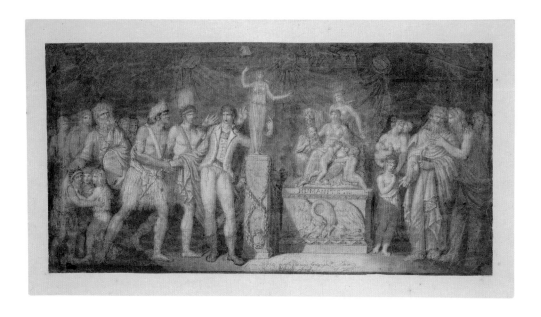

Proposal for a Monument: Equality of the Races or Abolition of Slavery, 1794. France. Pencil and chalk on paper, 14 × 25 ¼ inches (35.4 × 65 cm). The Menil Collection, Houston

Gandhi and the American Negroes

(1957)

Mohandas Gandhi was born nineteen months after my birth. As a school-boy in a small town in the north-eastern part of the United States, I knew little of Asia and the schools taught less. The one tenuous link which bound me to India was skin colour. That was important in America and even in my town, although little was said about it. But I was conscious of being the only brown face in my school and although my dark family had lived in this valley for two hundred years or more, I was early cognisant of a status different from that of my white school-mates.

As I grew up there seemed to be no future for me in the place of my birth, and at seventeen I went South, where formerly coloured people had been slaves, so that I could be trained to work among them. There at Fisk University I first became aware of a world of coloured folk and I learned not only of the condition of American Negroes but began to read of China and India; and to make Africa the special object of my study. I published my first book in 1896 while Gandhi was in South Africa, and my subject was the African slave trade. We did not at the time have much direct news from Africa in the American newspapers, but I did have several black students from South Africa and began to sense the tragedy of that awful land. It was not until after the First World War that I came to realise Gandhi's work for Africa and the world.

I was torn by the problem of peace. As a youth I was certain that free-dom for the coloured peoples of the earth would come only by war; by doing to white Europe and America what they had done to black Africa and coloured Asia. This seemed the natural conclusion from the fairy tales called history on which I had been nourished. Then in the last decades of the 19th century, as I came to manhood, I caught the vision of world peace and signed the pledge never to take part in war.

With the First World War came my first knowledge of Gandhi. I came to know Lajpat Rai and Madame Naidu. John Haynes Holmes was one of my co-workers in the National Association for the Advancement of Coloured people, and he was a friend and admirer of Gandhi. Indeed the "Coloured People" referred to in our name was not originally con-fined to America. I remember the discussion we had on inviting Gandhi

to visit America and how we were forced to conclude that this land was not civilised enough to receive a coloured man as an honoured guest.

In 1929, as the Depression loomed, I asked Gandhi for a message to American Negroes, which I published in *The Crisis*. He said: "Let not the 12 million Negroes be ashamed of the fact that they are the grandchildren of slaves. There is dishonour in being slave-owners. But let us not think of honour or dishonour in connection with the past. Let us realise that the future is with those who would be pure, truthful and loving. For as the old wise men have said: Truth ever is, untruth never was. Love alone binds and truth and love accrue only to the truly humble."

This was written on May day, 1929. Through what phantasmagoria of hurt and evil the world has passed since then! We American Negroes have reeled and staggered from side to side and forward and back. In the First World War, we joined with American capital to keep Germany and Italy from sharing the spoils of colonial imperialism. In the Depression we sank beneath the burden of poverty, ignorance and disease due to discrimination, unemployment and crime. In the Second World War, we again joined Western capital against Fascism and failed to realise how the Soviet Union sacrificed her blood and savings to save the world.

But we did realise how out of war began to arise a new coloured world free from the control of Europe and America. We began too to realise the role of Gandhi and to evaluate his work as a guide for the black people of the United States. As an integral part of this country, as workers, consumers and co-creators of its culture, we could not look forward to physical separation except as a change of masters. But what of Gandhi's programme of peace and non-violence? Only in the last year have American Negroes begun to see the possibility of this programme being applied to the Negro problems in the United States.

Personally I was long puzzled. After the World Depression, I sensed a recurring contradiction. I saw Gandhi's non-violence gain freedom for India, only to be followed by violence in all the world. I realised that the vaunted "hundred years of peace," from Waterloo to the Battle of the Marne, was not peace at all but war, of Europe and North America on Africa and Asia, with only troubled bits of peace between the colonial conquerors. I saw Britain, France, Belgium and North America trying to continue to force the world to serve them by monopoly of land, technique and machines, backed by physical force which has now culminated in the use of atomic power. Only the possession of this power by the Soviet Union prevents the restoration of colonial imperialism of

the West over Asia and Africa, under the leadership of men like Dulles and Eden. Perhaps in this extraordinary impasse the teachings of Mahatma Gandhi may have a chance to prevail in the world. Recent events in the former slave territory of the United States throw a curious light on this possibility.

In Montgomery, Alabama, the former capital of the Confederate States which fought for years to make America a slave nation, the black workers last year refused any longer to use the public buses on which their seats had long been segregated from those of the white passengers, paying the same fare. In addition to separation, there was abuse and insult by the white conductors. This custom had continued for 75 years. Then last year a coloured seamstress got tired of insult and refused to give her seat to a white man. The black workers led by young, educated ministers began a strike which stopped the discrimination, aroused the state and the nation and presented an unbending front of non-violence to the murderous mob which hitherto has ruled the South. The occurrence was extraordinary. It was not based on any first-hand knowledge of Gandhi and his work. Their leaders like Martin Luther King knew of non-resistance in India; many of the educated teachers, business and professional men had heard of Gandhi. But the rise and spread of this movement was due to the truth of its underlying principles and not to direct teaching or propaganda. In this aspect it is a most interesting proof of the truth of the Gandhian philosophy.

The American Negro is not yet free. He is still discriminated against, oppressed and exploited. The recent court decisions in his favour are excellent but are as yet only partially enforced. It may well be that the enforcement of these laws and real human equality and brotherhood in the United States will come only under the leadership of another Gandhi.

Reprinted from *Gandhi Marg* 1 (1957): 1–4.

Albert Mvumbi Lutuli

(ca. 1898–1967)

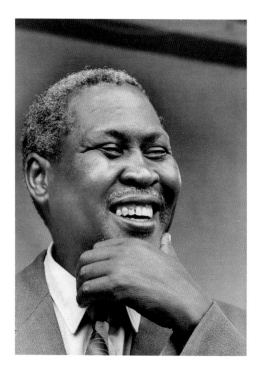

Albert Mvumbi Lutuli was the first African to be awarded the Nobel Peace Prize, bestowed in 1960 for his nonviolent advocacy of the rights of millions of black South Africans ruled by the Afrikaner descendants of Dutch colonists who in 1948 instituted a draconian separation of races in the apartheid system. The son of a Zulu missionary interpreter who died when he was ten, Lutuli was educated on his mother's earnings as a laundress and on a scholarship; after graduating, he became one of his mission college's few African teachers. Following fifteen years as an educator, Luthuli became president of the African Teacher's Association, in 1933. He was also active in Congregationalist Mission work, visiting India in 1938 and making a lecture tour of the United States in 1948.

Born in a lineage of chiefs, Lutuli was elected chief of his village of Groutville, Natal, in the mid 1930s. He joined the African National Congress (ANC) in 1944, supporting its call for enfranchisement and rights for nonwhites. He was elected president of the ANC's Natal division in 1951, and after helping organize nonviolent protests against discriminatory laws the next year, he was stripped of his chief's status, but almost immediately was elected the national president-general of the ANC. He served in this role until 1960, although for long periods he was banned from travel and spent, as well, a year in custody until treason charges against him and sixty-four others were dropped in 1957. Luthuli was arrested and found guilty of burning his pass in solidarity with the 69 peaceful protestors murdered in the Sharpeville massacre of March 1960–following which the ANC and Pan-African Congress were outlawed–but ill health led to a suspended jail sentence. A travel ban remained in effect. It was lifted temporarily in December 1961 so Lutuli and his wife could travel to Oslo for the Nobel Peace Prize ceremony (a year after his award). Despite its banning in South Africa, Lutuli's *Let My People Go: An Autobiography* went through many printings abroad. Continuing to serve the cause of justice until his death, Lutuli joined with Martin Luther King Jr. in 1962 to issue jointly "An Appeal for Action against Apartheid" calling for boycotts, divestment, and economic sanctions against the South African regime and for demonstrations on December 10, Human Rights Day.

Albert Mvumbi Lutuli, Oslo, 1961. Photograph by Terrence Spencer.
The LIFE Picture Collection/Getty Images

ALBERT MVUMBI LUTULI

The African Women's Demonstration in Natal (1959)

From the middle of June to the end of August 1959, there were widespread demonstrations throughout the South African province of Natal. The demonstrations were largely by women and had no precedent, at least, in Natal, wrote Luthuli, who went on to say this

THE CONGRESS METHOD OF STRUGGLE

[The African National] Congress has adopted the policy of using extra-parliamentary methods of struggle but strictly on the basis of non-violence. This policy has been adopted deliberately, following a profound study and experience of the South African situation. We believe that as conditions are in this country it is possible for the people by the use of overwhelming peaceful pressure to win all their demands for freedom. We are aware of the fact that people as a result of desperation at the terrible conditions under which they live and sometimes owing to deliberate provocative acts by the authorities may spontaneously resort to violence. But our task is to educate our people on the efficacy of Congress methods of struggle. We do not preach the use of non-violent methods for the benefit of our enemies but for the benefit of our own people and for the ultimate benefit of our multi-racial society. Under our conditions in South Africa violent struggle would probably leave a legacy of bitterness which would render it difficult to establish a firm and stable multi-racial democracy in the future. One point does deserve mention. By and large even where demonstrations in the past two months have contained a violent element it has not been directed against any persons or sections of the community but rather at institutions that appeared associated with policies that caused the people's suffering. It was fundamentally an attack on local or national government policies. I must emphasise, however, that demonstrators must forthwith desist from violence, whether they be Congress members or not. Violent methods of struggle are inimical to the best interests of the struggle and are not a practical proposition in any case in our situation.

"The African Women's Demonstration in Natal: Report by Albert Luthuli to the Natal People's Conference, 6 September 1959," African National Congress, Reports, http://www.anc.org.za/show .php?id=4712 (accessed January 20, 2014).

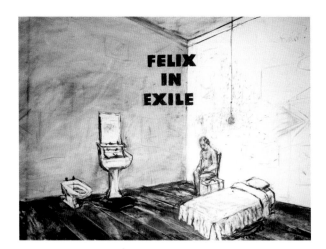 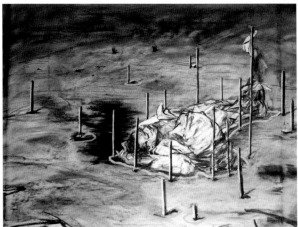

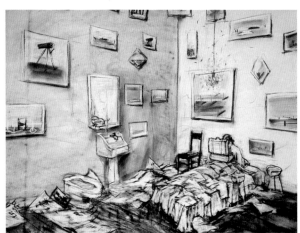 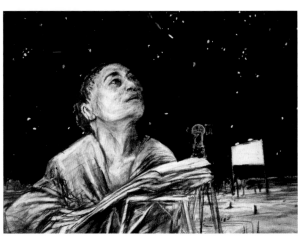

William Kentridge (South Africa, b. 1955), Felix in Exile, 1994. 35mm film
shown as video, black and white with sound, 8 min. 43 sec. Courtesy of the artist
and Marian Goodman Gallery, New York, and Paris

During the 1970s and 1980s I made some posters and drawings as well as theatre pieces, all of which I saw as acts of political opposition. More importantly, there were times when my own real anger formed the impetus behind particular works–and so became part of the process, without any expectation that the work itself would be an act of resistance. Sine then the work has become more a reflection of the political world, in terms of the way it affects us personally than an attempt to become part of it.

 –William Kentridge, 1999

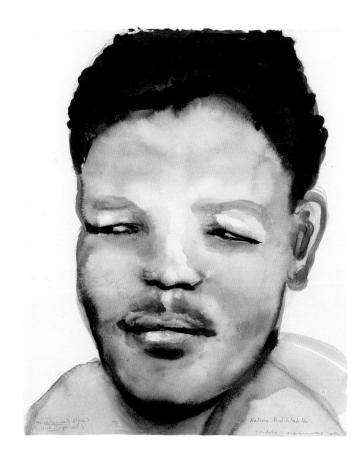

Because images of Nelson Mandela were banned for all those years he was
in prison, we didn't see photographs or images of him in the process of growing
older [see page 40]. You see him as a young man before he was sentenced, and
then as an old(er) man when he got out. This is strange in our times, when so many
images of everyone are spread around all the time. With Mandela portraits,
there is only a BEFORE and an AFTER.
 –Marlene Dumas

Marlene Dumas (b. South Africa 1953, active Netherlands), Nelson Rolihlahla Mandela–
Winnie Madikizela Mandela–Zindzi Mandela, 2004. Ink on paper, overall:
25 ⅝ × 60 ⅛ inches (65 × 150 cm). FWA–Foundation for Women Artists, Antwerp

Nelson Mandela

(1918–2013)

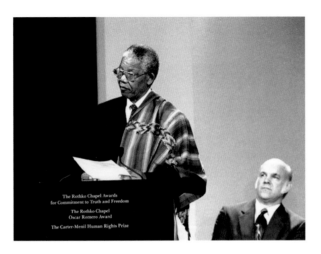

Nelson Rolihlahla Mandela was the son of the principal councilor to the king of the Thembu group of the Xhosa people. After matriculating at a missionary high school he went to college until he was expelled after a student protest. In 1941 he moved to Johannesburg, finished college, and began working in an attorney's office. Increasingly drawn into politics, Mandela helped organize the Youth League of the African National Congress (ANC) in 1944. He became volunteer-in-chief for a 1952 campaign of civil disobedience organized by the ANC and the South African Indian Congress against unjust laws; he and others were sentenced to nine months hard labor but the sentences were suspended. That same year he received a two-year diploma that enabled him to practice law, and he cofounded the first black law firm in South Africa. Mandela's freedom was restricted the next year when he was banned for the first time, and in 1955

he was arrested and became one of the accused in a famous treason trial for which acquittal did not come until 1962.

In March 1960 the nonviolence of black, colored, and Asian resistance to apartheid– symbolized by a "thumbs up" sign–was effectively brought to an end when police massacred 69 people in Sharpeville at a demonstration against the pass laws (requiring internal passports for non-whites). New techniques including armed struggle became favored, and after the treason trial acquittal Mandela went underground to help plan a national strike and secretly went abroad for military training. A five-year sentence in 1962 began nearly three decades of incarceration, because he also received a life sentence for sabotage. In 1964 Mandela was sent to the infamous Robben Island prison and work camp, where he remained until 1982. He subsequently served in mainland prisons or was in and out of hospitals until his release in 1990, when he and his then-wife Winnie Madikizela Mandela famously walked from the prison with clenched fists raised.

He had already begun negotiations between the now-unbanned ANC and the apartheid government, and in 19991 Mandela replaced his former law partner Oliver Tambo as president of the ANC. The negotiations of a peaceful transfer of power from the white minority resulted in Mandela and President

Nelson Mandela at the Rothko Chapel Awards ceremony commemorating the chapel's twentieth anniversary, Houston, December 8, 1991. Photograph by Anthony Allison. Rothko Chapel Archives, Houston

F.W. de Klerk sharing the Nobel Peace Prize in 1993 "for their work for the peaceful termination of the apartheid regime, and for laying the foundations for a new democratic South Africa." In the spring of the following year Mandela was able to vote for the first time and the next month was inaugurated as the first truly democratically elected president of South Africa. He embodied peaceful good will and helped the country navigate new enfranchisements and attempt to overcome more than a century of oppression and enmity. In 1996 a Truth and Reconciliation Commission was established by law; chaired by Nobel Peace Prize laureate Archbishop Desmond Tutu, it was charged with investigation, bearing witness, and the consideration of reparations, reconciliation, and possibly amnesty. Symbolic reconciliations were also undertaken, and a notorious Johannesburg prison where both Gandhi and Mandela were incarcerated was taken down and the bricks used to create a public plaza for all South Africans and new Constitutional Court buildings. Mandela promised to serve only one five-year presidential term, and after stepping down in 1999 served as an ambassador of peace and good will until mostly retiring from public life in 2004. In 2007 he organized a group called The Elders, an independent group of global leaders who work together for peace, human rights, and allaying human suffering.

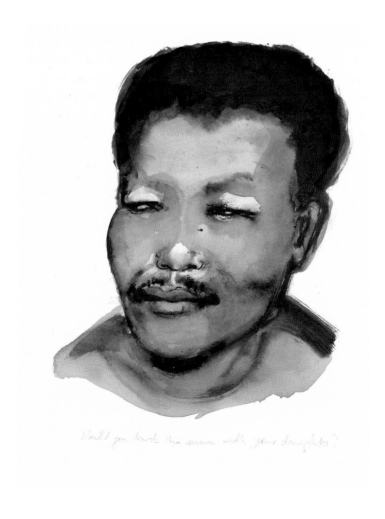

Marlene Dumas, Portrait of a Young Nelson Mandela (Would you trust this man with your daughter?), 2008. Piezograph on paper, 17 ¾ × 13 ¾ inches (45 × 34.9 cm). Karen and Frank Steininger

The Sacred Warrior (1999)

[Gandhi] is the archetypal anticolonial revolutionary. His strategy of noncooperation, his assertion that we can be dominated only if we cooperate with our dominators, and his nonviolent resistance inspired anticolonial and antiracist movements internationally in our century....

From his understanding of wealth and poverty came his understanding of labor and capital, which led him to the solution of trusteeship based on the belief that there is no private ownership of capital; it is given in trust for redistribution and equalization. Similarly, while recognizing differential aptitudes and talents, he holds that these are gifts from God to be used for the collective good.

He seeks an economic order, alternative to the capitalist and communist, and finds this in *sarvodaya* [uplift of all] based on nonviolence (*ahimsa*).

He rejects Darwin's survival of the fittest, Adam Smith's laissez-faire and Karl Marx's thesis of a natural antagonism between capital and labor, and focuses on the interdependence between the two.

He believes in the human capacity to change and wages *satyagraha* [the force of truth] against the oppressor, not to destroy him but to transform him, that he cease his oppression and join the oppressed in the pursuit of Truth...

Gandhi remains today the only complete critique of advanced industrial society. Others have criticized its totalitarianism but not its productive apparatus. He places priority on the right to work and opposes mechanization to the extent that it usurps this right. Large-scale machinery, he holds, concentrates wealth in the hands of one man who tyrannizes the rest. Above all, he seeks to liberate the individual from his alienation to the machine and restore morality to the productive process.

As we find ourselves in jobless economies, societies in which small minorities consume while the masses starve, we find ourselves forced to rethink the rationale of our current globalization and to ponder the Gandhian alternative.

Excerpted from Nelson Mandela, "The Sacred Warrior: The Liberator of South Africa Looks at the Seminal Work of the Liberator of India," *Time*, December 30, 1999.

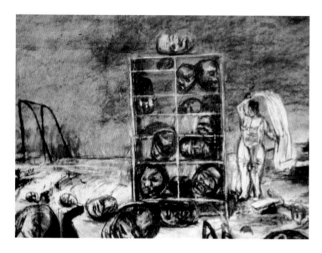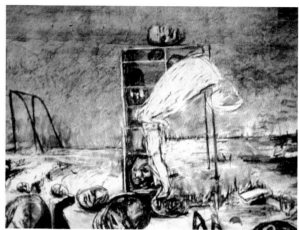
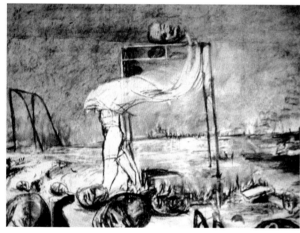

I like the fact that charcoal is actually a piece of burnt tree.
It suits South Africa.
　　　–William Kentridge, 2009

William Kentridge, Johannesburg, 2nd Greatest City after Paris, 1989.
35mm film shown as video, black and white with sound, 8 min. 2 sec. Courtesy of the artist
and Marian Goodman Gallery, New York and Paris

Dalai Lama

(b. 1935)

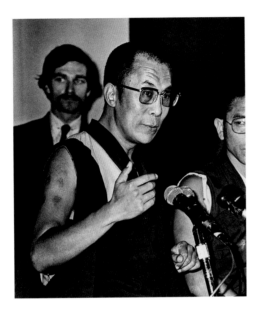

(Tib. Chenresig)–the Dalai Lama is a well known teacher/lecturer, promoter of inter-religious dialogue, and author of numerous books. He was given the Nobel Peace Prize in 1989 for his advocacy of nonviolent peace efforts for Tibet. As their website states, "When the Nobel Committee chose the Dalai Lama, it emphasized that he based his Buddhist peace philosophy on reverence for all living things and the idea of a universal responsibility that embraces both man and nature. It weighed heavily in the Tibetan leader's favor that he had showed willingness to compromise and seek reconciliation despite brutal violations."

Tenzin Gyatso is a Buddhist monk who was recognized at the age of two as the 14th Dalai Lama, a high-ranking lama in the Gelug lineage considered the chief spiritual and political leader of the Vajrayana Buddhists of Tibet. Following a monastic education, in 1950 he assumed the Dalai Lama's leadership role and began negotiating with China after that country's invasion of Tibet. Since fleeing in 1959, he has lived in Dharmsala, India, where he was recognized as the head of state by the Charter of Tibetans in Exile. A high-profile advocate for a peaceful reconciliation even as he strove to move the Tibetan state in exile from a theocracy to a democracy, the Dalai Lama retired from politics in 2011 to make way for a democratically elected leader.

A leading advocate of the Buddhist virtue of compassion and peace–and traditionally considered an incarnation of the Buddhist bodhisattva of compassion, Avalokiteshvara

In his acceptance speech, the Dalai Lama said, "I believe the prize is a recognition of the true values of altruism, love, compassion and nonviolence which I try to practice, in accordance with the teachings of the Buddha and the great sages of India and Tibet. I accept the prize with profound gratitude on behalf of the oppressed everywhere and for all those who struggle for freedom and work for world peace. I accept it as a tribute to the man who founded the modern tradition of nonviolent action for change–Mahatma Gandhi–whose life taught and inspired me. And, of course, I accept it on behalf of the six million Tibetan people, my brave countrymen and women inside Tibet, who have suffered and continue to suffer so much." He closed with, "I pray for all of us, oppressor and friend, that together we succeed in building a better world through human understanding and love, and that in doing so we may reduce the pain and suffering of all sentient beings."

The Dalai Lama speaking at the Rothko Chapel, Houston, September 1979.
Photograph by David Crossley. Menil Archives, The Menil Collection, Houston

Agnes Martin (United States, 1912–2004), Untitled, 1977. Watercolor, ink,
and graphite on paper, 12 ⅛ × 12 ¼ inches (31.2 × 30.5 cm). The Menil Collection,
Houston, Anonymous gift in honor of Mr. Walter Hopps

A Tribute to Gandhi (2009)

I am grateful for this opportunity to pay tribute to Mahatma Gandhi because I consider myself to be his follower. Indeed, he has been a source of inspiration to me ever since I was a small boy growing up in Tibet. He was a great human being with a deep understanding of human nature, who made every effort to encourage the full development of the positive aspects of the human potential and to reduce or restrain the negative.

Gandhiji took up the ancient but powerful idea of *ahimsa* or non-violence and made it familiar throughout the world, particularly during India's struggle for freedom. However, non-violence means more than the mere absence of violence. It is something more positive, more meaningful than that, for the true expression of non-violence is compassion. Some people seem to think that compassion is just a passive emotional response, rather than a rational stimulus to action. But to experience genuine compassion is to develop a feeling of closeness to others, as Gandhiji did, combined with a sense of responsibility for their welfare. His great achievement was to show through his own example that non-violence can be implemented effectively not only in the political arena, but also in our day-to-day life. This is why the title of [Narayan Desai's] biography, *My Life is My Message*, is so apt.

Even today, in our modern world, Gandhiji's principles of non-violence and reconciliation are relevant on a personal and political level. It may be possible to gain something through violence, but such gains tend to be only temporary. We may solve the immediate problem, but in the long run, we create another one. So the best solution is non-violence. It may take time, but it will generate no negative side effects.

Violence may still be rife in our world, but the trend of global opinion is to recognize that the future lies in non-violence. I wonder if this would have been the case were it not for Gandhiji's leadership? As a young man, I was deeply inspired first and foremost by his adoption of non-violence in India's struggle for freedom and I have, therefore, put this into practice in my own efforts to restore the fundamental human rights and freedoms of the Tibetan people. But, in addition, I admired the simplicity and discipline of Gandhiji's way of life. Although he had received a full modern education and was well versed in modern,

western ways of living, he returned to his Indian heritage and culti-
vated a simple wholesome life in accordance with Indian philosophy.
Consequently, he was acutely aware of the problems of the common
people, who everywhere constitute the majority.

I believe that if we can each cultivate compassion, kindness and respect
for truth within ourselves as he did, we will be fulfilling his legacy to us.

Foreword to Narayan Desai, *My Life is My Message* 4
vols. (New Delhi: Orient BlackSwan, 2009), 1:ix–x.

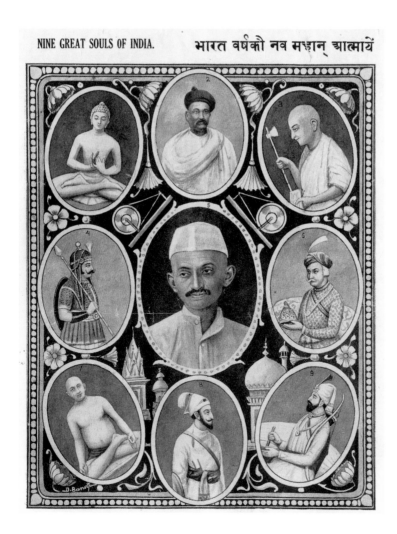

Nine Great Souls of India, 20th century. Chromolithograph on paper,
11 × 8 ¾ inches (28 × 22 cm). Collection of Kenneth and Joyce Robbins

Thich Nhat Hanh

(b. 1926)

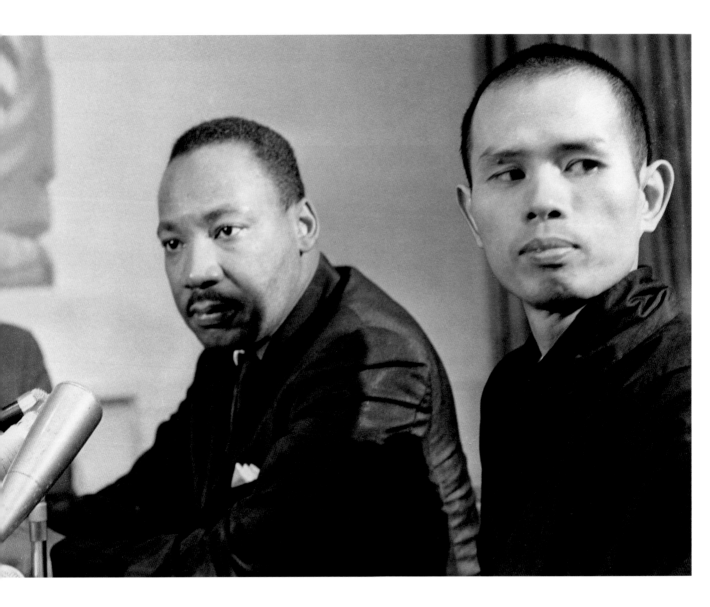

Martin Luther King Jr. and Thich Nhat Hanh at a news conference during
Nhat Hanh's visit to the United States sponsored by the Fellowship of Reconciliation's
International Committee of Conscience on Vietnam, Chicago, May 31, 1966.
Photographer unknown. UPI Photo

The Roots of War (1991)

There is a deep malaise in our society. Look at the way young people consume drugs. They use drugs as a way to forget. These are the seeds of war that we have to acknowledge if we want to transform them. We have to do it together, looking deeply into the nature of the war in our collective consciousness. The war is in our souls.

Many of us are not healthy within, and we continue to look for things that only harm us more. We come home from work exhausted, and we do not know how to relax. We feel a kind of vacuum in ourselves, so we turn on the television. We live in a society where we always feel we are lacking something, and we want to fill it. If we don't turn on the TV, we eat or read or talk on the telephone. We are always trying to fill our void with something. Some people do social service or political work in this way, but doing this only makes us less satisfied–hungrier–and we want to consume more. We feel alienated from ourselves. There is so much fear, hatred, and anger in us, and we want to suppress them, so we consume more and more things that only increase the level of toxicity already in us. We watch films that are very noisy, filled with screaming and violence, and we get exhausted. So much hatred, fear, and confusion are expressed in our magazines, television, films, and advertisements. But we do not even have the courage to turn off our TV, because we are afraid to go back to ourselves.

The night I heard President [George H.W.] Bush give the order to attack Iraq, I could not sleep. I was angry and overwhelmed. The next morning in the middle of my lecture, I suddenly paused and told my friends, "I don't think I will go to North America this Spring." The words just sprang out. Then I continued the lecture. In the afternoon, one American student told me, "Thây, I think you have to go to the United States. Many friends there feel the same as you do, and it would help if you would go and support them." I did not say anything. I practiced breathing, walking, and sitting, and a few days later, I decided to go. I saw that I was one with the American people, George Bush, and Saddam Hussein. I had been angry with President Bush, but after breathing consciously and looking deeply, I saw myself as President Bush. I had not been practicing well enough to change this situation. I saw that Saddam Hussein was not the only person who had lit the oil wells in Kuwait. All of us reached out our hands and lit the oil wells with him.

In our collective consciousness, there are some seeds of nonviolence, and President Bush did begin with sanctions. But we did not support and encourage him enough, so he switched to a more violent way. We cannot blame only him. The President acted the way he did because we acted the way we did. It is because we are not happy enough that we had a war. If we were happier, we would not take refuge in alcohol, drugs, war, and violence. Young people tell me that the most precious gift their parents can give is their own happiness. If Father and Mother themselves are happy, the children will receive seeds of happiness in their consciousness, and when they grow up, they will know how to make others happy too. When parents fight, they sow seeds of suffering in the hearts of their children, and with that kind of heritage, children grow up unhappy. These are the roots of war. If children are unhappy, they will look for other things that are exactly like war—alcohol, drugs, and some TV programs, magazines, films, and other violent "cultural products."

How can we transform our individual consciousness and the collective consciousness of our society? How can we refrain from consuming more toxic cultural products? We need guidelines—a diet—and we need to practice watering the seeds of peace, joy, and happiness in us. The most important practice for preventing war is to stay in touch with what is refreshing, healing, and joyful inside us and all around us. If we practice walking mindfully, being in touch with the earth, the air, the trees, and ourselves, we can heal ourselves, and our entire society can also be healed. If the whole nation would practice watering seeds of joy and peace and not just seeds of anger and violence, the elements of war in all of us will be transformed. This may sound simplistic, but I know it is true.

Finding peace within, refusing to ingest toxic cultural products that lead to war and more suffering, we can transform ourselves and then share our peace widely. If we practice mindful breathing and smiling, looking deeply into things, and taking care of ourselves and our children, peace has a chance. We must prepare ourselves, whether we have one minute, ten years, or one thousand years. If we don't have time, there is no use discussing peace, because you cannot practice peace without time. Do you have one minute? Use that minute to breathe in and out calmly and plant the seeds of calm, peace, and understanding in yourself. Do you have ten years? Use the ten years to prevent the next war. Do you have one thousand years? Please use the time to prevent the destruction of our planet.

Transformation is possible, but we need time. There are already seeds of peace in those we call "hawks." They need us to help water these seeds of peace and understanding, or else their seeds of anger and aggression will continue to dominate them. Don't be discouraged. Approach people with love and patience, and try to water the positive seeds in them. Getting angry will not help. They *are* us. Just by our way of looking at things and doing things, we influence other people. Helping just one person has a big effect. We should not condemn anyone. All of us are brothers and sisters. We have to help each other, being skillful, kind, and understanding. Blaming never helps.

People everywhere on the planet saw the image of the Los Angeles policemen beating Rodney King. The moment I first saw it, I saw myself as the one who was beaten, and I suffered. I think most of you felt the same. We were all beaten at the same time, and we were all the victims of violence, anger, the lack of understanding, and the lack of respect for our human dignity.

But looking more deeply, I was able to see that the policemen who were beating Rodney King were also myself. Why were they doing that? Because our society is full of hatred and violence. Everything is like a bomb ready to explode, and we are all part of that bomb. We are co-responsible for it. That is why I saw myself as the plicemen beating the driver. We all are these policemen.

In the practice of awareness, which Buddhists call mindfulness, we nurture the ability to see deeply into the nature of things and of human beings. The fruit of this practice is insight and understanding, and out of this comes love. Without understanding, how can we love? Love is the intention and capacity to bring joy to others, and to remove and transform the pain that is in them.

From the Buddhist perspective, I have not practiced deeply enough to transform the situation of the policemen. I have allowed violence and misunderstanding to exist. Realizing that, I suffer with them, for if they do not suffer, then why would they do what they did? Only when you suffer do you make other people suffer; if you are happy, if you are liberated, there will not be suffering in you to spill over to others. Putting the policemen on trial or firing the chief of police has not solved our fundamental problems. We have all helped to create this situation with our forgetfulness and our way of living. Violence has become a substance of our life, and we are not very different from those who did the beating.

Living in such a society, one can become like that quite easily. The half-million soldiers in the desert, along with the millions who daily absorb the violent images of television, are also being trained like those who did the beating: to accept violence as a way of life, and as a way to solve problems. If we are not mindful–if we do not transform our shared suffering through compassion and deep understanding–then one day our child will be the one who is beaten, or the one doing the beating. It is our affair. We are not observers. We are all participants.

Putting more policemen on the streets does not address the deepest issues. We have to look at the roots of the problem and not just on the surface.

We are interconnected. In me are many "non-me" elements, including President Bush, President Clinton, President Hussein, Rodney King, and the five policemen. If we take care of all of these elements that are in ourselves, we take good care of everyone, and we begin to have peace in ourselves. As soon as we begin to feel calm, the world will already benefit. When we can smile, we refresh ourselves, our family, and the whole of society. In the beginning it may be difficult for us to smile, but it is worth the effort. We can practice "mouth yoga." Doing so we will relax hundreds of muscles on our face, and that kind of relaxation has a transforming power.

From a series of lectures given in North America, spring 1991, and an interview in Houston, Texas, March 1991.

Reprinted from *Love in Action: Writings on Nonviolent Social Change* (Berkeley: Parallax Press, 1993), 81–85.

Shomei Tomatsu (Japan, 1930–2012), Beer bottle after the atomic bomb explosion,
1961, printed later. Gelatin silver print, 23 3/8 × 19 5/8 inches (59.4 × 49.9 cm).
The Museum of Fine Arts, Houston, The Allen Chasanoff Photographic Collection

Aung San Suu Kyi

(b. 1945)

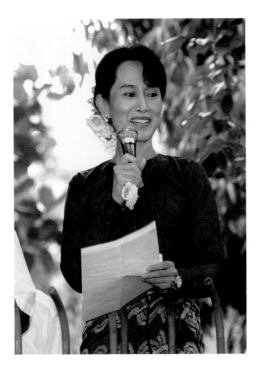

Aung San Suu Kyi is the spokesperson for freedom and democracy in Myanmar (called Burma from the British colonial era) and a leading light for peace and nonviolence. Daughter of Aung San–a general and popular leader in the country's independence movement who was assassinated before colonial rule ended in January 1948–and sometimes also named with Daw, that of her mother (who served as ambassador to India), Suu Kyi is a eloquent speaker and writer. She was schooled at Oxford and in the 1960s worked at the United Nations for the Burmese Secretary General U Thant. Married to a British Himalayan scholar who taught in Bhutan and then Oxford, Suu Kyi wrote a biography of Aung San published in Australia in 1984. She returned to her home-land to care for her ailing mother in 1988

during a time of demonstrations against the military dictatorship that had ruled since 1962. Although the popular sentiment resulted in the head general resigning, massacres of demonstrators and the brutal suppression of the 8-8-88 freedom move-ment marked a tightening down by the military; Suu Kyi began to speak out for elections and democratic government. The next year she was prohibited from standing for elections and placed under house arrest, where she was to remain for most of the next two decades. In 1990 parliamentary elections, the National League for Democracy, of which she was secretary-general, achieved a broad victory, but the results were annulled. Suu Kyi repeatedly ignored bans against speaking and attempts to foster participation; recog-nized internationally as a voice of freedom and peace, she was awarded two human rights prizes that year, including the European Parliament's Sakharov Prize for Freedom of Thought. The next year Suu Kyi received the Nobel Peace Prize "for her non-violent struggle for democracy and human rights." A collection of her writings, *Freedom from Fear*, was first published in England in 1991.

In the late 2000s there was a loosening of the military reins and highly restrictive elec-tions were held were in 2010, right after which Suu Kyi was released from house arrest. The National League for Democracy was not recognized for participation until elections in 2012, in which they won virtually all open seats, and Suu Kyi became leader of the parliamentary opposition.

Aung San Suu Kyi speaks to supporters from her gate in defiance of new government laws banning public meetings, Yangon, Myanmar, June 15, 1996. Photograph by Stuart Isett. AP Photo/Stuart Isett

Freedom from Fear (1991)

It is not power that corrupts but fear. Fear of losing power corrupts those who wield it and fear of the scourge of power corrupts those who are subject to it. Most Burmese are familiar with the four *a-gati*, the four kinds of corruption. *Chanda-gati*, corruption induced by desire, is deviation from the right path in pursuit of bribes or for the sake of those one loves. *Dosa-gati* is taking the wrong path to spite those against whom one bears ill will, and *moha-gati* is aberration due to ignorance. But perhaps the worst of the four is *bhaya-gati*, for not only does *bhaya*, fear, stifle and slowly destroy all sense of right and wrong, it so often lies at the root of the other three kinds of corruption.

Just as *chanda-gati*, when not the result of sheer avarice, can be caused by fear of want or fear of losing the goodwill of those one loves, so fear of being surpassed, humiliated, or injured in some way can provide the impetus for ill will. And it would be difficult to dispel ignorance unless there is freedom to pursue the truth unfettered by fear. With so close a relationship between fear and corruption it is little wonder that in any society where fear is rife corruption in all forms becomes deeply entrenched.

Public dissatisfaction with economic hardships has been seen as the chief cause of the movement for democracy in Burma, sparked off by the student demonstrations of 1988. It is true that years of incoherent policies, inept official measures, burgeoning inflation, and falling real income had turned the country into an economic shambles. But it was more than the difficulties of eking out a barely acceptable standard of living that had eroded the patience of a traditionally good-natured, quiescent people–it was also the humiliation of a way of life disfigured by corruption and fear. The students were protesting not just against the death of their comrades but against the denial of their right to life by a totalitarian regime which deprived the present of meaningfulness and held out no hope for the future. And because the students' protests articulated the frustrations of the people at large, the demonstrations quickly grew into a nationwide movement. Some of its keenest supporters were businessmen who had developed the skills and contacts necessary not only to survive but to prosper within the system. But their affluence offered them no genuine sense of security or fulfillment, and they could not but see that if they and their fellow citizens, regardless of economic status were to achieve a worthwhile existence, an

accountable administration was at least a necessary if not a sufficient condition. The people of Burma had wearied of a precarious state of passive apprehension where they were as "water in the cupped hands" of the powers that be.

Emerald cool we may be
As water in cupped hands
but oh that we might be
As splinters of glass
In cupped hands.

Glass splinters, the smallest with its sharp, glinting power to defend itself against hands that try to crush, could be seen as a vivid symbol of the spark of courage that is an essential attribute of those who would free themselves from the grip of oppression. Boyoke Aung San regarded himself as a revolutionary and searched tirelessly for answers to the problems that beset Burma during her times of trial. He exhorted the people to develop courage: "Don't just depend on the courage and intrepidity of others. Each and every one of you must make sacrifices to become a hero possessed of courage and intrepidity. Then only shall we be able to enjoy true freedom."

The effort necessary to remain uncorrupted in an environment where fear is an integral part of everyday existence is not immediately apparent to those fortunate enough to live in states governed by the rule of law. Just laws do not merely prevent corruption by meting out impartial punishment of offenders. They also help to create a society in which people can fulfill the basic requirements necessary for the preservation of human dignity without recourse to corrupt practices. Where there are no such laws, the burden of upholding the principles of justice and common decency falls on the ordinary people. It is the cumulative effect of their sustained effort and steady endurance which will change a nation where reason and conscience are warped by fear into one where legal rules exist to promote man's desire for harmony and justice while restraining the less desirable destructive traits in his nature.

In an age where immense technological advances have created lethal weapons which could be, and are, used by the powerful and the unprincipled to dominate the weak and the helpless, there is a compelling need for a closer relationship between politics and ethics at both the national and international levels. The Universal Declaration of Human Rights of the United Nations proclaims that "every individual and every organ of society" should strive to promote the basic rights

and freedoms to which all human beings regardless of race, nationality, or religion are entitled. But as long as there are governments whose authority is founded on coercion rather than on the mandate of the people, and interest groups which place short-term profits above long-term peace and prosperity, concerted international action to protect and promote human rights will remain at best a partially realized ideal. There will continue to be arenas of struggle where victims of oppression have to draw on their own inner resources to defend their inalienable rights as members of the human family.

The quintessential revolution is that of the spirit, born of an intellectual conviction of the need for change in those mental attitudes and values which shape the course of a nation's development. A revolution with aims merely at changing official policies and institutions with a view to an improvement in material conditions of the spirit, the forces which produced the iniquities of the old order would continue to be operative, posing a constant threat to the process of reform and regeneration. It is not enough merely to call for freedom, democracy, and human rights. There has to be a united determination to persevere in the struggle, to make sacrifices in the name of enduring truths, to resist the corrupting influences of desire, ill will, ignorance, and fear.

Always one to practice what he preached, Aung San himself constantly demonstrated courage–not just the physical sort but the kind that enabled him to speak the truth, to stand by his word, to accept criticism, to admit his faults, to correct his mistakes, to respect the opposition, to parley with the enemy, and to let people be the judge of his worthiness as a leader. It is for such moral courage that he will always be loved and respected in Burma–not merely as a warrior hero but as the inspiration and conscience of the nation. The words used by Jawaharlal Nehru to describe Mahatma Gandhi could well be applied to Aung San: "The essence of his teaching was fearlessness and truth, and action allied to these, always keeping the welfare of the masses in view."

Gandhi, that great apostle of nonviolence, and Aung San, the founder of a national army, were very different personalities, but as there is an inevitable sameness about the challenges of authoritarian rule anywhere at any time, so there is a similarity in the intrinsic qualities of those who rise up to meet the challenge. Nehru, who considered the instillation of courage in the people of India to be one of Gandhi's greatest achievements, was a political modernist, but as he assessed the needs for a twentieth-century movement for independence, he found himself looking back to the philosophy of ancient India: "The greatest

gift for an individual or a nation ... was *abhaya*, fearlessness, not merely bodily courage but absence of fear from the mind."

Fearlessness may be a gift but perhaps more precious is the courage acquired through endeavor, courage that comes from cultivating the habit of refusing to let fear dictate one's actions, courage that could be described as "grace under pressure"–grace which is renewed repeatedly in the face of harsh, unremitting pressure.

Within a system which denies the existence of basic human rights, fear tends to be the order of the day. Fear of imprisonment, fear of torture, fear of death, fear of losing friends, family, property, or means of livelihood, fear of poverty, fear of isolation, fear of failure. A most insidious form of fear is that which masquerades as common sense or even wisdom, condemning as foolish, reckless, insignificant, or futile the small, daily acts of courage which help preserve a man's self-respect and inherent human dignity. It is not easy for a people conditioned by the iron rule of the principle that might is right to free themselves from the enervating miasma of fear. Yet even under the most crushing state machinery courage rises up again and again, for fear is not the natural state of civilized man.

The wellspring of courage and endurance in the face of unbridled power is generally a firm belief in the sanctity of ethical principles combined with a historical sense that despite all setbacks the condition of man is set on an ultimate course for both spiritual and material advancement. It is his capacity for self-government and self-redemption which most distinguishes man from the mere brute. At the root of human responsibility is the concept of perfection, the urge to achieve it, the intelligence to find a path towards it, and the will to follow that path if not to the end at least the distance needed to rise above individual limitations and environmental impediments. It is man's vision of a world fit for rational, civilized humanity which leads him to dare and to suffer and to build societies free from want and fear. Concepts such as truth, justice, and compassion cannot be dismissed as trite when these are often the only bulwarks which stand against ruthless power.

First released to commemorate the author's receiving of the 1990 Sakharov Prize for Freedom of Thought from the European Parliament, and published in numerous international newspapers on July 10, 1991, when Suu Kyi was awarded the prize in absentia.

Reprinted from Aung San Suu Kyi, *Freedom from Fear*, ed. Michael Arris, 2nd edition (London and New York: Penguin Books, 1991), 180–85.

Bar of soap carved by a prisoner in Myanmar, 1999. Soap, 3 ⅞ × 2 × 1 inches
(10 × 5 × 2.5 cm). International Red Cross and Red Crescent Museum, Geneva

Cesar Chavez

(1927–1993)

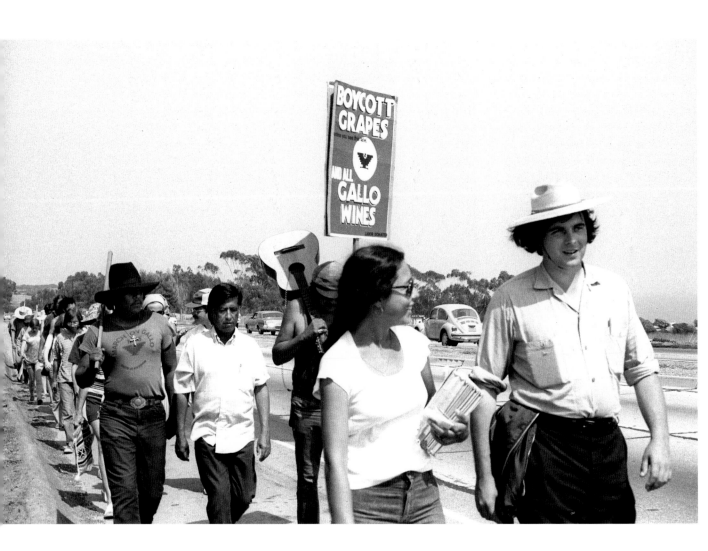

Cesar Chavez (second row) and others on the United Farm Workers'
1,000 Mile March drawing attention to the upcoming union elections,
California, Summer 1975. Photograph by Cathy Murphy. Getty Images

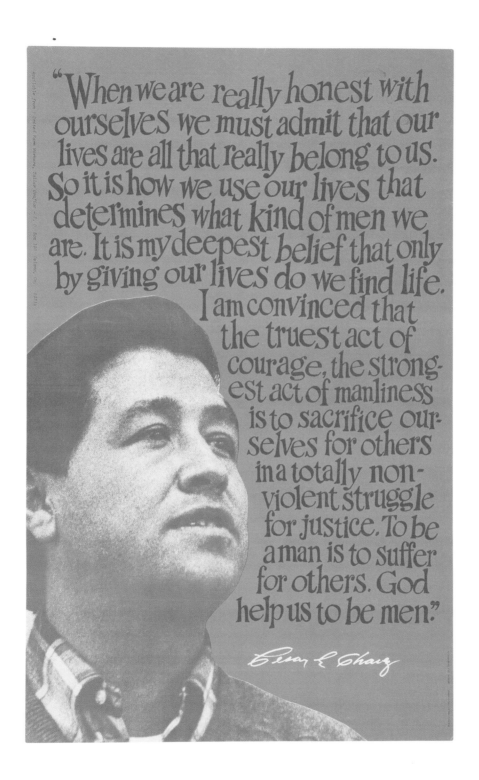

United Farm Workers poster with image of Cesar Chavez and a quote from one of his speeches, n.d. Designed by Leo Tanenbaum, photograph by Sid Harris. Offset lithograph on paper, 22 × 14 inches (55.9 × 35.6 cm). The Menil Collection, Houston

Óscar Romero

(1917–1980)

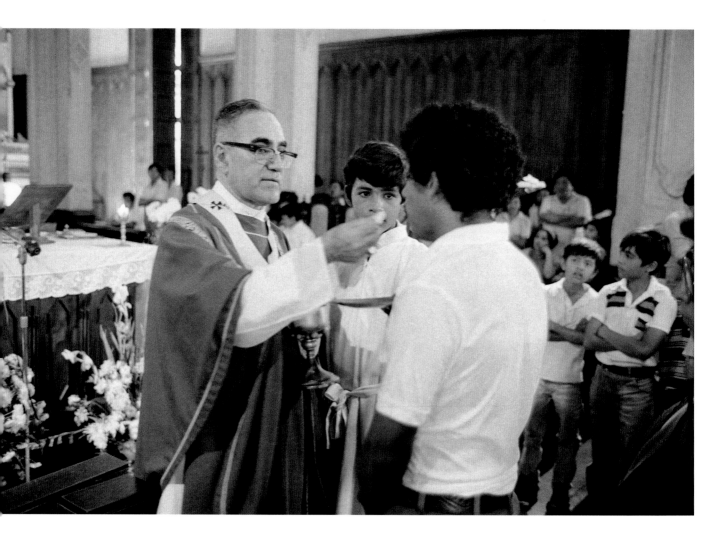

*Peace is not the product of terror or fear. Peace is not the silence of cemeteries.
Peace is not the silent result of violent repression. Peace is the generous, tranquil
contribution of all to the good of all. Peace is dynamism. Peace is generosity.
It is right and it is duty.*

— Óscar Romero, Archbishop of San Salvador (1917–1980) from his
homily for January 8, 1978, celebration of the Epiphany

The archbishop was gunned down, probably by government death
squads, on March 24, 1980, while celebrating Mass.

Óscar Romero giving communion, San Salvador, El Salvador,
October 1, 1979. Photograph by Alain Keler. Sygma/Corbis

Nobel Peace Prize Nomination Letter (1978)

House of Commons
London SW1A 0AA

Stortingets Nobelcommmittee,
Drammencveien 19,
Oslo,
Norway.

August 1978

We would like to strongly recommend Archbishop Oscar Arnulfo Romero y Galdames, Archbishop of San Salvador, El Salvador for the Nobel Peace Prize.

There is growing international awareness and concern over the increasing and widespread violations of human rights in so many countries through the world. Those who have the courage to speak out against abuses of human rights often run very grave risks. Archbishop Romero is an inspiring example of such a person. Since his appointment as Archbishop, he has consistently and uncompromisingly denounced the numerous arbitrary arrests, detentions, tortures, disappearances and killings taking place in El Salvador today. As a committed man of peace, he has rejected violence from whatever quarter and has advocated social and economic reforms to remove the injustices of El Salvador's poverty-ridden feudal society. Almost alone he has become the champion of the poor and defenceless. As a result he is subject to daily vilification in the press and elsewhere as insane, subversive, as a man who "sells his soul to the Devil."

On the thirtieth anniversary of the UN Declaration of Human Rights, we feel that Archbishop Romero is a particularly suitable candidate for the Nobel Peace Price and we hope that the Committee will take his candidature into serious consideration.

Yours sincerely,

[signatures of 116 members of the House of Commons and House of Lords]

The Chipko Movement, Wangari Maathai, Rigoberta Menchú Tum

Indigenous movements for the recognition of traditional land use, values, and rights often share Gandhian values both ethically and practically, whether resulting from explicit interactions or not. In addition to asserting the right to independence not only for India but for all peoples–especially people of color–Gandhi advocated a Constructive Program that centered on one model of localized, economic self-sufficiency; it was based on the Mahatma's belief that the agricultural village of traditional India was an ideal. The Chipko Movement of the 1970s for the preservation of hill country ecologies and economies in the Indian state of Uttarakhand (then Uttar Pradesh) represents a confluence of spontaneous nonviolent resistance to state-sponsored economic exploitation of the forests with Gandhian-inflected activism. Since the 1870s the Himalayan foothills had seen intermittent efforts by residents to preserve their forests and sustainable dependence on them from their sale by the British and then Indian governments to commercial and industrial interests. In 1973 and 1974, following disastrous floods worsened by deforestation, village communities were galvanized and organized highly visible and effective protests, including processions, the surrounding of work crews, and–symbolically at least–hugging trees to protect forest stands. (Chipko means "to hug.") In March 1974 the women of Reni village banded together to stop the commercial foresters,

bringing recognition to the important role of women in the movement and economic life of their cultures. Much of the groundwork for the women's actions in the region had been laid by two women followers of Gandhi, Mira Behn, who promoted replanting of appropriate native trees rather than cash-crop trees, and the organizer and ashram-founder Sarala Behn; their work was carried forward by Bimla Behn and her husband, the avowed *satyagrahi* Sunderlal Bahuguna. Although men's extractive economic cooperatives started by Gandhians were involved in conservation, most of the protests were organized locally and much of the risk was taken by women villagers. Not only did Chipko tactics spread to other regions and states in India–their lessons and techniques have been propounded by the Uttarakhand native Vandana Shiva–since that time women have been increasingly recognized for their vital roles in the traditional economies and cultures of indigenous communities on many continents.

Wangari Maathai (1940–2011) became famous not just as the first African woman to receive a Ph. D. and the first female university professor in her native Kenya but for her pivotal role in the reforestation of Central Africa and empowering women in the effort. In 1977 Maathai began a grassroots effort to mobilize village women to ameliorate the desertification that threatened traditional livelihoods, and in 1986 this

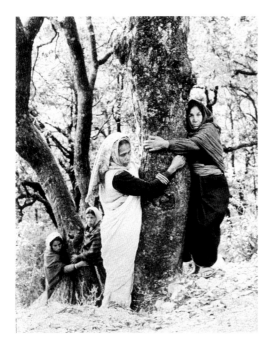

Above left Women in the Chipko Movement, ca. 1970s.
Photograph by Bhawan Singh. India Today Group/Getty Images

Above right Rigoberta Menchú Tum being honored after her nomination
for the Nobel Peace Prize, Rothko Chapel, Houston, April 29, 1992.
Photograph by Nicolas Russell. Rothko Chapel Archives, Houston

Below Wangari Maathai (center right) and others striving to save Karura forest,
Kenya, n.d. Anthony Kaminju/Independent Contributors/Africa Media Online

Green Belt Movement expanded into a Pan African Green Belt Network, which spread the work beyond Kenya and promoted ecological thinking by world leaders. More than thirty million trees have been planted. Maathai was known as a forceful voice for her causes and represented them to the United Nations. After being elected in 2002 to Kenya's National Assembly she was appointed assistant minister of environment, natural resources, and wildlife. Maathai was awarded the Nobel Peace Prize in 2004 for "her holistic approach to sustainable development that embraces democracy, human rights, and women's rights in particular."

The Quiche activist Rigoberta Menchú Tum was born in Guatemala in 1959, and as a Mayan grew up amid government repression of native people. While a teenager she began working for social reform through the Catholic Church and campaigned for the rights of women and indigenous minorities. After two years of intense activism during which she lost three family members to violence perpetrated by the Guatemalan army, Menchú went into hiding and then voluntary exile. A strong advocate for ending military oppression of minorities, Menchú became a noted promoter of ethnic and cultural reconciliation. In 1993–five hundred years after Christopher Columbus's arrival in the Americas–Menchú was

awarded the Nobel Peace Prize "in recognition of her work for social justice and ethno-cultural reconciliation based on respect for the rights of indigenous peoples." The next year she began serving as the United Nations' official spokesperson for the International Decade of Indigenous Peoples, and she remains an active voice for their rights.

The decentralized work of preservation and protection of land rights continues in many countries and across continents, and that in the Indian state of Odhisha (Orissa) is the subject of Amar Kanwar's installation and archive *The Sovereign Forest*.

Destruction of Palm-Trees.
ताड़ का सर्वनाश

महात्मा गांधी

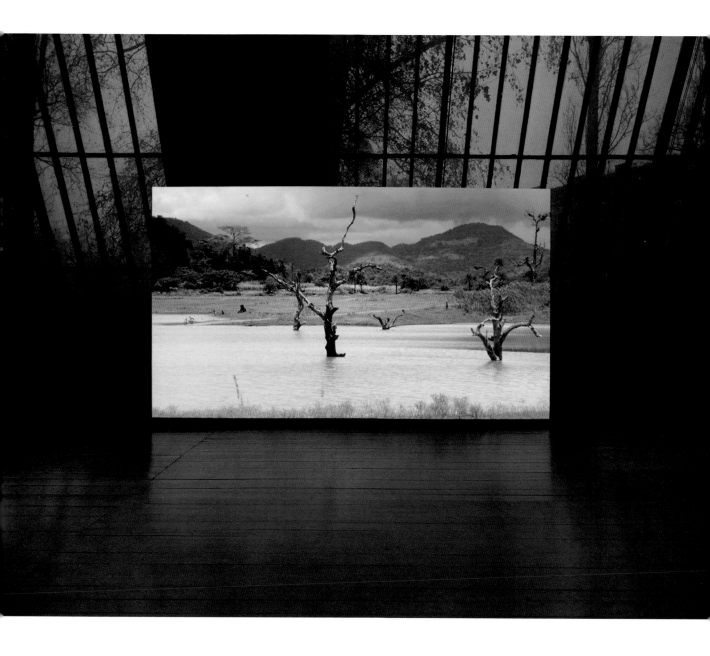

Opposite page Destruction of Palm Trees. Popular print, 14 ⅝ × 10 inches (37.1 × 25.4 cm).
Collection of Vinay Lal

Above Amar Kanwar (India, b. 1964), The Scene of the Crime, in The Sovereign Forest,
2012/ongoing. Mixed media installation: single-channel videos, handmade books with pro-
jections, handmade books, found evidence, and digitally-printed photographs; dimensions
variable. Courtesy of the artist and Marian Goodman Gallery, New York and Paris

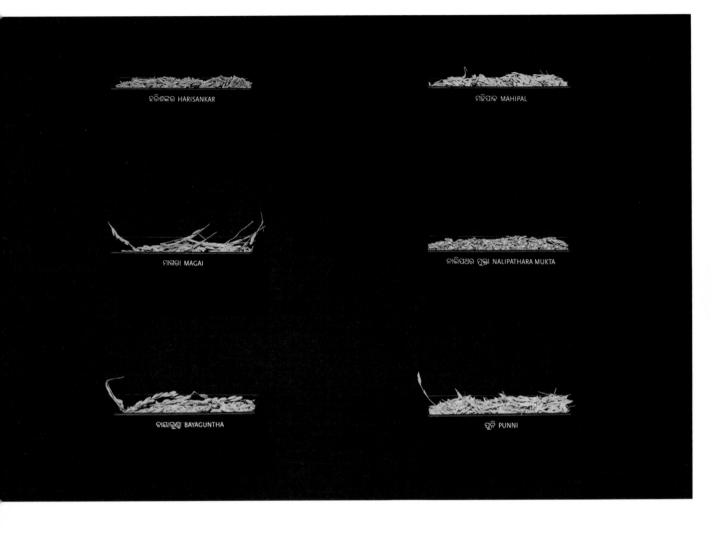

ହରିଶଙ୍କର HARISANKAR

ମହିପାଳ MAHIPAL

ମାଗାଇ MAGAI

ନଳିପଥର ମୁକ୍ତା NALIPATHARA MUKTA

ବାୟାଗୁଣ୍ଠା BAYAGUNTHA

ପୁନି PUNNI

Amar Kanwar, 272 Varieties of Indigenous Organic Rice Seeds (above) and Selections
from the Evidence Archive (opposite page), in The Sovereign Forest (see previous page)

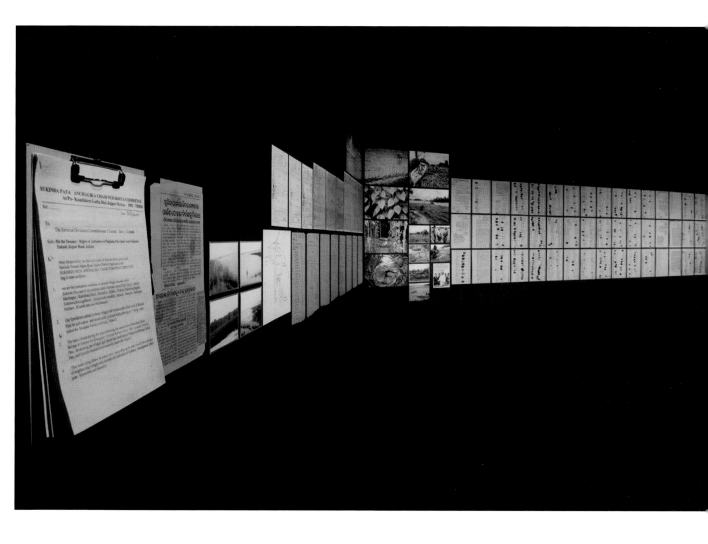

Gene Sharp

(b. 1928)

Gene Sharp has spent a lifetime studying and writing about theories, techniques, and tactics of nonviolent action, making them easily available in book form and now online. The utility of these materials is succinctly characterized by the name of a 2011 film about him and his methods: *How to Start a Revolution*. A native of Ohio, Sharp spent nine months in jail during the Korean War for protesting the drafting of soldiers; after his release he worked for the famous Christian pacifist and revolutionary A.J. Muste. Sharp spent most of the rest of the 1950s conducting research in London and Oslo. In 1960 his first book, *Gandhi Wields the Weapon of Moral Power: Three Case Histories*, was published in Ahmedabad by Navajivan Trust, a publishing house founded by Gandhi, and with a foreword by Albert Einstein. Almost twenty years later he published *Gandhi as a Political Strategist*. Sharp has taught or held research posts at several American and European universities, and is professor emeritus of political science at the University of Massachusetts, Dartmouth. In 1983 he founded the Albert Einstein Institute in Boston to "to advance the worldwide study and strategic use of nonviolent action in conflict."

Examining mechanisms of Gandhi's *satyagraha* (truth force), the work of Muste, and all manner of politics and political theory, Sharp has produced numerous studies of the mechanisms of state power as well as means for its disruption when it does not serve the people from whom, he says, political power ultimately derives. The three volume *The Politics of Nonviolent Action* (1973) is summative, and in recent years books whose texts are placed in the public domain and documents published on the Internet in multiple languages have made principles of nonviolent struggle easily available in most parts of the world. As stated on the Einstein Institute's website, Sharp "maintains that the major unsolved political problems of our time–dictatorship, genocide, war, social oppression, and popular powerlessness– require us to rethink politics in order to develop fresh strategies and programs for their resolution. He is convinced that pragmatic, strategically planned, nonviolent struggle can be made highly effective for application in conflicts to lift oppression and as a substitute for violence."

198 Methods of Nonviolent Action

THE METHODS OF NONVIOLENT PROTEST AND PERSUASION

Formal Statements

1. Public speeches
2. Letters of opposition or support
3. Declarations by organizations and institutions
4. Signed public declarations
5. Declarations of indictment and intention
6. Group or mass petitions

Communications with a Wider Audience

7. Slogans, caricatures, and symbols
8. Banners, posters, and displayed communications
9. Leaflets, pamphlets, and books
10. Newspapers and journals
11. Records, radio, and television
12. Skywriting and earthwriting

Group Representations

13. Deputations
14. Mock awards
15. Group lobbying
16. Picketing
17. Mock elections

Symbolic Public Acts

18. Displays of flags and symbolic colors
19. Wearing of symbols
20. Prayer and worship
21. Delivering symbolic objects
22. Protest disrobings
23. Destruction of own property
24. Symbolic lights
25. Displays of portraits
26. Paint as protest
27. New signs and names
28. Symbolic sounds
29. Symbolic reclamations
30. Rude gestures

Pressures on Individuals

31. "Haunting" officials
32. Taunting officials
33. Fraternization
34. Vigils

Drama and Music

35. Humorous skits and pranks
36. Performances of plays and music
37. Singing

Processions

38. Marches
39. Parades
40. Religious processions
41. Pilgrimages
42. Motorcades

Honoring the Dead

43. Political mourning
44. Mock funerals
45. Demonstrative funerals
46. Homage at burial places

Public Assemblies

47. Assemblies of protest or support
48. Protest meetings
49. Camouflaged meetings of protest
50. Teach-ins

Withdrawal and Renunciation

51. Walk-outs
52. Silence
53. Renouncing honors
54. Turning one's back

THE METHODS OF SOCIAL NONCOOPERATION

Ostracism of Persons

55. Social boycott
56. Selective social boycott
57. Lysistratic nonaction
58. Excommunication
59. Interdict

Noncooperation with Social Events and Institutions

60. Suspension of social and sports activities
61. Boycott of social affairs
62. Student strike
63. Social disobedience
64. Withdrawal from social institutions

Withdrawal from the Social System

65. Stay-at-home
66. Total personal noncooperation
67. "Flight" of workers
68. Sanctuary
69. Collective disappearance
70. Protest emigration (*hijrat*)

THE METHODS OF ECONOMIC NONCOOPERATION:

ECONOMIC BOYCOTTS

Action by Consumers

71. Consumers' boycott
72. Nonconsumption of boycotted goods
73. Policy of austerity
74. Rent withholding
75. Refusal to rent
76. National consumers' boycott
77. International consumers' boycott

Action by Workers and Producers

78. Workers' boycott
79. Producers' boycott

Action by Middlemen

80. Suppliers' and handlers' boycott

Action by Owners and Management

81. Traders' boycott
82. Refusal to let or sell property
83. Lockout
84. Refusal of industrial assistance
85. Merchants' "general strike"

Action by Holders of Financial Resources

86. Withdrawal of bank deposits
87. Refusal to pay fees, dues, and assessments
88. Refusal to pay debts or interest

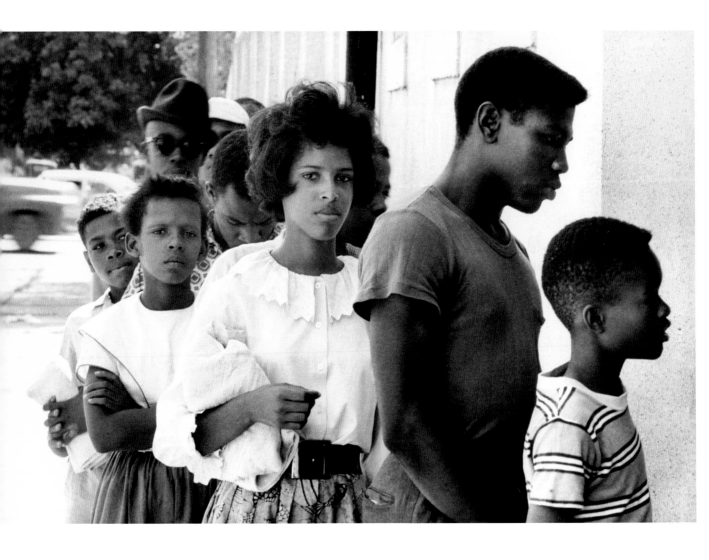

Danny Lyon (United States, b. 1942), Demonstration at an "all-white"
swimming pool in Cairo, Illinois, 1962, printed 2000. Gelatin silver print,
11 × 14 inches (27.9 × 35.6 cm). The Menil Collection, Houston,
Gift of Edmund Carpenter and Adelaide de Menil

Domestic Governmental Action

149. Quasi-legal evasions and delays
150. Noncooperation by constituent governmental units

International Governmental Action

151. Changes in diplomatic and other representation
152. Delay and cancellation of diplomatic events
153. Withholding of diplomatic recognition
154. Severance of diplomatic relations
155. Withdrawal from international organizations
156. Refusal of membership in international bodies
157. Expulsion from international organizations

THE METHODS OF NONVIOLENT INTERVENTION

Psychological Intervention

158. Self-exposure to the elements
159. The fast
 a) Fast of moral pressure
 b) Hunger strike
 c) *Satyagrahic* fast
160. Reverse trial
161. Nonviolent harassment

Physical Intervention

162. Sit-in
163. Stand-in
164. Ride-in
165. Wade-in
166. Mill-in
167. Pray-in
168. Nonviolent raids
169. Nonviolent air raids
170. Nonviolent invasion
171. Nonviolent interjection
172. Nonviolent obstruction
173. Nonviolent occupation

Social Intervention

174. Establishing new social patterns
175. Overloading of facilities
176. Stall-in
177. Speak-in
178. Guerrilla theatre

179. Alternative social institutions
180. Alternative communication system

Economic Intervention

181. Reverse strike
182. Stay-in strike
183. Nonviolent land seizure
184. Defiance of blockades
185. Politically motivated counterfeiting
186. Preclusive purchasing
187. Seizure of assets
188. Dumping
189. Selective patronage
190. Alternative markets
191. Alternative transportation systems
192. Alternative economic institutions

Political Intervention

193. Overloading of administrative systems
194. Disclosing identities of secret agents
195. Seeking imprisonment
196. Civil disobedience of "neutral" laws
197. Work-on without collaboration
198. Dual sovereignty and parallel government

Catalogued by Gene Sharp and first published in
The Politics of Nonviolent Action 3 vols. (Boston: Porter
Sargent, 1973). From the Albert Einstein Institution
website, www.aeinstein.org.

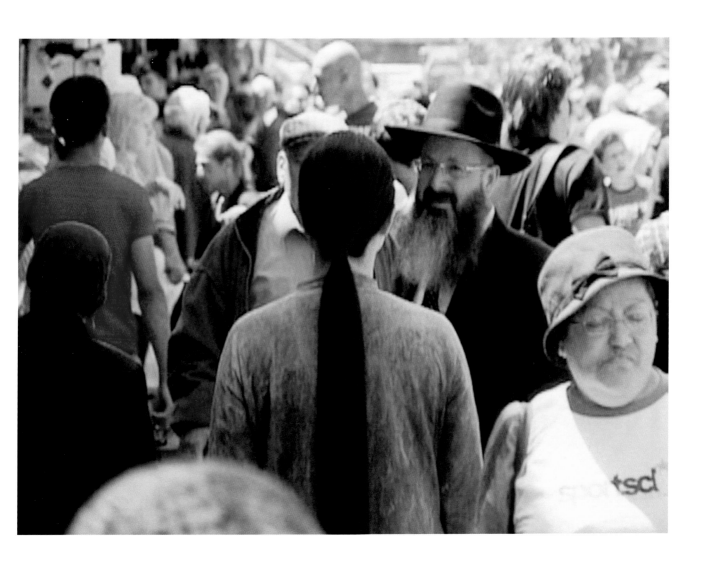

Kimsooja (b. South Korea 1957, active United States), A Needle Woman (Jerusalem), 2005.
Six-channel video projection, color, 10 min. 40 sec. loop. Courtesy of Kimsooja Studio

A Needle Woman

When making a performance video on the streets of Tokyo, after walking around for two hours, I came to a street in Shibuya where hundreds of thousands of people were passing, like waves of a human ocean ebbing and flowing. I couldn't walk anymore and had to stop right there and be still in order to tame the inner scream accumulating in my body from the energy of all the people. It was a breathtaking moment. As it became more and more extreme I felt as if I were getting wrapped inside of my own body like a bundle. Standing still, creating a contradictory position against the flow of the pedestrians, like a needle or an axis, I observed and contemplated their passing, weaving through and against my body as a medium.

I felt a great empathy for the humanity around me, just by gazing at people coming and going. It's a short moment, but in it one can grasp the essence of human reality, and I felt affection toward the people I was encountering. All of those emotions about people were accumulating in my body and embracing me. The presence of my body seemed to be gradually erased by the crowd. Simultaneously, my sustained immobility was leading me toward a state of peace and balance in my mind, and I passed through the state of tension between the self and others—and reached a point at which I could bring and breathe others into my own body and mind. My heart began to slowly fill with compassion and affection for all human beings living today. Experiencing the extreme state that the body and mind could reach, and embracing

Kimsooja, A Needle Woman (Havana; Patan, Nepal; Rio de Janiero, Brazil; N'Djameno, Chad), 2005. Six-channel video projection, color, 10 min. 40 sec. loop. Courtesy of Kimsooja Studio

sympathies for humankind, paradoxically liberated my mind and body from the crowd. I saw an aura of a bright white light emerging from an unknown source beyond the horizon, and I cannot help but feel that it was a mysterious, transcendental experience.

This powerful experience enabled me to meet the people in the world's most crowded cities. For the first series of *A Needle Woman* performances (1999–2001), I chose the most populous locations in order to meet oceans of people: Shanghai, Delhi, Cairo, New York, Mexico City, London, and Lagos. Before this, I wasn't really acutely aware of the conflicts, violence or poverty that exist around the world, or how challenging and violent the world seems. In 2005 I created another series of *A Needle Woman* performances dedicated to cities in conflict, ones experiencing poverty, violence, postcolonialism, civil wars, and religious conflicts: Patan in the Kathmandu Valley, Havana, Rio de Janeiro, N'Djamena in Chad, San'a in Yemen, and Jerusalem. My intention was to present a critical perspective on current conditions of humanity. Created in slow motion, it was another opportunity for me to explore the question of time, long important to me, and shows the subtlety of relationships between bodies, and their emotional transitions and psychologies. The condition of humanity in each place and my growing inner awareness intersect, leading to deeper and broader questions.

The spiritual dimension in twentieth-century abstract painting
is a matter of aesthetically autonomous construction that can reflect spiritual
beliefs without ever being a translation of them.
 – Ulrich Loock

Suzan Frecon (United States, b. 1941), indigo form on found scrap of old Indian
paper ("darkened water," from Rumi), 2009. Watercolor on found old Indian paper,
5 ½ × 6 ⅜ inches (14 × 16.2 cm). Courtesy of the artist and David Zwirner, New York/London 237

The Sermon on The Mount

Matthew 5

1. And seeing the multitudes, he went up into a mountain: and when he was set, his disciples came unto him:

2. And he opened his mouth, and taught them, saying,

3. Blessed are the poor in spirit: for theirs is the kingdom of heaven.

4. Blessed are they that mourn: for they shall be comforted.

5. Blessed are the meek: for they shall inherit the earth.

6. Blessed are they which do hunger and thirst after righteousness: for they shall be filled.

7. Blessed are the merciful: for they shall obtain mercy.

8. Blessed are the pure in heart: for they shall see God.

9. Blessed are the peacemakers: for they shall be called the children of God.

10. Blessed are they which are persecuted for righteousness' sake: for theirs is the kingdom of heaven.

11. Blessed are ye, when men shall revile you, and persecute you, and shall say all manner of evil against you falsely, for my sake.

12. Rejoice, and be exceeding glad: for great is your reward in heaven: for so persecuted they the prophets which were before you.

13. Ye are the salt of the earth: but if the salt have lost his savour, wherewith shall it be salted? it is thenceforth good for nothing, but to be cast out, and to be trodden under foot of men.

14. Ye are the light of the world. A city that is set on an hill cannot be hid.

15. Neither do men light a candle, and put it under a bushel, but on a candlestick; and it giveth light unto all that are in the house.

16. Let your light so shine before men, that they may see your good works, and glorify your Father which is in heaven.

…

38. Ye have heard that it hath been said, An eye for an eye, and a tooth for a tooth:

39. But I say unto you, That ye resist not evil: but whosoever shall smite thee on thy right cheek, turn to him the other also.

40. And if any man will sue thee at the law, and take away thy coat, let him have thy cloke also.

41. And whosoever shall compel thee to go a mile, go with him twain.

42. Give to him that asketh thee, and from him that would borrow of thee turn not thou away.

43. Ye have heard that it hath been said, Thou shalt love thy neighbour, and hate thine enemy.

44. But I say unto you, Love your enemies, bless them that curse you, do good to them that hate you, and pray for them which despitefully use you, and persecute you;

45. That ye may be the children of your Father which is in heaven: for he maketh his sun to rise on the evil and on the good, and sendeth rain on the just and on the unjust.

46. For if ye love them which love you, what reward have ye? do not even the publicans the same?

47. And if ye salute your brethren only, what do ye more than others? do not even the publicans so?

48. Be ye therefore perfect, even as your Father which is in heaven is perfect.

Excerpted from the Book of Matthew, in the King James Version of the Protestant Bible

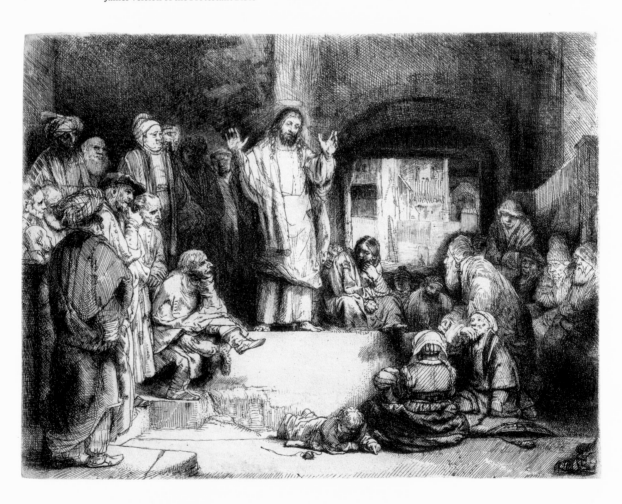

Rembrandt van Rijn (Netherlands, 1606–1669), "La Petite Tomb," Christ Preaching, ca. 1652. Etching, drypoint, and engraving on paper, 6 ⅛ × 8 ⅜ inches (15.5 × 20.6 cm). The Menil Collection, Houston

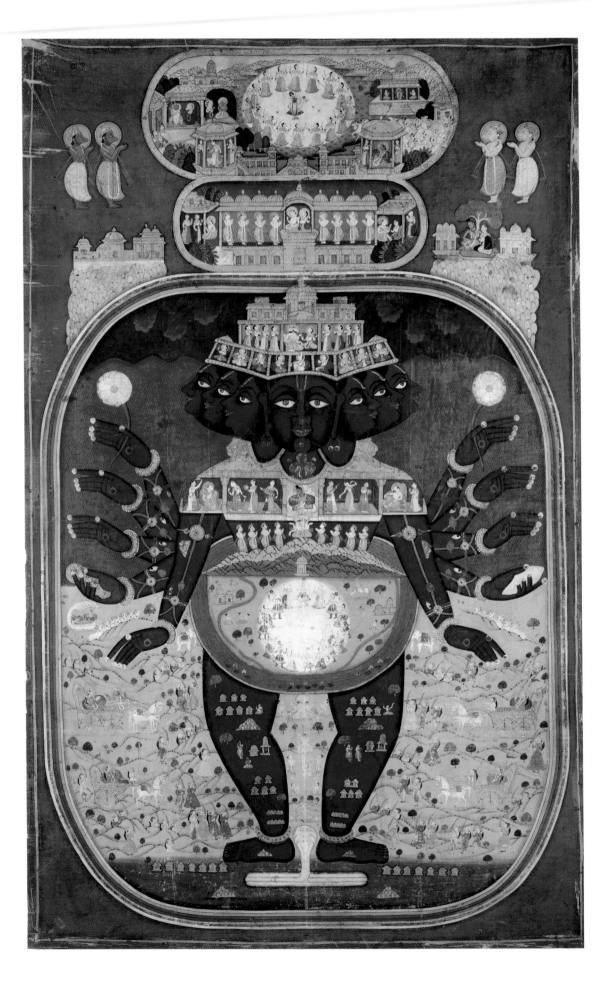

Bhagavad Gita, GANDHI'S FAVORITE PASSAGE
The Song of The Lord (Krishna)

Chapter 2, verses 54–72

Arjuna
Krishna, what defines a man
deep in contemplation whose insight
and thought are sure? How would he speak?
How would he sit? How would he move?

Krishna
When he gives up desires in his mind,
is content with the self within himself,
then he is said to be a man
whose insight is sure, Arjuna.

When suffering does not disturb his mind,
when his craving for pleasures has vanished,
when attraction, fear, and anger are gone,
he is called a sage whose thought is sure.

When he shows no preference
in fortune or misfortune
and neither exults nor hates,
his insight is sure.

When, like a tortoise retracting
its limbs, he withdraws his senses
completely from sensuous objects,
his insight is sure.

Opposite page Krishna in His Universal Form (Vishvarupa). India, Rajasthan; 19th or 20th century. Opaque watercolor and gold on cloth, 56 × 36 inches (142.2 × 91.4 cm). Nancy Wiener Gallery, New York

Sensuous objects fade
when the embodied self abstains from food;
the taste lingers, but it too fades
in the vision of higher truth.

Even when a man of wisdom
tries to control them, Arjuna,
the bewildering senses
attack his mind with violence.

Controlling them all,
with discipline he should focus on me;
when his senses are under control,
his insight is sure.

Brooding about sensuous objects
makes attachment to them grow;
from attachment desire arises,
from desire anger is born.

From anger comes confusion;
from confusion memory lapses;
from broken memory understanding is lost;
from loss of understanding, he is ruined.

But a man of inner strength
whose senses experience objects
without attraction and hatred,
in self-control, finds serenity.

In serenity, all his sorrows
dissolve;
his reason becomes serene,
his understanding sure.

Without discipline,
he has no understanding or inner power;
without inner power, he has no peace;
and without peace where is joy?

If his mind submits to the play
of the senses,
they drive away insight,
as wind drives a ship on water.

So, Great Warrior, when withdrawal
of the senses
from sense objects is complete,
discernment is firm.

When it is night for all creatures,
a master of restraint is awake;
when they are awake, it is night
for the sage who sees reality.

As the mountainous depths
of the ocean
are unmoved when waters
rush into it,
so the man unmoved
when desires enter him
attains a peace that eludes
the man of many desires.

When he renounces all desires
and acts without craving,
possessiveness,
or individuality, he finds peace.

This is the place of the infinite spirit;
achieving it, one is freed from delusion;
abiding in it even at the time of death,
one finds the pure calm of infinity.

Translation by Barbara Stoler Miller

The Bhagavad-Gītā: Krishna's Counsel in Time of War,
translated and with an introduction and afterword
by Barbara Stoler Miller (New York: Bantam, 1986),
39–42.

Raghupati Raghav Raja Ram

In the Gangetic Plains, the terrain that Gandhi made his own as he came to assume the leadership of the movement for Indian independence, villagers have for centuries commonly greeted each other and strangers with the words "Ram-Ram" and "Jai Siya Ram." Much of north India is also *Ramcaritmanas* country, where the sixteenth-century poet-saint Tulsidas's majestic retelling of the Rama story holds sway. Gandhi himself came to venerate the text, even if he was critical of some of its passages, but it is equally certain that his idea of Rama–often described in textbooks as an incarnation of Vishnu but held up by his devotees as the supreme God, an ideal ruler, and a perfectly realized being–was not derived only from the *Ramcaritmanas*. Gandhi gave it as his opinion, in an article published in *Young India* on January 22, 1925, that "Rama, Allah and God are to me convertible terms," and on subsequent occasions he came to affirm the idea that the Rama of which he spoke had no correspondence to "the historical Rama," a ruler of Ayodhya and the son of King Dasharatha (*Harijan*, April 28, 1946). Indeed, "true understanding," when "the little self perishes and God becomes all in all," required one to disavow all the common associations conjured by the name of Rama: "Rama, then, is not the son of Dasharatha, the husband of Sita, the brother of Bharata and Lakshmana and yet is God, the unborn and eternal" (*Harijan*, September 22, 1946).

In his youth, on Gandhi's own testimony, he was urged by his nurse Rambha to take the name of Rama when in distress, and he held this counsel close to his heart throughout his life. The utterance of the name of Rama was "an infallible remedy" and "a cure for all disease," wrote Gandhi in his journal *Harijan* on March 24, 1946, a point reinforced in rather more striking language on October 13 of the same year: "I have said that to take Ramanama from the heart means deriving help from an incomparable power. The atom bomb is as nothing compared with it. This power is capable of removing all pain." But the name of Rama was not to be taken in jest, and it should come from the heart, for "to attain the reality is very difficult." To install the Ramanama in one's heart in turn required "infinite patience" and a cultivation of the "virtues of truth, honesty and purity within and without" (Speech at Prayer Meeting, May 25, 1946).

It may have been to facilitate the recitation of the Ramanama, and to lodge the names of the divine pair Sita and Ram in one's heart, that Gandhi perhaps found so endearing the devotional song beginning, "*Raghupati raghav raja Ram / patit pavan Sita Ram*" (Chief of the House of Raghu, Lord Ram / Saviors of the downtrodden, Sita and Ram). Known in popular parlance as the *Ramdhun*, the *bhajan* (devotional song) goes on to affirm the presence of "Sita Ram," showering praise on them, and concluding: "God and Allah are your names / May God bestow wisdom on all" (*Ishvar Allah tere nam / sab ko sanmati de bhagavan*). Muslims, Hindus, Christians, and the practitioners of other faiths may all know God by different names, but Gandhi did not doubt that behind this multifariousness in form there was one essential unity. Yet Indian civilization was ecumenical in other respects, too, and the Ramdhun controverts the reading, rendered more common with the advent of Hindu nationalism, of Rama as a wholly patriarchal figure. Gandhi was not among those who thought of Sita as only Rama's consort, and she was much more than the perfect wife and the idealized form of womanliness. As in the many diverse traditions of the story of Rama, Gandhi was inclined to accept Sita as the equal of Rama in every respect, and, on account of her unrivaled capacity for sacrifice, a greater embodiment of the power of nonviolence.

While the origins of the Ramdhun are not entirely clear, reportedly Vishnu Digambar Paluskar (1872–1931), one of those credited with securing the foundations of Hindustani classical music, composed the Ramdhun for Gandhi with the hope that he would take it to the masses. We may say, echoing Pablo Neruda's majestic "Ode to Paul Robeson"– "And the voice of Paul Robeson / was divided from the silence"–that when Paluskar's son, the child prodigy D.V. Paluskar (1921–1955), sang the Ramdhun, it sent his listeners into a blissful trance. The Ramdhun, alongside Narasinha Mehta's bhajan *Vaishnavajana to*, became a staple at Gandhi's daily prayer meetings, and Gandhi would often discourse on the power of the Ramdhun, even likening it to the tune of a military band to which hundreds of thousands of nonviolent soldiers could march in disciplined unison. Narayan Desai, the son of Gandhi's beloved secretary Mahadev Desai, who spent some years of his childhood around Gandhi, later recalled that the Ramdhun seemed to have become popular during the Salt March and the subsequent civil disobedience movement, and it continues to resonate strongly, and not only among devout Hindus, in contemporary India.

VINAY LAL

Raghupati Raghav Raja Ram

TRADITIONAL

Chief of the Raghu family, Lord Rama,
Purifiers of the fallen, Sita and Rama.

Sita and Rama, Sita and Rama,
Dear friend, sing the glory of Sita and Rama.

Ishvar and Allah are your names.
Lord, bless everyone with noble understanding!

raghupati raghav raja ram,
patit pavan sita ram.

sita ram, sita ram,
bhaj pyare tu sita ram.

ishvar allah tere nam
sab ko sanmati de bhagavan

Translation by Neelima Shukla-Bhatt

Rama is the hero of the epic *Ramayana*, worshipped
by Hindus as an incarnation of Vishnu. Sita is Rama's
wife, considered an incarnation of Vishnu's
consort Lakshmi.

In Indic languages, *Ishvar* is "Lord" or "God,"
as is *Allah* in Arabic and Islamic traditions.

Vaishnavajana to

NARASHINA MEHTA

Call only that one a true Vaishnava (religious) person,
 who understands others' pain;
 who helps them in their suffering,
 but has no arrogance in his heart.

The one
 who bows to everyone in the world,
 and speaks ill of none,
 who is unwavering in speech, action, and thought,
 truly blessed is his mother!

The one
 who sees everyone as equal, and has given up desires,
 who views another's wife as mother,
 whose tongue does not lie,
 who does not touch another's wealth,
 who is not bound by illusory attachments,
 whose detachment is firm,
 and whose heart is immersed in Ram's name.
 all places of pilgrimage are within his body.

The one
 who is without greed or deceit,
 who has subdued anger and lust,
 on seeing that one, says Narasainyo:
 seventy-one generations are saved.

Translation by Neelima Shukla-Bhatt, from her
*Narasinha Mehta of Gujarat: A Legacy of Bhakti in Songs
and Stories* (New York: Oxford University Press, 2014).

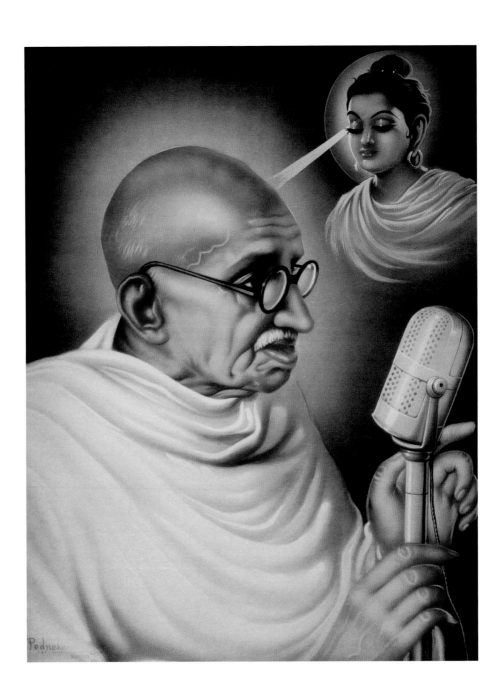

The Communication of Wisdom: The Buddha, Gandhi, and All-India Radio.
Popular print, 19 ⅝ × 13 ¾ inches (49.8 × 34.9 cm). Collection of Vinay Lal

VAISHNAVAJANA TO

Gandhi's Anthem for Moral Inspiration

An important experiment undertaken by Gandhi in both South Africa and India was communal living with interfaith prayers as one of its core components. In daily prayer meetings at his communes, the residents sang hymns from diverse religious traditions that were later compiled in *Ashram Bhajanvali (Collection of Ashram Devotional Songs)*. Gandhi was deeply fond of them. But among all the hymns he knew, *Vaishnavajana to*, a popular devotional song by Gujarat's saintly poet Narasinha Mehta (fifteenth century) that defines a religious person in terms of compassion and moral integrity, remained his favorite. "That hymn is enough to sustain me," he once said, "even if I were to forget the *Bhagavad Gita*."[1] In view of Gandhi's attachment to the *Gita*, the Hindu sacred text that he regarded as his "mother," this statement clearly indicates his attachment to the song.[2] Indeed Gandhi's secretary and translator of his autobiography Mahadev Desai termed *Vaishnavajana to* "almost as life-breath of Gandhiji."[3]

Gandhi's writings make recurrent references to the hymn. It was regularly performed in his ashrams and at all important moments in his public and personal life, including his son's wedding and wife's death. Traditionally sung in the morning-hymn tune (*prabhatiyu*) popular in Gujarat, it was set to a new semiclassical tune–raga Mishra Khamaj–by Narayan Khare in 1920s, enhancing its appeal for people across India. Gandhi made his attachment to the hymn widely known and incorporated it in his public life. He effectively lifted the song out of its traditional context of Hindu devotion in Gujarat and brought it to the national public platform as a song of moral inspiration.

Why did this song so resonate with Gandhi? Growing up in Gujarat, he must have known it since childhood. But the song seems to have grown on him gradually. His writings indicate that the hymn appealed to him because it lays out a pathway for moral perfection in simple and moving words. He found his favorite teachings from diverse religions crystallized in it.[4] The first quality listed in the song is compassion, which Gandhi often identified as the most important criterion for evaluating

1 *Young India,* December 10, 1925, in *Collected Works of Mohandas Gandhi* (CWMG [Electronic]), http://www.gandhiserve.org/e/cwmg/cwmg.htm, 33:273 (accessed February 12, 2014).

2 See Gandhi's *Gita: My Mother,* ed. Anand T. Hingorani (Bombay: Bharatiya Vidya Bhavan, 1965).

3 *Harijan,* June 3, 1933, CWMG (E) 61:480.

4 Narayan Desai, *My Life is My Message,* Vol. 3, *Satyapath (1930–1940),* trans. Tridip Suhrud (New Delhi: Orient BlackSwan, 2009), 102.

a religion. A comparison of the song with the Sermon on the Mount from the New Testament (Matthew Chapters 5–7), Gandhi's favorite Christian text, shows striking similarities in terms of content and form. Both *Vaishnavajana to* and the Sermon on the Mount contain definitions of a follower of true religiousness. Both highlight the virtues of compassion, humility, truthfulness, purity of heart, and firmness in righteous behavior. Further, the definitions offered by these texts do not refer to qualities of a spiritual person as mere abstractions. They emphasize how such a person acts with moral integrity and compassion in relation to others.

Gandhi, a man of action, not only incorporated *Vaishnavajana to* in the daily prayers at his ashrams, he actively used it in his social reconstruction programs. In early 1920s, he employed it in his fight against the practice of untouchability (treating some groups as too polluted to touch) in Hindu society. He argued in a series of articles that the true definition of a Hindu and a worshipper of Vishnu is contained in this hymn; and not in the texts upheld by the orthodoxy that discriminate people based on the notions of purity and pollution. He also alluded to Narasinha Mehta's own example of disregarding such notions and associating freely with people from all strata of his society. He thus effectively drew on the popularity of the hymn and the saint among Hindus of Gujarat to make his argument for an important reform at the beginning of his public career in India.

Gradually, Gandhi took the hymn beyond this context. While still in South Africa, he had discovered that *Vaishnavajana to* appealed also to his devout Christian and Muslim friends who sometimes requested the singers at his commune to replace the word "Vaishnava" with "Christian" or "Muslim." In view of the song's appeal for non-Hindus, Gandhi saw in it a powerful vehicle to convey his idea of a moral person to larger publics.

As Gandhi's stature grew in India, along with verses from the *Gita* and short prayers from world religions, the performance of *Vaishnavajana to* became an integral part of important public events in Gandhi's life. It was sung at the beginning and end of his many fasts. During his famous Salt March, which he undertook as a way of noncooperation with the British government, it was sung at the beginning, several times on the way, at the time of the actual breaking of law in collecting salt, and then the moment of Gandhi's arrest. With repeated performances, the song

drew immense media attention and began to circulate in India beyond Gandhi's ashrams and communities of followers in Gujarat. Within Gandhi's lifetime, the song had moved beyond the sphere of traditional religion as a cultural resource for moral inspiration.

Today, *Vaishnavajana to* continues to be performed as a tribute to Gandhi in multiple contexts. Often, it forms a part of celebrations related to the Mahatma or the Indian nation.[5] It was played during President Obama's visit to India and at the inauguration of the Commonwealth Games in New Delhi in October 2010. The song is often performed in the contexts of peace-building projects inspired by Gandhi. Two recent peace marches had the song interwoven in their formats. One was a journey of a group of Gandhians (October 2010–February 2011) to spread the message of peace across India. The other peace march, termed "International Dandi March" emulating Gandhi's Salt March, was undertaken by political activists from India and Pakistan who traveled to Gaza via Iran, Syria, and Egypt (December 2010–January 2011). The group, composed of Hindus, Muslims, Buddhists, atheists, and followers of other religions, sang *Vaishnavajana to* at all important meetings on the way.[6] A version is found, for example, on the website of the Gandhi-King Community for Global Peace with Social Justice in a Sustainable Environment.[7]

In its continuing journey in the public sphere, the song has taken a life of its own even without reference to Gandhi. It has become so deeply associated in India's public culture with service to the underprivileged that its performance recurs at related events organized by people of Indian origin in all parts of the world. On April 2, 2011, it was performed at the beginning of benefit concert organized by the Boston, Massachusetts, chapter of Nanhi Kali, an organization promoting the education of poor girls in India.[8] A charity event for the disabled held in March 2011 in Kolkata was advertised with a clip of the song on the Internet-based social network Facebook.[9] In several Hindi movies produced in Bollywood, the song or its instrumental rendering plays in the background during scenes related to service and moral inspiration. Comments on the numerous recordings of the song on YouTube reflect how it touches deep chords in the hearts of the listeners. "Peace and solace is [*sic*] always restored with the serene words and the sweet tune," one commenter writes and describes it as "a song for life, happiness, serenity and beyond." Even more moving are the interfaith and intercultural dialogs occurring in these comments.

5 For example, on October 2, 2009, at a grand celebration of Gandhi's birthday, it was performed in Chennai by non-Gujaratis for a South Indian audience. See *The Hindu*, October 10, 2009.

6 Subhajit Roy, "Gandhigiri with Hamas, Ahmedinejad," *Indian Express*, January 11, 2011, http://www.indianexpress.com/news/gandhigiri-with-hamas-ahmedinejad/735905/1 (accessed May 22, 2011).

7 http://gandhiking.ning.com/video/vaishnav-jan-to-tene-kahiye-gandhi-ji-favorite-hymn-2nd-oct (accessed May 22, 2011).

8 "Nanhi Kali Benefit Concert by the Mt. Auburn String Quartet," Nanhi Kali, Boston Chapter, http://nanhikaliboston.org/nanhi-kali-benefit-concert-by-the-mt-auburn-string-quartet (accessed May 22, 2011).

9 See http://www.facebook.com/goddessdurga/posts/129785757091277 (accessed May 22, 2011).

The journey of *Vaishnavajana to* is strikingly similar to that of the most-widely sung Christian hymn in English, *Amazing Grace*. Written by John Newton, *Amazing Grace* has traveled from a small parish of late-eighteenth-century England to many parts of the English-speaking world, overflowing from religious to nonreligious contexts as a song of hope and renewal. It has been sung in venues as diverse as demonstrations during the Civil Rights movement led by Martin Luther King Jr., a concert honoring Nelson Mandela, and ceremonies related to the September 11, 2001, tragedy in New York. Its power to touch the deepest chords of people's moral being, has made it perhaps "America's most beloved song."[10] *Vaishnavajana to* has emerged as such a song in India and traveled beyond its shores, offering an image of a person with whom people dedicated to service and peace can identify. Gandhi's deep engagement with the song at multiple levels was yet another of his experiments with truth.

NEELIMA SHUKLA-BHATT

10 Steve Turner's book *Amazing Grace: The Story of America's Most Beloved Song* (New York: Ecco, 2002) narrates the story of the composition of the song and its dissemination.

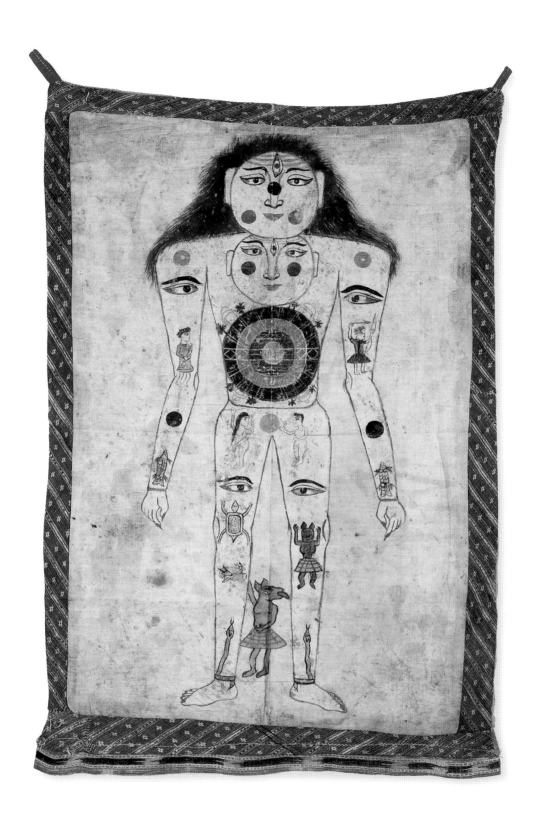

Cosmic Man. India, 19th century. Opaque watercolor on cloth, 19 ½ × 13 ⅜ inches
(49.5 × 34 cm). The Menil Collection, Houston, Gift of Sonali Sen Ray

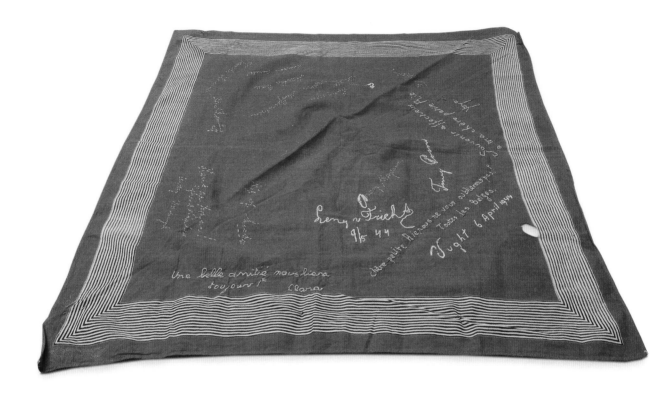

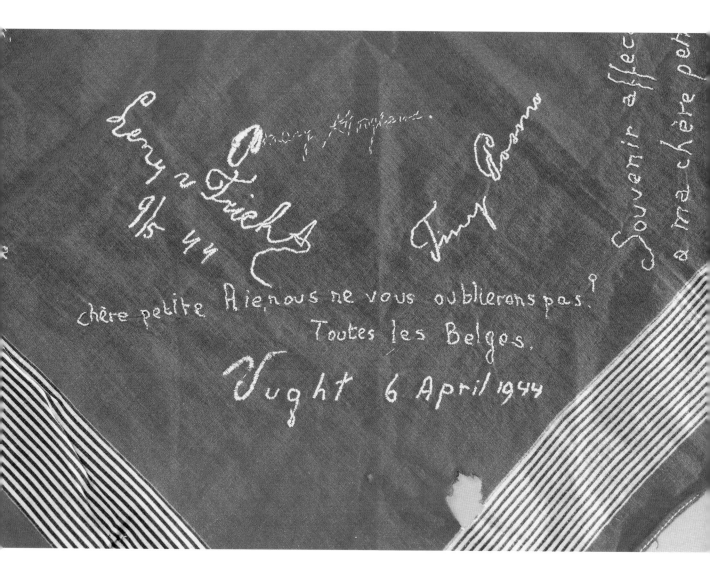

Kerchief issued to Maria Margaretha Spronk-Hughes at Vught Concentration Camp
as part of the uniform, embroidered with names of fellow prisoners, 1944.
Fabric with embroidery thread, 21 ¼ × 23 ¼ inches (54 × 59.1 cm). On loan from
Maria Margaretha Spronk-Hughes, Courtesy of Holocaust Museum Houston

Folio from a Qur'an in Hijazi script, Sura 15. ca. 650–700. Ink on parchment,
14 ¼ × 10 ⅝ inches (36 × 27 cm). The Museum of Fine Arts, Houston,
Collection of Cathy Kooros

Five Great Jain Vows

Non-violence or Non-injury, *Ahimsa*
Truth, *Satya*
Non-stealing, *Achaurya* or *Asteya*
Celibacy or Chastity, *Brahmacharya*
Non-attachment or Non-possession, *Aparigraha*

Five Moral Principles of Yoga

Non-violence
Truthfulness
Abjuration of stealing
Celibacy
Absence of Greed

Gandhi's Vows
for the Satyagraha Ashram

Truth, *Satya*
Love, *Ahimsa*
Chastity, *Brahmacharya*
Control of the Palate
Non-Stealing
Non-possession or Poverty
Fearlessness
Removal of Untouchability
Bread Labor
Tolerance for the equality of religions
Humility
Sacrifice, *Yajna*
Swadeshi, self-sufficiency through cottage industry

Respectively: The Jinas Parshvanatha and Mahavira;
Yoga Sutra of Patanjali, 2:30, trans. B.S. Miller;
M.K. Gandhi, *From Yeravda Mandir* (Ashram
Observances, 1930), SWMG 4.

Meditating Jina

The Jain religion–famous for its doctrine of non-harming, or *ahimsa*–is based on teachings attributed to twenty-four teachers called Jinas, meaning liberator or conqueror. Jain art often depicts the different Jinas for reverence by worshippers and as examples of those who have achieved the goal of liberation, leaving the wheel of rebirth, through ascetic practices. Both of these images show naked, or "sky clad" (Digambara), figures. The stone figure from eastern India (p. 1) depicts the Jina Rishabhanatha, the first liberator, and the south Indian bronze (opposite) probably depicts the twenty-fourth and most recent Jina, Mahavira, whose life was approximately contemporary with that of Gautama the Buddha. The auspicious mark visible on the chest of the stone example indicates unequivocally that he is a Jina (many other aspects of style and iconography are very similar to Buddhist images from the same place and time). Both sit in postures of meditation and embody the calm of one who has crossed over from the chaos of the mundane world to that of the liberated being.

The art historian Pratapaditya Pal in his exhibition catalogue *The Peaceful Liberators: Jain Art from India,* has said of the bronze that "few sculptures in the entire range of Indian art have realized the ideal yogi as perfectly this bronze figure. Although the proportions are idealized, the meditating figure is convincingly lifelike. Even as the body is immobile, it exudes a spiritual vitality that is almost palpable."

Gandhi, called by many a mahatma or great soul, drew strength from his own meditation and prayerful attitude and attributed much of his worldly achievement to a strong spiritual base and the focus that a day of silence every Monday imparted. Many would compare him with the passage from the *Bhagavad Gita* quoted by Pal to describe this sculptured Jina:

Let the yogin yoke himself at all times, while remaining in retreat, solitary, in control of his thoughts, without expectations and without encumbrances.... As he sits on his seat let him pinpoint his mind, so that the working of the mind and senses are under control, and yoke himself to yoga for the cleansing of his self. Holding body, head and neck straight and immobile, let him steadily gaze at the tip of his nose, without looking anywhere else. Serene, fearless, faithful to his vow of chastity, and restraining his thinking, let him sit yoked.[1]

1 Quoted in Pratapaditya Pal, *The Peaceful Liberators: Jain Art from India* (Los Angeles: Los Angeles County Museum of Art,),160, translation by J. A. B. van Buitenen.

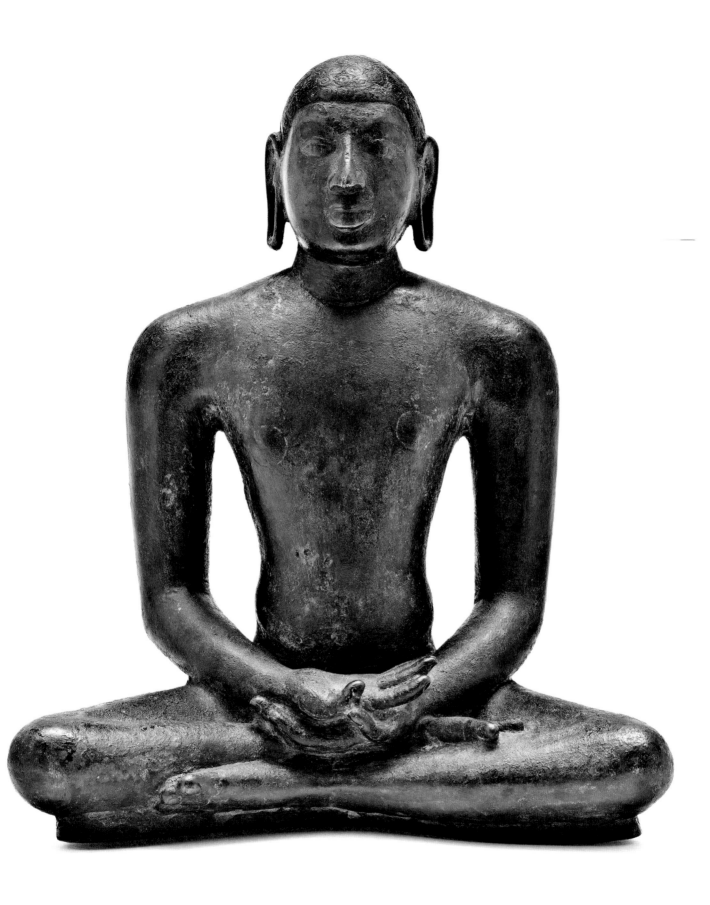

Jina, possibly Mahavira. India, Karnataka or Tamil Nadu; second half of the 9th century.
Copper alloy, 8 ⅞ × 7 ⅝ × 3 ¼ inches (22.5 × 19.4 × 8.3 cm). Los Angeles County Museum
of Art, From the Nasli and Alice Heeramaneck Collection, Museum Associates Purchase

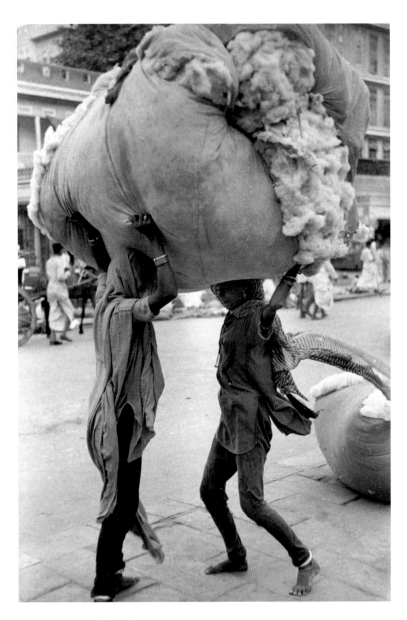

Muslim working women.

Henri Cartier-Bresson (France, 1908–2004), Jaipur, Rajasthan, India,
end of June or early July 1948. Gelatin silver print, 9 ¾ × 6 ⅝ inches
(24.8 × 16.9 cm). Collection Fondation Henri Cartier-Bresson, Paris

Subtle Cloth

Subtle, subtle, subtle
is the weave
of that cloth.

What is the warp
what is the weft
with what thread
did he weave
that cloth?

Right and left
are warp and weft
with the thread at the center
he wove
that cloth

The spinning wheel whirled
eight lotuses, five elements,
three qualities, he wove
that cloth

It took ten months
to finish the stitching
thok! thok! he wove
that cloth

Gods, sages, humans wrapped
the cloth around them
they wrapped it
and got it dirty
that cloth

Kabir wrapped it with such care
that it stayed just as it was
at the start
that cloth.

Subtle, subtle, subtle
is the weave
of that cloth.

Translations by Linda Hess
Singing Emptiness, 76–77

This poem is in Gandhi's *Ashram Bhajanavali*
collection of devotional songs.

A Fakir's Song

This mind, my friend, has learned to love
owning nothing.

The happiness you get singing God's name,
you won't get that happiness from money.

Listen to everyone, good and bad,
live at ease in poverty.

I live in the city of love,
my well-being comes from contentment.

a water-gourd in my hand, a stick to lean on,
my land grant stretches in four directions.

At last this body will turn to ash.
Why strut with pride?

Kabir says, listen seekers:
in contentment
you meet God!

oral

This poem is in Gandhi's *Ashram Bhajanavali*
collection of devotional songs.

Opposite page Saint Onouphrios. Creto-Venetian; Crete, Iraklion; early to mid 17th century.
Attributed to Emmanuel Lambardos (active ca. 1593–1647). Tempera and gold leaf
on wood, 21 ⅞ × 14 ⅜ inches (55.6 × 36 cm). The Menil Collection, Houston

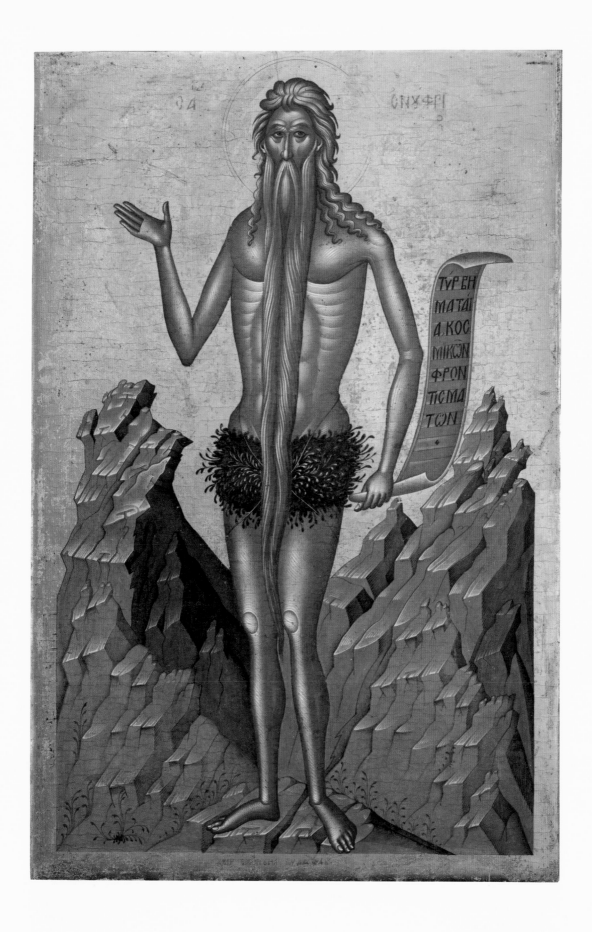

ΘΑ ΟΝΥΦΡΙ

ΤΥΡ ΕΗ
ΜΑΤΑΙ
Α ΚΟC
ΜΙΚΩΝ
ΦΡΟΝ
ΤΙϹΜΑ
ΤΩΝ

A Foreign Country

It's a foreign country, you can't stay here.

This world
is a bundle of paper.
A few drops fall, it melts away.

This world
is shrubs and sticks.
A touch of fire, it burns up.

This world
is a patch of thorns
where you get tangled and die.

Kabir says, listen seekers—
make your home in the Name
with the true teacher.

It's a foreign country, you can't stay here.

oral

This poem is in Gandhi's *Ashram Bhajanavali*
collection of devotional songs.

Overjoyed

The heart is overjoyed. What to say?

You can put something small
on the scale.
When it overflows the tray,
what to weigh?

You found a diamond,
tied it in a cloth.
Why keep untying it,
counting your riches?

The swan has found
Lake Mansarovar.
Why paddle around
in ponds and ditches?

Kabir says,
listen seekers:
here's God
in the pupil of your eye!

oral

This poem is in Gandhi's *Ashram Bhajanavali*
collection of devotional songs.

That House

Dear friend, that house
is utterly other
where he lives, my man,
my complete one.

There's no grief or joy,
no truth or lie,
no field of good and evil.
There's no moon or sun,
no day or night,
but brilliance
without light.

No wisdom, no meditation,
no recitation, no renunciation,
no Veda, Qur'an,
or sacred
song.
Action, possession, social
convention, all
gone.

There's no ground, no space,
no in, no out, nothing like
body or cosmos,
no five elements, no three qualities,
no lyrics, no couplets.

No root, flower, seed, creeper.
Fruit shines
without a tree.
No inhale, exhale, upward, downward,
no way to count
breaths.

Where that one lives,
there's nothing.
Kabir says, I've got it!
If you catch my hint, you find
the same place–
no place.

The World Is Mad

Saints, I see the world is mad.
If I tell the truth, they rush to beat me.
If I lie, they trust me.
I've seen the pious Hindus, rule-followers,
early-morning bath takers–
killing souls, they worship rocks.
They know nothing.
I've seen plenty of Muslim teachers, holy men
reading their holy books
and teaching their pupils techniques.
They know just as much.
And posturing yogis, hypocrites,
hearts crammed with pride,
praying to brass, to stones, reeling
with pride in their pilgrimage,
fixing their caps and their prayer beads,
painting their brow-marks and arm-marks,
braying their hymns and their couplets,
reeling. They never heard of soul.
The Hindu says Ram is the beloved,
the Turk says Rahman.
Then they kill each other.
No one knows the secret.
They buzz their mantras from house to house,
puffed with pride.
The pupils drown along with their gurus.
In the end they're sorry.
Kabir says, listen saints:
they're all deluded!
Whatever I say, nobody gets it.
It's too simple.

Bijak 42–43

Opposite page Buddha. India, Ladakh region, Lamayuru Monastery; 15th century.
Mineral colors on cloth, 65 ½ × 39 inches (161.3 × 99 cm). Collection of Marilyn Oshman

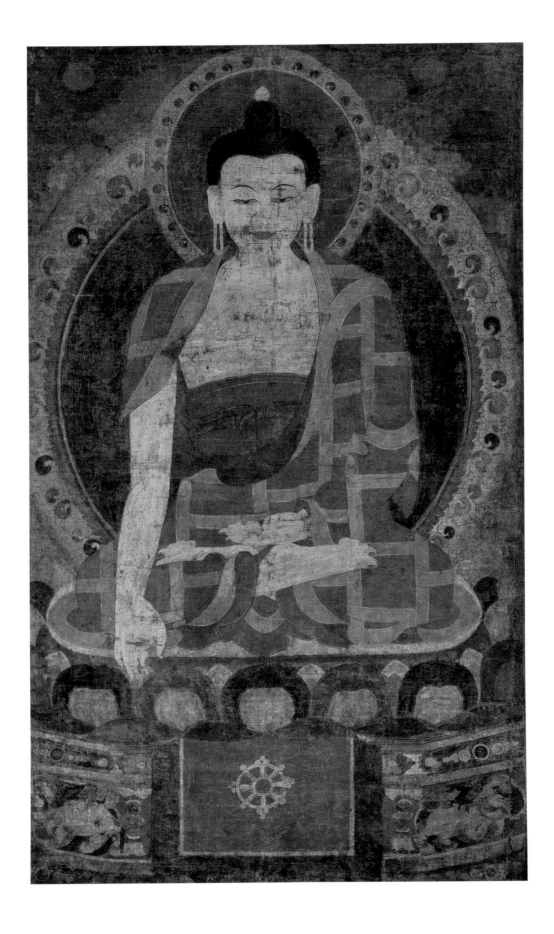

My True Guru

My true guru pierced through me
He put his finger
on my pulse and waves
surged in my veins,
my heart rocked.
He gave me knowledge,
gave me vision
in the middle
of my body.
Syllables burst
into light.

My true guru is a healing herb
in the courtyard.
Let everyone take it!
He turns my faults to virtues,
all that's bad in me
falls away.
He gave me knowledge,
gave me vision
in the middle
of my body.
Syllables burst
into light.

My true guru is gold, 100%,
not the tiniest flaw.
He aimed his spear
and it struck my heart.
He wounded me!
He gave me vision
in the middle
of my body.
Syllables burst
into light.

This feeling, this healing
herb spreads,
it fills space, it spreads through time,
in the gathered assembly, we're always
ready, and the more we share,

My true guru wounded me,
gave me vision
in the middle
of my body.
Syllables burst
into light.

My mind is a thief.
Awareness is the cord
that can tie it together.
The guru's service is a cup of nectar,
he made me drink,
he gave me knowledge,
gave me vision
in the middle
of my body.
Syllables burst
into light.

oral

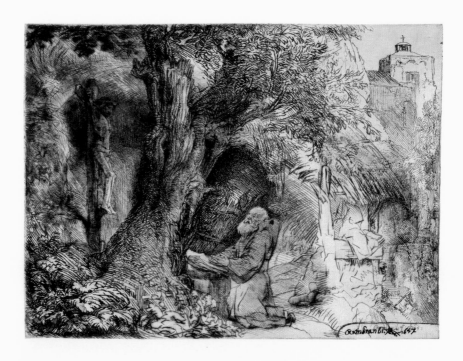

Rembrandt van Rijn (Netherlands, 1606–1669), Saint Francis Praying Beneath a Tree,
1647. Drypoint and etching on paper, 7 ⅛ × 9 ¾ inches (18.1 × 24.7 cm). Princeton
University Art Museum, Gift of James H. Lockhard Jr., Class of 1935

The Brilliant Palace

In the brilliant palace,
the wondrous city,
come on my swan,
my brother, see
the visible mantle
on the formless king.

My brother!
There's no god in that temple.
What's the point
of beating the gong?

My brother!
There's no road
to the limitless.
Why show a sign
to one who can't see
the guru?

My brother!
Fill your cup,
pour the nectar.
How can you hide
from your own brother?

My brother!
Kabir shouts:
Find the sign
in the sign!

oral

Opposite page Green Tara. India, Bihar; 9th or 10th century. Stone, 26 ⅜ × 15 inches (67 × 38.1 cm). Nancy Wiener Gallery, New York

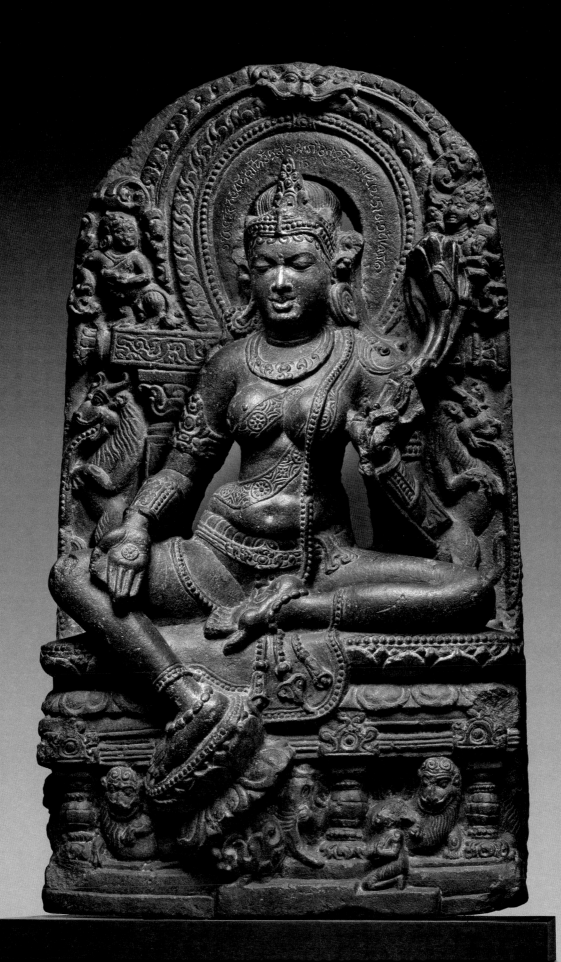

Allah-Ram's Baby

The creatures are like you, Allah-Ram.
Lord, be kind to them.

Why bump that shaven head on the earth,
why dunk those bones in the water?
Parading as a holy man,
you hide yourself, and slaughter.
Why wash your hands and mouth, why chant
with a heart full of fraud?
Why bow and bow in the mosque, and trudge
to Mecca to see God?
Twenty-four days for the Hindus,
thirty days for the Turks–
a month each year for fasting,
eleven for other works.
Does Khuda live in the mosque?
Then who lives everywhere?
Is Ram in idols and holy ground?
Have you looked and found him there?
Hari in the East, Allah in the West,
so you like to dream.
Search in the heart, in the heart alone:
there live Ram and Karim!
Which is false, Qur'an or Veda?
False is the darkened view.
It's one, one, in every body!
How did you make it two?
Every man and woman born,
they're all your forms, says Kabir.
I'm Ram-and-Allah's foolish baby.
He's my guru and pir.

Bijak, 73–74

Gandhi and Kabir

First, who is Kabir? For those who have not met him before, here is a brief introduction. Kabir is one of the great vernacular poets of *bhakti*– a term signifying intense devotion and often mystical experience–who sprang up in the various linguistic regions of India between the sixth and eighteenth centuries. Through these *sants'* creativity and passion, as the great scholar and translator A.K. Ramanujan has said, Indian poets for the first time in spoke to God in the mother tongue.

Regarded as one of the great poets of Hindi literature, Kabir lived in fifteenth-century Varanasi, North India. He is a revered figure in religious history, an iconoclastic mystic who bore marks of both Hindu and Muslim traditions but refused to be identified with either. Stories about his life come to us as legends, most of them unverifiable. He grew up in a family of Muslim weavers and practiced the weaving craft himself. He is widely believed to have had a Hindu guru, and poetry that bears his name is full of Hindu terminology and references to Hindu beliefs and practice. Muslim singers in India and Pakistan still sing Kabir's verses in Sufi musical styles, their texts showing a greater frequency of Perso-Arabic vocabulary. In the late sixteenth century he was adopted as one of the exemplary devotees whose poetry was inscribed in the sacred book of the nascent Sikh religion. Meanwhile some of his admirers turned him into a divine avatar and took to worshiping him in a sect called the Kabir Panth. His own poetry subverts and criticizes religious identities and institutions, but such subversion has never stopped religions from co-opting their critics. Kabir also has a life beyond established religions, his couplets taught to school children all over India, his poems and songs appreciated by people of all classes and regions. Such people may think of themselves as religious, spiritual, secular, or atheist, but they all have their reasons for liking Kabir.

Compositions associated with Kabir have a uniquely powerful style, expressing his own spiritual awakening, urging others to wake up, observing delusion in individuals and society. Kabir's voice is direct and anti-authoritarian. He was of a low social status, and most of his sectarian followers belong to communities now called Dalit (former "untouchables"). His poetry has a vivid streak of social criticism, making trenchant observations on caste prejudice, religious sectarianism, hypocrisy, arrogance, and violence. At the same time it is profoundly inward-looking. It examines the nature of mind and body, points out the tangle of delusions in which we live, urges us to wake up and cultivate consciousness. The imminence of death and the transiency of all

things are frequently invoked. The journey within is permeated with the imagery of yoga--its map of a subtle body made of energy, lotus-centers, coursing breath-streams, sound and light. A key word associated with Kabir's spiritual stance is *nirgun*–"no quality"–indicating an ultimate reality that can't be visualized in form or described in language. While invoked negatively, it conveys simultaneously emptiness and fullness.

Gandhi loved the bhakti poets and was particularly familiar with those who composed in Hindi and his native Gujarati. Over the years he built up a religiously eclectic collection of songs and chants to be used in the devotional gatherings that were built into the daily life of his ashrams, eventually codified in the *Ashram Bhajanavali* songbook. North Indian bhakti poets figure prominently in this collection, along with favorite Sanskrit passages and short selections from the Qur'an, the Bible, and other non-Hindu sources. Sixteen poems of Kabir are in the *Bhajanavali*.

Surely Gandhi admired Kabir. But judging from the number and nature of his references in other writings, he was more emotionally attached to Vaishnava poets like Tulsidas, Narsinha Mehta, Surdas, and Mirabai. They share with Kabir profound devotion and intense religious experience; they do not share his iconoclastic fervor, his anti-authoritarian attitude, his incisive social commentary, or his sharp satiric tongue.

Since Kabir composed orally and was preserved through popular oral traditions, by the twentieth century there was a huge and wide-ranging body of poetry attributed to him. Prominent themes in the Kabir poems selected for the *Bhajanavali* include devotion to God and the true guru; love, self-surrender, and humility; the power of invoking God's name (especially the name of Ram); reminders of the transient nature of life and the value of detachment from material things; religious experience as internal and not dependent on rituals or priests.

Beyond the content of these sixteen songs, Gandhi definitely had other reasons for admiring Kabir. Foremost among these was Gandhi's passion for building interfaith harmony, especially (but not only) between Muslims and Hindus. One of the tragic conundrums in Gandhi's life trajectory was that despite his constant promotion of religious tolerance and the essential oneness of religions, he ended up alienating powerful Hindu and Muslim factions, to great consequence. On one side Mohammad Ali Jinnah, mistrusting Gandhi's promise of equal respect and rights for Muslims in India, became a hostile opponent and the founder of Pakistan. On the other side, extreme Hindu nationalists hated Gandhi's "weak" and "effeminate" ideology of nonviolence and his "coddling" of Muslims, and they eventually killed him. One of the quasi-legendary beliefs about Gandhi was that he cried out the name

of Ram after being shot. No one will ever be able to prove that the sound he made after receiving three bullets to the chest was "Ram." But interestingly, less than a year before his death, he wrote this: "Even if I am killed, I will not give up repeating the names of Rama and Rahim, which mean to me the same God. With these names on my lips, I will die cheerfully." Rahim is a Muslim name for God emphasizing God's compassionate nature. Gandhi also used other pairings of Muslim and Hindu divine names, such as Khuda-Ishvar, and he is said to have added the line *Ishvar Allah tero nam* (your name is Ishvar-Allah) to the popular traditional hymn to Ram, *Raghupati Raghava Raja Ram*, usually cited as his favorite hymn.

Kabir's voice has always been associated not only with nonsectarianism but with antisectarianism. He criticizes narrow religious identities and the arrogant, deluded, oppressive, often violent behaviors associated with them. Kabir's own ambiguous location between and beyond both Hinduism and Islam contributes to his authority in debunking rigid identities. He invoked the word-pair Ram-Rahim, as Gandhi often did. I have included some of Kabir's well-known poems on these themes, even though Gandhi did not put them in the *Bhajanavali*. Why not? I can only guess that he preferred the emotionally more attractive and safer themes summarized above, about love, surrender, nonattachment, God's name, and so on. Gandhi's famous contemporary and interlocutor Rabindranath Tagore showed the same preferences in his influential *Songs of Kabir*, published in 1915, two years after he became the first Asian to receive the Nobel Prize for Literature.

Gandhi would also have identified with Kabir's criticisms of untouchability, as Gandhi was absolutely committed to its elimination. Again, no such poems appear in the *Bhajanavali* (though they appear in my selection below). Could this be because Kabir's radical tone was too strong for Gandhi, who maintained ambivalent attitudes toward caste throughout his life? Or because he wanted to avoid ruffling feathers in the pious atmosphere of his evening *satsangs* where ashram residents and guests gathered to sing, chant, and pray?

Finally Gandhi specifically pointed to Kabir's association with the dignity of manual labor–a value that Gandhi promoted throughout his career and that was integrally connected to his ideal of village-based economies. Kabir was a weaver. Hand-spinning and weaving were crucial practical and symbolic components of Gandhi's movement for Indian freedom. Once, after mentioning that the Mughal emperor Aurangzeb made his own caps, Gandhi wrote, "A greater emperor–Kabir–was himself a weaver and has immortalized the art in his poems" (CWMG Vol. 21, p. 71).

The connection between Gandhian values and Kabir may be more important for people in India today than it was for Gandhi–or at least prominent in different ways. The last twenty-five years have seen a strong resurgence of Hindu nationalism, with a rise in politics of polarization and hate, communal conflict, and violence. Secularists, pluralists, humanists, leftists–often people who have no particular love for religion or who repeat the familiar mantra "I'm spiritual, not religious"–have raised the banner of Kabir and kindred poets in *sant* and Sufi traditions. Those who resist religious nationalism, communal polarization, violence, and caste oppression see Kabir as speaking for the India they believe in. An influential series of documentary films on Kabir music and social meanings by Shabnam Virmani has ignited new enthusiasms and connections between urban and rural performers and audiences (see http://www.kabirproject.org). Kabir festivals have sprung up in the metros, featuring singers from different regions and backgrounds. A major contemporary Hindi poet and cultural leader, Ashok Vajpeyi, has characterized Kabir as one who fearlessly speaks truth to power, will not stay silent in the face of injustice, and acts out of desire for the good of others. (See the short, brilliant interview conducted by Balaji Narasimham at http://youtu.be/eo—ogSiuoXw.) And a fiery public intellectual and writer, Purushottam Agrawal, is at once the most important current Indian scholar of Kabir and an ardent articulator of the continued power and profundity of Gandhi's message to India and the world.

LINDA HESS

The Translations
My translations included in this volume are based on two of my publications and on oral performances. Four of the poems, are in Gandhi's *Ashram Bhajanavali*. My translations of them are based on Hindi sources that are very close but not identical to the versions in the *Bhajanavali*.

The Bijak of Kabir, trans. Linda Hess and Shukdev Singh. New York: Oxford University Press, 2002.
Singing Emptiness: Kumar Gandharva Performs the Poetry of Kabir. Calcutta: Seagull Books, 2009.

Heartfelt thanks to Anand Venkatkrishnan and Neelima Shukla-Bhatt for their contributions to research for this essay.

Opposite page Zarina (b. India 1937, active United States), Veil, 2011. Gold leaf on bamboo blinds, 142 × 48 inches (360.7 × 121.9 cm). Courtesy of the artist and Luhring Augustine, New York

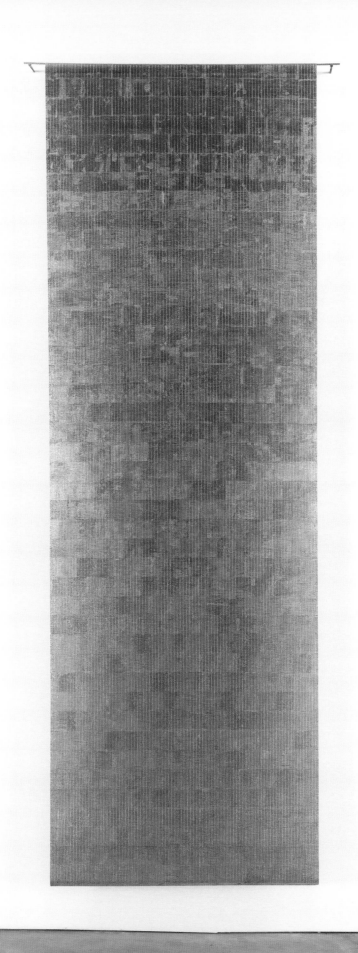

Say I Am You

I am dust particles in sunlight.
I am the round sun.

To the bits of dust I say, *Stay.*
To the sun, *Keep moving.*

I am morning mist,
and the breathing of evening.

I am wind in the top of a grove,
and surf on the cliff.

Mast, rudder, helmsman, and keel,
I am also the coral reef they founder on.

I am a tree with a trained parrot in its branches.
Silence, thought, and voice.

The musical air coming through a flute,
a spark off a stone, a flickering in metal.

Both candle and the moth crazy around it.
Rose and nightingale lost in the fragrance.

I am all orders of being, the circling galaxy,
the evolutionary intelligence, the lift and the falling away.

What is and what is not.
You who know Jelaluddin,

You are the one in all, say who I am.
Say I am you.

Translations by Coleman Barks
Rumi: The Big Red Book, 280

Sublime Generosity

I was dead, then alive.
Weeping, then laughing.

The power of love came into me,
and I became fierce like a lion,
then tender like the evening star.

He said, "You're not mad enough.
You don't belong in this house."

I went wild and had to be tied up.
He said, "Still not wild enough
to stay with us!"

I broke through another layer
into joyfulness.

He said, "It's not enough."
I died.

He said, "You're a clever little man,
full of fantasy and doubting."

I plucked out my feathers and became a fool.
He said, "Now you're the candle
for this assembly."

But I'm no candle. Look!
I'm scattered smoke.

He said, "You are the sheikh, the guide."
But I'm not a teacher. I have no power.

He said, "You already have wings.
I cannot give you wings."

But I wanted *his* wings.
I felt like some flightless chicken.

Then new events said to me,
"Don't move. A sublime generosity is
coming toward you."

And old love said, "Stay with me."

I said, "I will."

You are the fountain of the sun's light.
I am a willow shadow on the ground.
You make my raggedness silky.

The soul at dawn is like darkened water
that slowly begins to say *Thank you, thank you.*

Then at sunset, again, Venus gradually
changes into the moon and then the whole nightsky.

This comes of smiling back
at your smile.

The chess master says nothing
other than moving the silent chess piece.

That I am part of the ploys
of this game makes me
amazingly happy.

The Essential Rumi, 134–35

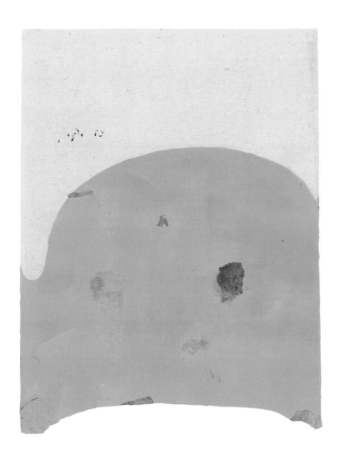

Suzan Frecon (United States, b. 1941), lapis and sun_composition, 2012.
Watercolor on found old Indian paper, 8 ⅞ × 6 ⅝ inches (22.5 × 16.8 cm).
Courtesy of the artist and David Zwirner, New York/London

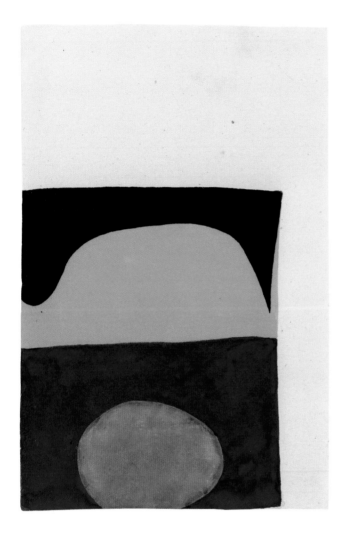

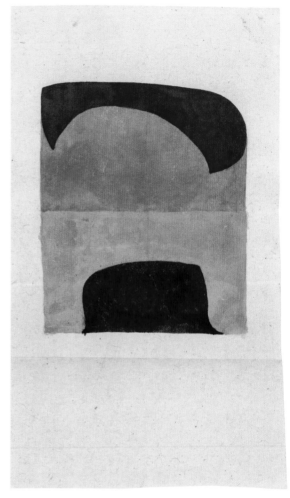

Left Suzan Frecon, four-color composition on small paper 1 (fountain and shadow), 2009. Watercolor on found old Indian paper, 11 × 7 ¼ inches (27.9 × 18.4 cm). Courtesy of the artist and David Zwirner, New York/London

Right Suzan Frecon, four-color composition on small paper 2 (love dogs), 2009. Watercolor on found old Indian paper, 10 ¾ × 6 ¼ inches (27.3 × 15.9 cm). Courtesy of the artist and David Zwirner, New York/London

Opposite page Suzan Frecon, four-color composition on small paper 3 (dust and sun), 2009. Watercolor on found old Indian paper, 10 ⅝ × 6 ⅜ inches (27 × 16.2 cm). Courtesy of the artist and David Zwirner, New York/London

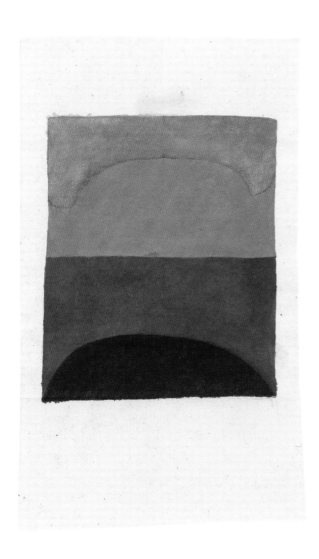

Out beyond ideas of wrongdoing and rightdoing, there is a field. I'll meet you there.
 –Rumi

Love Dogs

One night a man was crying,
 Allah! Allah!
His lips grew sweet with the praising,
until a cynic said,
 "So! I have heard you
calling out, but have you ever
gotten any response?"

The man had no answer to that.
He quit praying and fell into a confused sleep.

He dreamed he saw Khidr, the guide of souls,
in a thick, green foliage.
 "Why did you stop praising?"
"Because I've never heard anything back."
 "This longing
you express *is* the return message."

The grief you cry out from
draws you toward union.

Your pure sadness
that wants help
is the secret cup.

Listen to the moan of a dog for its master.
That whining is the connection.

There are love dogs
no one knows the names of.

Give your life
to be one of them.

The Essential Rumi, 155–56

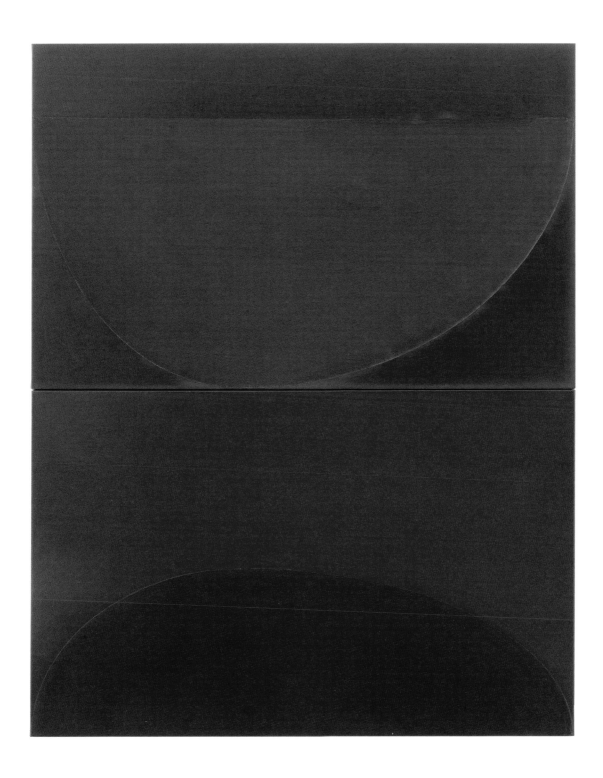

Suzan Frecon, full and empty (DUST), 2014. Oil on linen, 36 × 29 ⅛ inches
(91.4 × 74 cm). Courtesy of the artist and David Zwirner, New York/London

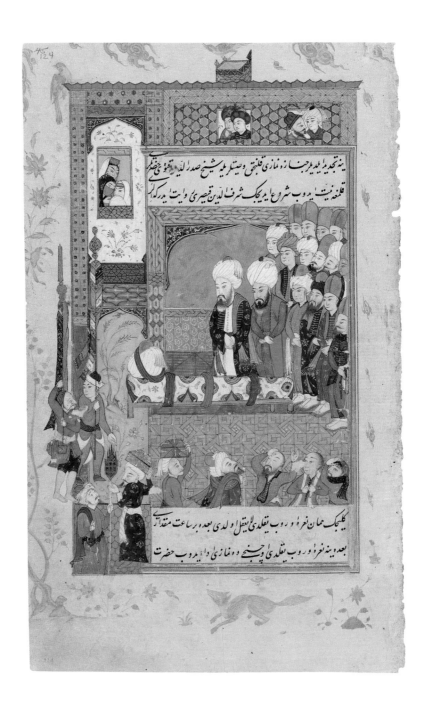

The funeral of Jelaluddin Rumi, from *Tarjuma-i Thawaqib-i Manaqib* (a Turkish
translation of Abdul-Wahhab Hamadani's work based on Aflaki's biography of Rumi).
Probably Iraq, Baghdad; 1590s. Opaque watercolor, ink, and gold on paper,
8 ¾ × 5 ¼ inches (22 × 13.5 cm). The Pierpont Morgan Library, New York, MS M.466 fol.

124r, Purchased by J. Pierpont Morgan in 1911

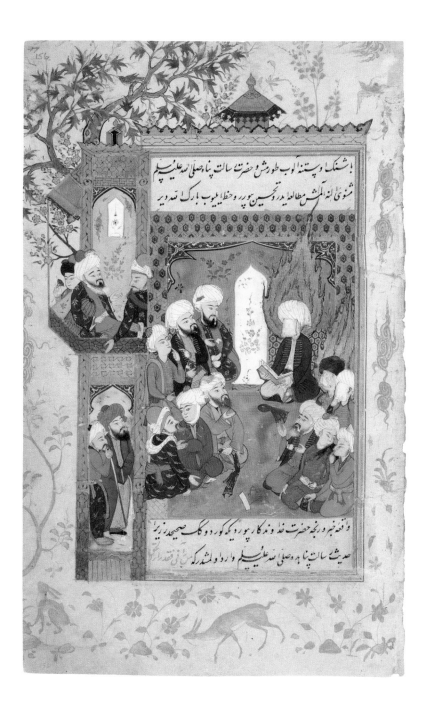

Husamuddin Chelebi, in a dream, sees the Prophet Muhammad reading Rumi's *Masnavi*, from *Tarjuma-i Thawaqib-i Manaqib*, 9 × 5 ¾ inches (22.8 × 14.5 cm). The Pierpont Morgan Library, New York, MS. M.466, fol. 156r, Purchased by J. Pierpont Morgan in 1911

Out beyond ideas of wrongdoing and rightdoing,
there is a field. I'll meet you there.

When the soul lies down in that grass,
the world is too full to talk about.
Ideas, language, even the phrase *each other*
doesn't make any sense.

Open Secret, no. 158, p. 8

*Rumi: The Big Red Book. The Great Masterpiece Celebrating
Mystical Love & Friendship; Odes and Quatrians from
"The Shams,"* ed. Coleman Barks, trans. Coleman Barks
with others (New York: Harper One, 2010).

The Essential Rumi, trans. Coleman Barks with
John Moyne, A. J. Arberry, Reynold Nicholson
(San Francisco: Harper, 1995).

Open Secret: Versions of Rumi, trans. John Moyne and
Coleman Barks (Putney, VT: Threshold Books, 1984).

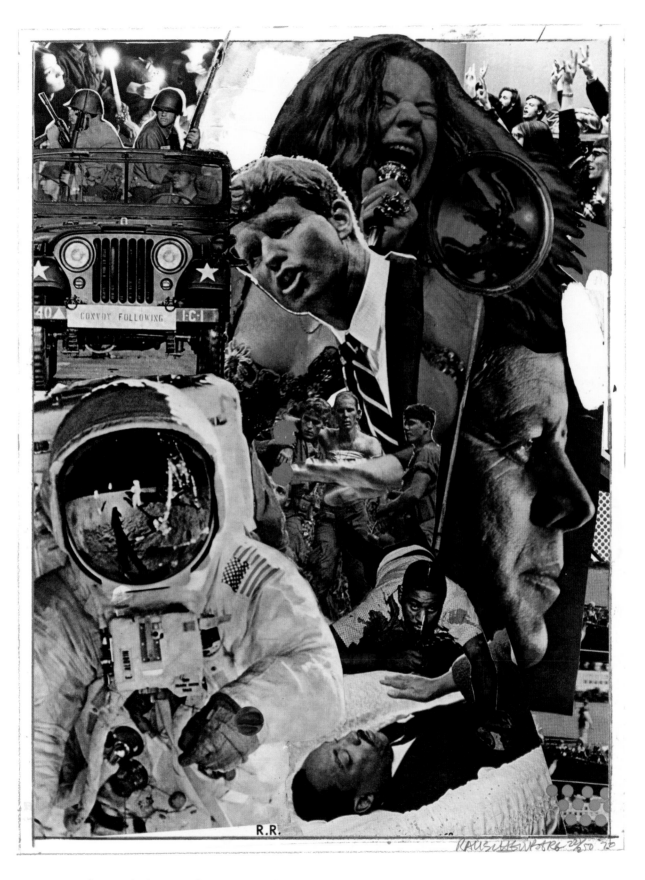

Robert Rauschenberg (United States, 1925–2008), Signs, 1970. Screenprint, 43 × 34 inches (109.2 × 86.4 cm). The Museum of Modern Art, New York, Gift of Jean-Christophe Castelli in memory of Toiny Castelli

Robert Gober (United States, b. 1954), Untitled, 2003–7.
Wood, iron, plaster, latex paint, and lights, opening: 24 7/8 × 25 5/8 inches
(63.2 × 62.5 cm). The Menil Collection, Houston, Anonymous gift

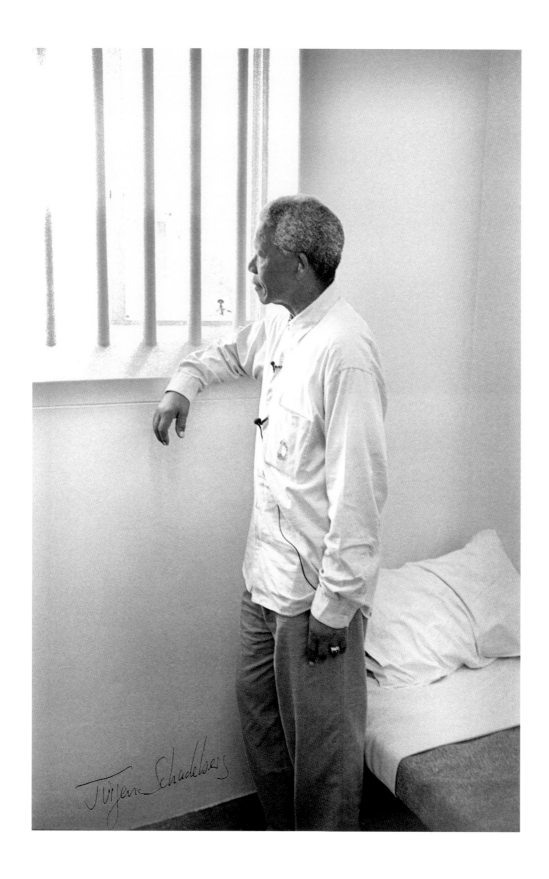

Jürgen Schadeberg (b. Germany 1931, active South Africa), Nelson Mandela
revisiting his prison cell on Robben Island, South Africa, 1994. Gelatin silver print,
19 ⅞ × 15 ½ inches (50.5 × 39.4 cm). The Menil Collection, Houston, Purchased
with funds provided by an anonymous donor

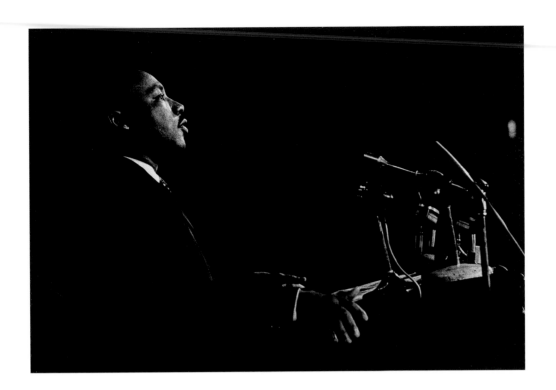

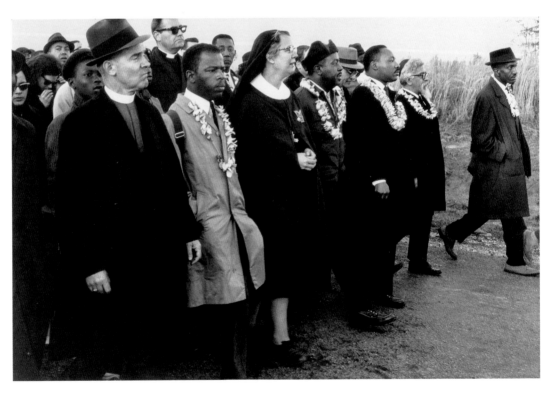

Above Frederick C. Baldwin (b. Switzerland 1929, active United States), Martin Luther King, Savannah, Georgia, 1963. Gelatin silver print, 6 ½ × 9 ⅝ inches (16.5 × 24.3 cm). The Menil Collection, Houston, Gift of Fred Baldwin

Below Dan Budnik (United States, b. 1933), Selma to Montgomery March: John Lewis and Martin Luther King Jr. leading religious dignitaries at the end of the first day, Hall Farm Road, Dallas County, Alabama, March 21, 1965. Gelatin silver print, 16 × 20 inches (40.6 × 50.8 cm). The Menil Collection, Houston, Gift of Edmund Carpenter and Adelaide de Menil

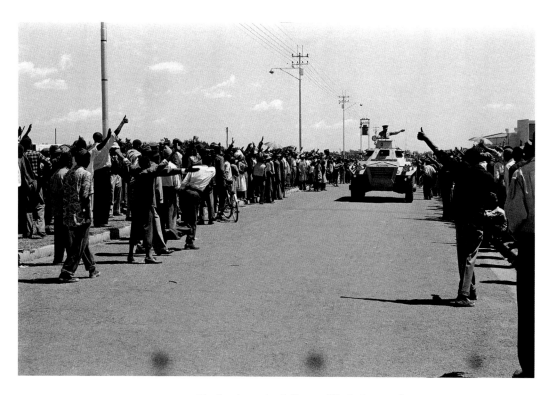

The thumbs-up sign indicates solidarity in nonviolent protest.

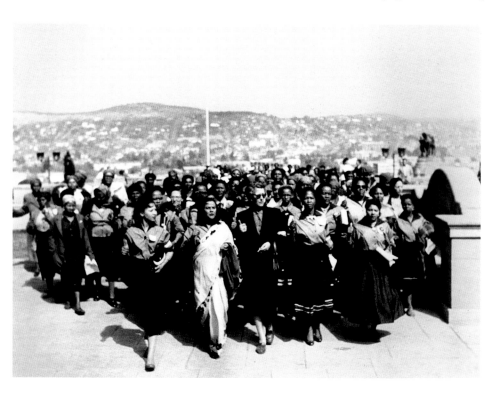

Above Just before the Sharpeville Massacre, a Saracen armored vehicle drives through a crowd of chanting demonstrators, some of whom will be dead minutes later, March 21, 1960. Photographer unknown. Drum Stories/Baileys African History Archive/Africa Media Online

Below Around 20,000 women march with a petition to the Union Building in Pretoria, South Africa, as part of the anti-pass campaign, August 9, 1955. Photograph by Peter Magubane. Drum Stories/Baileys African History Archive/Africa Media Online

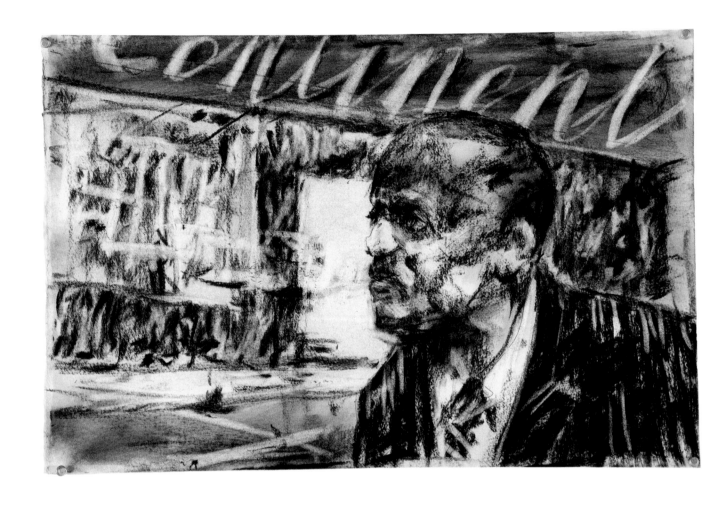

William Kentridge (South Africa, b. 1955), Other Faces, 2011.
35mm film shown as video, color with sound, 9 min. 36 sec., loop. Courtesy of the artist
and Marian Goodman Gallery, New York and Paris

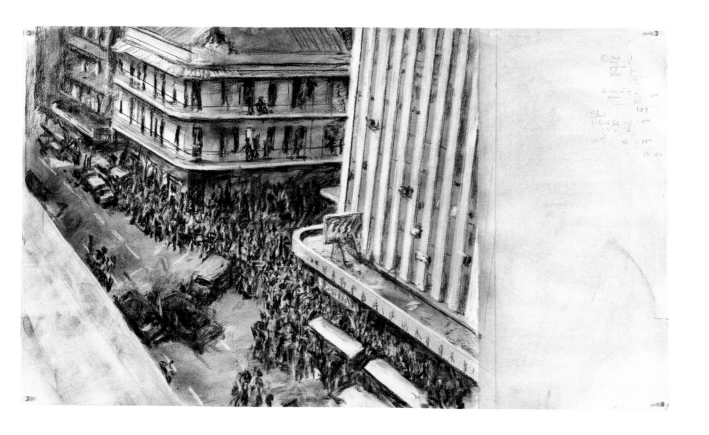

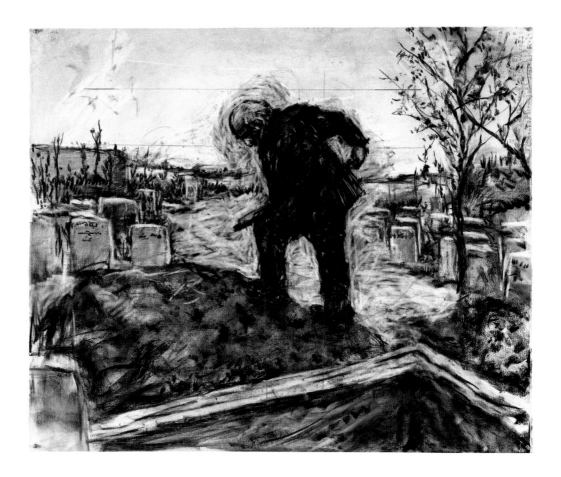

Theaster Gates (United States, b. 1973), Hose for Fire and Other Tragic Encounters, 2014.
Fire hose and wood, 96 ¼ × 55 ¼ × 8 ½ inches (244.5 × 140.3 × 21.6 cm). Courtesy of the artist

A New Song

It is always the seemingly abject that has the most potency. The thing we miss or fail to acknowledge or disregard as filth that is quietly making way for itself and the deep surrender of ignorance in the face of power. Peacemaking in black space has always been a struggle. Black bodies as an ambitious world commodity to be muscle and back and till; black gold and blood diamonds subjugate black bodies even still. We begin to understand the resonance of materiality in telling the story of world struggle, inequity, and long-suffering. I want to make work that can bring forward these issues of struggle alongside questions of artistic practice. I constantly consider the question of social transformation playing over the action of another set of harmonic tones. Why do we protest, what is its form, how might it be most effective, what is the return on the deep investment, and what are the potential losses?

My Civil Tapestry series made from decommissioned fire hoses–like the work included here–has become iconic, but it is not possible for me to feel it is my only work; it has to be fortified against action. And so, like other artists, I continue all the work together; performance, making, institution building. The deep harmonic is that I have to continue to go to the studio and go to the university where I teach and go where the heat is, and continue to give whatever I can: a hymn of protest, a candy bar, a quiet listening, an altar, an offering. When there are no more protests needed, that day, I'll sing a new song.

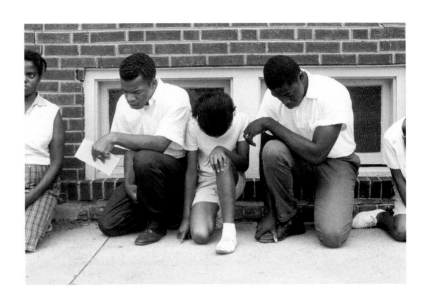

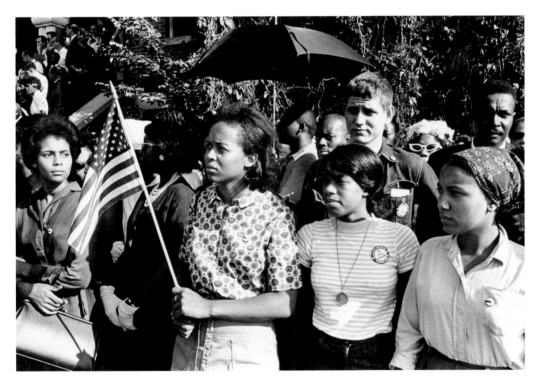

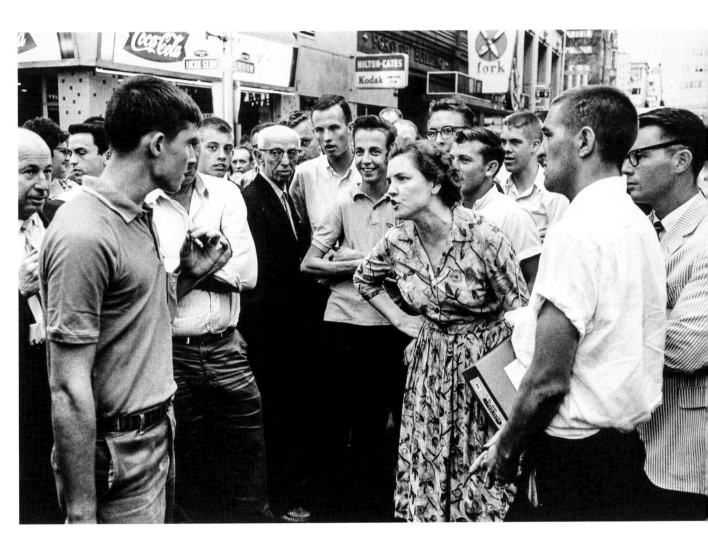

Opposite page above Danny Lyon (United States, b. 1942), Come let us build a new world together, Cairo, Illinois (Basis for SNCC poster), 1962, printed 2000. Gelatin silver print, 11 × 14 inches (27.9 × 35.6 cm). The Menil Collection, Houston, Gift of Edmund Carpenter and Adelaide de Menil

Opposite page below Danny Lyon, Student Nonviolent Coordinating Committee (SNCC) workers outside the funeral for girls killed at the Sixteenth Street Baptist Church: Emma Bell, Dorie Ladner, Dona Richards, Sam Shirah, and Doris Derby, 1963, printed 2000. Gelatin silver print, 11 × 14 inches (27.9 × 35.6 cm). The Menil Collection, Houston, Gift of Edmund Carpenter and Adelaide de Menil

Above Danny Lyon, As demonstrators block traffic in front of Leb's restaurant, a mob begins to abuse them with kicks, blows, and burning cigarettes. An anonymous woman confronts the mob, holds it at bay, and joins the demonstrators, Atlanta, 1964, printed 2000. Gelatin silver print, 11 × 14 inches (27.9 × 35.6 cm). The Menil Collection, Houston, Gift of Edmund Carpenter and Adelaide de Menil

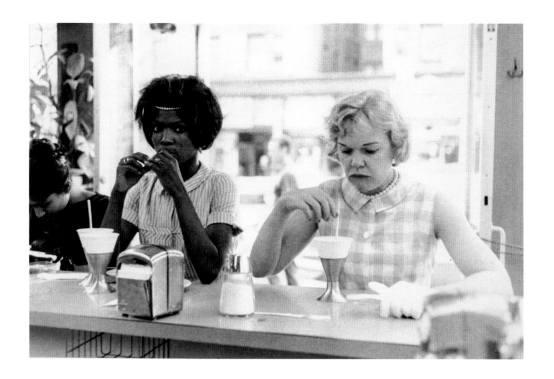

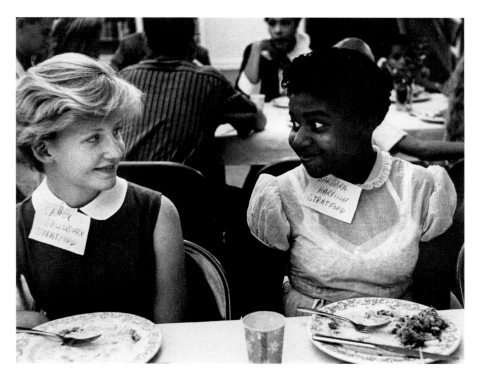

Above Bruce Davidson (United States, b. 1933), Two Women at Lunch Counter, New York, 1962. Gelatin silver print, 5 ¼ × 7 ⅞ inches (13.3 × 20 cm). The Menil Collection, Houston, Gift of Adelaide de Menil Carpenter

Below Eve Arnold (United States, 1912–2012), Integration Party, Alexandria, Virginia, 1958. Gelatin silver print, 11 × 14 inches (27.9 × 35.6 cm). The Menil Collection, Houston, Gift of Adelaide de Menil Carpenter

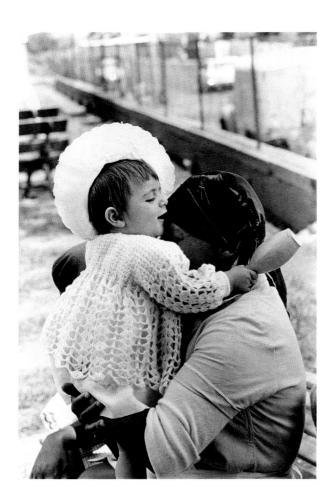

Servants are not forbidden to love. Woman holding child said, "I love this child, though she'll grow up to treat me just like her mother does. Now she is innocent."

Ernest Cole, *House of Bondage* (1967)

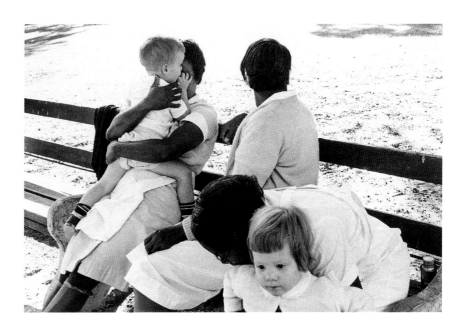

Above Ernest Cole (South Africa, 1940–1990), Woman holding a child, before 1967, printed ca. 1970. Gelatin silver print, 12 ⅝ × 8 ¾ inches (32 × 22 cm). Courtesy of the Hasselblad Foundation and the Ernest Cole Family Trust

Below Bruce Davidson, Nannies and Children on Bench, 1966. Gelatin silver print, 6 × 8 ⅞ inches (15.2 × 22.5 cm). The Menil Collection, Houston, Gift of Adelaide de Menil Carpenter

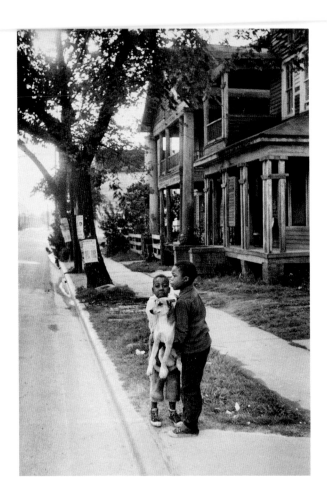

ROBERT GOBER

There is a photograph that hangs in a guest house that belongs to the
Menil. The photograph is black and white, modest and unlabeled.
I know this because while I was staying at the house a few years back
and curious about the unfamiliar image, I took it off of the wall to see
what and whose it was. It is tender and embracing and still moves
me when I look at the photo that I took of it to bring back home with
me. Mary Kadish, who was for many years the collections registrar at
the Menil, guessed that it was taken by Cartier-Bresson during a stay in
Houston. The presence of both Warhol's race riot image–where a dog is
encouraged to attack a black man–and this image of two trusting black
children supporting and carrying a similar hound, expresses for me
the complex understanding of people and of art that is a hallmark of
John and Dominique deMenil's collecting eye and mind, building
a collection that can hold together these human contradictions.

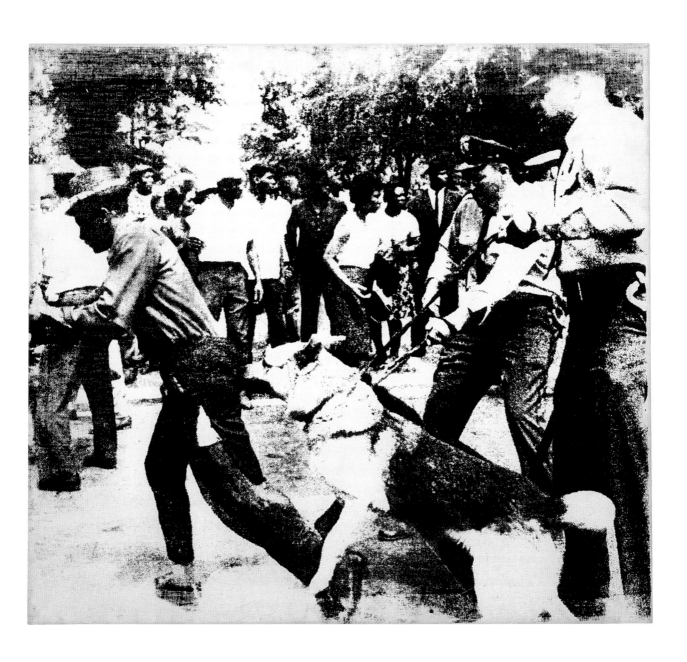

Opposite page Henri Cartier-Bresson (France, 1908–2004), Boys with dog,
Houston, April 1957. Gelatin silver print, 13 ⅜ × 9 ⅛ inches (34 × 23.2 cm).
The Menil Collection, Houston

Above Andy Warhol (United States, 1928–1987), Little Race Riot, 1964. Silkscreen
ink on linen, 30 ⅛ × 33 inches (76.5 × 83.8 cm). The Menil Collection, Houston

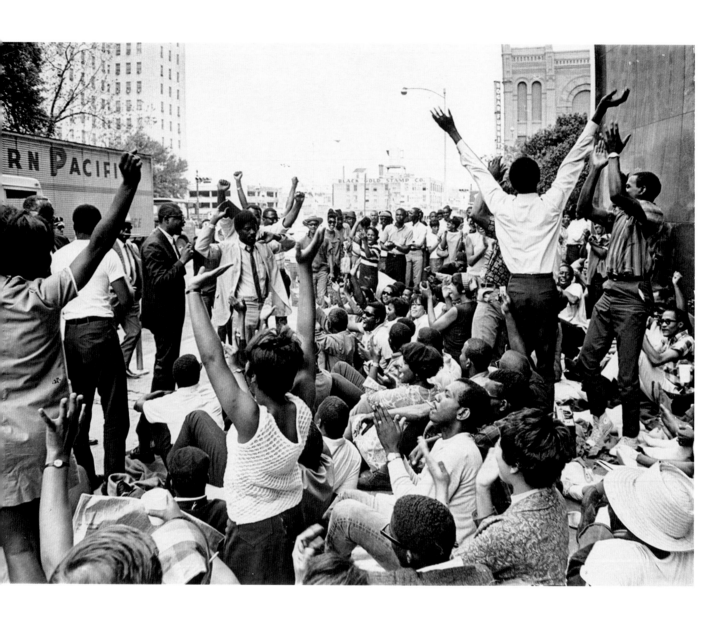

Texas Southern University students protesting outside Harris County Courthouse,
Houston, April 6, 1967. Houston Post Collection, Houston Metropolitan Research Center

MIMI CROSSLEY DETERING

Styles of Change: John de Menil and Civil Rights in Houston

Houston in the 1950s was still part of the Old South, with an overlay of recent oil companies, whose families formed a colony of sorts, with their livelihoods centered on a forest of refineries growing up on a ship channel built for the cotton trade. The city, though, was steeped in the ways of rigid racial segregation, with one of the highest urban concentrations of African Americans in the nation. The years following World War II saw rural blacks pour out of the Piney Woods of East Texas to places in Houston known as the Wards, Pearl Harbor, Sunnyside (named for one of the largest antebellum plantations in the South), and the Settegast neighborhood, which wouldn't have sewers and clean water for another decade. No large-scale protests were evident. A local blues musician called Leadbelly sang out the streets in downtown Houston where blacks could go only at their peril.

When change came, it was after two United States Supreme Court decisions and a flurry of federal actions aimed at striking down segregation "with all deliberate speed," and it was met with a resistance whose motto could have been *festina lente,* "make haste slowly." Since it was mostly *lente*, few changes occurred.

In the 1960s, with cities across the US in racial turmoil, one group of Houston business leaders organized quietly to open public facilities, stores, hotels, and restaurants to blacks–provided there was no mention in any media of their action.

Another group, mainly attorneys for the National Association for the Advancement of Colored People (NAACP), slugged it out in state and federal court in an effort to desegregate Houston public schools.

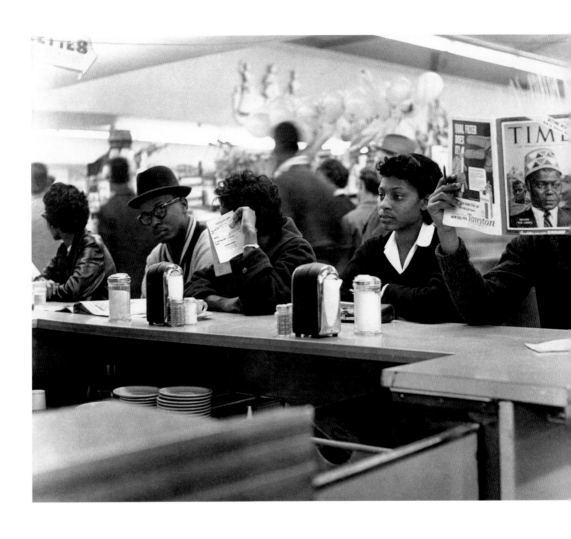

Above Texas Southern University students during a lunch counter sit-in
at a Weingarten's grocery, Houston, March 5, 1960. Houston Post Collection,
Houston Metropolitan Research Center

Opposite page Flyer for the Black Panthers' Free Breakfast for School Children
program, Houston, 1973. Menil Archives, The Menil Collection, Houston

Others, led by white appointees and black activists, wrangled with local government over a flurry of ever-changing, poorly financed federal agencies while most of Houston's wealthy white citizens sat it out.

One didn't.

John de Menil, French-born industrialist, chairman of the board of Schlumberger, Inc., one of the largest international oil services companies, based in Houston, made no secret that beyond mere legal desegregation, he advocated integration. He believed it and he lived it. It was a style of open acceptance of complete racial equality by a leading industrialist with major civic standing. De Menil and his wife, Dominique, were prominent art collectors active in museums in New York and Houston, local colleges, and community efforts to improve conditions in black neighborhoods–run by blacks themselves. Dinner at the De Menils usually included painters, sculptors, young black legislators, musicians, and writers of all races.

It was a style of change not seen before in Houston, or most anywhere in a nation in the throes of major upheaval. John de Menil created waves of change and drew scores of young people and those hungry to make a difference in a once-stifling city. In addition to public sponsorship of art exhibitions, creating the Rothko Chapel dedicated to human rights, and events at places like the de Menil–created Media Center at Rice University that aimed to break down artistic and racial barriers (aided by such luminaries as filmmaker Roberto Rossellini), John de Menil also acted personally and quietly. Only a fraction of his personal interests are known today: scholarships to young inner-city children; help for black friends running community centers; paying the bills for lawyers defending four students wrongfully accused of shooting a Houston policeman; and a longtime association with Mickey Leland, who became a Texas legislator and then a US Congressman and a regular member of the de Menil inner circle.

A de Menil friend and long-time observer, Bob Lee, described the de Menil style. Originally from Houston's Fifth Ward, Lee became a VISTA volunteer in Chicago and joined the Black Panther Party in the late sixties. After studying with Chicago labor organizer Saul Alinsky at the Industrial Areas Foundation, Lee came back to Houston and the city's charity hospital as a patient in the tuberculosis ward. Mickey Leland, then a local community organizer, asked Bob Lee for help with a project meeting resistance from the black neighborhood where Lee grew up. An art group sponsored by the Menil Foundation had leased an old, closed-down movie theater on Lyons Avenue called the De Luxe for an art show of the latest abstract painting and sculpture with

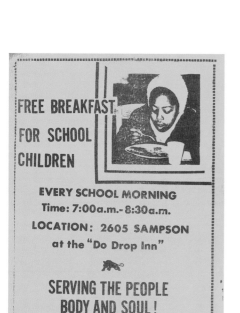

FREE BREAKFAST FOR SCHOOL CHILDREN

EVERY SCHOOL MORNING
Time: 7:00a.m.-8:30a.m.

LOCATION: 2605 SAMPSON
at the "Do Drop Inn"

SERVING THE PEOPLE
BODY AND SOUL!

a curator from New York. Neighbors shunned the young, black and white team of curators and artists; a slumlord across the street rented rooms by the hour to a clientele that poured out onto Lyons Avenue day and night.

"It was a Sunday. I stood at the window on the fourth floor of the TB ward and saw a big Mercedes pull up. A man got out, he wore a beautiful silk suit with his jacket tossed over his shoulders and loafers with no socks. I knew it had to be John de Menil." The two talked and Lee told de Menil of Alinsky's organizing methods. Identify the neighborhood institutions–churches, schools, businesses. Make up flyers. Hire neighborhood people to go door to door explaining what the art show was all about. Hire neighborhood students as guards and guides. De Menil put the plan into motion and Lee convinced the slumlord that he was violating several city and state laws and should close down right away. In trademark style, the oilman and the Black Panther became friends for the rest of de Menil's life, and sat together for hours when the older man became ill.

"The De Luxe show was the beginning of a renaissance for Lyons Avenue," Lee said. "It brought in investment, new business, paved streets, and health clinics. It was the seed for a major change you can see today."

"It's almost impossible to overestimate the impact of John de Menil on the black community in Houston," mused Curtis Graves, who, with Barbara Jordan, served in the Texas Legislature in the sixties, a place that had not seen a black representative seated since Reconstruction. Graves told what happened behind the scenes of a now-famous incident that took place in Houston in 1967, when Martin Luther King Jr. came to speak and raise money for civil rights efforts: "Andrew Young (then an aide to King) called me, because we had been childhood friends. He said Reverend King was holding concerts around some of the big cities to raise money for his civil rights effort. King wanted to bring Aretha Franklin, Harry Belafonte, and Joan Baez to Houston and could I organize a venue. So I lined up the Coliseum, and Ticketron agreed to sell the tickets."

But a few weeks before the concert, Ticketron was hit with smoke bombs and its employees with death threats. "We had only three weeks to go, and we had sold only five hundred tickets, and Ticketron bowed out," Graves said. King, accompanied by Belafonte, arrived the day before the concert was to go on. "We had stories in the black

Community activist Mickey Leland, Granville Sawyer, and John de Menil at the opening of *Some American History*, Rice Museum, Rice University, Houston, 1971. Photograph by Hickey-Robertson. Menil Archives, The Menil Collection, Houston

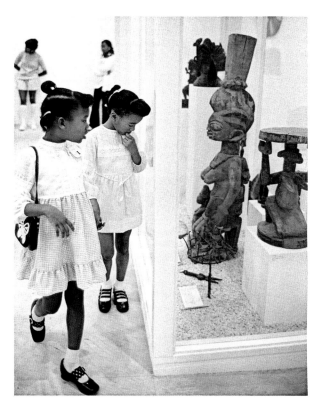

Left Visitors to *Tribal Art of Africa*, Black Arts Gallery, De Luxe Theater, Houston, 1973. Photograph by Hickey-Robertson. Menil Archives, The Menil Collection, Houston

Above right Barbara Jordan and Mickey Leland at Wheatley High School Alumni Day at *The De Luxe Show*, De Luxe Theater, Houston, 1971. Photograph by Hickey-Robertson. Menil Archives, The Menil Collection, Houston

Below right Mickey Leland and Andrew Young escorting a delegation of African visitors to the Rothko Chapel, Houston, 1979. Photograph by David Crossley. Rothko Chapel Archives, Houston

neighborhood newspapers and we had gone to churches and clubs to sell tickets but we still sold only fifteen hundred total. We had to reach four thousand to pay expenses and raise some money."

Sitting in a suite at the Shamrock Hilton, Graves faced a room with King, Belafonte, interfaith leader Rabbi Robert Kahn, and Young. The atmosphere was tense. Joan Baez had been arrested in another city. Death threats had come to King from the Ku Klux Klan warning him not to appear. And Graves's report was not encouraging. "There was no way we could fill the Coliseum. Everybody talked and we were getting more and more depressed. Then King said there was one thing we hadn't done. He knelt down holding the back of a chair, and started praying. Out loud. Rev. King told God what we had tried to do, and how hard we tried, and went on talking for another fifteen minutes." Suddenly King stood up and said, 'Give them away. Give all the tickets away for free.'"

Early the next morning, Graves went to the garage of a friend who was keeping the tickets. "We were making plans to hit the parks and shopping malls to give away the tickets, when a big car pulled up," Graves related. A man got out and handed Graves an envelope, saying it was from John de Menil. "I didn't know who that was. He said Mr. de Menil wanted to buy two thousand tickets and gave us the money. We were stunned and started counting out the tickets. The limousine driver stopped us. He told us Mr. de Menil didn't want to actually *have* the tickets. We asked the driver what we were supposed to do. He said Mr. de Menil wanted us to give them away. Give them all away."

The October concert went on as planned. Some four thousand people filled the Coliseum. Smoke bombs were thrown into the hall, and the KKK marched in the street. The bills were paid and money was raised for King's next march. In April, King was assassinated.

Meeting later, Curtis Graves and John de Menil became friends. After Mayor Louie Welch and the Houston City Council turned down a gift from the de Menils of a Barnett Newman sculpture dedicated to King, Graves received a call. "John knew I was thinking of running for mayor in the next election. He bought billboards, television and radio time, and we got as many votes as had been cast in any previous mayoral race," Graves said. Welch supporters, however, fanned the flames of racial fears among white voters, who swamped the election.

John de Menil never made public why he felt strongly about racial injustice, except to say wryly that he was "always for the underdog." His experience as a young man in the French army in Africa may have formed his sympathies, and later disastrous French defeats in colonial wars in Southeast Asia and Algeria gave him insight into growing opposition to US involvement in Vietnam by civil rights and student leaders.

Activist and author John Maher Jr. witnessed the de Menil style up close. "I was back at my parents' home in Houston when a call came in, telling me to meet John de Menil at the Petroleum Club. There was no question that I was being summoned, and my father said I had no choice. He told me to get down to the Petroleum Club." Maher, a Harvard graduate, had recently worked on the staff of US Senator Gaylord Nelson before becoming an organizer for the Students for a Democratic Society (SDS) in Boston.

(In 1965, the US started heavy bombing in Vietnam, accompanied by an increase in the draft. Those opposing the war were frequently labeled communist sympathizers and organizers of the resistance were often subject to attention by the FBI. Certain prominent Houston business interests were deeply involved in US war contracts.)

"I probably came to Mr. De Menil's notice because I had been on the radio and in the newspapers debating the war," Maher related. "At lunch in the Petroleum Club, he grilled me on what I was doing, point by point. But as he went on, I realized he wasn't taking the opposite position. Not at all. He wanted to know what was going on inside the Civil Rights and antiwar movements. He wanted me to know what I was up against, and whether I was strong enough to do it." Maher continued his activities, later amassing an FBI dossier of two thousand pages and writing a book about the era, *Learning from the Sixties: Memoirs of an Organizer.*

Some forty years after John de Menil's death, Houston bears little resemblance to that Old South city. As the fourth largest and the most racially diverse city in the nation, the echoes of segregation, red-baiting, police repression, and fear are mostly a distant memory. Mostly. Houston has seen a distinguished black mayor, women mayors, and men and women of many colors and opinions take prominent places in government, law and business. That's just what John de Menil wanted.

Black Panthers

I am in favor very exciting mil

Memo to Grants Committee: Miles Glaser
 Dominique de Menil
 Simone Swan
 Helen Winkler November 15 1972

You will remember no doubt a recent memo about the DeLuxe. Should
we continue that program? Do we have a real communication there? Are
we catering to the people, or are we being caught in a power play? On
the other hand, should we abandon a substantial investment and the
possibility of showing art to the street?

A solution has come to mind. Why not operate the DeLuxe in cooperation
with the Black Panthers? They are evolving from violent revolution to well
organized social work, typified by their breakfast program for school
children. The agreement we have in mind is as follows:

- the Menil Foundation has a one year lease on
 the DeLuxe.

- the foundation organizes an exhibition of African
 tribal art from the Ménil collection: a high quality
 exhibition involving a value of $500,000 or more of
 irreplaceable material.

- the Black Panthers are co-sponsors of that exhibition.

- the Black Panthers are responsible for security: two
 or three men in attendance around the clock.

- for this service the Black Panthers will be paid the
 same fee as professional guards, and this money will
 go towards their breakfast program.

- every morning there will be a free breakfast at the
 exhibition. Nothing hot because we don't want to
 run the risk of fire, but milk, cereals, sandwiches,
 juices.

- SHAPE will be invited by the Panthers to be
 part of this breakfast program.

- bus transportation will be organized to the
 extent needed to enable children to come and
 get breakfast, see the exhibition and develop
 the desire to come back.

- the foundation will prepare for the Black Panthers
 an application to the National Endowment for the
 Arts for a grant of $20,000 to support the program.

- should this grant be turned down by the Endowment,
 the foundation would substitute.

- the Black Panthers and the foundation would make
 efforts to secure insurance coverage for the show
 Black, white and Lloyd underwriters. It would be
 a reasonable risk for them to take, and it would
 break a precedent.

Do you agree with this proposal which would be an art education
project of first magnitude? At the same time good social work and
uncompromising cooperation between Blacks and whites. Whites taking
the risks and Blacks the responsibility.

John de Menil

JdeM:ec

313

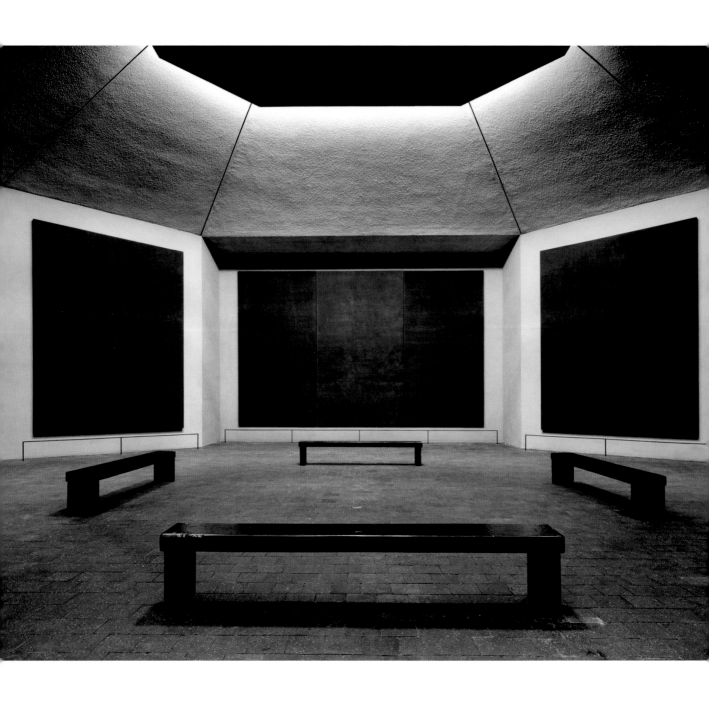

Rothko Chapel, Houston, with north triptych and northeast
and northwest wall paintings. Rothko Chapel, Houston

ANDRÉ SCRIMA

Martin of Tours and the Word "Chapel"

The origin of the term *chapel*, present in all our modern languages, coincides with a turning point in the history of Europe (the fourth century, the passage between antiquity and the Middle Ages) and expresses a certain basic ideal of the western world. A young knight and military commander of that time, Martin of Tours, received the faith, and meeting a poor man on his way almost immediately afterwards, he cut his knightly mantle in half and shared it with him. Later on, after Martin's death, the place where the relics of his mantle (Latin: *cappa*) were kept as an abiding sign came to be named *capella* (chapel). The conversion from military might to sainthood through the mediation of the "poor one" lays also (believe it or not) at the foundation of our western civilization, and the very word *chapel* is there to echo it even in a subdued way. And behold, here at the other "end," if we may say, of the western itinerary stands the Rothko Chapel without any "trace" inside, neither material remnants nor figurative forms. The "poverty" is fully there in the Chapel. The shape of the Chapel, consonant to one of the most enigmatic symbols of all traditions of knowledge, the Ogdoad–Octagon–cipher of the "consummation of all," leads to no definite end. The dark–or rather beyond any color–panels allow no "point of view" which would still mark a sedentary, restrictive attitude, engendering sooner or later petrified if not petrifying systems, ideologies, exclusivistic dogmatism. No dead end either: the mind recommences its forgotten pilgrimage under the spell of the (in)visible, formless presence into the space suddenly opened from beyond the obscure dark by a living fire akin to the dancing stars and vast breathing of beings.

Adapted from his introduction to *Contemplation and Action in World Religions,* ed. Yusuf Ibish and Ileana Marculescu (Houston: Rothko Chapel, 1978), 14–15.

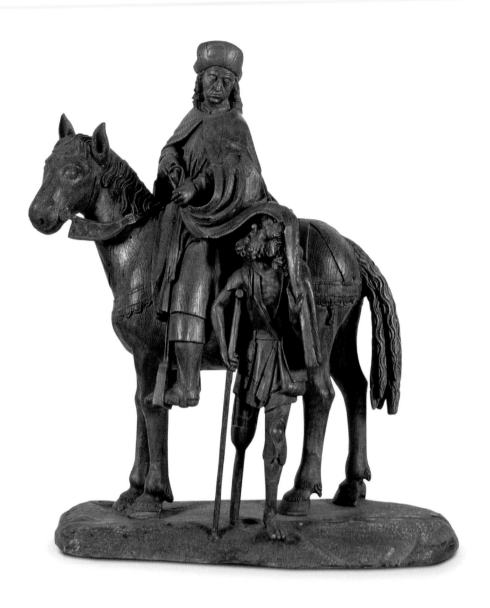

Above Saint Martin and the Beggar, ca. 1500–10. Northern Netherlands, possibly Utrecht. Wood, 31 ½ × 28 ½ × 12 inches (80 × 72.4 × 30.5 cm). Collection of the McNay Art Museum, Gift of Dr. and Mrs. Frederic G. Oppenheimer

Opposite above Fragment of a Qur'an folio in *mahaqqaq* script, Sura 31. ca. 1400. Attributed to Umar al-Aqta. Ink and opaque pigment on paper, 8 ½ × 28 inches (21.6 × 96.5 cm). The Museum of Fine Arts, Houston, Collection of Cathy Kooros

Opposite below Helveti-Jerrahi dervishes of Konya, Turkey, at the Rothko Chapel Houston, 1978. Photograph by Hickey-Robertson. Menil Archives, the Menil Collection, Houston

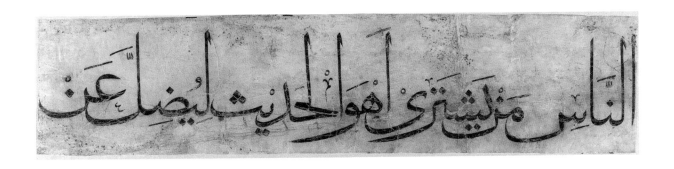

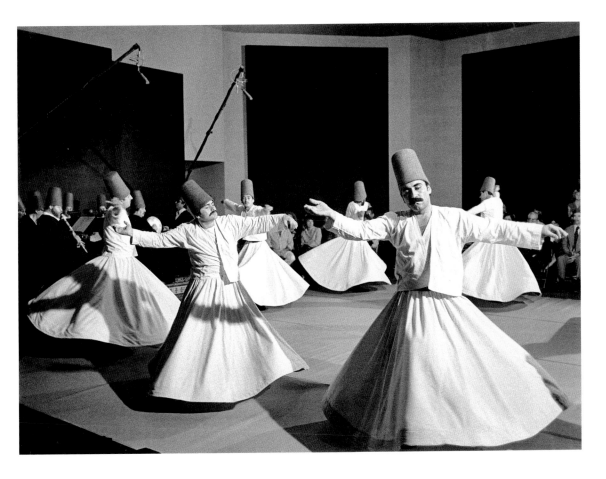

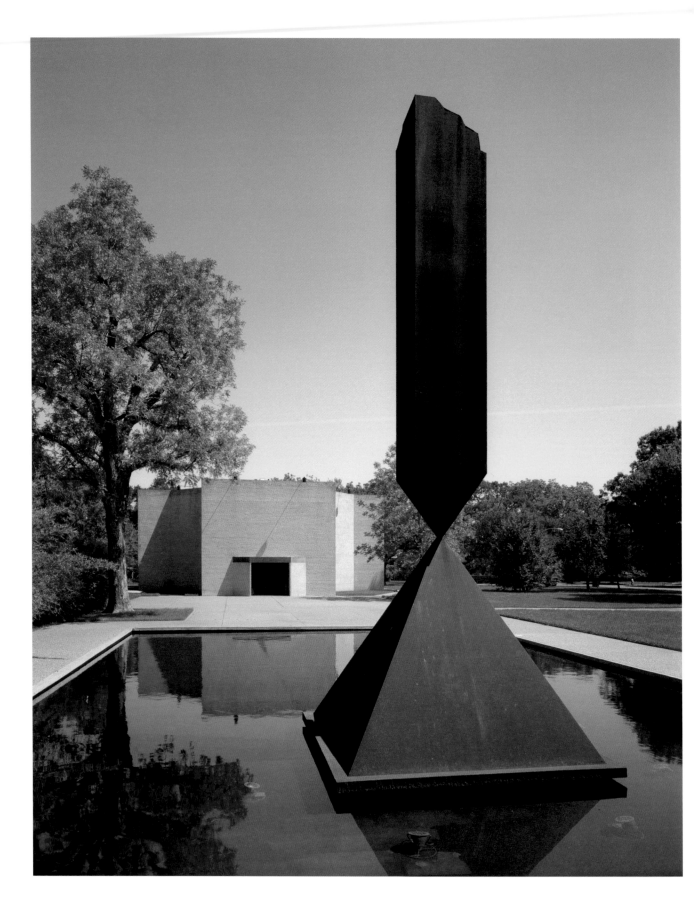

Barnett Newman (United States, 1905–1970), Broken Obelisk, 1963–67.
Cor-ten steel, 26 feet × 10 feet 5 ½ inches × 10 feet 5 ½ inches (7.9 m × 318.8 cm × 318.8 cm).
Rothko Chapel, Houston

Can the Sacred Withstand the Violence of Truth?

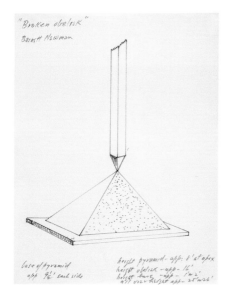

Art to me is an anecdote of the spirit.
 –Mark Rothko

We see that we face today a world more violent and where the value of truth
is more perverted…. Violence does not come only from the dispossessed,
the desperate, but, to a greater extent, from the powerful.
 –Dominique de Menil, On the occasion of the first Óscar Romero
 Award for Human Rights in 1986

If God exists, then God simply is what is. No one, no thing, no time, no place stands outside the realm of holiness. The sacred encompasses all. So mystics have claimed throughout the ages.

A beautiful vision.

And how troubling!

For if all is blessed, then to whom, to what can one appeal in the face of injustice? Is the holy truly capable of absorbing the full extent of humankind's cruelty, without being desecrated?

The Rothko Chapel symbolizes the paradox between the mystical claim that all is sacred and the reality of the human condition which

Barnett Newman, Broken Obelisk Drawing, n.d. Felt pen on paper, 11 × 8 ½ inches
(27.9 × 21.6 cm). The Menil Collection, Houston, Gift of Annalee Newman

too often is dominated by violence, cruelty, and indifference. Together, the chapel's art, site, and activities offer one response as to how the sacred can indeed withstand the violence of truth.

Hailed as one of the greatest artistic achievements of the mid-twentieth century, the Rothko Chapel was dedicated as a sacred space. Religious leaders from across the globe attended its opening ceremony in 1971 that included a liturgy of hymns and readings from the Islamic, Jewish, and Christian traditions.

With its permanent painting installation, it is a place drenched in the presence of Mark Rothko's luxurious canvases of deep purples, blues, rusts, and blacks. As an act of radical hospitality, the chapel is open every day of the year at no charge for visitors to experience the transformative power of its art, the tranquility of its grounds.

The Rothko Chapel shares its site with the magnificent *Broken Obelisk* sculpture by Barnett Newman, which is set in a reflection pool opposite the building's entrance. At the request of John and Dominique de Menil and with the express permission of Barnett Newman himself, the sculpture is dedicated to slain civil rights leader Martin Luther King Jr.

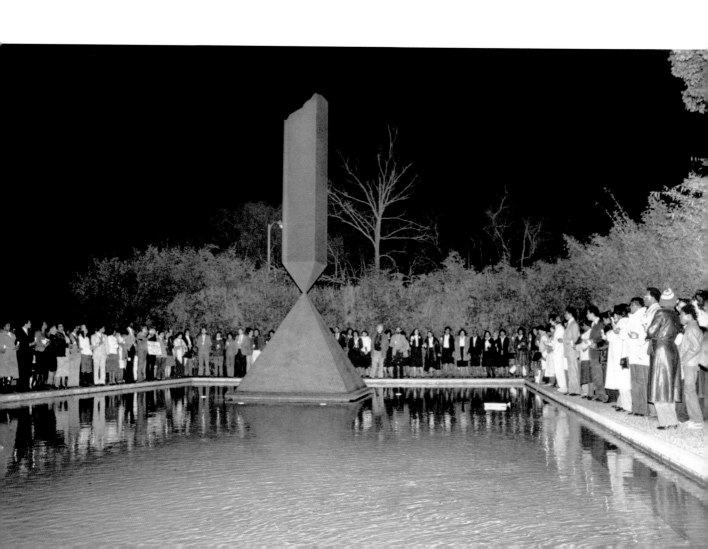

August 26, 1969

Dear John and Dominique:

I am sending you the Washington Post and New York Times stories. Considering the circumstances, I think they did very well. I am, however, annoyed at the New York Times for not have made a sufficient effort to reach me, so that I could publicly express my thanks to you for your generosity and pay tribute, in particular, to your courageous act.

May I now express my appreciation and my admiration for your great courage, which it was thought I should not do in the Houston release.

When you honored your gift by dedicating it to the memory of Martin Luther King, you also honored my work by rescuing it from the Philistines, who would have destroyed it as a work of art and madeit a political "thing".

I am very moved by what you have done and I feel with you, I am sure, a very special sense of happiness. After all it is not every day that we can stand up to the Philistines and win. Bless you both for making it possible.

I hope that my sculpture goes beyond only memorial implications. It is concerned with life and I hope that I have transformed its tragic content into a glimpse of the sublime.

Annalee joins me in sending you both our love.

Cordially,
Barney

685 West End Avenue
New York, N. Y. 10025

Opposite page Martin Luther King birthday observance around the reflecting pool with Barnett Newman's Broken Obelisk, Rothko Chapel, January 15, 1981. Photograph by David Crossley. Menil Archives, The Menil Collection, Houston

Above Barnett Newman to John and Dominique de Menil, August 26, 1969. Menil Archives, The Menil Collection, Houston

In an address delivered by cofounder Dominique de Menil, she explains, "The Rothko Chapel was dedicated ... as a sacred place where people coming from all horizons could pray and meet in search of love, truth, justice, and freedom. The search for truth is difficult. It demands that we do not exclude ourselves from criticism and that we recognize honestly that we, too, directly or indirectly, are supporting the structures of oppression."

As its stated mission, the Rothko Chapel inspires people to action through art and contemplation, nurtures reverence for the highest aspirations of humanity, and provides a forum for global concerns.

As an ecumenical, world-embracing entity, the Rothko Chapel is alive with songs of worship, contemplative concerts, meditation teachings, movement practices, silent reflection, and even laughter yoga.

It is in its capacity as a forum that the chapel most overtly juxtaposes the sacred and the profaned. Rothko's fourteen panels, themselves an exquisite homage to the *mysterium tremendum*, have been silent witnesses to a litany of testimonies of man's inhumanity to man. For more than forty years, the Rothko Chapel has been a place for speaking the truth about global human rights violations, devastations of dignity, and travesties of justice that occur day in and day out, all over the world.

As such, it struggles to be a place that can contain both horror and the sublime. It insists in the reality of the transcendent while also confronting the gnawing sense that in light of what we have done and continue to do to one another, all is lost and there can be no redemption for our kind.

In a statement on the occasion of the chapel's tenth anniversary, Dominique de Menil said, "It is a good time to reaffirm its vocation and question our faithfulness to it. It is a vocation so simple, so basically human, that it is understandable by all–yet so difficult to observe. It commits us to honesty, to justice, to compassion. In the end it demands that we recognize 'the other' as another 'I.' The other–the others! Millions of them are left to sink. They are asphyxiated, starved, tortured, reduced to silence."

Gaza. Abu Ghraib. Juarez. Guantanamo. Child soldiers in the Congo. The Disappeared in Algeria. Chinese factory workers. US Prisoners. Sex slaves trafficked through Houston. The list of horrors addressed by journalists, advocates, survivors, and spiritual leaders in the Rothko Chapel goes on.

Despite the fact that perpetrators of violence are never given a platform by the chapel and their heinous acts never sanctioned, one wonders at times whether the sanctity of the Rothko Chapel is tarnished in some way by naming these realities. This concern was voiced by a human rights attorney representing Yemeni detainees in Guantanamo Bay detention center who had been invited to speak at the chapel about the deplorable conditions, religious intolerance, and travesties of justice endured by his clients. He walked into the space for the first time an hour before his talk and his face turned ashen. With pain in his voice, he turned and said that he felt he could not, should not, deliver the talk he had prepared. Though he did end up giving it, he did not want to desecrate what he immediately sensed was a genuinely sacred place.

The Rothko Chapel gives a biennial award to grassroots human rights activists who at great risk to themselves stand against powers of violence and oppression. This award's name commemorates the sacrifice of Óscar Arnulfo Romero, Archbishop of El Salvador, martyred on March 24, 1980, while conducting Mass.

In the eloquent words of Michael D. Higgins, delivered at a Rothko Chapel Óscar Romero Award ceremony conducted in Vienna, Austria, in 1993: "Oscar Romero has become a symbol of the gaze not averted, the heart not stifled, the voice not silenced in the midst of oppression, death, torture, militarism and intimidation of many kinds. He is a symbol of something perhaps most important of all, a fundamental truth, that having come to knowledge of the sources of great wrong, truth requires a set of responses that will require pain but which suggests a moral journey that is inescapable."

The Rothko Chapel is on this moral journey. It invites all to join. It aspires to equip each and every visitor with the spiritual fortitude to cultivate hope in the midst of despair, to engage in compassionate action even at great cost to oneself, and when all else fails to at least not avert our gaze. To recognize ourselves in both victim and perpetrator. To be a moral witness.

Nelson Mandela, during his 1991 visit to the chapel, stated, "Our *common humanity* transcends the oceans and all national boundaries. It binds us together to unite in a common cause against tyranny, to act together in defense of our very humanity."

This bond is forged out of pragmatic necessity, to be sure. But it is also rooted in a conviction that interconnectedness is woven into the nature of reality itself, that the human condition is defined by transcendent, inescapable mutuality.

Archive copy of a medal created by Jim Love for the second Rothko Chapel Awards to Commitment to Truth and Freedom, 1986. Bronze, 3 ½ × 3 ½ × ½ inches (8.9 × 8.9 × 1.3 cm). Rothko Chapel, Courtesy of The Menil Collection, Houston

It is an awareness of this mutuality that Mark Rothko's paintings so poignantly demand. "A picture lives by companionship, expanding and quickening in the eyes of the sensitive observer. It dies by the same token. It is therefore a risky and unfeeling act to send it out into the world. How often it must be impaired by the eyes of the unfeeling and the cruelty of the impotent," he wrote. To him, the act of desecration could be as simple yet devastating as the glance of an insensitive observer. An indifferent eye.

Rothko suggested that art must be experienced as a "revelation, an unexpected and unprecedented resolution of an eternally familiar need." He maintained that, "if I must place my trust somewhere, I would invest it in the psyche of sensitive observers who are free of the conventions of understanding. I would have no apprehension about the use they would make of these pictures for the needs of their own spirits. For if there is both need and spirit there is bound to be a real transaction."

For an encounter with a piece of art to be transformative, it requires a receptive posture and an attunement to humanity's deepest needs. It necessitates the fortitude to be present to the full range of human experience and emotion.

Rothko understood his art as an extension of this ethic. "I would like to find a way of indicating the real involvements in my life out of which my pictures flow and into which they must return. If I can do that, the pictures will slip into their rightful place: for I think that I can say with some degree of truth that in the presence of the pictures my preoccupations are primarily moral and that there is nothing in which they seem involved less in than aesthetics, history or technology."

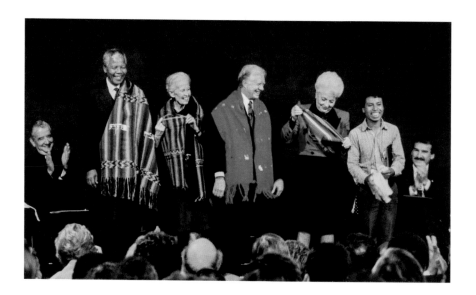

Commitment to Truth and Freedom Award Ceremony, Rothko Chapel, December 8, 1991. From left to right: Rodolfo Quezada Toruño, Nelson Mandela, Dominique de Menil, Jimmy Carter, Ann Richards, Sebastian Suy Perebal, and Ramiro de León Carpio. Photograph by Anthony Allison. Menil Archives, The Menil Collection, Houston

In a letter to the de Menils reflecting on the commission to create what would become the Rothko Chapel, the artist wrote, "The magnitude, on every level of experience and meaning, of the task in which you have involved me, exceeds all my preconceptions. And it is teaching me to extend myself beyond what I thought was possible for me. For this, I thank you."

By being open every day of the year, by being a place dedicated to each individual's personal quest for truth beholden to no particular ideology or religion, by championing human rights, the chapel continues to invite people to exceed their preconceptions and go beyond themselves.

It is in these encounters–between artist, witness, and truth–that the Rothko Chapel resolves the paradox of how the sacred confronts and transcends the violence of truth. The art invokes the holy. The truth may be cruel. Even extremely so. And yet those who gather as compassionate witnesses during a human rights program, who lend a listening ear to another human being during a community dialogue, who genuinely offer themselves to Rothko's demanding artistic vision, redeem the place, the moment, and perhaps themselves.

Mrs. de Menil writes, "When people meet in the Rothko Chapel, they know they meet in a place that was dedicated to God for the express purpose of fostering brotherhood, love, understanding. The mere fact of assembling in the chapel gives a spiritual orientation to the debates. It means that man's reality implies transcendence. This may look to many as a marginal circumstance–to me it is central."

It is said that Gandhi began his grand experiment believing God is Truth and concluded in the end that Truth is God.

Human reality implies transcendence.

The sacred *can* withstand the violence of truth.

May it be so.

Note on sources: Quotes from Mark Rothko are in his *Writings on Art*, ed. Miguel Lopez-Ramiro (New Haven, CT: Yale University Press, 2006), except for epigraph, from *Twentieth Century Artists on Art*, ed. Dore Ashton (New York: Pantheon, 1986); quotes from Dominique de Menil are in her *The Rothko Chapel: Writings on Art and the Threshold of the Divine* (New Haven, CT: Yale University Press in association with The Rothko Chapel, Houston, 2010); quote from Michael Higgins, from *The Rothko Chapel Oscar Romero Award, June 16, 1993, Vienna, Austria* (Houston: The Rothko Chapel, n.d.).

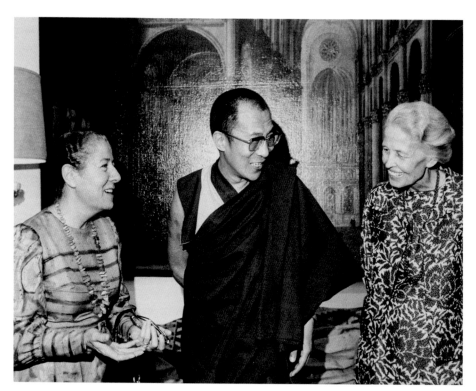

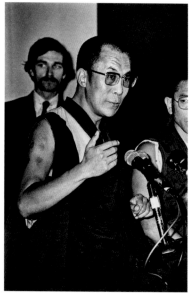

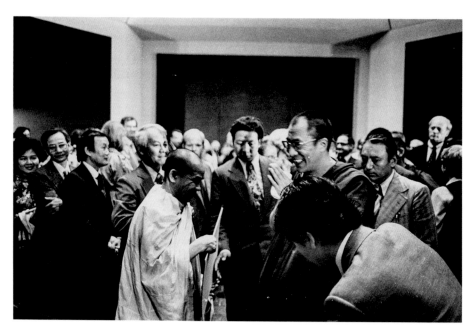

Left and below right The Dalai Lama speaking at the Rothko Chapel, September 1979.
Photographs by David Crossley. Menil Archives, The Menil Collection, Houston

Above Nabila Droubi, the Dalai Lama, and Dominique de Menil at the
de Menil's home in Houston, September 1979. Photograph by David Crossley.
Menil Archives, The Menil Collection, Houston

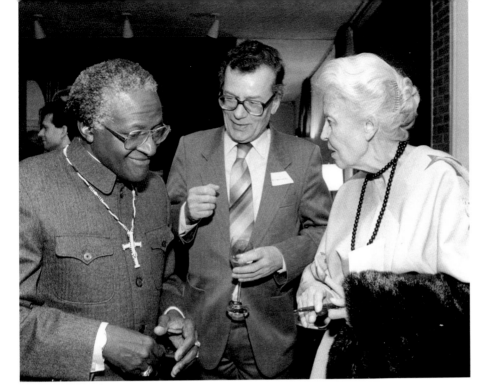

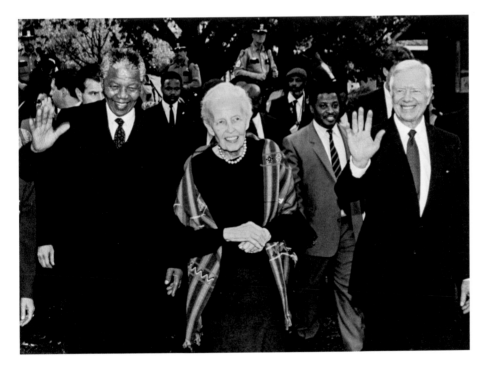

Above left Desmond Tutu, Cronid Lubarsky, and Dominique de Menil at the second Rothko Chapel Awards for Commitment to Truth and Freedom, December 10, 1986. Photograph by David Crossley. Rothko Chapel Archives, Houston

Below left Nelson Mandela, Dominique de Menil, and Jimmy Carter at the sixth Carter–Menil Human Rights Prize awards, Rothko Chapel, December 8, 1991. Photograph by David Crossley. Menil Archives, The Menil Collection, Houston

Right Desmond Tutu and Congressman G.T. Mickey Leland, Washington, DC, May 11, 1988. Photographer unknown. George Thomas "Mickey" Leland Papers, Mickey Leland Center for Environment, Justice, and Sustainability, Texas Southern University, Houston

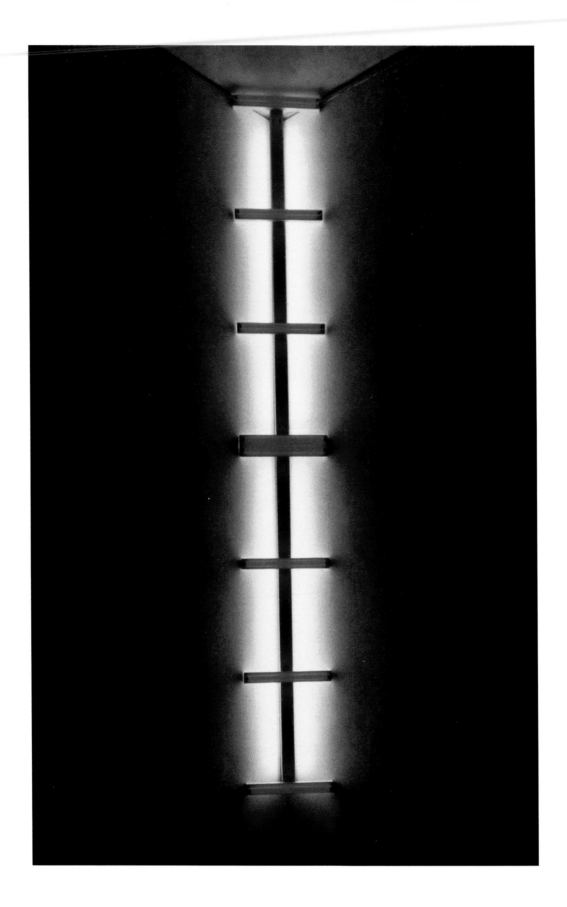

Dan Flavin (United States, 1933–1996), untitled [to the young woman and men murdered in Kent State and Jackson State Universities and to their fellow students who are yet to be killed], 1970. Fluorescent tubes and metal fixtures, 16 feet × 24 inches (4.9 m × 61 cm). Stephen Flavin, New York, Courtesy of David Zwirner, New York/London

VINAY LAL

On the Art of Dying: Death and the Specter of Gandhi

Such was the end, Echecrates, of our friend: concerning whom I may
truly say, that of all men of his time whom I have known, he was the wisest
and justest and best.
 —Plato, *Phaedo*

I: THE TIMEPIECE AND THE LAST WALK

On the evening of January 30, 1948, around ten minutes past five
o'clock, Gandhi emerged from the interior of Birla House, where he had
been immersed in a meeting with his close associate Sardar Patel,
and began to walk towards the garden for his customary evening prayer.
A crowd was gathered as usual to catch a glimpse of the old man
and seek his audience; among those awaiting his presence were the
American journalist Vincent Sheean and BBC's Delhi correspondent,
Bob Stimson. But something was amiss: though scarcely a Protestant,
Gandhi could well have been mistaken for one, considering that
he swore both by punctuality and by the maxim that "cleanliness is
next to Godliness," and yet this evening the prayer meeting had
not commenced at 5 pm. Gandhi had failed to keep time, prompting
Stimson to remark to Sheean, "Well, this is strange. Gandhi's late. He's
practically never late."[1] Gandhi's life was governed by the watch to an
unusual degree, but he was no prisoner of time; remarkably, though
he adhered to a meticulous, even punishing, schedule for much of his
life, Gandhi was generous in giving his time to others, whatsoever
their station in life. Hundreds of people who were close to him have
written that even as he was preoccupied by weighty matters, among
them the struggle for the achievement of Indian independence, the
oppressive burdens placed upon Dalits, or the tenor of Hindu-Muslim

[1] Vincent Sheean, *Lead, Kindly Light:*
Gandhi and the Way to Peace (New
York: Random House, 1949), 202.

329

relations, he never neglected to inquire into the well-being of those around him, looking into the minutest details of everyday matters, and furnishing solace and comfort to all those who came to him with their sorrows. Punctual to a fault, Gandhi yet adhered to the most capacious conception of time—the time spent in service to others was time well spent.

If the slightest slackening of the disciplined life was calculated to agitate Gandhi, we should not be surprised that he was in a somewhat disturbed frame of mind as he commenced his last walk. His grand-niece, Manu, who tended to his daily needs, later recalled that he scolded her and Abha, his other caregiver and "walking stick," for having failed to enforce the time. "I do not like," Manu recalled Gandhi telling her, "being late for the prayer meeting. Today's delay is due to your negligence . . . Even a minute's delay for the prayer causes me great discomfort."[2] Yet she had not had the heart to pull him away from Patel: though bereft of any official responsibilities, since Gandhi held no post in the newly minted nation, he had taken upon himself the onerous responsibility of healing the much-talked about rift between Prime Minister Jawaharlal Nehru and the Home Minister Sardar Patel and thus holding the nation together as it lay engulfed by communal killings, arson, and the social disorder in the wake of mass displacement of people following the Partition of India into two new nation-states. So, coming out of Birla House, Gandhi quickened his pace; at around twelve minutes past five, Stimson finally saw him walking across the grass and remarked to Sheean, "There he is."

Approaching the elevated platform from where he conducted the prayer meeting, Gandhi had taken his hands off the shoulders of Abha and Manu in a gesture of greetings to his well-wishers. Nathuram Godse, a middle-aged high-caste Hindu from Pune, elbowed his way into Gandhi's path, brushing aside Manu who sought to stop him as they were already late for the prayer, and with a revolver fired three shots at Gandhi in rapid succession and at point-blank range. Some say that as Gandhi slumped forward, the words "Hey Ram, Hey Ram" escaped his lips; others argue that he merely gasped, or that he only uttered a faint "ah" as breath left his body. The assassin's brother, also implicated in the conspiracy (as it was termed by the government of India) to murder Gandhi, would claim in an interview given in 2000 that "the government knew that he [Gandhi] was an enemy of the Hindus, but they wanted to show that he was a staunch Hindu. So the first act they did was to put 'Hey Ram' into Gandhi's dead mouth."[3] As for the assassin, it is somewhat more reliably reported that before pumping bullets into the "Father of the Nation," he folded his hands in the traditional Indian greeting of *namaskar*: misguided though he

2 Manubehn Gandhi, *The End of an Epoch*, trans. Gopalkrishna Gandhi (Ahmedabad: Navajivan Publishing House, 1962), 41.

3 Gopal Godse, "Events and Accused," introduction to Nathuram Godse, *May It Please Your Honor* (Delhi: Surya Prakashan, 1987), 11. See also interview with Gopal Godse, "His Principle of Peace Was Bogus," *Time* (Asia Edition), February 14, 2000; and Gopal Godse, *Gandhiji's Murder and After*, trans. S. T. Godbole (Delhi: Surya Prakashan, 1989), 64.

thought Gandhi may have been, his assassin nonetheless recognized him as a devoted servant of the nation who strangely deserved both respect and a sentence of death.

As Gandhi collapsed to the ground, his timepiece, always tucked into his loincloth, broke: it had served its master well and had now lost its raison d'être. Months before, a nation had been vivisected; now a man was severed from his watch, a country from its guiding light. Time itself stood still, and a silence descended upon the country. Some sixty years later, on the anniversary of his death, the Delhi Government's Directorate of Information and Publicity rendered homage to Gandhi with a newspaper advertisement bearing his name, an image of a timepiece, and a caption which says, "Even time cannot forget."

II: THE ART OF DYING

Gandhi appears to have been preparing for death almost from the moment that he entered into public life in South Africa. He had arrived in Natal in May 1893, and soon thereafter, in circumstances that have been discussed, disputed, and dissected in thousands of books and articles, found a niche for himself in South Africa as an advocate of the rights of Indians, founding what Nelson Mandela would much later describe as "the first anti-colonial political organization in the country, if not in the world."[4] Gandhi's reputation as an agitator who aimed to take on South Africa's white establishment would precede him as he returned to Durban from Bombay in 1897, and he barely survived the beating of a lynch mob that had gathered at the port to receive him.[5] A decade later, Gandhi would again be tested: in pursuance of his agreement with General Jan Smuts, who agreed to repeal the Transvaal Asiatic Registration Act if the majority of Indians agreed to voluntary registration, which entailed the taking of fingerprints,[6] Gandhi was perceived by some of his fellow Indians as a traitor. A Pathan client, Mir Alam, thereby took an oath, "I swear with Allah as my witness that I will kill the man who takes the lead in applying for registration." One conception of the truth met another; both Gandhi and Mir Alam would be true to their words. As Gandhi led a group of Indians to the registration office, Mir Alam and his friends pounced upon him and some of his companions; Gandhi was dealt a severe blow to the head and kicked in his ribs. "I at once fainted with the words *He Rama* (O God!) on my lips," wrote Gandhi years later, "[and] lay prostrate on the ground and had no notion of what followed."[7] The assault might well have continued but for the fact that European passers-by were attracted by the commotion, and Mir Alam and his companions fled—only to be picked up by the police.

4 This is a reference to the Natal Indian Congress, established by Gandhi in 1894—see Mandela's, "Gandhi the Prisoner: A Comparison," in *Mahatma Gandhi: 125 Years*, ed. B.R. Nanda (New Delhi: Indian Council for Cultural Relations, 1995), 8. The Indian National Congress was founded in 1885, but whether it was "anti-colonial" at its inception is a different question.

5 M.K. Gandhi, *Satyagraha in South Africa*, trans. Valji Govindji Desai (1928; 2nd rev. ed., Ahmedabad: Navajivan Publishing House, 1950), 48–60.

6 Though fingerprinting is now fairly ubiquitous, a sign of how far the state everywhere in the world has appropriated powers of surveillance and disciplinary regimentation, only a few decades ago it was still largely criminals who were asked to give fingerprints.

7 Gandhi, *Satyagraha in South Africa*, 145–55.

Newspaper advertisement by the Delhi Government Directorate of Information and Publicity, published in multiple papers, January 30, 2011. Courtesy of Vinay Lal 331

ON THE ART OF DYING: DEATH AND THE SPECTER OF GANDHI

It is perfectly apposite that the practitioner of *satyagraha* should be prepared to confront death at any moment: as Gandhi was to write, "Just as one must learn the art of killing in the training of killing for violence, so one must learn the art of dying in the training for nonviolence."[8] In an intensely probing and brilliantly hermeneutic piece on Gandhi's assassination, the cultural critic and political psychologist Ashis Nandy argues that the assassin was motivated not merely by rage at Gandhi's alleged pampering of the Muslims and his alleged betrayal of the Hindu community. Godse was disturbed rather more by Gandhi's concerted attempts "to change the definition of centre and periphery in Indian society," and equally by Gandhi's "negation of the concepts of masculinity and femininity implicit in some Indian traditions and in the colonial situation."[9] It is telling that, at his trial for the murder of Gandhi, Nathuram Godse complained bitterly about how the *bania* (merchant-class) Gandhi had shipwrecked Indian politics with his quaint and enfeebling idea of nonviolence. Gandhi understood well the homology between colonial dominance and masculinity, and he sought to bring to the body politic a conception of politics that valorized the feminine, the non-Brahminical, and the mythos of Indian civilization. Nathuram Godse thus divined what many others did not, namely that Gandhi represented a threat to the idea of India as a masculine, modern nation-state, indeed to the very idea of "normal politics." Godse himself hailed from Maharashtra, "a region where Brahmanic dominance was particularly strong";[10] and the Chitpavan Brahmin community of which he was a member had seen the gradual erosion of its power, first under colonial rule and then with the ascendancy of the likes of Gandhi, who belonged to a merchant caste and had little affinity for the worldview associated with the traditional Brahmin elites. Not surprisingly, three previous attempts to assassinate Gandhi–in 1934, and twice in 1944, one in which Godse was implicated–all involved Maharashtrian Brahmins.

However, there was more to the "art of dying" than a series of providential escapes from the jaws of death. Gandhi had often expressed the desire to live to 125 years–and some suspected that the old man, considering the rigorous discipline to which he subjected himself in every respect, could well have lived that long. As the prospect of independence became brighter, the communal killings intensified, and his associates showed an unseemly preoccupation with the quest for power, Gandhi cut an increasingly lonely figure. At the prayer discourse on what would turn out to be last birthday, October 2, 1947, Gandhi noted that "there was a time when I wanted to live for 125 years, but I do not desire to live to be a hundred, or even ninety, I have lived for 78–79 years and that is enough for me."[11] Some months earlier, on May 22, he had told Manu that while he had "no longer the desire to live for 125 years," he also did not wish to "die of lingering

8 *Gandhi on Non-Violence: Selected Texts from Mohandas K. Gandhi's Non-Violence in Peace and War*, ed. Thomas Merton (New York: New Directions, 1965), 68.

9 Ashis Nandy, "Final Encounter: The Politics of the Assassination of Gandhi," in *At the Edge of Psychology: Essays in Politics and Culture* (Delhi: Oxford University Press, 1980), 70–98, quotes on 71.

10 Ibid., 77.

11 Cited by Sudhir Chandra in *Speaking of Gandhi's Death*, ed. Tridip Suhrud and Peter Ronald deSouza (Delhi: Orient BlackSwan, 2010), 44.

illness"–such a death would obligate Manu to signal to the world that he "was not a man of God but an imposter and a fraud. If you fail in that duty I shall feel unhappy wherever I am. But if I die taking God's name with my last breath, it will be a sign that I was what I strove for and claimed to be."

Nathuram Godse was among the men who were determined that Gandhi should die at their hands. On January 20, 1948, he and a handful of others had engineered a bomb explosion at Birla House with the hope of killing Gandhi, but the attempt was a resounding failure; two days later, Gandhi took Manu aside and told her, "I wish I might face the assassin's bullets while lying on your lap and repeating the name of Rama with a smile on my face. But whether the world says it or not–for the world has a double face–I tell you that you should regard me as your true mother." Gandhi would even suggest to Manu, the night before his murder, that the manner of his death would reveal to the world whether he was a real Mahatma or not: in words reminiscent of his earlier admonition to her, she was to shout from the rooftops to the whole world that he was a "false or hypocritical Mahatma" if he were to die of a "lingering disease, or even from a pimple." Yet if an explosion took place, as it had last week, "or if someone shot at me," Gandhi continued, "and I received his bullet in my bare chest without a sigh and with Rama's name on my lips, only then should you say that I was a true Mahatma."[12]

Does the "art of dying" mean only, then, that we should be able to choose the timing and manner of our death? On the morning of his assassination, Gandhi gave Pyarelal, his secretary, the draft constitution for the Congress Party that he had completed the previous night; he then called for Manu, who replied that she was busy with something and would join him shortly. Thereupon Gandhi replied: "Who knows, what is going to happen before night fall or even whether I shall be alive?" He also penned a letter of condolence to a colleague who had lost his daughter: "What can I write to you? What comfort can I give you? Death is a true friend. It is only our ignorance that makes us to grieve."[13]

III: THE SPECTER OF GANDHI

Robert Payne was among Gandhi's first biographers to describe his murder as a "permissive assassination."[14] India had emerged as a new nation-state from two centuries of colonial rule, and India's elites, among them some who were Gandhi's associates, were keen that the country should take its place in the world as a strong nation-state resolutely committed to modernization, industrialization, and the kind of central planning that characterized the policies of the Soviet Union.

12 Manubehn Gandhi, *Last Glimpses of Bapu* (Delhi: Shiva Lal Agarwala, 1962), 234, 297–98.

13 See Narayan Desai, *My Life is My Message*, trans. Tridip Suhrud, 4 vols. (Delhi: Orient BlackSwan, 2009), vol. 4, *Svarpan (1940–48)*, 476–79.

14 Robert Payne, *The Life and Death of Mahatma Gandhi* (1969; reprint, New York: Smithmark Publishers, 1995), 647.

Yet Gandhi had initiated a far-reaching critique of industrial civiliza-
tion and the very precepts of modernity in his tract of 1909, *Hind Swaraj*,
and his critics worried that his pervasive influence would be detrimen-
tal to the development of India as an economic and political power.
Gandhi was, though this could scarcely be admitted, a nuisance, even
a hindrance; and when Godse pulled the trigger, there were certainly
others who thought that the man had died not a moment too soon. The
government had cast the murder as a "conspiracy" among Nathuram,
his brother Gopal, the ideologue Vinayak Savarkar, and a few other men;
but it was the bureaucrats and elites who, viewing Gandhi as expend-
able, had secretly conspired to let him die.

Gandhi has, however, had to be killed repeatedly. It may well be that is
likewise the fate of others whom a nation seeks to exorcise. A cartoonist
for the *Chicago Sun-Times* in the aftermath of the assassination of
Martin Luther King Jr. appears to have understood this well: a seated
Gandhi looks up to the slain civil rights leader and remarks, "The odd
thing about assassins, Dr. King, is that they think they've killed you."
A modern nation-state has many ways to excise the memory of those
who are most despised, resented, or feared. It is a criminal offence in
Germany, for instance, to perpetuate the memory of Hitler, or take up
his cause in any fashion. The case of Gandhi is, of course, far more
complicated: as I have argued elsewhere, every constituency in
India–Dalits, modernizers, feminists, Marxists, Hindu nationalists,

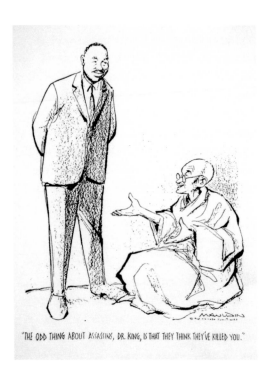

"THE ODD THING ABOUT ASSASSINS, DR. KING, IS THAT THEY THINK THEY'VE KILLED YOU."

Bill Mauldin cartoon published in the *Chicago Sun-Times* the day after
Martin Luther King Jr.'s assassination, April 5, 1968

15 Vinay Lal, "The Gandhi Everyone Loves to Hate," *Economic and Political Weekly* 43, no. 40 (October 4–10, 2008): 55–64.

self-proclaimed revolutionaries, and various worshippers at the altars of violence, science, and development–"loves to hate" him,[15] but he is also revered by many. Gandhi is none other than the "Father of the Nation," and whatever politicians think of him on the sly, the proper obsequies must be paid: his statues are garlanded, his birthday is uniquely observed as a mandatory national holiday, and a requisite number of seminars proclaiming his "relevance" are held every year with gusto. For decades after his death, the commercial Hindi film captured the Janus-faced sentiment with which Gandhi is received with simple elegance: in the police station or the bureaucrat's office, underneath the required framed picture of Gandhi, the functionary of the state invariably pockets a bribe. Gandhi's fellow Gujaratis, in and out of India, have banished him from their worldview; rather shamefully, the guardians of his own Sabarmati Ashram in Ahmedabad, from where Gandhi set out on the Salt March, shut close its doors in the face of the Muslim refugees seeking protection from the hoodlums baying for their blood in the killings of 2002. Yet it is the same Gujaratis who, mindful of the fact that no figure in India's modern history commands the kind of cultural capital that Gandhi does, unfailingly attempt to avail themselves of the goodwill generated by their kinsman's name, especially internationally.

Yet, however much India's elites and middle classes have attempted to relegate Gandhi to the margins, engaging in campaigns of slander, obfuscation, and trivialization, Gandhi continues to surface in the most unexpected ways. He is the (sometimes hidden) face of most of India's most significant ecological movements, from the Chipko agitation to the Narmada Bachao Andolan, just as he is the face of intellectual dissent, little insurrections, and social upheaval. Every so often someone comes along purporting to unmask the "real" Gandhi, the Gandhi that "no one knows," the Gandhi who was patriarchal, bourgeois, casteist, a sexual puritan, contemptuous of Africans, an enemy of progress and development, even a "friend of Hitler'. (Gandhi authored two short very short letters to Hitler, neither of which the war-time British censors permitted to reach the intended recipient, urging him to renounce violence.) Yet Gandhi refuses to disappear: we have heard of the Gandhian moment in Iran's Green Revolution, the Gandhi who appears on Israel's Separation Wall, and of the "little Gandhi" thrown up by every revolution over the last few decades. Few Indian artists of any caliber have not entered into an engagement with his life and work; the very iconography of Gandhi–the shining bald head, the pair of round spectacles, the timepiece, the walking stick, the sandals, the Mickey Mouse ears, the pet goat–is now part of the national imaginary. He is everywhere, in every act of nonviolence and, more significantly, every act of violence–a spectral presence to remind us of the supreme importance of the ethical life.

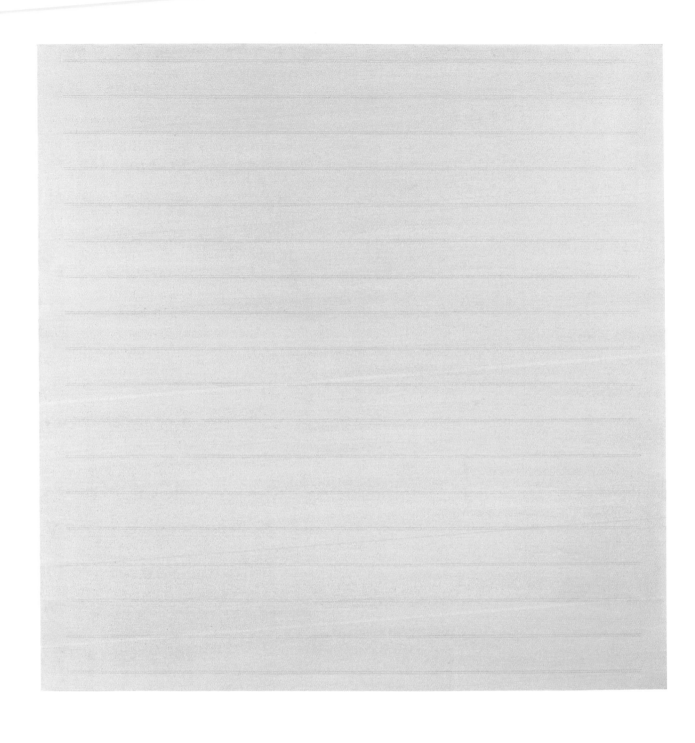

Agnes Martin (United States, 1912–2004), Untitled #6, 1984. Acrylic and pencil
on canvas, 72 × 72 inches (182.9 × 182.9 cm). Private collection, Houston

Universal Declaration of Human Rights

PREAMBLE

Whereas recognition of the inherent dignity and of the equal and inalienable rights of all members of the human family is the foundation of freedom, justice and peace in the world,

Whereas disregard and contempt for human rights have resulted in barbarous acts which have outraged the conscience of mankind, and the advent of a world in which human beings shall enjoy freedom of speech and belief and freedom from fear and want has been proclaimed as the highest aspiration of the common people,

Whereas it is essential, if man is not to be compelled to have recourse, as a last resort, to rebellion against tyranny and oppression, that human rights should be protected by the rule of law,

Whereas it is essential to promote the development of friendly relations between nations,

Whereas the peoples of the United Nations have in the Charter reaffirmed their faith in fundamental human rights, in the dignity and worth of the human person and in the equal rights of men and women and have determined to promote social progress and better standards of life in larger freedom,

Whereas Member States have pledged themselves to achieve, in cooperation with the United Nations, the promotion of universal respect for and observance of human rights and fundamental freedoms,

Whereas a common understanding of these rights and freedoms is of the greatest importance for the full realization of this pledge,

Now, therefore,

The General Assembly,

Proclaims this Universal Declaration of Human Rights as a common standard of achievement for all peoples and all nations, to the end that every individual and every organ of society, keeping this Declaration constantly in mind, shall strive by teaching and education to promote respect for these rights and freedoms and by progressive measures,

national and international, to secure their universal and effective recognition and observance, both among the peoples of Member States themselves and among the peoples of territories under their jurisdiction.

ARTICLE 1

All human beings are born free and equal in dignity and rights. They are endowed with reason and conscience and should act towards one another in a spirit of brotherhood.

ARTICLE 2

Everyone is entitled to all the rights and freedoms set forth in this Declaration, without distinction of any kind, such as race, colour, sex, language, religion, political or other opinion, national or social origin, property, birth or other status.

Furthermore, no distinction shall be made on the basis of the political, jurisdictional or international status of the country or territory to which a person belongs, whether it be independent, trust, non-self-governing or under any other limitation of sovereignty.

ARTICLE 3

Everyone has the right to life, liberty and security of person.

ARTICLE 4

No one shall be held in slavery or servitude; slavery and the slave trade shall be prohibited in all their forms.

ARTICLE 5

No one shall be subjected to torture or to cruel, inhuman or degrading treatment or punishment.

ARTICLE 6

Everyone has the right to recognition everywhere as a person before the law.

ARTICLE 7

All are equal before the law and are entitled without any discrimination to equal protection of the law. All are entitled to equal protection against any discrimination in violation of this Declaration and against any incitement to such discrimination.

ARTICLE 8

Everyone has the right to an effective remedy by the competent national tribunals for acts violating the fundamental rights granted him by the constitution or by law.

ARTICLE 9

No one shall be subjected to arbitrary arrest, detention or exile.

ARTICLE 10

Everyone is entitled in full equality to a fair and public hearing by an independent and impartial tribunal, in the determination of his rights and obligations and of any criminal charge against him.

ARTICLE 11

1. Everyone charged with a penal offence has the right to be presumed innocent until proved guilty according to law in a public trial at which he has had all the guarantees necessary for his defence.
2. No one shall be held guilty of any penal offence on account of any act or omission which did not constitute a penal offence, under national or international law, at the time when it was committed. Nor shall a heavier penalty be imposed than the one that was applicable at the time the penal offence was committed.

ARTICLE 12

No one shall be subjected to arbitrary interference with his privacy, family, home or correspondence, nor to attacks upon his honour and reputation. Everyone has the right to the protection of the law against such interference or attacks.

ARTICLE 13

1. Everyone has the right to freedom of movement and residence within the borders of each State.
2. Everyone has the right to leave any country, including his own, and to return to his country.

ARTICLE 14

1. Everyone has the right to seek and to enjoy in other countries asylum from persecution.
2. This right may not be invoked in the case of prosecutions genuinely arising from non-political crimes or from acts contrary to the purposes and principles of the United Nations.

ARTICLE 15

1. Everyone has the right to a nationality.
2. No one shall be arbitrarily deprived of his nationality nor denied the right to change his nationality.

ARTICLE 16

1. Men and women of full age, without any limitation due to race, nationality or religion, have the right to marry and to found a family. They are entitled to equal rights as to marriage, during marriage and at its dissolution.
2. Marriage shall be entered into only with the free and full consent of the intending spouses.
3. The family is the natural and fundamental group unit of society and is entitled to protection by society and the State.

ARTICLE 17

1. Everyone has the right to own property alone as well as in association with others.
2. No one shall be arbitrarily deprived of his property.

ARTICLE 18

Everyone has the right to freedom of thought, conscience and religion; this right includes freedom to change his religion or belief, and freedom, either alone or in community with others and in public or private, to manifest his religion or belief in teaching, practice, worship and observance.

ARTICLE 19

Everyone has the right to freedom of opinion and expression; this right includes freedom to hold opinions without interference and to seek, receive and impart information and ideas through any media and regardless of frontiers.

ARTICLE 20

1. Everyone has the right to freedom of peaceful assembly and association.
2. No one may be compelled to belong to an association.

ARTICLE 21

1. Everyone has the right to take part in the government of his country, directly or through freely chosen representatives.
2. Everyone has the right to equal access to public service in his country.

3. The will of the people shall be the basis of the authority of government; this will shall be expressed in periodic and genuine elections which shall be by universal and equal suffrage and shall be held by secret vote or by equivalent free voting procedures.

ARTICLE 22

Everyone, as a member of society, has the right to social security and is entitled to realization, through national effort and international co-operation and in accordance with the organization and resources of each State, of the economic, social and cultural rights indispensable for his dignity and the free development of his personality.

ARTICLE 23

1. Everyone has the right to work, to free choice of employment, to just and favourable conditions of work and to protection against unemployment.
2. Everyone, without any discrimination, has the right to equal pay for equal work.
3. Everyone who works has the right to just and favourable remuneration ensuring for himself and his family an existence worthy of human dignity, and supplemented, if necessary, by other means of social protection.
4. Everyone has the right to form and to join trade unions for the protection of his interests.

ARTICLE 24

Everyone has the right to rest and leisure, including reasonable limitation of working hours and periodic holidays with pay.

ARTICLE 25

1. Everyone has the right to a standard of living adequate for the health and well-being of himself and of his family, including food, clothing, housing and medical care and necessary social services, and the right to security in the event of unemployment, sickness, disability, widowhood, old age or other lack of livelihood in circumstances beyond his control.
2. Motherhood and childhood are entitled to special care and assistance. All children, whether born in or out of wedlock, shall enjoy the same social protection.

ARTICLE 26

1. Everyone has the right to education. Education shall be free, at least in the elementary and fundamental stages. Elementary education shall be compulsory. Technical and professional education shall be made generally available and higher education shall be equally accessible to all on the basis of merit.

2. Education shall be directed to the full development of the human personality and to the strengthening of respect for human rights and fundamental freedoms. It shall promote understanding, tolerance and friendship among all nations, racial or religious groups, and shall further the activities of the United Nations for the maintenance of peace.

3. Parents have a prior right to choose the kind of education that shall be given to their children.

ARTICLE 27

1. Everyone has the right freely to participate in the cultural life of the community, to enjoy the arts and to share in scientific advancement and its benefits.

2. Everyone has the right to the protection of the moral and material interests resulting from any scientific, literary or artistic production of which he is the author.

ARTICLE 28

Everyone is entitled to a social and international order in which the rights and freedoms set forth in this Declaration can be fully realized.

ARTICLE 29

1. Everyone has duties to the community in which alone the free and full development of his personality is possible.

2. In the exercise of his rights and freedoms, everyone shall be subject only to such limitations as are determined by law solely for the purpose of securing due recognition and respect for the rights and freedoms of others and of meeting the just requirements of morality, public order and the general welfare in a democratic society.

3. These rights and freedoms may in no case be exercised contrary to the purposes and principles of the United Nations.

ARTICLE 30

Nothing in this Declaration may be interpreted as implying for any State, group or person any right to engage in any activity or to perform any act aimed at the destruction of any of the rights and freedoms set forth herein

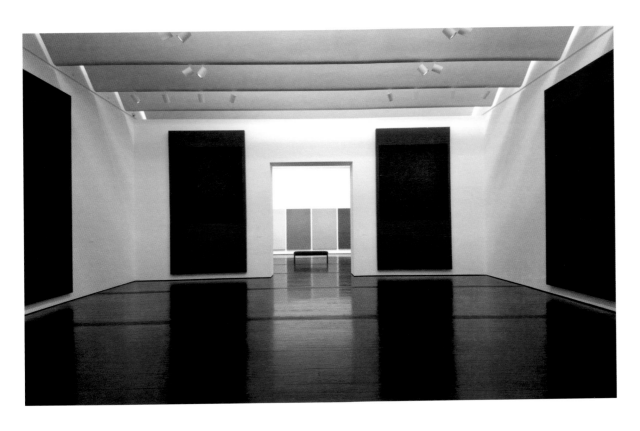

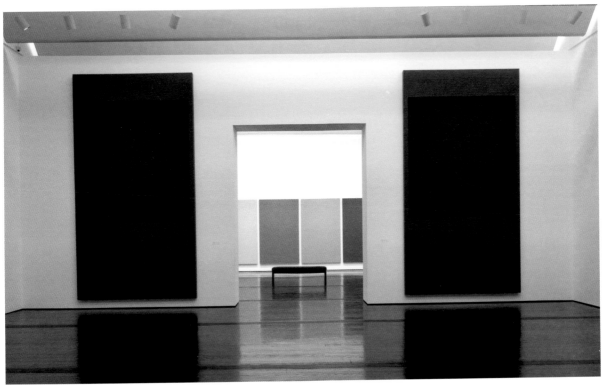

Mark Rothko (b. Russia, active United States, 1903–1970), Untitled (Rothko
Chapel Alternate Panels), 1966, installed at the Menil Collection, Houston, 2011.
Dry pigment, rabbitskin glue, egg/oil emulsion, and synthetic polymer on canvas,
each 177 ¼ × 114 ¼ inches (450.2 × 290.2 cm)

A CHRONOLOGY OF SELECTED NONVIOLENT AND HUMANITARIAN ACTIONS

Compiled by Clare Elliott and
Joseph N. Newland with Eric M. Wolf

ca. 1750 BCE
The Code of Hammurabi–the first known attempt to codify the conduct of war–expresses the king of Babylon's belief that the strong should not oppress the weak.

ca. 539 BCE
The Persian leader Cyrus the Great declares the freedom of religion and abolition of slavery on a clay cylinder ("Cyrus Cylinder").

ca. 480 BCE
The Analects–a collection of speeches and ideas compiled by the followers of Confucius promotes ethical behavior as the foundation for legitimate political power.

ca. 260 BCE
Edicts of Ashoka–inscribed on columns and rock-cut inscriptions dispersed broadly across mainland South Asia, the edicts describe the Mauryan emperor Ashoka's Buddhist principals of tolerance, justice, and nonviolence.

1222 CE
Manden Charter proclaimed in the Kurukan Fuga (now Guinea and Mali) and transmitted orally advocates "social peace in diversity, the inviolability of the human being, education, the integrity of the motherland, food security, the abolition of slavery…and freedom of expression."

1650s
In England, a group of worshippers gathers around George Fox who embrace a Christianity that abjures war and physical conflict in any form, soon forming the Religious Society of Friends, or Quakers. Quakers become known for their dedication to social justice and being at the forefront of many humanitarian causes.

1775
Quakers in Philadelphia found the first organization in the United States to call for abolishing slavery in the country, the Society for the Relief of Free Negroes Unlawfully Held in Bondage.

1776
Declaration of Independence–the Continental Congress of the 13 colonies that became the United States of America proclaims all men to be created equal and to be possessed of "inalienable" rights, among them life, liberty, and the pursuit of happiness.

1789
Declaration of the Rights of Man and the Citizen (*Déclaration des droits de l'homme et du citoyen*) defining a set of individual and collective rights shared universally by all citizens adopted by the National Constituent Assembly of France.

1791
The Bill of Rights, the first 10 amendments to its constitution, ratified by the United States of America. Among other rights it guarantees freedom of speech, freedom from unreasonable search and seizure, freedom of religion, right to trial by jury, and the prohibition of cruel and unusual punishment.

1847
Former slave Frederick Douglass founds an abolitionist newspaper that until 1863 serves as an important voice for the eradication of slavery in the United States.

1849
Henry David Thoreau publishes the influential essay "On Resistance to Government," generally called "Civil Disobedience," making the case for resistance to laws one considers morally wrong and serving in jail rather than giving in.

1851
At the Ohio Women's Rights Convention in Akron the former slave Sojourner Truth galvanizes the gathering with her forceful call for the abolition of slavery and granting equal rights to women, an intersection of two then-important justice movements in the United States.

1859
The book *Notes on Nursing* by Florence Nightingale helps legitimate the nursing profession and revolutionize care given to the ill and those wounded in war.

1862
Publication of *A Memory of Solférino* by Henry Dunant promotes the idea of neutral noncombatants allowed on fields of battle to minister to the wounded.

1863
In Geneva, an international conference considers the inadequacies of military medical services in the field; establishes the International Committee for Relief to the Wounded, which in 1876 becomes the International Committee of the Red Cross.

The Emancipation Proclamation declaring the freedom of slaves in the rebellious Southern States is legislated and signed by Abraham Lincoln, and all slaves are freed by the 13th amendment to the US Constitution approved the next year.

1864
Signing of the Convention for the Amelioration of the Condition of the Wounded in Armies in the Field, referred to as the first Geneva Convention.

1869
Mohandas Karamchand Gandhi is born October 2 in Porbandar, the capital of a small principality in Gujarat. His father is chief minister of the district, his mother a devoutly religious Vaishnava (follower of the god Vishnu), who practices morally rigorous Hindu and Jain concepts such as vegetarianism, fasting for purification, and *ahimsa* (non-injury to all living beings).

1879–81
In the face of land expropriation by British settlers invading New Zealand, indigenous Maori led by Te Whiti-o-Rongomai III begin a resistance campaign to retain their lands. In 1881 1,500 constables come to evict 2,000 demonstrators, who sit down and refuse to move. After their dispersal, Te Whiti is arrested and spends two years in jail.

1888–91
Gandhi studies law in London; joins the London Vegetarian Society, which includes idealists and progressives who endorse cooperation and simplicity. He reads a life of the Buddha and, for the first time, the *Bhagavad Gita,* in an English translation.

1893
Gandhi goes to Durban, Natal Colony, in South Africa for a one-year job as an attorney. He experiences institutionalized racism and responds with noncooperation.

1894
Gandhi organizes opposition to legislation depriving Indians in South Africa of the vote. The effort fails, but diverse stakeholders join to form the Natal Indian Congress; Gandhi widely publicizes the poor treatment of resident Indians.

Leo Tolstoy publishes abroad and in translation his Christian anarchist book *The Kingdom of God Is Within You,* which condemns government on the basis of nonresistance (Christ's "resist not evil").

1895
In keeping with their pledge to end military service and war-making, three groups of Doukhobors, radical Christian pacifists, in the Southern Caucasus hold bonfires of weapons.

1904
Gandhi reads John Ruskin's critique of capitalism *Unto this Last* and adopts its ideas of living simply, equally valuing all forms of labor (including manual), and sharing

344

resources communally. He founds Phoenix Settlement outside of Durban to enact these principles.

1905

The Russian Revolution against the Tsarist autocracy results from largely spontaneous actions demanding a voice in government. Improvised strikes quickly spread across numerous industries and sectors, and after demonstrators in large peaceful actions are gunned down, the majority of the population turns against the government. Concessions are granted, but after an escalation turns violent and is put down, calls for and action toward change die out for another ten years.

1906

In the South African province of Transvaal Gandhi organizes a meeting of Indian residents to protest and mobilize against required registration. Based on the crowd's response, he spontaneously formulates the technique of bringing change and righting injustice by inviting rather than inflicting suffering, later calling it *satyagraha* (truth or moral force). He asks his audience to defy the ordinance using any method but violence. During a peaceful demonstration, Gandhi is arrested and jailed.

1909

Gandhi and Tolstoy correspond, Gandhi reporting the influence of *The Kingdom of God is Within You* on him, Tolstoy sending Thoreau's "Civil Disobedience."

1910

Gandhi establishes Tolstoy Farm near Johannesburg as a refuge for families with members arrested in civil disobedience. A first example of his notion of trusteeship, the land is bought for the cause by Gandhi's friend and supporter Hermann Kallenbach.

1912

Two years after the South Africa Act takes away all political rights of indigenous Africans in three of the new country's four states, the African National Congress is formed to organize indigenes in the struggle for civil rights.

1913

The Supreme Court of South Africa declares all marriages between Hindus, Muslims, and Parsis invalid; protests by Indian women are led by Gandhi's wife, Kasturba, and many are jailed. Gandhi joins striking Indian miners evicted from their company housing and organizes a protest march to Johannesburg, which is joined by sympathizers, the first large march by *satyagrahis*, practitioners of truth-force in action.

1914

After negotiating with Gandhi, the government of South Africa repeals laws limiting Indians' rights, including the Black Act.

1914–15

Growing out of a conference of European Christian pacifists, the first Fellowship of Reconciliation is founded in Britain by a Quaker who comes to New York the next year and with John Haynes Holmes and others organizes an American branch. The FOR works for many antiwar causes, helping conscientious objectors, collaborating with labor to create alternatives to a culture of war, and, as the Civil Rights Movement burgeoned, helping train people for nonviolent resistance.

1915

Gandhi returns to India and establishes an ashram in a village near Ahmedabad, Gujarat. Two years later it moves near the Sabarmati River, and although named Abode of the Heart, it is usually called the Sabarmati Ashram. A stricter code of conduct than in his South African communities develops (see the "vows" on p. 257).

ca. 1918

Gandhi begins to use publicly a spinning wheel (*charkha*) to produce homespun cloth (*khadi*), to exemplify his belief in the goodness of labor and the necessity of Indian villagers to develop home industry for economic independence.

1920

A military coup d'etat in Germany fails when noncooperation and strikes by organized labor, government workers, and an unconvinced populace bring the country to a standstill for days, until those in revolt are forced to give back the reins of government.

1920–22

Two years after beginning a campaign of civil disobedience that he calls off when violence erupts, Gandhi is arrested and charged with sedition. He pleads guilty and is sentenced to six years but is released after less than two.

1924

Gandhi advocates to an All India Congress session unifying the various nationalist movements arising and declares the need for Muslim-Hindu unity. He asks for a boycott of foreign cloth.

1929

Adoption of the Geneva Conventions Relative to the Treatment of Prisoners of War.

In India's Northwest Frontier Province, Abdul Ghaffar Khan founds the Servants of God (Khudai Khidmatgar), a Pakhtun service organization pledged explicitly to nonviolence.

1930–31

To start a new campaign for independence, Gandhi leads the Salt March, protesting the tax on salt. Starting out from the Sabarmati Ashram with less than 100 trained *satyagrahis*, on the 241 mile walk to the Arabian Sea hundreds and hundreds join in. At Dandi he and about 4,000 people collect natural salt or seawater to make salt. Gandhi is arrested and jailed, and after the Salt Satyagraha spreads across the country, by the end of 1931 so are about 100,000 more.

1930–34

After Ghaffar Khan supports the Jawaharlal Nehru–led All India Congress's call for full Indian independence; Pakhtuns in the Northwest Frontier join campaigns of noncompliance and civil disobedience. The rapidly growing Servants of God organization maintains nonviolence despite injurious suppression, murderous attacks, and brutal mass imprisonment, but the resistance continues until Gandhi calls off the campaign.

1932

After starting a new civil disobedience campaign, Gandhi is returned to jail. He begins a fast in protest of a governmental decree that untouchables (Harijans to Gandhi, now Dalits) be segregated as a separate electorate. After six days, the hunger strike is successful and the untouchables are given a reservation of seats in the greater Indian electorate.

1933

Gandhi fasts for 21 days for the Harijans' plight; he is released from jail at the start of his fast. When he calls for more civil disobedience, Gandhi is arrested and sentenced to a year in jail.

1934

The Philosophy of Non-Violence by Richard B. Gregg is published in the US and UK, and then in India by Gandhi's Navajivan Trust; it becomes a key text in spreading Gandhian techniques and philosophy of nonviolent resistance.

1934–36

Gandhi starts a Village Industries Association and then in 1936, to test further his Constructive Program (see pp. 93–97), founds Sevagram, "village of service," hoping to live among the villagers near Wardha in Maharashtra state.

1942

Gandhi launches the Quit India campaign, seeking the British colonials' and their government's complete withdrawal. The movement's leaders are immediately imprisoned.

1943

As Jews are rounded up in Berlin for deportation to Auschwitz, hundreds of husbands of ethnic German women are included. In front of the Gestapo headquarters on Rosenstrasse, a number of these wives gather to ask for information, and over the next seven days a spontaneous assembly grows to include hundreds of vocal, demanding citizens. When public support for the demonstrators became evident and the news spreads outside Germany, Joseph Goebbels–the propaganda minister–has all the men, close to 2,000, released.

Gandhi begins his ninth fast, which lasts 21 days. The British Viceroy, describing the strike as blackmail, refuses his demands. Gandhi is released in May 1944, several weeks after his wife dies in prison.

1944

After a month-long nonviolent revolution succeeds in neighboring El Salvador, student-led petitioners in Guatemala call for the resignation of its cruel military dictator. Suppression of peaceful demonstrations and the martyring of a woman schoolteacher bring about a spontaneous general strike and completely shut down the country for several days. With no "enemy" or targets to fight, the dictatorship simply crumbles, and after the problem of a rigged election is solved, Guatemala enjoys ten years of democratic government.

1947

India and Pakistan are granted independence. In Calcutta Gandhi spends the day in fast in protest of the Hindu/Muslim riots. He announces his plan to live with the Hindu minority in Pakistan. After Independence Day, violence between Hindus and Muslims intensifies in Calcutta. Gandhi declares a "fast unto death" in response; rioting stops within days. Gandhi is credited with restoring peace in the city, but warns that he will fast again if violence resumes.

1948

Gandhi fasts for the end of Muslim-Hindu conflict; he stops the fast when Hindu, Muslim, and Sikh leaders agree to keep the peace in Delhi. On January 30, Nathuram Godse, a Hindu nationalist activist, assassinates Gandhi.

On December 10 (later declared Human Rights Day) the UN General Assembly ratifies the Universal Declaration of Human Rights–the first international affirmation that all human beings are free and equal in dignity and rights; in 1976 after two additional covenants are ratified, they become international law.

1949

Adoption of the four Geneva Conventions. Following the atrocities of the Second World War, the fourth Convention provides for the protection of civilian persons in time of war.

1951

In South Africa the Bantu Homelands Act strips millions of blacks of their citizenship; considered foreigners in the white-controlled country, they need passports to enter (and pass laws begin). The next year the African National Congress and South African Indian Congress begin a Defiance Campaign against Unjust Laws.

1955–56

The success of a year-long boycott and campaign against segregation on buses in Montgomery Alabama helps ignite a widespread Civil Rights Movement in the US and catapults Rev. Martin Luther King Jr. to its forefront. Actions based on Christian teachings of love and Gandhian nonviolent tactics become a hallmark of the Movement.

1960–62

Lunch counter sit-ins and interstate Freedom Rides spearheaded by young African Americans trained in Gandhian methods of nonviolent resistance, most by James Lawson or Bayard Rustin, spread across the South in the effort to end legal and de facto racial discrimination.

Albert Mvumbi Lutuli becomes the first African awarded the Nobel Peace Prize, for his leadership of nonviolent defiance against apartheid while he was president of the African National Congress in the 1950s.

1962–66

Two years after 69 black South Africans die and almost 200 are wounded in a peaceful demonstration in Sharpeville and a draconian state of emergency is declared, nonviolent protests end. The United Nations calls for sanctions against South Africa and establishes a special committee charged to monitor progress on ending apartheid. An International Day for the Elimination of Racial Discrimination is declared to mark the anniversary the Sharpeville Massacre.

1963

The March on Washington for Jobs and Freedom, organized by the Congress on Racial Equality, Southern Christian Leadership Conference, Student Nonviolent Coordinating Committee Brotherhood of Sleeping Car Porters, National Association for the Advancement of Colored People, and National Urban League.

1966

As resistance to America's Viet Nam War mounts, the Fellowship of Reconciliation's International Committee of Conscience on Vietnam brings the Buddhist peace and social justice advocate Thich Nhat Hanh to the United States. He later settles in France and becomes a prominent teacher of "peace in every breath, peace in every step."

1965–70

Cesar Chavez and Dolores Huerta lead the United Farm Workers in a campaign of strikes and marches, and a national boycott against California grape growers to eradicate unfair labor practices and agribusiness's exploitation of migrant workers. Sabotage and threats of violence by impatient laborers prompt Chavez to undertake a fast, which lasts more than twenty days but brings an end to the violence. Succeeding after five long years, Chavez reiterates that "through nonviolent action… social justice can be gotten."

1968–69

A few months into the so-called Prague Spring, in which the Communist government of Czechoslovakia loosens hard-line controls, the Soviet Union invades the country and within 48 hours establishes complete military dominance. No resistance is offered, and the government and citizens completely neutralize the occupation through lack of engagement. For months. Although failed negotiations with the Soviets are unable to maintain the reforms for more than a year, there are few casualties despite the massive invasion force.

1970s

The Chipko Movement in Uttarakhand, India, spontaneously creates a method and a Gandhian model for protection of ecologically sound lifestyles based in local ecologies. The United Nation passes increasingly stringent recommendations against and condemnations of the South African government and apartheid, passing more and more encompassing bans on relations with the country. In 1974 South Africa loses seat in United Nations General Assembly, not restored for thirty years.

1971

The Rothko Chapel opens in Houston, dedicated to art, spirituality, and human rights. It begins to organize colloquia exploring interfaith understanding, lectures, and performances exploring the aspirations of the human spirit. It soon develops award programs honoring peace and justice advocates, especially the unsung.

1976
A Green Belt Movement in Central Africa begins when Wangari Maathai mobilizes groups of women in Kenya to plant trees and begin reforestation.

1977
Adoption of the Protocols additional to the Geneva Conventions of 1949. The Protocols strengthen the protection granted to victims of international armed conflicts and, for the first time, of non-international armed conflicts; and they establish a distinction between civilians and combatants.

1977–83
The Mothers of the Plaza De Mayo, as they become known, in Buenos Aires, Argentina, start with silent, low-key gatherings of mothers and wives, who walk in a circle wearing headbands embroidered with the names of "disappeared" loved ones–those eliminated in a continuous, invisible purge by the military dictatorship. After their numbers grow and efforts are made to quell them, their weekly demonstrations are one of the country's few visible signs of discontent. By 1982 the junta is weak and the Mothers increasingly visible; after elections and a change of governments, the issue of the disappeared is not allowed to be forgotten.

1980
Óscar Arnulfo Romero, Archbishop of El Salvador, known for his ministry to the poor and oppressed, is martyred while conducting Mass; in 2014 he is declared a Catholic saint.

1980s
In less than ten years, worker demands in a faltering Communist state in Poland lead first to spontaneous cooperation in strikes that begin achieving their demands, then a nationwide independent labor union, Solidarity. It soon counts more than a third of the population as members. After two years of martial law, concerted efforts begin to create a social economy outside the state apparatus, and in 1989 the government negotiates with Solidarity, which is swept to power by election, and a non-Communist state is peacefully created.

International boycott of businesses and government of South Africa, bans of South African product imports, and citizen demands for major companies to quit South Africa. By late eighties pressure results in repeal of some segregationist laws.

1983
The Albert Einstein Institute is founded in Boston, USA, by peace activist and political theorist Gene Sharp to advance the worldwide study and strategic use of nonviolent action in conflict.

1986
After the assassination of the opposition leader and the patent, obvious rigging of Philippine President Ferdinand Marcos's reelection, the fall of his government and army is brought about not by an aborted coup but by "people power" led by Corazon Aquino, who is popularly recognized as the election's rightful winner. Over a million people surround the encamped rebels to protect them, and the army turns back. A second assault that faces a smaller crowd is aborted by its commander, who refuses to cause civilian casualties, and after Marcos flees, the people's president is inaugurated.

1988–90
Burmese citizens, led by students, openly defy a long-standing military dictatorship and call for a participatory government. After violent repression of a general strike and mass arrests, the recently returned expatriate Aung San Suu Kyi becomes an eloquent democracy advocate. Elections are won by the National League for Democracy, but the dictators refuse to give up power and Suu Kyi's years of house arrest soon follow.

1989
The 14th Dalai Lama is awarded the Nobel Peace Prize for his insistence on a nonviolent solution to the occupation of Tibet and suppression of its native culture, which he bases on Buddhist teachings of compassion and nonharming.

In Czechoslovakia student protests violently quelled lead to a general student strike, around which opposition groups form a Civic Forum that generates meetings of 200–300,000 people in Prague's main square. Their demands are met in two phases by the government, the second of which includes its resignation. In less than one month, government by the Communist Party is replaced by a government of the people, and the leader of 1968's Prague Spring, Alexander Dubcek, and the Civic Forum's leader, Vaclav Havel, are named its leaders.

1990
Nelson Mandela, in prison since 1962, is released and with re-legalized African National Congress negotiates for apartheid's end and representative government.

1991
South African President F.W. de Klerk repeals apartheid laws and calls for a new constitution.

1992
Rigoberta Menchú Tum of Guatemala is awarded the Nobel Peace Prize for her advocacy of indigenous peoples, social justice, and peaceful reconciliation in the aftermath of years of brutal military dictatorship.

1993–94
Nelson Mandela and the F.W. de Klerk are jointly awarded the Nobel Peace Prize for ending apartheid and preparing for a new government in South Africa. The next year, in the country's first free, inclusive election, the African National Congress wins legislative majority, and Nelson Mandela is elected president. Mandela announces the nation subscribes to the Universal Declaration of Human Rights; the United Nations ends its sanctions, readmits the country.

1996
Truth and Reconciliation Commission headed by Archbishop Desmond Tutu begins hearings that conclude South Africa's apartheid was a crime against humanity and tries to heal human rights abuses and suffering caused by all parties to the conflict.

2004
Wangari Maathai is awarded the Nobel Peace Prize for her promotion of sustainable development and human rights, particularly those of women.

2010–11
"Arab Spring" begins with protetsts in Tunisia in late 2010, and the toppling of the government in January 2011. Large nonviolent demonstrations spread to Egypt, Morocco, and Bahrain, and world attention centers on Cairo's Tahrir Square; Egyptian President Hosni Mubarak steps down in February.

2013
Bayard Rustin is awarded a posthumous Presidential Medal of Freedom by President Barak Obama.

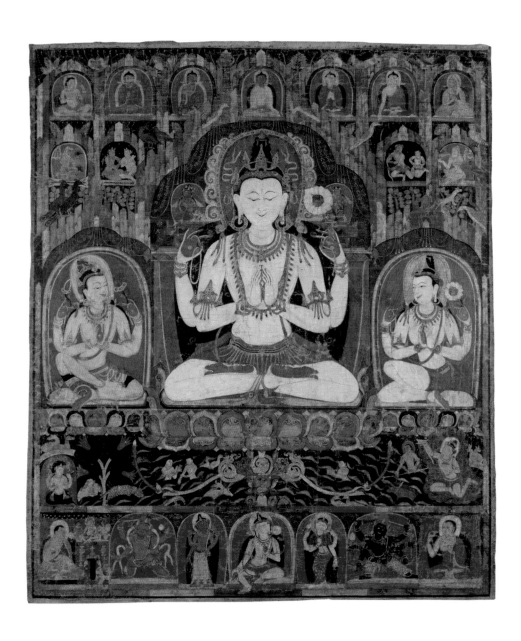

Shadakshari Lokeshvara Triad and Other Deities. Tibet, early 12th century.
Pigment on cotton, 34 × 29 ⅜ × 28 ¾ inches (86.4 × 74.6 cm). Walters Art Museum,
Baltimore, Promised Gift of John and Berthe Ford

Published in conjuction with the exhibition

Experiments with Truth: Gandhi and Images of Nonviolence

organized by The Menil Collection, Houston
Curated by Josef Helfenstein

The Menil Collection
October 2, 2014–February 1, 2015

International Red Cross and Red Crescent Museum, Geneva
April 14, 2015–January 3, 2016

This exhibition is generously supported by:
Clare Casademont and Michael Metz; Franci Neely
Crane; Anne and David Kirkland; Anne and Bill
Stewart; Nina and Michael Zilkha; H-E-B; Skadden,
Arps; Suzanne Deal Booth; Janet and Paul Hobby;
Marilyn Oshman; Baker Hughes Foundation; Diane
and Mike Cannon; Molly Gochman in honor of
Louisa Stude Sarofim; Mark Wawro and Melanie Gray;
Mahatma Gandhi Library; and the City of Houston.

United Airlines is the Preferred Airline
of the Menil Collection.

Published by
The Menil Collection
1511 Branard Street,
Houston, Texas 77006

Distributed by Yale University Press
P.O. Box 209040
302 Temple Street
New Haven, Connecticut 06520-9040
www.yalebooks.com/art

ISBN 978-0-300-20880-1
Library of Congress Control Number: 2014948503

Produced by the Publishing Department of the
 Menil Collection
 Joseph N. Newland, Director of Publishing, and
 Sarah E. Robinson, Assistant Editor
Edited by Joseph N. Newland
Picture research by Sarah E. Robinson
Proofread by Russell Stockman
Graphic design by Lorraine Wild and Amy Fortunato,
 Green Dragon Office, Los Angeles
Production management by The Actualizers, New York
Printed by SYL Creaciones Gráficas, Barcelona, Spain

This book is typset in Lexicon and printed on
GardaPat Kiara

Printed and bound in Spain

Cover: Some of Gandhi's last possessions, ca. 1948–50.
Photographer unknown. James Otis/GandhiServe

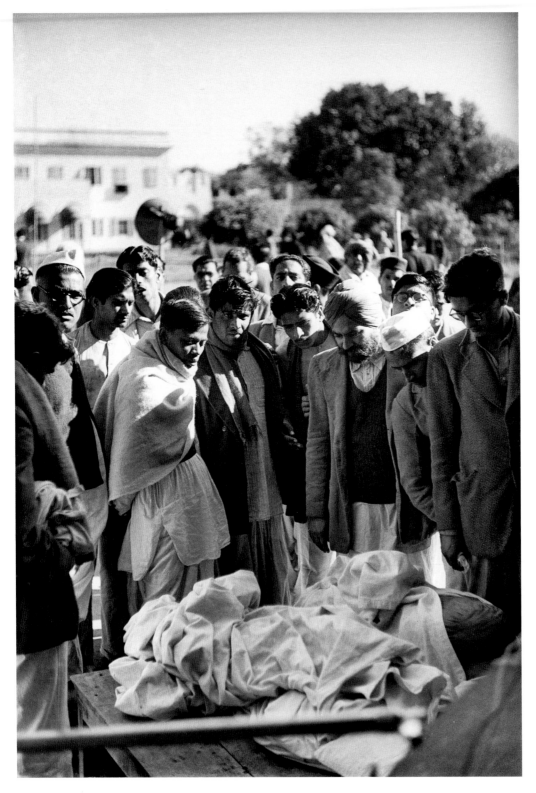

The cloth Gandhi was wearing, just after his death.

Henri Cartier-Bresson (France, 1908–2004), Cloth, Birla House, New Delhi,
January 30, 1948, printed 1960s or 1970s. Gelatin silver print, 10 × 8 ⅛ inches
(25.3 × 20.6 cm). Collection Fondation Henri Cartier-Bresson, Paris